MODERN ENGLISH PAINTERS

Volume Three Hennell to Hockney

Other books by Sir John Rothenstein include

The Artists of the Eighteen-Nineties

Morning Sorrow (novel)

British Artists and the War

Nineteenth-Century Painting

The Life and Death of Conder

Augustus John

Edward Burra

Manet

Turner

London's River (with Father Vincent Turner, S.J.)

The Tate Gallery

British Art Since 1900

Augustus John

Paul Nash

Sickert

Matthew Smith

Turner

Francis Bacon (with Ronald Alley)

Turner (with Martin Butlin)

Autobiography:

 Summer's Lease

 Brave Day, Hideous Night

 Time's Thievish Progress

John Nash

MODERN ENGLISH PAINTERS
JOHN ROTHENSTEIN
Volume Three Hennell to Hockney

MACDONALD & CO

London & Sydney

A MACDONALD BOOK

© John Rothenstein 1952, 1976, 1984

First published in Great Britain in 1952.
First revised edition 1976.
This edition published in 1984
by Macdonald & Co (Publishers) Ltd
London & Sydney

A member of BPCC plc

British Library Cataloguing in Publication Data

Rothenstein, *Sir* John
 Modern English painters.
 Vol. 3: Hennell to Hockney
 1. Painting, Modern—19th century
 2. Painting, Modern—20th century
 3. Painting, English
 I. Title
 759.2 ND467

ISBN 0-356-10355-2

Typeset, printed and bound in Great Britain by
Hazell Watson & Viney Limited
Member of the BPCC Group
Aylesbury, Bucks

Macdonald & Co (Publishers) Ltd
Maxwell House
74 Worship Street
London EC2A 2EN

CONTENTS

CONTENTS

LIST OF ILLUSTRATIONS

(A list of the locations of works mentioned in the text [public galleries only] appears at the end of the book.)

ACKNOWLEDGMENTS

For information, for permission to reproduce pictures and to quote from letters, for assistance in collecting the necessary photographs, and for help of many kinds, I am so deeply in dept that no full list of my obligations is possible. By gracious permission of Her Majesty Queen Elizabeth the Queen Mother, I have been able to reproduce Paul Nash's *Landscape of the Vernal Equinox*. For exceptional help I am indebted to Esther Pissarro, Rachel Fourmaintraux-Winslow, Olivia Walker, Grace Gilman, E. M. O'R. Dickey, H. L. Wellington, Augustus and Dorelia John, Edwin John, Mary Gore, Frederick Turner, Matthew and Gwendolin Smith, Father Vincent Turner, Grace English, Silvia Hay, Derek Hudson, Eric Westbrook, the Matthiesen and Mayor Galleries and Messrs Arthur Tooth, Rex Nan Kivell, George Barker, John Malkin, Prunella Clough, Michael Ayrton, Robert Frame, Keith Vaughan, Sebastian Barker, Benny Creme, the Hon. Anne Ritchie, Barbara Ker-Seymer, William Chappell, Beatrice Dawson, Annette Armstrong, Catharine Chaloner, Kathleen Freedman, Tim Biggs, Anne Spalding, Ian Rogerson, Richard Macleod, Sir James Richards, Anne Williams, James and John Ravilious, Noel Carrington, Thomas Balston, Kathleen Nevinson, Kathleen Wadsworth, Kate Lechmere, Edward Bawden, Mrs Grove and Count Vanden Heuvel. Also to the members of the staff of the Tate Gallery, in particular Corinne Bellow, Elizabeth Bell and the Librarians. To the artists themselves of whom I treat and almost all of whom I was able to approach directly I owe much gratitude for their ready and kindly response to my queries and requests, also to Victoria Funk of Macdonalds.

PREFACE TO NEW EDITION

When the publication of the new edition of this book was under discussion with a friend he asked me how I made the choice of the artists to be included. I replied that it was done purely on the basis of personal conviction. But after the friend had left the relevance of the question remained.

The difference between writing about contemporary artists, even those of a century ago, and about those of a remote past is surely radical. To omit Turner and Constable from a book on early nine-teenth-century British painters would be an unthinkable absurdity. With works of today and the recent past, however, there are no such certainties; it now takes time for certainties to emerge. A few decades ago, for instance, Victorian paintings were regarded widely as pretentious jokes 'only fit for provincial galleries'. Today those jokes – the best of them – are sold regularly at auctions for formidable prices. Until recently even the Pre-Raphaelites, although highly regarded by a few collectors and scholars as radical exceptions, were generally despised. 'Young women who will prattle with assurance of Pruna or Poussin' – I quote from Evelyn Waugh's *PRB: An Essay on the Pre-Raphaelite Brotherhood 1847–1854* – 'will say, should the topic ever arise, "The Pre-Raphaelites – Burne-Jones and people like that – my dear, you can't admire them" '.

The reputation of contemporaries will prove still more elusive. We regard Picasso and Moore as great masters, all but beyond criticism, but we cannot know with any precision how they will be regarded by collectors and scholars a century hence, or who, among their innumer-able contemporaries, will be 'discovered' and acclaimed as masters. For example, only a few years have passed since Henry Moore was discovered and acclaimed. I remember that in 1939 The Contemporary Art Society, which acquired his *Recumbent Figure* – carved the previous year – offered it as a gift to the Tate. Both Kenneth Clark, responsible for its acquisition by the Society, and I were determined that the offer should be accepted, and both had reason to doubt the response of certain of the Gallery's Trustees, even though they showed, in the main, exceptional discernment. ('Discernment', future readers may sneer, because our opinions often coincided.) We

9

accordingly found occasion to express our ardent admiration for
Moore, and for the *Recumbent Figure* in particular, to every Trustee.
We had neither of us ever so acted before. Whether owing to our
words or not I now have no idea, but to our delight the work was
accepted. It today seems very strange to reflect that there was reason
to doubt the acceptance – and as a gift from a Society of notable
discernment – of a work which would receive unquestioning acclaim
and which would cost hundreds of thousands of pounds. Yet some
years hence we may be judged to have shown an enthusiasm, if not
altogether misplaced, at least excessive.

I recall this event as a reminder of the fact that, while in earlier
ages, such as those of ancient Greece and Rome, the Renaissance and
many others, there were certain accepted qualities which enabled the
public to judge works of art. The masters were accordingly afforded
full recognition that has remained virtually constant: Egyptians,
Greeks, Giotto, Michelangelo, Raphael, Rembrandt, Dürer, Turner, to
name a few among a great number. During the last two centuries,
however, reputations have been subject to radical change.

In our times – the last century or so – the qualities earlier referred
to by which all works of art were authoritatively judged no longer
universally apply: those of a wide-ranging variety are universally
accepted. Outstanding public collections are almost all wide-ranging,
their differing, often radically contrasting possessions having been
acquired by the exercise of diverse concepts of quality. But where
contemporary art is concerned there are no such concepts: collectors
who acquire fine works by Blake, Rossetti, Rouault, Picasso, Stanley
Spencer or Moore would be unlikely to be accused of inconsistency,
but rather praised for the wide range of their perception.

In writing about one's contemporaries, unlike those of earlier ages,
one has no incontrovertible standards by which to judge their work.
The writer must form his own judgments, well aware that in the
future the qualities and shortcomings of his subjects are likely to be
assessed quite differently. He must also be aware of his own
shortcomings.

When the question of how to organize my material arose I decided
that the artists should be introduced strictly in the order of their
appearance in the world. To insist upon an artist's identity with a
group is to compromise his individuality; groups have a way of
dissolving under scrutiny, of proving to be more fortuitous in their
composition and more ephemeral than they at first appeared. Unlike
the individuals who compose them, they have no hard core. In earlier,
less disintegrated periods, there was some meaning in the classifi-
cation of artists according to the tradition to which they belonged,
but in our time the general enfeeblement and even collapse of

tradition has made the classification of original artists almost impossible: they exist by virtue of their individual selves alone. The chronological arrangement of the chapters that follow is intended to emphasize the individuality of their subjects by cutting them off from all fortuitous and ephemeral groupings.

My treatment of my various subjects has been deliberately varied. In the cases of painters who are the subjects of adequate biographies either already available or in preparation, it has been primarily critical, or else directed towards the elucidation of lesser-known aspects of their work, lives and personalities. But when my subjects are artists apt to be neglected or almost forgotten, such as Ethel Walker or Gwen John, in such cases I have tried to evoke a degree of recognition of value of their art and interest in their lives and personalities. Those artists who are included for the first time in this edition were added because they seemed to me to be inadequately served by recent scholarship.

I have called the subjects of this book English rather than British because there are notable Scottish painters whose works I have had no opportunity to study. Also because, with the exception of Gwen John, England is or was their home, and it was primarily by the intellectual, emotional, social and physical climate of England that they were all predominantly formed. Several of them were not English-born, and I have in fact dwelt in certain cases upon the effects of their country of birth and early environment: Irish in that of Orpen, Dutch in that of Houthuesen, and Scottish in that of Pryde.

The artists treated in this book are those whose work makes a strong personal appeal – in one or two cases a little less ardent than when I first put pen to paper, but only a little. There is nothing in the pages that follow, I trust, to suggest that I believe that those included are the only serious English painters of our time. I have in fact paid tribute to a number of others in a variety of publications. The volume of talent in Britain in the present century has been formidable, and I would not for a moment doubt that there is much of which I am not fully aware or else entirely ignorant.

THOMAS HENNELL
1903 – 1945

Thomas Hennell was a man virtually without personal ambition, who participated in no 'movement', which would have enabled him to attract the notice of the critics who supported it, and he died at the age of forty-two. There is nothing spectacular about his work, which may easily be overlooked by visitors to public galleries or mixed exhibitions. Recognition of his rare and versatile achievement, however, has grown gradually but increasingly. It is not yet widely recognized, although it is by many fellow artists and writers whose recognition is worth earning.

Thomas Barclay Hennell was born on 16 April 1903 at Ridley Rectory, Kent, son of the Rector of Ridley. The Hennells – no fewer than twenty-one of them – for about a century and a half before Tom's father had been engaged in the making of fine objects in silver. It is therefore not surprising that Tom Hennell should have manifested so profound and wide-ranging a concern with craftsmanship, both as regards his own work and that of craftsmen in general, but in particular that of countrymen. His fascination by the countryside at first covered the region where he was born, near Samuel Palmer's 'Valley of Vision' at Shoreham, and later became widely extended. In his illuminating trio of essays Michael MacLeod appropriately quotes a few lines from 'The House', one of Hennell's poems relating to his early years – so appropriately that I cannot resist following his example:

> Our home stood far from
> turnpike, by lanes which
> turn and twist
> Nor came there often neighbours,
> nor were neighbours missed.

Hennell attended Hildersham House, a school at Broadstairs, from 1912 until 1915. When he arrived there he objected to the regulation school uniform; with surprising toleration the headmaster allowed him to choose a suit for himself. He chose, in his own words, 'a tweed, something the birds wouldn't mind'. What provoked his objection is uncertain – for birds surely do not discriminate between

13

the ways in which boys are dressed – but what was evident was the strength of his conviction – a strength which, however gentle his disposition – was always present. (I did not come to know him until a number of years later and never saw him wearing anything but tweeds.)

In January 1915 Hennell went on to Bradfield School where he remained until April 1921. By the time he had left school, although he had shown ability in academic subjects, he was already determined to be an artist and he persuaded his father, who had decided he should go to a university, to allow him to study art. He accordingly attended the Regent Street Polytechnic School of Art between 1921 and 1926, studying drawing and painting.

Among Hennell's teachers was Marion Richardson who affected him profoundly and with whom he fell passionately in love; she is 'Clarissa Firestone' in his novel, *The Witnesses* (1938); it was she who intensified his interest in the art of children.

Two or three years later Hennell joined the staff at Kingswood School, Bath, also teaching drawing one day a week at the nearby Bruton School. The basis of his teaching was the exact understanding and precise representation of the subject. A letter from one of his Bath students gives a convincing impression:

> Most of his teaching ... was done by taking individual boys into a corner where he would talk to them with tremendous seriousness. He was a man who could express himself with great clearness but needed a more sympathetic and more developed mind in his listeners than he ever found with us. But he would never let his students go until he thought the lesson had been understood. This often took some time and we used to dread being taken over to the corner. The answer to an enquiry about a windmill once took him half the morning. Hennell at these times became totally absorbed in his subject. His descriptions were athletic. He became the sails of a windmill, he became the miller carrying sacks, he showed with his fingers the meshing of the cogs and gave lists of the hardwoods used for the different parts of the mechanism.

Another, more recent account reads:

> It was winter and after supper round the fire he brought out bowls of apples and nuts. These were important because he had grown them himself ... and explained how they had to be cultivated and how long he had had the trees ... and how different was the fruit from similar trees on other soils in Essex, Somerset, Herefordshire, Wales, Scotland and Ireland. He had an intimate knowledge of his own neighbourhood and could quote all the crops and operations for the last twenty years or more.

Hennell left Kingswood in about 1930 in order to devote himself to making watercolours and to collecting material for *Change in the Farm*

(1934), his first book, which he wrote and illustrated. It is an extraordinarily informative description of the old and disappearing tools of husbandry. The first two sentences of the preface precisely describe his aims:

> In every farmyard, outhouse and contingent building throughout the country are to be seen – piled-up relics of past generations of farmers – the remains of old ploughs, wagons, implements crumbling away behind the new steam-thresher and brightly-painted iron rakes harrows.
>
> The following compilation is an attempt to collect and arrange some of this lumber, whose wormy and twisted forms with their crust of fowl-dung may prevent their uses from being discerned, though upon closer scrutiny their character becomes recognizable.

Hennell's 'attempt' is impressively realized in this extraordinarily wide-ranging description of the tools of husbandry, but far more is in fact realized than descriptions of objects which still exist. He refers, for instance, to the differences in the use of remnants of an old Celtic language in Westmorland, between Borrowdale and Wasdale, giving examples. The illustrations in the book, made in 1930, are impressive: a simple drawing of some very ordinary object, the nuts of a wheel or a wagon for example, portrayed very precisely, rivet the attention. This book evoked a well-deserved tribute from Michael MacLeod:

> *Change in the Farm* is a detailed and informative piece of research. It indicates that Hennell, as a landscape painter, knew more about the land, the people who live by it, the machines with which they work it and the livestock they tend, than most major British artists, Constable and Palmer included.

Hennell's constant travels were made on his bicycle, on which he covered enormous distances, and he was constantly on the alert for landscapes to draw, archaic farmcarts or agricultural machines, or wildflowers of any particular interest – all this primarily to assemble material for *Change in the Farm*.

Among Hennell's close friends were Edward Bawden and Eric Ravilious, whom he first came to know at Brick House, Great Bardfield. Nearly fifty years later Edward recalled the circumstances of their first meeting:

> One morning in 1931, when Eric Ravilious and I came down to the kitchen to wash ourselves ... we found a stranger stripped to the waist, pumping water over his head and making quite a splash in the large slate sink. He was tall and thin, with black beady eyes rather close set, dark, slightly curly hair and as he greeted us his voice had a deep booming parsonic ring, which echoed even more loudly when he laughed. Outside, leaning against the doorpost was a heavy, khaki-coloured Army bike, and on it, tied to the bar between the saddle and the steering wheel, a large, perfect specimen of a corndolly of the sort

known as the Lord's Table. Tom greeted us in the most friendly manner.
Our identity was divulged in a matter of seconds and friendship
established immediately . . .

It was a strange meeting, but explained by the fact that Hennell had
arrived in Bardfield late the previous evening and had been given a
room by *their* landlady.

In the chapter on Bawden a brief account is given of Hennell's,
Ravilious's and their wives' friendship and of their invention and
narration of *Lady Filmy Fern*, in which Hennell took no part but
eventually wrote it down; also of the strange fate of the manuscript,
which did not find a publisher until almost half a century later.

The years 1930 and 1931 were an extraordinarily productive period
in Hennell's life, during which, besides writing and illustrating the
original, erudite and wide-ranging *Change in the Farm*, he made
numerous drawings and watercolours, all of which came to a sudden
and tragic interruption lasting several years.

In the autumn of 1932 Hennell suffered a mental collapse and was
confined for just over three years for treatment: first, briefly, at Stone,
near Aylesbury; then, on 25 October, he was transferred to the
Maudsley Hospital, Denmark Hill, London, where he was diagnosed
as schizophrenic. Here he remained until April 1933 when he was
again transferred to Claybury Hospital in Essex as a private patient,
whence he was discharged on 31 October 1935 as 'recovered'.

Hennell wrote an account of these years in *The Witnesses*. It is an
extraordinary book: an extremely detailed account of his impending
madness, of its wild and terrible climax and of his gradual but
complete return to sanity. It is in fact autobiographical with names
invented for real people. Regarding the time before he was confined
for treatment, he wrote:

> I began to take notice of some mental effects in myself which were new
> to my waking consciousness. These apparitions were over before I had
> well understood them to have begun, like the sudden conflagration of
> a half-made firework, so that they could be read only from the
> impression which they printed on the memory.

Then, a little later, as a patient at Stone:

> The door being now opened, I followed the unruly route into a long
> and mean passage which was crowded with such a disorderly, shocking
> rabble as I never saw; worse than any beggars or ruffians . . . A large
> safe or strong-room was opened: it was managed that I should enter,
> and this door was instantly shut fast . . . In the room from which I came
> there had been a man sitting up in bed, whose right hand pointed at
> me as though it held a pistol, but there was no weapon and the hand
> was withered . . . Of nights . . . the call grew smaller, and I dwindled
> with it as we descended in a spiral curve: then my body was no bigger
> than a glow-worm. And then we were on the point of entering nether

worlds, hollow globes filled with electric light, guarded by small
uniformed men, who were half-mechanical . . . Somehow I had got into
a long and pointed glass case (there were two or three other such cases)
filled with a peculiar unnatural light. No possible way was there of
getting out of this case, which nodded and tottered on the edge of a
precipice . . .

And he was haunted by a motley crowd of figures, grotesque, ethereal,
transmutable and mostly sinister.

Eventually, after a long period of horror, made credible by his
extraordinarily retentive memory and his literary skill, Hennell
regained his sanity. In the last chapter of the book, entitled 'Out of
the Wood', he relates how his offer to make three wall-paintings as a
gift to Claybury Hospital was accepted. They were his first wall
decorations and he worked on them over several months. Of these,
however, no traces remain. 'My path to my daily occupation lay
through a wood,' he wrote, 'a small forest of oak and sweet chestnut,
with lesser trees such as crab, dogwood, wildservice, and dense
bramble thickets.' After references to other natural beauties, he
continued:

> And yet as mediums and types of aspiration these trees were lovelier
> and more real to my mind: they were known individually and connected
> by a practice of thought with trees in other places that I knew well – as
> though these might bear messages; and under their branches I used to
> desire blessings . . . The solitary woods were free enough to purge
> many uncouth fancies: by this contact with nature the inconsistencies
> of hallucinatory voices (now well under conscious dominance) grew
> more clear and lovely in harmony with the virtue of these scenes.

On his release Hennell settled in Orchard Cottage, Ridley, where
he was greatly helped in its domestic management by Danny Nangle,
an old and valued family friend.

He resumed his work as both writer and artist – not that he had
ceased drawing entirely during his confinement: his *Study of Trees* –
watercolour washes of pink, yellow and pale blue over an ink
drawing, and another on the reverse side – MacLeod believes to have
been made in about 1935 when Hennell was still at Claybury.
(Another drawing certainly made there will be referred to shortly.)
Hennell's friend E. Owen Jennings told MacLeod that several years
after his return from hospital Hennell chanced to notice the drawing
and gave it to him saying, 'I did it when I was in the looney-bin'.
Jennings gave it to MacLeod in exchange for ten picture frames. Had
Hennell produced nothing except *Change in the Farm* and *The Witnesses*
his creative life would have been memorable: to have created by his
mid-thirties two such notable works yet of a character so radically
different is a rare achievement.

Although his remaining years were relatively few, they were marked by a growing mastery of watercolour, a medium about which he wrote an article in 1943 entitled 'In Praise of Watercolour', in which he gives lucid expression to his own convictions. There follow some extracts:

> An oil painting, which aims to realize much, may end as a cumbrous piece of furniture: a drawing of no pretension, the simpler the better may convey more: it may preserve a precious instant

> . . . painting is oftenest and longest enjoyed in a glance, or when conscious percipience is in abeyance.

> Turner, who developed the technique of drawing and colour beyond former human achievement, was sometimes defeated by rivalry between his world and the world outside.

> Style with faultless craftsmanship such as Cotman's, which gives dignity and distinction to simple ordinary things . . .

> We look in a landscape painting not primarily for a rationalized statement, nor for a description of fact, but for the moment of vision. Rarely indeed is that supreme moment captured in an 'important work'; though the great old landscapes include such moments in due sequence and order just as an epic poem includes phrases and passages of lyrical quality. But the lyric today is our forte, and today we come nearer to it in watercolour than in words.

> No doubt too in times of austere need, at at present and in the past war, there is more stuff in our best efforts. Life is more urgent, more realistic: the sanctuary of nature is no temple of idleness.

> Watercolour is the most lovely, delicate and flower-like of all ways of painting. A clear wash laid on swiftly and allowed to dry untroubled, the light of the paper shining through its transparency has a natural likeness to sky or water. The mystery is multiplied when a second wash, of a different tint, is laid on as partly to veil the first, without disturbing it. The appreciation of these effects in relation to the changes of light and tone in nature: the subtle, half-unconscious foreseeing in management of their incidents, intensify the likeness to an illusion.

> The affinity between paper and colour is most palpable when it is about to rain; when the sky is overcast, the atmosphere limpid. One's brain is then most clear and vigorous, and the desire to paint in watercoloure is strongest.

> The powers of sky and landscape are seen most vividly as nature prepares to intensify and enrich her colours. Now is the moment: in a few minutes the clouds which have been drifting and building to a perfect form, will already be condensing or dispersing. And now comes the rain, falling first in clear blots, then in a too generous sprinkle, at last in waving sheets.

In these paragraphs several of Hennell's basic feelings and ideas are manifest: his passionate dedication to watercolour and his prejudice against oils; his intense preference for the lyrical, 'the

moment of vision', over 'the important work'; again for the spon-
taneity attainable in watercolour over the 'rationalized statement'
which he associates with oils; and his enchantment with clouds and
rain 'falling . . . in waving sheets.' And with what increasing mastery
was Hennell able to give visual expression to the emotions and ideas
here so poetically, and lucidly, expressed!

Hennell had several close friends, among them Bawden, Ravilious
and Cyril Mahoney, and I used to hear them speak of him with
admiration and affection. I had also read *The Witnesses*, which
impressed me deeply. After seeing some of his watercolours I wrote
to him at the beginning of the Second World War expressing the
hope that I would have the opportunity of seeing some of his works
with a view to an example being considered for acquisition by the
Tate. I received the following reply:

> Orchard Cottage
> Ridley
> Wrotham, Kent.
> *20th Sept. 1940*

Your letter and invitation have given me such encouragement as I find
difficult to express. Will it suit you if I come with the drawings next
Wednesday, Aug. 28th at 11 a.m. or up till 3 p.m.? I should like if
possible to have your advice on what I should leave. But I will leave
them on Wednesday morning, unless I hear from you that some other
day & hour would be more convenient.

I was on a four-day visit to my parents at their home at Far
Oakridge, Gloucestershire, where Hennell arrived on the day pro-
posed. The entry in my diary reads: 'In morning Thos. Hennell came
to see me. A tall, awkward rustic chap, but one of obvious sensibility,
&, I shd. think, of complete integrity. V. modest, showing traces of
the nervousness suggested in *Witnesses*, but v. slight ones. Seemed
greatly delighted at my invitation to bring his work. Chose several
things to show Bd. (Board of Trustees)'.

Hennell had arrived on his bicycle, on which I had been told he
almost invariably travelled, and which might have been one of the
old and disappearing agricultural tools he talked about before he set
off again. It was rusty, with a big iron carrier made for him, he said,
by a local blacksmith, filled with the tools of his calling.

In appearance he was as Bawden described him, but I also noticed
his extremely long macintosh and his hobnail boots. In response to
an enquiry about his method of working on several of the drawings,
he explained that he had used a pencil dipped in ink to give marked
emphasis to his lines at certain relevant points, and that these were
sometimes the basis of a watercolour and at others imposed on top of
the painting.

I wished he could have talked of his work at length, but he was expected at some far distant place. He did, however, leave a number of watercolours and pen-and-ink and wash drawings. Of these, three watercolours and a pen-and-ink drawing were acquired by the Tate Gallery (two of the watercolours were purchased and one was given as the anonymous gift of the artist). The drawing *We are Debtors to the Sane*, reproduced as the frontispiece to *The Witnesses*, was made in about 1935 at Claybury Hospital. It is one of Hennell's finest drawings and gives ample evidence of his recovery, but it is of a terrible subject: three inmates sitting helplessly together, one of them having a pocket picked by a member of the staff, at whom he gazes uncomprehendingly. At first glance it seems a sketch, yet every feature – not only the vacant melancholy faces of the inmates and every pose but even the clothes – are intensely expressive; so too is the routinely unscrupulous face of the robber.

On 18 June 1941 Hennell called on me at the Tate to express his delight that these purchases had been made and talked at length and with perceptive enthusiasm about Charles Mahoney's mural paintings at Campion Hall, Oxford. As he mounted his bicycle to leave, the sound of distant bombing could be heard.

Some four months later, on 19 October, I again visited my parents. After dinner that evening we talked of Hennell. 'If he chooses to go for it,' my father said, 'he can be one of the writers of our time: *The Witnesses* is a great book. What is his poetry like?' I handed him *Poems* – published in 1936 – from which he read several verses aloud. 'It's no good,' he said, 'he's a real literary man and can write anything he wants, but this is simply an intelligent man's echoes of what Crabbe and others have written.'

These poems evoked ardent, if sometimes qualified, admiration. Gerard Hopkins, author of the book's introduction, wrote of Hennell's 'sensibility unfettered by fashions of literature, and the note he strikes has not been heard in the poetry of today. The farmer, the painter and the mystic combined as authors of his unequal utterance.'

One of Hennell's watercolours, *Frost and Lime*, evoked my particular admiration, and on 20 September 1942 he wrote telling me that it was 'mounted and ready for me', offering to either leave it at the National Gallery or bring it himself, but adding, 'But what I am really hoping is that you may find an opportunity of coming here' (to Orchard Cottage), which, to my regret, wartime circumstances did not allow. I had been warned by friends we shared in common that praise of a particular work was almost certain to result in Hennell offering it as a gift. Of this I took note and in his next letter he wrote: 'The price was 6 guineas: if you are willing to call it £6.10s. that will cover my expenses . . .'

I found Hennell's company exceptionally enjoyable: he was very friendly and instructive about many subjects. The war, however, made it difficult and eventually impossible for us to meet. Soon after its outbreak he offered his services to the War Artists' Commission. MacLeod relates that, 'Informed that the Commission was short of funds Hennell replied: "I offer my services in return for food and accommodation only, and these of a private soldier, the work done to remain the property of the Ministry of Information". The Commission regretted, however, that it was not possible to make an arrangement on the terms proposed.'

The War Artists' Advisory Committee was established late in 1939, but it was not until 1941 that one of Hennell's works, *A Threshing Team*, was purchased. A few months later several of Hennell's watercolours, also of country subjects, were considered by the Ministry of Information. As a result he was commissioned, although for some reason with hesitation, to record the harvest of that year, which was followed by several quarterly contracts, in accordance with which he made drawings for several other government departments. The recognition of his talents by Sir Kenneth Clark – who besides being Director of the National Gallery held a post in the Ministry of Information – makes it all the more surprising that Hennell's appointment as a war artist was delayed for so long. For it was not until June 1943 that he was invited by the War Artists' Committee to 'record aspects of the War in Iceland', as an Honorary Lieutenant, RNVR, for a period of three months, his pay being £162. In the interest of security he was warned to show none of his works, even to his friends.

Hennell's term of service in Iceland, he wrote in a letter to a friend – I quote from MacLeod – 'was a great experience and a definite advance to me as a painter . . . Iceland is certainly magnificent. The mountains are grand masses especially at evening when they have enormous shadows. In a midday light they are black and tawny with a sheen rather like an animal's skin.' He enjoyed Iceland, found the Icelanders most likeable, and to his surprise they showed interest in his work. His base in Reykjavik was the Sailors' Trefoil Rest, which he described as 'easily the best and most interesting club in the town. Old Aberdeen skippers, Americans (who then occupied the country) and Icelanders came in as though to a sort of spiritual stove.'

In Iceland he worked hard and well, making some of his best watercolours, but he also found time to teach a drawing class which had been started for visitors at Sailors' Rest. Towards the end of the year he returned to England and was commissioned by the Ministry of Agriculture and Fisheries to make drawings of trawler fleets and shipbuilding on the east coast. After recording preparations for the

D-Day landings of 6 June, he arrived in Normandy five days later. Hennell was appointed a War Artist, replacing Ravilious, and for a while shared lodgings with Albert Richards: tragic associations, for within a brief span of time all three met their deaths.

As it had on Bawden and Ravilious – to name only two who were his close friends – the war had an exhilarating effect on Hennell's art. He had never before made such masterly watercolours as, for instance, *S.S. Polar Bear in the Slips at Reykjavik* (1943) or *The Tithe Barn at St Pierre-sur-Dives* (1944). In a letter of 13 July 1944 to his old friend Danny Nangle, he wrote: 'We saw the great air attack on Caen two nights ago from a point near the coast. It was a magnificent evening and some five or six hundred machines must have come over – some dropping showers of incendiaries. When it was dusk we saw a red glow: but the bombing produced a dust storm that darkened and obscured everything.'

With the advancing Allied armies Hennell went into Holland and, briefly, Germany, but in February 1945 he was recalled. A few months later he was attached to the RAF 'to record aspects of the War in India, Burma and the East Indies' against Japan. He visited Rangoon, Calcutta, Colombo, Penang and Java, where he made, among other watercolours, such as *HMS Nelson receiving a Japanese vessel to make arrangements for the British occupation of Penang 3 September 1945*. This was the end of the war. In a letter to his friend Margery Kendon – again I quote from MacLeod – he wrote:

> I am eager to get back to England and I should like to spend some of the winter days in the V & A and the British Museum now that they are reopened. It's a very long time since I heard from London and I don't know whether I shall be home by Christmas . . . I am hoping . . . to pull off a trip by junk to Sumatra with a Dutch ex-POW who speaks good Malay and is also an artist.

Some time in November Hennell was captured by Indonesian nationalists. He was last seen armed with a sten-gun guarding civilians who had taken refuge in an hotel in what was then called Batavia, and was reported missing, later presumed killed. He was forty-two.

ERIC RAVILIOUS
1903 – 1942

The subject of this essay, born in Acton, London on 22 July 1903, was named Eric William but, from his student years at least, Eric was considered not to suit him, and instead he was called 'The Boy' or 'Rav'. He was the youngest of the four children of Frank Ravilious and Emma, born Ford, the daughter of a coachman who lived at Kingsbridge in Devon. The name Ravilious probably derives from that of a Huguenot refugee, possibly Revilion or Revalier.

Frank Ravilious – as had James, his father – ran a draper's shop in Acton. It failed, and the family moved to Eastbourne, where Frank ran an antique shop, with indifferent success, for he was not a businessman but a man obsessed by a highly personal concept of Christianity. He was not, accordingly, a member of any particular sect, and on Sundays the family went – morning and evening – to Baptist, Wesleyan, Methodist or Presbyterian chapels. It was the family habit to walk to chapel arm-in-arm, which probably accounts for 'the Boy's' marked and abiding dislike of walking with arms linked with anyone.

The changing contents of his father's shop no doubt enhanced the innate keenness of Ravilious's perception, and it was here that he first saw early English watercolours. The shop's miscellaneous contents may well have contributed to his lifelong practice of assembling scrapbooks containing oddments which he considered of possible use in addition to his own working notes. All of this material was then stuck into large books together with a wide variety of miscellanea, including photographs, newspaper cuttings and a number of his childhood pencil drawings – anything, in fact, that he considered a useful reminder or the germ of an idea.

Among his early drawings is one dated 22 October 1914 of an egg in an eggcup, which anticipates the delicate clarity of his mature years. How early and proficiently he came to use pen-and-ink and watercolours is apparent in a number of pictures made two years later, all dated September 1916. Among these is a pencil drawing of a tall building set in an orchard. The treatment of the apple trees is marked by a delicate precision, the more impressive for being the

23

work of a boy who appeared to have no intention of becoming an artist.

After attending a small church school at Willingdon and the East-bourne Grammar School from 1914 until 1919, Ravilious sat for the Cambridge Senior Local Examination and passed with distinction in drawing. He was then awarded a scholarship at the Eastbourne School of Art, where he remained for the next three years. He became an art student almost by chance, yet having done so he worked, as he did for the rest of his life, with intense dedication. In any case it was a demanding school. A copy of the timetable for his first term shows that there were classes every morning, including Saturday, and even-ing classes on Tuesdays and Fridays. The subjects were pen drawing, still-life, elementary design, lettering, nature study, antiques, com-position and life drawing.

In his last year he also attended life-classes at Brighton with a fellow student, Donald Towner. Another fellow student and friend, John Lake, wrote a description of them for Helen Binyon, author of the highly informative *Eric Ravilious, A Memoir of an Artist*. This reads in part:

> From the first Ravilious had an extraordinary, almost Pan-like charm and was a shy but very amusing person who from time to time came up with some most unexpected remarks. He and I played tennis together . . . It was the originality of both Towner and Ravilious in particular which impressed me. I always particularly admired and indeed was envious of Eric's hands and I can see them now in my mind's eye. The delicate long, sensitive spatulate fingers . . . he always seemed to me to be slightly somewhere else, as if he lived a private life which did not completely coincide with material existence.

While the three of them were on a walking tour Towner was annoyed 'at being woken sometimes in the night by Ravilious's loud laughter in his sleep – so entertaining were his dreams'.

The Eastbourne School of Art awarded one scholarship a year to a student wishing to go to the Royal College of Art. In the examination Ravilious came second, but the student who came first decided that her true vocation was to be a missionary and the scholarship was accordingly passed to Ravilious. He and Towner arrived there on the first day of the autumn term, 1922, and entered the school of design.

Ravilious's outstanding talent and capacity for work were quickly recognized. For instance, the recently appointed Leon Underwood – an artist of exceptional talent in several media and an inspiring teacher – also conducted classes in his own home in the evenings to which only students for whom he had a high regard were admitted. Among those included were Henry Moore, Barbara Hepworth and Eric Ravilious.

As noted earlier, on his arrival at the College Ravilious met Edward Bawden with whom he formed an intimate and enduring friendship. Another close friend was Douglas Percy Bliss, who – to quote from the description of him in Helen Binyon's biography – thus described Ravilious:

> He was educating himself, finding . . . the particular nourishment he needed. He was fastidious and assimilative, culling his fruits from any bough, trying out conventions from Gothic tapestries, Elizabethan painted cloths, the wood cuts of Incunabula, or Persian miniatures. He had exquisite taste and sifted with the skill of an anthologist in the rare things that could help him in his work . . . (he) went his own way, rather like a sleepwalker, but with a sure step and an unswerving instinct for style.

A member of the staff who taught for one day a week in the design school was Paul Nash, whose original vision and technical accomplishment evoked the ardent admiration of a number of the students. Among them, whose tentative beginnings as a wood-engraver he warmly encouraged, was Ravilious.

Ravilious was no less preoccupied with mural painting, which he selected for his examination subject. He not only took the College diploma with distinction but was awarded the Design School Travelling Scholarship as well. In Italy – he spent most of his time in Florence, although briefly visiting San Gimignano, Siena and Volterra – he visited Bernard Berenson, to whom my father had given him a letter, and heard him discourse on the Florentine masters. But the immediate effect of the visit was negative. Ravilious was overwhelmed by the sheer volume of the painting he saw, did little work and instead went for long walks beside the Arno and over the surrounding countryside.

It was some time after he returned home that he made the fullest use of that he had seen but only half-consciously assimilated. The delay also had another cause: the surge of enthusiasm for wood-engraving in which Ravilious, Bawden, Bliss and a number of others were caught up. (The winners of Rome scholarships usually brought back copies of works by the Italian masters as evidence of their studies; Ravilious only brought back four small wood-engravings. These, however, pleasantly surprised his tutors.)

This enthusiasm for wood-engraving found expression in *The Students Magazine*, of which Bliss was the editor. In June 1925 its name was changed to *Gallimaufry*. Ravilious designed its audacious new cover and inside were two of his wood-engravings. Bliss's editorial proclaimed: 'We have tried to give you something cheerier, with clearer type, more stimulating designs and a touch of colour, hand applied by the Committee for love of you all.' *Gallimaufry* was

an immediate success: several copies were bought for the Print Room at the British Museum where two were placed on exhibition, and another presented to the Bibliothéque Nationale in Paris. Francis Meynell, who had recently founded the Nonesuch Press, impressed by the handling of colour, persuaded Bliss to undertake, together with some of his friends, the colouring of a Nonesuch book.

Redliffe Road, where Ravilious, Bawden and Bliss – and a number of other College friends – had studios, became a centre of extraordinary activity and success. Bawden wrote to Ravilious asking about the choice of books to illustrate: 'Please advise me what to choose or to refuse.' And Ravilious wrote to their friend and fellow student Cecilia Dunbar Kilburn, '. . . Aren't Bliss and Bawden going it just at present; publishers fall to them, Bliss says, at the rate of four a week. Bawden is overdoing it now I think, he will kill himself . . . Do you know anyone he could marry? Perhaps God will create a wife (from a rib) for such a diligent servant as Edward. He is quite as peculiar a case as Adam.'

Ravilious, however, was no idler; although he played, and frequently, a variety of games – cricket, football, hockey and squash – was susceptible to pretty students, never missed a dance and was in general socially disposed, nevertheless he worked very long hours, often far into the night.

To most of his fellow students he appeared extremely sociable, with his friendly smile and his habitual whistling of popular tunes, but there was a contrary aspect to his disposition. He was subject to nightmares, one of which he described at length in a letter to Cecilia Dunbar Kilburn: 'I forgot to say . . . that just as I was on the point, as I thought of dying I had sung as strongly as I could "Hard-hearted Hannah" (please believe me about this) and after that shouted something unmentionable . . . Then I realized that these were not estimable last words and sang an Elizabethan song . . . that seemed in better taste than the thing I had shouted out.'

After leaving the College in September 1926 Ravilious accepted the position of a part-time teacher at the School of Art at Eastbourne. Thus he was able to stay with his parents and keep his London studio. He retained this position for several years. In the summer he took his students on sketching expeditions which enabled him to explore a part of the country which was and remained a source of delight.

Ravilious's second year at Eastbourne was marked by a crucial event: he fell in love. For him this was far from unusual – as earlier intimated he was highly susceptible – but this time it was deeply, with a newly arrived student at the School. She was Tirzah Garwood, ('Tirzah' means 'third' in Hebrew, hence the name by which, although

christened Eileen, she was always known) aged eighteen, and beautiful; the third child of Lieutenant-Colonel Garwood, who, on his retirement, had settled in Eastbourne with his wife and five children. He kept a diary, and an entry for 30 September 1926 is significant: 'Tirzah suddenly very keen and energetic about School of Art'; likewise another for 24 November: 'Tirzah's first wood-block'. Her enthusiasm for the medium was justified, for a year later she had four engravings accepted for exhibition by the Society of Wood-Engravers. She was also awarded prizes for drawing as well as engraving.

Partly because of class prejudice and partly because of Tirzah's attachment to a young man in the Colonial Service whom they favoured, her parents were severely opposed to her growing friendship with Ravilious. It took her some time to reach a decision. They were married, however, on 23 May 1930 in a Presbyterian Church in London, Bawden being best man.

Ravilious accepted a one-day-a-week post at the Royal College and taught occasionally at the Ruskin School of Art in Oxford. In the meantime he and Tirzah had taken a flat at 5 Stratford Road, Kensington, shortly moving to a house in Welje Road, Hammersmith at the corner of Upper Mall where they rented the ground floor and basement. The bay window of their sitting room overlooked the river. A training ship, the *Stork*, anchored opposite, features in several of the paintings.

It was probably in 1927 that Ravilious painted his portrait of Bawden seated painting at an easel – remarkable for the elegant clarity with which every feature of the studio is represented, in particular the curtained window, the big cluster of rolls of paper, upright, and Bawden himself seated before his canvas – a compelling likeness in posture and the small profile head. Remarkable, too, as an achievement in oils, a medium Ravilious tended consistently to eschew and was apt to compare unfavourably with watercolour. It should be in the National Portrait Gallery instead of the Royal College of Art.

At the beginning of 1928, the most ambitious of Ravilious's and Bawden's mural paintings were begun at Morley College in London. Completed some two years later, on 6 February 1930 the opening ceremony was performed by the Prime Minister, Stanley Baldwin.

The two artists, although each was responsible for his own areas of wall space, worked in the closest concert. In Ravilious's there appeared the Wilmington Giant, which he had taken his Eastbourne students to see. There were several more immediately autobiographical features: in a six-room house without a front wall a father and

father-in-law discussed the young couple in the opposite room. The girl was Tirzah – in fact there were several Tirzahs.

My father, who was largely responsible for the project, wrote to Ravilious: 'I cannot express my happiness in yr wall, each time I see it, so full of beauty, wit and poetry as it is – I hope many will feel as I do about these admirable paintings.' About the wall paintings, which are referred to in the chapter on Bawden in the second volume of this series, I propose to say no more. They were destroyed in an air-raid in the Second World War.

In the autumn of 1925 Ravilious was elected a member of the Society of Wood-Engravers, his proposer being Paul Nash. Considering the high distinction of others proposed – among them Charles Ginner and David Jones – it was a particular honour for someone so recently a student. The Society's founder was Robert Gibbings, who was to figure significantly in Ravilious's career, and among other founder members were Lucien Pissarro, Gordon Craig, Eric Gill and Paul and John Nash.

Gibbings had been a student in the illustration class at the Central School of Art and Crafts under Noel Rooke, a now somewhat forgotten figure who in fact exercised a radical influence on the practice of wood-engraving. For decades before the First World War many splendid book illustrations had been printed from wood-cuts. The process taught and advocated by Rooke was that of the wood-engraving, as distinct from the wood-cut, which prints as a white rather than a black line. 'A wood engraving', he maintained, 'would only have the quality of an original work of art if it were designed by the artist, graver in hand, with incisions dictated by the medium itself, and not by the quite alien pen or pencil.'

Gibbings had bought the Golden Cockerel Press in 1922 and during the following nine years it produced seventy-two books, forty-eight of which were illustrated by wood-engravings, a number of these his own. Eric Gill was a close collaborator. Gibbings was a man of high enterprise and alert for talent; accordingly, his meeting with Ravilious was significant for both of them. During the years ahead a number of his finest engraved illustrations were commissioned by the Golden Cockerel Press.

The first publisher to commission Ravilious to make wood-engravings was not, however, the Golden Cockerel Press but Jonathan Cape; these were illustrations for *Desert*, by Martin Armstrong, which appeared in 1926. His delicately cut engravings, Ravilious found, had in places lost their definition – indeed some entirely lack the qualities by which his finest are so conspicuously marked – and he accordingly took pains to develop his craftsmanship so as to enable them to be printed with entire clarity. The next two books he illustrated, *A Ballad*

Upon a Wedding by Sir John Suckling and *The Twelve Months*, by Nicholas Breton, were both published the following year by the Golden Cockerel Press.

Ravilious and a number of his fellow printmakers, however great their respect for the publications of the private presses, were increasingly desirous of applying the knowledge they had derived from these to the practices of an industrial printing house. The publication the *Fleuron* magazine had been established in 1922 'with the aim of producing one book a year to demonstrate to collectors and anyone else who was interested, that books set by machines could be as beautiful as the books of the Hand Presses'. Ravilious had four works published by *Fleuron*, four more by the Golden Cockerel Press and still others by a variety of concerns. He also executed designs for business and miscellaneous purposes. To take a few examples virtually at random: 'Cover of Prospectus for Golden Cockerel Press, of 1933'; 'Cover Design for Curwen Press News, Letter 6'; 'Design for Prospectus for the *Cornhill Magazine* and Shakespeare's *Twelfth Night*', a superb achievement. Even if he had made nothing else, his wood-engravings would have been memorable.

Ravilious worked, too, in a variety of other media, including furniture design and pottery. However, painting always remained, until the very end of his life, the art for which he felt most deeply.

In 1933 a new Midland Railway hotel was being built at Morecombe in the Lake District, and Ravilious was commissioned to paint a mural for a circular tearoom and bar. It was an ill-fated undertaking: there was something seriously wrong with the building and several entries in Tirzah's diary record: 'found walls would have to be stripped as paint isn't safe – 2 days' work to come off', 10 April, and later 'walls still peeling'. Eric Gill, who was also commissioned to paint a mural for the tea-room and bar, arrived on 10 May to face comparable conditions. Moreover, Ravilious had to return for his weekly two days' teaching at the Royal College. In his absence Tirzah carried on the work. Months after his paintings were completed inch-wide cracks had opened and Ravilious had to return and restore them. His and Tirzah's effort and anxieties were unrewarded, for, like his work at Morley College, that at Morecombe suffered destruction during the war.

For a considerable time both Ravilious and Bawden had felt an increasing desire to do more landscape painting. In the chapter on Bawden an account is given of their discovery in 1930 of Brick House at Great Bardfield, their establishment there, and the Ravilious's subsequent move to Bank House in nearby Castle Hedingham in 1935. Both couples delighted in the countryside and felt at home in a sense that they never had before.

Many of the miniature engravings Ravilious made for the *The Kynoch Press Notebook* (1933) are of Bardfield subjects. But painting became increasingly their primary concern. About this Tirzah wrote:

> The garden and the countryside round Bardfield inspired them both and they competed with one another in conditions of various hardships, such as ghastly weather or working with the sun bang in their eyes. They painted several pictures very early in the morning from the roof of their house . . . Bawden thought that you ought to finish the painting on the spot, but Eric might do half his at home.

Happy as he was in Bardfield, Ravilious was never wholeheartedly responsive to Essex. Unlike Bawden who, until as a War Artist travelled widely in the Middle East and elsewhere, he discovered endless subjects in Bardfield and the surrounding country, rarely moving away. Ravilious explored ever more frequently; his attachment to his native Sussex, however, remained constant.

Ravilious was fascinated by Cecilia Dunbar Kilburn's description of her long visit in the winter of 1927–28 to the Far East, India and elsewhere, and I remember his speaking with excitement of his own possible visit to China. I recently discovered an undated letter from him – the only one, to my regret, that I now possess – written in the mid-1930s and illustrated by a delightful pen-and-ink drawing:

> Bank House,
> Castle Hedingham,
> Essex
> *Sunday*

> I wondered if you had been to the Southern States when you were in America? Because I have a feeling it would be nice to go and make some drawings this winter time and money allowing. It would be a change from the Home Counties to go off to a place like Groton, Mass. and have a look at the Colonial houses and the wall painting(.) Groton and Salem seem to have the best ones. Do you know if the landscape looks at all like this?

> (Drawing)

> – creeks, steam boats and small islands with trees I hope the scene is small in scale but it most likely isn't. Do you think my idea a good one?

> With best wishes,
> Yours sincerely,
> *Eric Ravilious*

> PS. The background the Huckleberry Finn must be something of the kind.

I never knew Ravilious well but we met from time to time from his student days, occasionally at my parents' 'open house' on Sunday evenings or at his London lodgings. I remember his disappointment at one of these when T. E. Lawrence, whom he was eager to meet,

was taken off by one of the social hostesses. Ravilious was tall, slender, with eyes large and dark, and an elegance of movement as well as looks. From time to time he would smile as though at something distant.

In 1934 he and Tirzah visited their friend and former fellow student at the Royal College, Peggy Angus, who lived in a cottage called Furlongs near Lewes. Their welcoming hostess and the rare beauty of the countryside attracted many artistic visitors. Eric delighted in its aerial spaciousness; it even made him feel that his much-loved Essex was by comparison, as he put it, 'domestic'.

Bank House was one of a row of small eighteenth-century buildings and formerly a shop; the front room with its big window became Ravilious's studio. The bank next door, from which it derived its name, occupied only the ground floor and its upper storeys formed part of the house. The interior of the Ravilious's house offered a marked contrast to that of the Bawdens; it was of an elegant austerity, whereas theirs was filled with a variety of fascinating arts and crafts.

The art which gave Ravilious the deepest sense of fulfillment, and with an ever greater intensity, was watercolour, but the high reputation he had won as an engraver brought him frequent, at times constant, invitations not only from the Curwen, the Golden Cockerel and other presses, but a wide variety of commercial undertakings as well. When accepted – and when minor, which they usually were – they were efficiently and light-heartedly carried out. To major undertakings Ravilious gave careful consideration, accepting only those likely to involve him deeply.

One such was an invitation from the Golden Cockerel Press in 1935 – the year of the Silver Jubilee of King George V – to do illustrations for *The Hansom Cab and The Pigeons, Being Random Reflections Upon the Silver Jubilee of King George V* by L. A. G. Strong. Oddly, it was the first book which the Golden Cockerel Press had commissioned Ravilious to illustrate that was not a reprint and of a contemporary subject. Even though it was required to be completed in only a fortnight, he set about it immediately and with delight; it was completed in time. Its full-page frontispiece is impressive: a broken-down hansom cab with pigeons sitting on it or flying around. The other illustrations are, understandably, small, and of a decorative character.

Ravilious was happy in Hedingham but he still missed the landscapes of Sussex, which he revisited several times in 1938. But for all the pleasure this afforded him he used to complain of the difficulty of finding country in Sussex, or elsewhere, that did not remind him of other people's paintings. But he took advantage of any respite from commissions to make watercolours in Essex of

subjects in both his immediate environment and beyond, as well as in Sussex.

Hard as he worked, he was sociable as always: he made friends and played cricket, once against the village for the Double Crown Club, for which he designed the cover of the menu for its dinner at the Café Royal.

His constantly recurring desire to work in watercolour did not deter him from either continuing to make wood-engravings or trying his hand at other media. One he briefly adopted with particular enthusiasm was lithography. In this medium his principal work was *The High Street Book of Shops*, consisting of twenty-four colour lithographs, which was produced in 1937 and published the following year. The painter in him enjoyed the introduction of colour into his prints, likewise the wandering along streets in search of attractive shop-fronts which it involved.

The series was completed during the previous year and three examples were reproduced in the March 1937 issue of *Signature*, accompanied by a tribute by John Piper:

> Ravilious is English in a most important way; . . . in this matter of control over line – line that can express fluently movement or stillness, and grace as well as volume. The delight of his new lithographs of shop-fronts is of a kind that is rare enough. It is the delight one gets from work which one feels has been specially suited to an artist's taste and feeling; and there is probably no one else who could have made these records so faithfully and so imaginatively.

It was in the first issue of *Signature*, November 1935, that another notable tribute to Ravilious was published: *The Printed and Published Wood-Engravings of Eric Ravilious*, the anonymous author being the publication's editor, Oliver Simon.

Ravilious was also associated with the firm Dunbar-Hay: the partners were his old friend Cecilia Dunbar Kilburn and Athole and Silvia Hay, who in 1934 opened a shop at 15 Albemarle Street in London. Their intentions – I quote from the printed letter they circulated – was to 'open a shop for the sale of subjects of applied art which in the ordinary way might be difficult to market. Every year a great deal of excellent work is done which falls into obscurity between gallery and shop. The gallery is altogether too formidable: the ordinary shop is too commercial and wants quantity for cheapness'.

Their aim was to sell the best work of its kind, whether hand- or machine-made. Athole and Silvia Hay were both intimate friends of mine (it was I who introduced them to one another), and I remember the admiration with which they and Cecilia Dunbar Kilburn, who was installed as manager, spoke of Ravilious. They asked him to design for them, paying him a small retainer, and commissioned him

to design and engrave their trade-card on which there is a window of a doll's house shop. In the doll's house are displayed a variety of household objects entertainingly distorted in scale: a big teapot floats above a small round table, forks and spoons are as big as an armchair; on two oval trays are engraved the words 'China, Glass, Interior Decorations and Furniture'. He also designed a chair inlaid with boxwood.

Ravilious's principal work sold by Dunbar Hay was the pottery he was commissioned to decorate by Wedgwood. In 1935 he had made a number of trial designs suitable for reproduction by the eighteenth- and nineteenth-century process of transfer-painting, whereby patterns printed on paper from engraved copper plates were transferred to pottery or porcelain and finally fired, the paper being burnt. In July the following year he visited Stoke-on-Trent to show these designs to Josiah Wedgwood, the managing director. The first of those accepted was the mug he made to celebrate the coronation of King Edward VIII in 1937 – an elegant creation – to be produced by Christmas. The first shop to have it on sale was Dunbar Hay, who amply deserved it, for Cecilia had visited Wedgwood's and, by her eloquent enthusiasm, had overcome the doubt its originality had evoked. Its first purchaser was Mrs Simpson. I had the pleasure of receiving one of these justly celebrated mugs as a present from Ravilious.

Ravilious designed other pottery for Wedgwood, all in earthenware except for one china tea-set. He continued to work for the firm for some six weeks in the year until the outbreak of war. For this he was not highly paid, but sufficiently to enable him to give up teaching and devote more time to watercolour, as he had long intended.

In the summer of 1937 a big international exhibition was held in Paris, 'concerned' – to quote from the guide to the British Pavilion – 'with the arts and crafts of industry (between art and craft there can be no true distinction).' It had been decided 'to picture to the world those elements of the current civilization . . . contributed mainly by Great Britain.' One of the subjects referred to was 'Sport'.

Ravilious was commissioned to design the cover of the official catalogue. After prolonged discussion his proposal that he should portray the Royal Arms was accepted. It is similar to but simpler in design than his coronation mug for Edward VIII. There are no fireworks, but the shield and crown are more detailed. They and the lion and unicorn were printed in blue and are shown against illuminated signs; the awning above and the background of the lettering below are in yellow ochre. In addition Ravilious designed and engraved the back cover with a bouquet of rose, thistle, shamrock and leek. To perfect this – one of Ravilious's finest wood-engravings

– he took immense trouble, even cutting the complex blocks twice over, being dissatisfied with the first.

Ravilious was also commissioned to carry out an exhibit depicting 'Tennis', always one of his favourite games. Four alert players, made of plywood cutouts, were portrayed in front of rows of spectators; behind them was placed a curving backcloth on which appeared linear indications of racquets, nettings and a garden roller.

While still engaged on the engraving of these catalogue covers, Ravilious and Tirzah paid a Christmas visit to their friends Clissold and Diana Tuely, who lived at Wittersham in Kent. It was a memorable visit. Ravilious was enchanted by the landscape and by a visit to a neighbour, Colonel Bertram Buchanan, who farmed at Iden. A friend of Paul Nash, who had lived there from 1925 until 1929, the Colonel owned a number of his drawings and engravings: *Tench Pond in a Gale* (1921–22) was made on his estate. Ravilious was an ardent admirer of Nash, as were his friends at the Royal College. In addition the Colonel owned three drawings by Samuel Palmer in which Ravilious delighted. Likewise, the surrounding landscape, to which he was determined to return to and to paint.

Ravilious's determination to devote himself primarily to painting increased steadily. He had given up teaching and was becoming more selective regarding what he called 'things to be done'. Apart from teaching, to which he became somewhat indifferent – even though he taught admirably, not always, but in recurrent moments of inspiration – he enjoyed doing 'things to be done', but he became ever more selective regarding the commissions that he accepted. Some he had to accept, being his basic source of income.

In May 1937, at the very time when his enthusiasm for painting was particularly ardent, he received an offer to illustrate a book which he was unable to resist: a new two-volume edition of Gilbert White's *Natural History of Selborne*. He immediately accepted and with Tirzah visited Selborne where they spent several days exploring the village and its environs. The best of these illustrations are not only among his finest but are acutely expressive of the character of the book.

Ravilious's first one-man exhibition, consisting entirely of water-colours, was held at the Zwemmer Gallery in 1933, and was successful. Even more so was the second, at the same gallery in 1936, consisting of thirty-eight watercolours of Essex and Suffolk land-scapes. Of these, all except three were sold.

Ravilious's sense of perfection was such that he tore up two out of every three of his paintings. In Helen Binyon's biography there is an excellent description of his working procedures:

Eric liked to get up very early, occasionally at sunrise, and paint all

morning. After a picnic lunch he might have a short sleep and then
paint again by the afternoon and evening light. He usually worked on
a drawingboard which would take a Royal size sheet of paper, and
Tirzah made him a canvas satchel large enough to carry it. He had a
light sketching easel at which he could work standing, or he might sit
with the board on his knees . . . Possibly the special qualities of his
painting came from the way he could keep his visions of whatever had
first struck him and made him choose that subject. Its appeal would
inevitably change as the day went on and the light altered, yet he did
not lose or dissipate the intensity of his first vision, and so communicate
his excitement about it to the spectator. Later on he achieved this by
working more from memory at home on a drawing begun at the place
of discovery.

Ravilious's deep attachment to the landscape of Sussex, and to a
lesser degree to that of Essex, never discouraged him from working
in a number of other places. These included – besides those already
mentioned – Capel-y-Ffin, near Llantony, South Wales; Aldburgh,
Suffolk, Wiltshire, Kent, Bristol and Buckinghamshire – the last two
with John Nash – as well as Normandy, where he stayed at Havre St
Valery-en-Caux and Fecamp.

In June 1939 an exhibition of his work with that of Sir Timothy
Eden was held at Arthur Tooth's Gallery and, like the others, it was
a conspicuous success and evoked the praise of leading art critics.
However, Ravilious's elation at his exhibition's reception was only
temporary. In fact, his happiness in his increasing success and self-
confidence; in the recognition of his command of so wide a variety of
media; in his freedom to travel to places in which he most delighted,
and in the affection of his many friends was not so complete as it
usually appeared. Although we had long been on friendly terms, I
was not one of his intimates and we rarely met, yet of his dissatisfac-
tion I was vaguely aware. But Richards, long an intimate friend,
clearly was. When I read the following passage in his *Memoirs* I
immediately recognized its truth:

> Eric was, especially in the last years before the war, restless and uneasy.
> I suppose, looking back, the variety of media he was working in and
> his willingness to try his hand at one task after another were symp-
> tomatic of his restlessness of spirit as well as of the versatility of a
> freelance artist . . . had to show in order to earn a living . . . But nothing
> seemed settled or secure.

Like most others during that time, Ravilious's life was darkened by
the impending war, by which he was acutely disturbed; intensely
purposeful, he hated the uncertain situation in which – like so many
others – he found himself. He thought of enlisting in the Artists'
Rifles, about which he wrote to John Nash, who had served with
them in the First World War, who, however, dissuaded him.

When Neville Chamberlain told the country over the radio that we were at war with Germany, uncertainty ended and Ravilious served part-time at one of the observer posts – that at Hedingham – which were set up all over the country by the Royal Observer Corps. He wrote to Helen Binyon from 'The Hedingham Front' with an amusing sketch of himself in the open air in front of some apparatus:

> Here is a picture of me saving the country. I work at odd hours of the day or night . . . watching aeroplanes . . . and work with a partner . . . we wear lifeboatsmen's hats outfits against the weather and tin hats for show. It is like a Boys Own Paper story, what with spies and passwords and all manner of nonsense: all the same as far as wars go, it is a congenial job, and the scene lovely, mushrooms about and blackberries coming along and the most spectacular sunrises . . .

On Christmas Eve 1939 Ravilious received a letter from Richard Gleadowe, Admiralty Representative of the War Artists' Committee, telling him that the Admiralty had appointed one official full-time artist and that he and John Nash had been selected to work on a part-time basis, should he be willing. Delighted, Ravilious accepted instantly and, after frustrating delays, was made a captain in the Royal Marines. Bawden, with whom he maintained his customary close touch, wrote in a Christmas letter to Tirzah:

> . . . tell Eric that I accepted the camouflage appointment but have since chucked it, thereby casting my bread – nearly dry bread now – upon troubled waters – with a gesture of wild abandon. This sort of feckless behaviour on the part of one so prudent cannot but move him to admiration. (Bawden was himself shortly appointed an Official Artist.)

In early February Ravilious wrote the following letter to Helen Binyon from the Royal Naval Barracks, Chatham:

> I wanted to write to you, but have been so busy about so many unfamiliar things I've not done any writing to speak of. Work is biting cold when there is a wind, but two drawings – snow of course – are on the way. It is lovely doing some drawing again: and this uniform keeps most people off even in crowded docks and places, though I am looked on with the utmost suspicion and produce my sheaf of passes all day. The Mess is a wonderful place, huge and tasteless, but very nice food, and even nicer drinks. Then you go off into an equally big lounge and drink port, captains and commanders, admirals and lieutenants all about in two's and three's, and very pink and jocular and 'damn it sir' – I do like them, and they are very indulgent about my many breaches of etiquette and extraordinarily kind and helpful – I hardly dare mention any simple idea I have in case they set going some elaborate machinery to bring it about . . . Tomorrow I've an etiquette course and a gas course. The saluting is appalling in a barracks and when in addition you meet a platoon of 30 or 40 men and the sergeant gives the 'Eyes Right', it is hard not to laugh. They do this with unbelievable efficiency, and fixed look – the sentries plunge bayonets at you after

dark, and you have to be quick remembering who you are . . . The figureheads about the place are lovely – I long to draw them . . .

Not finding sufficient subjects relating to the war, Ravilious moved on to Sheerness. From here he wrote to Tirzah:

I have just reached here from an exhilarating weekend with a naval party at Whitstable. After Chatham, it was like being let out of school, and I managed a drawing, or very nearly, and was out in a small boat for hours in what seemed to me a rough sea. This was the best sort of outing, packed with excitement, and it is a pity I can't tell you about it – may it happen again.

The purpose of this 'outing' was to salve a German magnetic mine; of it he made a drawing, shown at the First War Artists' Exhibition, entitled *Rendering Mine Safe*, but subsequently *Dangerous Work at Low Tide*. Of the area he wrote that 'Sheerness, itself . . . That is to say the Docks . . . is good and has lovely Regency buildings, almost Venetian in parts, and oh, the still-life of buoys, anchors, chains and wreckage! I must try to remember what I am here for, and only do one drawing of this kind.' From Grimsby on 24 April he wrote to Cecilia Dunbar Kilburn: 'The docks are nice and I work here all day but won't be sorry either to go to sea from here or get away somewhere and finish the drawings of divers, destroyers, ropes, floats and lightships.' And this to Helen Binyon from HMS *Highlander*:

We have been in the Arctic as high as 70°–30°, which I looked up and was delighted to see how far north it was. So I've done drawings of the midnight sun and the hills of Chankly Bore – I simply loved it, especially the Sun. I do like the life and the people (the Norwegians), in fact it is about the first time since the war I've felt any peace of mind or desire to work. It is so remote and lovely in these parts and the excitements, from above and below, don't interrupt much.

The voyage lasted for a month. 'The excitements' he refers to were attacks by German aircraft and submarines. His fellow officers were astonished and impressed by his ability to concentrate and his delight in drawing while the ship was under attack. To Diana Tuely he wrote, also from the *Highlander*:

It has been a wonderful trip with excitements here and there from planes and submarines, but the grand thing was going up in the Arctic Circle with a brilliant sun shining all night . . . I simply loved it and in fact haven't enjoyed anything so much since the war . . . Now having at last got into harbour out of the fog we are to sail first thing in the morning. There will be some excitement this time I think . . . it is strange not seeing land, or woman or darkness for so long. It is like some unearthly existenss.

Among works begun on board, completed on his return and shown at the first War Artists' Exhibition at the National Gallery in July,

were *HMS Glorious in the Arctic* – a vessel to which his own served as escort until the day before she was lost – and *HMS Ark Royal in Action*.

On 23 July he wrote to Tirzah from Portsmouth:

> The Admiral – the C.-in-C. – is very like Millais to look at; a naval Millais, and is a nephew in fact . . . You know he *is* Bubbles, and called by that name by the Navy. At a grand lunch today, he was in cracking form all the time . . . I still draw submarine interiors exclusively and hope to have something to show you when you come. [She was due to come the following weekend.]

From HMS *Dolphin*, at Gosport, a base for submarine training, he wrote to EMO'R Dickey:

> It is awfully hot below when submarines dive and every compartment small and full of people at work. However, this is a change from destroyers and I enjoy the state of complete calm after the North Sea – there is no roll or movement at all in submarines, which is one condition in their favour – apart from the peculiar submarine smell, the heat and the noise. There is something jolly good about it, if only I can manage it, a blue gloom with coloured lights and everyone in shirts and braces. People go to sleep in odd positions.

From Royal Naval Headquarters, Newhaven:

> I have at last arrived here after an exciting . . . two days in London (and what nights!) and a day in Eastbourne. This was a bad dream. It was like the ruins of Pompeii, and both our families gone, the town all but empty – 60,000 people have left . . .

Grays, Western Road, Newhaven:

> . . . We are bombed in the afternoon, about 3.30, but there are raids all day . . . The weather has been perfect for work and all the old Raviliouses are now on the way, some bad, some good. I don't seem able to go quicker or slower, whatever is done – you buzz like a bee over it, obsessed for days . . . (With luck I ought to finish these drawings by Monday . . . I am going up to the cliffs twice a day like a man to the office . . . It is a pretty quiet life here except for raids. There is so little to worry me and all the troops *inside* the fort. I draw in perfect peace of mind on this side the moat. It is simply wonderful. I could jump for joy sometimes.)

The drawings referred to are seven watercolours of coastal defences. These completed, Ravilious worked on a series of lithographs of submarines.

Ravilious's six-month contract as a War Artist ended on 10 August and, although unpaid, he worked unconcernedly and completed the drawings he had begun. By November it had been decided to renew the artists' grants, and he agreed to work for a further six months, also suggesting that he should go to Iceland.

The War Artists' Committee decided not to publish the submarine

lithographs, likewise several private firms, so Ravilious decided to make them himself, arranging for a firm in Ipswich to print them. To Diana Tuely he wrote:

> I work away at these drawings of submarines, and have nearly finished three. It is fairly difficult and wholly absorbing trying to work out the superimpositions of five colours in all sorts of tones and texture and the rest. Lithography ink is beastly stuff, greasy and thick. The printer at Ipswich is very good and willing to make expensive experiments, and as I pay for the job instead of a publisher I rather want to try what experiments I can.

Although the preliminary drawings had been passed by the censor, the set of ten lithographs were not. He wrote to Dickey:

> I was rather sorry to hear about the censor's decision and wish I had known about him earlier on. They seem to have come down heavily on those Newhaven drawings, not to mention the magnetic mine I shall have quite a lot at the end of the war in their vaults and archives.

In late April 1942 the Ravilious family – a third child and first daughter had been born on 1 April – moved away from Castle Hedingham to not far distant Ironbridge Farm, Shalford. Its owner was John Strachey, a man exceptionally responsive to the arts: half the annual rent he required was to be paid in pictures, to the value of £70, and a similar sum in cash.

Ravilious painted in Dover, being engaged on work for the Admiralty, making a brief visit in May and for a longer period in June. In August he wrote to Helen Binyon:

> Dover is a good place. Except for shelling all the bombardments take place on the other side and is an extraordinary sight – Fireworks very clear and small . . . Last night there was more shelling as well as wind and rain, it was pandemonium for a short time – the beaches are fuller than ever of curious flotsam and there was a skeleton under the cliff the other day; it was hard to tell but I think it was a horse . . .

Told by John Nash, who was on the Commander-in-Chief's staff at Rosyth, that he would find good subjects in the east-coast ports of Scotland, Ravilious enthusiastically responded. In October he went North, first to Rosyth. John and Christine Nash rented a cottage near Dunfermline, where Ravilious stayed, and made it a base to which he returned between periods of work, by the Forth Bridge on board HMS *Killarney* and other islands in the Firth of Forth.

From the Royal Naval Signals station, May Island, he wrote to Tirzah:

> I've landed here by way of destroyer – and an RAF launch – and am now living with this small naval mess, five officers and a few ratings. They are all very nice people. The island is rocky and rolling and wild, in peacetime a bird sanctuary. Hoodie crows and golden-crested wrens

are about. I wish you could see the island. You would love it. There is the oldest beacon – 1636 – in the centre (you light a fire on the roof of a thing like a large dovecot) and the turf is just like a pile carpet. They took me to the lighthouse lantern this morning. I've just been entranced with the place all day and explored without working, so must have an early bed (one game of darts) and work early tomorrow.

In the meantime Ravilious had developed an ardent enthusiasm for drawing aircraft at the Royal Naval Aircraft station at Dundee where he stayed the longest. In November he wrote to Dickey from HMS *Ambrose*, Mayfield Hostel, Ferry Road, Dundee:

This is an excellent place for work . . . I spend my time drawing sea planes and now and again they take me up; this morning rather uncomfortably in the tail, but it was worth it for the view. I do very much enjoy drawing these queer flying machines and hope to produce a set of aircraft paintings . . . what I like about them is that they are comic things with a strong personality like a duck, and designed to go slow.

In another letter: '. . . The planes and pilots are the best things I have come across since this job began . . . they . . . take me up when they can . . . It is a joke dressing up with flying suit, parachute, Mae West and all and climbing in over the nose . . .'

By Christmas he was home, but his enthusiasm resulted in his invitation to luncheon by the Air Ministry representative on the War Artists' Advisory Committee, Lord Willoughby de Broke, who gave him valuable advice. As a result Ravilious went to an RAF station in York, arriving on 1 March to draw Lysanda aircraft. He had scarcely begun when he was suddenly summoned home: Tirzah had recently undergone a minor operation and now required a major one. A letter to Helen Binyon, in which he described the situation, concluded: 'As a sort of gesture against calamities I'm trying to paint in oils – I don't know what will come of it.' 'Reading that now', she wrote, 'it strikes a chill.' And in a later letter: 'My oil painting came to nothing – it didn't seem to strike roots at all.'

Instead of York, Ravilious arranged to work at the airfield at nearby Dibden and then at that at Sawbridgeworth in Hertfordshire. To a friend he wrote:

Here I am committed to drawing planes for some time . . . and find it slow work because conditions aren't easy. Everything is fluid and shifting and I work in a feverish haste and then the subject matter just leaves the field . . . I may go up to Stratford-on-Avon . . . But . . . I don't feel too sure about being able to draw giant bombers. They are such repellant things . . . How I've been working this last few weeks, successful drawings being in the usual proportion of one out of two or three – If only aeroplanes weren't all so alike and so edgy and tinny. And to Dickey:

The idea is to return to Sawbridgeworth for some flying, as it would be a good plan to try some drawing from the air in this weather . . . Now for some work and jolly hard work for a bit because it starts from almost nothing you could call solid or substantial. Air pictures don't have enough horizontals and verticals; they are all clouds and patterned fields and bits and pieces of planes.

While Ravilious's enthusiasm for drawing aircraft did not diminish, his enthusiasm for the North was even more ardent. I remember his talking, in his student days, of his delight in the watercolours of Francis Towne, in particular, and of his perception of Swiss mountains, their snowy peaks and glaciers. There was an example in the Victoria and Albert Museum which he especially admired. This was one of the reasons why – as Helen Binyon observed with sympathetic insight – 'his imagination was so taken with the idea of painting in Iceland'. 'But even more,' she continued, 'it was that magical experience of sailing up into the Arctic Circle and seeing the Midnight Sun that had left him feeling that for him the North was the Promised Land. So he reminded the authorities of his suggestion of going to paint in Iceland. Lord Willoughby de Broke hoped to be able to arrange it.'

In August he wrote to Tirzah: 'I went to Northwood and to the Air Ministry twice, so things ought to be moving at last, though it will be a passenger plane from Scotland and not a bomber – so much the better.' Tirzah received a postcard he sent her from Prestwick on 27 August: 'It is calm and fine here with no wind. I hope very much we go tomorrow.'

In his *Memoirs* Richards thus records what seemed to him – and he is a perceptive observer – Ravilious's state of mind at the time of his departure: 'He slept at my flat in London the night before he left . . . and seemed more tranquil in his mind than he had been throughout the proceeding years. Yet I discerned, behind his talk that night, a sense that within him he had come to the end of what he had to do.'

On 5 September Tirzah received a telegram, and next day the following letter:

In confirmation of the Admiralty's telegram despatched today, I am commanded by My Lords Commissioners of the Admiralty to state that they have been informed that your husband, temporary Captain Eric Ravilious, Royal Marines, has been reported as missing since Wednesday last, 2nd September, 1942 when the aircraft in which he was a passenger failed to return from a patrol.

My Lords desire me to express to you their deep sympathy in the great anxiety which this news must cause you and to assure you that any further information which can be obtained will be immediately communicated.

The details of the tragic event were reported to Lord Willoughby de Broke at the Air Ministry:

> I am sorry that the visit of Captain Ravilious to this country has ended so tragically. He had intended, he informed me on his arrival, to remain here until practically Christmas and having introduced him all round people were looking forward to his proposed stay with them. He went to Kaldarnes, which is one of our stations, where I think he was going to remain for about a fortnight. On the night of 1st of September one of our aircraft was reported missing from an operational job and a search by three aircraft was organized at dawn on the 2nd to sweep the area 300 miles to seawards. Ravilious went in one of these, which happened to be the Air Sea Rescue craft, no doubt to use the rescue as a subject for one of his drawings. From the time of take-off of his aircraft until now, we have heard nothing more.
>
> Further, the most exhaustive search, lasting four days, has been carried out and I am afraid we must now give up all hope and assume that they are lost. The American Army have been grand in the way they have combed the whole of the South West Peninsula of this Island on foot all this time, whilst in co-operation with the air, we have also searched the sea, but with no result.
>
> We are all very distressed at these two losses as you will appreciate.

There follow extracts from Ravilious's only letter from Iceland, his last:

Care of R.A.F.?
Iceland

Sunday 31st August

My darling Tush,
. . . The journey here was very good, (censored word) of perfectly calm flying – no tea of course but a dinner to make up for it on arrival. Yesterday was spent making the usual visits and they were all very helpful and nice people. I was taken to lunch in the town to eat Icelandic food and the spread was unbelievable like Fortnum at his best, caviar and pate, cheese, goodness knows what. You assemble a pyramid of all this on the plate and drink milk with it. The shops have rather nice things, I see, though pretty expensive. Would you like a pair of gloves – sealskin with the fur on the back – but what size shall I buy? Draw round your hand on the writing paper. I saw a splendid narwhal horn yesterday, delicately spiralled and about six-foot high as far as I remember. Perhaps if I go to Greenland it may be possible to find one. It is a beautiful thing, heavy of course and quite useless. No plane would take it I'm afraid. I am promised an expedition to see the geysers next week. They seem to need soap to start them off. It is jolly cold here, and windy and rainy too, like January, after the hot sun in Scotland: no place for you at all, though you would like the country, especially the flowers and the seals. I hope to visit them soon. I might collect some flowers for you and shells for John, if there are such things, but the weather is too rough to go and look for them. I wish I had brought Di's pillow as there isn't one here. One must travel with that

and looking glass for shaving and a towel. I shall buy them later. There are no sheets either but I don't mind that at all. I sleep well without.

Is Edward home yet? And how is my father? I will write to him when there is a chance. All my love to James and John and Anne and I hope James doesn't mind being away from the family. Give my love too to Ariel and Evelyn. I mean to write to John Crittall and lots of people – but explain to them how difficult writing is on these trips.

We flew over that mountain country that looks like craters on the moon and it looked just like those photographs the M. of Information gave me, with shadows very dark and shaped like leaves. It is a surprising place. There are no mosquitoes so far but clouds of dust make up for their absence. The rain has laid the dust a bit today.

Write to this address all the time, as they will forward letters, and I shall be travelling about the island a lot; also of course remember that letters are censored . . .

I quote one more from Richards's account of his last meeting with Ravilious: 'I thought I discerned behind his talk that night, a sense within him that he had come to the end of what he had to do. It may have been no more than a sense of resignation: that he was now content to let events determine the next phase of his life.'

Most of his friends must have heard Ravilious express his dread of the effects of middle-age on his work. Certainly I heard him do so in his very early years. As Helen Binyon has written with authority: 'Eric was always aware how few artists are able to keep alive the excitement of the first flowering of their work, and how soon it can sink into dullness. Edward Bawden remembers how Eric in his middle twenties spoke of the early thirties as a difficult time.' She also quotes from Tirzah's diary that on his thirty-fourth birthday she had noted a rare occurrence: 'Eric drunk and disorderly.' 'But he was now' – Helen Binyon wrote – 'in his late thirties. He would be thirty-nine on July 22nd. This,' she continues, 'is a quotation from a letter to me: "What do you think I wonder about that depressing theory of mine about middle-aged painters? Anyway let's not start applying it yet. I would very much like to be the camel that gets the Eye of the Needle if I knew how to set about it." '

It is hardly possible to even surmise how middle-age would have affected Ravilious's art. Being a man of outstanding intelligence it is improbable that his dread of middle-age was wholly groundless, yet paradoxically over the years his mastery of watercolour – the medium in which his achievement will ultimately be judged – steadily increased.

Let me conclude with this tribute from Edward Bawden who, although his oldest and most intimate friend, would never allow friendship to affect his judgment:

As a painter he preferred watercolours to oil which he said was like

using toothpaste. It was perhaps the natural choice for a draughtsman. The difference between the early and the late work is not only a greater dexterity in the use of a difficult medium, that was inevitable, but something else seems to happen, a change of attitude to the medium as can be seen when a freely drawn and lightly coloured sketch is compared to a later painting which is more consciously designed and has colour and textural effects carefully calculated, everything being carried out with intentional completeness. Design has permeated the whole painting and conditioned its treatment. In other respects a change is not so noticeable. The mood, even when it is most dramatic as it is in some of the war paintings, still remains lyrical though concerned with action in war rather than the serenity of nature itself. It might be said – and truthfully – that Eric was one of the best painters to emerge between the wars.

But deeply as he admired the painter, he admired the engraver more:

Eric's engravings . . . have a freedom, liveliness and invention that has not been equalled since the age of Bewick. He is undoubtedly one of the great original English engravers surpassed only by Thomas Bewick himself.

GRAHAM SUTHERLAND
1903 – 1980

One of the most conspicuous differences between artists is the way in which they discover the language best suited to express their imagination, or their observation of nature. Bridget Riley, for instance, in spite of the talent evident in her early life-drawings, remained a frustrated searcher after a language until her ideas were clarified, largely by constant discussion and study with a learned and highly intelligent mentor. Houthuesen, Collins, Colquhoun and Freud made the discovery early in their careers.

However different his earliest engravings from the paintings of his maturity, Graham Sutherland belongs in essence to the second category, in that there was a steady consistency in his evolution. Steadiness and consistency were not incompatible with moments of exhilarating discovery, of new subjects – one of particular importance – or of his discarding one medium in favour of another. From the time – it would hardly be an exaggeration to say from the moment – of this discovery, he formed a vision of his subject which, whatever he absorbed from other painters, was unmistakably his own, and so remained. His subjects, too, in characteristically logical fashion, became more varied and wide-ranging, although reaching, at a certain time, a point when, in essentials, they changed little.

Graham Vivian Sutherland was born in South London on 24 August 1903, the elder son of George H. V. Sutherland, a Civil Servant, and his wife Elsie. He went to preparatory school in Sutton, Surrey, in 1912 and two years later to Epsom College, where he remained until 1919, spending his holidays at Merton Park, Surrey, and Rustington, Sussex. After leaving Epsom College he served as an apprentice in the engineering branch of the Midland Railway works at Derby. During the year he spent there he became convinced that he had no vocation for engineering; he had already begun to draw and to feel the first stirring of artistic aspiration. Accordingly he returned to London in 1921 and became a student at Goldsmiths' College of Art. During his five years there he worked with a zest often lacking in the student who has done sufficiently well in art classes at school to go, as a matter of course, to a college of art; he drew diligently from casts and from life. Owing, perhaps, to the influence of two highly

45

respected teachers, Malcolm Osborne and Stanley Anderson, engraving became, and for several years remained, his chosen medium. The aptitude he showed attracted the notice of the eminent engraver F. L. Griggs, who befriended him and fostered his enthusiasm for an artist who became the principal influence over his early work, Samuel Palmer.

It is not surprising that Sutherland should have regarded engraving as his chosen medium, for it is difficult to believe that anything so assured and accomplished as his *Barn Interior*, a drypoint, was the work of a student; it was in fact made in 1922, the year after he went to Goldsmiths'. By 1925 Palmer's influence was ascendent, as is apparent from etchings such as *Peckham Wood* and *Cray Fields* (both 1925) and *St Mary Hatch* and *Lammas* (1926), in which the romantic pastoral spirit of Palmer and his friends at Shoreham is vividly recalled. But by 1930, in another etching, *Pastoral*, there is a change of style which clearly anticipates Sutherland's future course. The earlier prints referred to are sharply and minutely linear, but *Pastoral* is broader in treatment and seen at a distance could easily be mistaken for a wash drawing.

The following year the market for etchings collapsed as a result of the calamitous slump in the United States, and the career that had won him high respect came to a sudden end. He had held two exhibitions, in 1925 and 1928, at the XXI Gallery and had taught engraving at the Chelsea School of Art since 1926 (where he remained until 1940, teaching, from 1935, composition and book illustration). Even though he had begun to think that he had 'said his say' as an engraver (he had made, since 1923, some thirty etchings) and to feel the need to liberate himself from the pervasive influence of Samuel Palmer, the abrupt ending of a career which had achieved much and promised more was an embarrassment, more especially as he had been married not long before, in 1927, to Kathleen Frances Barry, who had been a fellow student at Goldsmiths' and had taken a house at Farningham in Kent. Accordingly during the 1930s Sutherland accepted commissions to design posters for Shell-Mex, the London Passenger Transport Board and the Post Office. In the meantime he was increasingly attracted by the wider possibilities offered by painting then engraving and, by 1932, if not a little earlier, he began to paint, making landscapes in Cornwall and Dorset. Later on his perception was enhanced by new surroundings, but these early landscapes appear to have been destroyed, except *Dorset Farm* (1932), a well-composed, sober but conventional work, which would be unlikely to be recognized as by Sutherland even by someone familiar with his painting. But before long his painting was marked by a greater fluency. It was also – not unnaturally during this period –

marked by echoes of the work of other painters whom he admired:
– *Men-an-Tol* (1931) by that of Paul Nash, whose example did much
to emancipate him from the conventional tradition to which *Dorset
Farm* unequivocally belongs; and some of his fallen trees derive,
although more remotely, from Henry Moore's reclining figures.

By the middle of the decade Sutherland was on the way to evolving
his own pictorial language. One of the most conspicuous and
permanent features of it was aptly described in the first book on
Sutherland, of the Penguin Modern Painters series, by Edward
Sackville-West. Writing of 'the linear exactitude which – all appear-
ances to the contrary – in fact supplies the structure of all his mature
paintings', he continues, 'you will observe that a discreet but tough
thread of black cotton stitches the design . . .' and he later refers to
darker passages as 'made of that same black thread, rolled into a mass
and pulled out again to define . . . the centre of visual interest'. The
black thread, which, viewed casually, may appear to sag, to wander,
even aimlessly, in fact holds together the various elements in his
designs. In spite of the sunset radiance of his earlier paintings and
the brightness of the later, Sutherland, like Moore and Collins, for
example, was a linear painter as distinct from, say, Francis Bacon,
who is a 'painterly' one.

During the early 1930s he still had not quite found his way. It was
in 1934 that, wishing finally to free himself from the still-lingering
influence of Palmer, difficult as long as he lived in Kent, he decided
to visit the most westerly part of Wales and wandered along 'the
arms of land which embrace the great area of St Bride's Bay' in
Pembrokeshire. The following quotation comes from a long letter that
he wrote to an early friend and patron Colin Anderson. It is an
important letter for our understanding of Sutherland. 'It was in this
country that I began to learn painting,' he forthrightly declared. To
quote from another passage, which reads like a description of some
of his finest landscapes,

> I wish I could give you some idea of the exultant strangeness of this
> place . . . the left bank as we see it is all dark – an impenetrable damp
> green gloom of woods which run down to the edge of low blackish
> moss-covered cliffs – it is all dark save where the mossy lanes (two each
> side) which dive down to the opening, admit the sun, hinged, as it
> were, to the top of the trees, from where its rays, precipitating new
> colours, turn the red cliffs of the righthand bank to tones of fire. Do you
> remember the rock in Blake's Newton drawing? . . . Cattle crouch
> among the dark gorse. The mind wanders from the contemplation of
> the living to their dead ghosts. It is no uncommon sight to see a horse's
> skull or horns of cattle lying bleached on the sand . . .' [This 'sketchbook'
> throws light upon both his methods and his way of seeing.] 'At first I
> attempted to make pictures on the spot. But I soon gave this up. It

became my habit to walk through, and soak myself in the country. At times I would make small sketches of ideas on the backs of envelopes, and in a small sketch book, or I would make drawings from nature of forms which interested me and which I might otherwise forget . . . sometimes . . . I would lie on the warm shore until my eye, becoming rivetted to some sea-eroded rocks, would notice that they were precisely reproducing, in miniature, the forms of the inland hills.

The sentences quoted evoke his forms and their radiant but sombre sunset illumination; they show how he worked from notes made on the spot, especially of individual objects, and something of the way in which he used small objects, closely observed, to represent those greater. He also refers to fields 'each with a spear of rock at its centre'. This, too, is significant, for although spearlike forms were not common in the work of his early maturity, they quickly became so, and whether in the form of palm-leaves, horns, thistles, thorns and the like, the spear form occurs in numerous works. To West Wales where he 'began to learn painting' (to which he applied himself intensively from 1933) he returned during his vacations from Chelsea for the five following years, only ceasing with the outbreak of war.

Sutherland differs from painters such as Lowry or Stanley Spencer, who drew inspiration from their native environment or from wherever they have made their home, by having been most strongly affected by the elements of strangeness he discovered in the unfamiliar. He never settled in Wales, and, accordingly, these elements affected him strongly, more especially as he visited different parts of the region, among others, Dale, Solva, St David's and Haverfordwest. Kent, on the other hand, where he made his home as long as he remained in Britain, moving from Farningham to Eynsford in 1931 and to Trottiscliffe five years later, had little effect upon his painting, apart from that, dwindling in any case, inherited from his early discipleship of Samuel Palmer.

By the late 1930s he had found a way, impressively his own, of expressing his perception of the strangeness of nature. To this time belong several of his most memorable paintings, among them *Entrance to Lane, Gorse on Sea Wall, Green Tree Farm, Interior of Wood* (all 1939) and *Small Boulder* (1940), which show how effective was his power of observing something small and depicting it as the 'equivalent' – to use a favourite expression of the artist's – of something far larger in scale.

No sooner, however, had Sutherland attained stature as a landscape painter, shown by these and a number of other works than, like everyone else, his life was transformed by the war, and from 1940 until 1944 his employment as a war artist occupied the greater part of his time.

From time to time Sutherland showed a predilection for the sinister, even the ferocious. One of the finest of all his drawings, *Blasted Oak* (1941), resembles as much an open-jawed ravening beast of prey as a damaged tree. There is no ferocity of outlook evident in any of his war pictures, but the scenes of devastation he often chose to depict gave wide scope for this predilection, which also shows itself in subjects of a quite different kind, such as his several 'furnaces' which are also pervaded by an infernal aura. This, in representations of almost any aspect of the most devastating war in history, was all but inevitable. War paintings evoked a feature in Sutherland's art scarcely evident before, namely a preoccupation with his fellow men. In several of the early etchings of Palmeresque themes, such as *St Mary Hatch* and *Lammas*, a Palmeresque figure or two wanders; but their absence would hardly be noticed – they are mere adjuncts to romantic pastoral scenes. When human beings figure in the landscape of the 1930s (which they rarely do) they are trivial, such as the man running in *Road and Hills in Setting Sun* (1938), who is a mere accent. A more significant, although perhaps unconscious, indication of Sutherland's interest is apparent in the human qualities in some of the studies, for instance *Green Tree Farm*, but far more clearly in *Association of Oaks* (1940), in which two trees closely resemble sparring boxers. These examples are far from isolated. There are also works in which landscape features resemble birds, animals or insects. In *Landscape with Mounds* (1943) the mound in the foreground might be taken for a strange sitting bird, but the resemblance of *Blasted Oak*, already mentioned, to a ferocious animal is unmistakable.

Sutherland's work as a war artist began the liberation of his urge to depict not only men and women but from time to time animals, birds and insects. But it only initiated it: the figures in the war pictures are as anonymous as figures in a crowd. The head in *Man and Fields* (1944) and *Woman in a Garden* (1945) are unconvincing and even a little absurd. The focus on animate life, later to become so lucid, was curiously slow to develop, especially in an artist generally very conscious of his aims, as his *Welsh Notebook* and other writings and interviews show. But however subordinate and anonymous the human being in the war pictures, his destructiveness is shown with a dramatic power; they have, as Eric Newton wrote while they were actually in progress, 'a wild, crucified poignancy'.

The knowledge gained during his apprenticeship at Derby gave Sutherland a particular interest in devastated machinery. The finest of his machines are those that are sharply focused. 'He is best,' as James Thrall Soby observed, 'when he peers rather than scans.' The virtual compulsion to portray a wide variety of subjects at relatively high speed expanded his field of interest and increased his technical

resources. Although he worked fast, it was never on the spot but, like his earlier work, always from notes and memory. And unlike many other painters, who can impose their particular way of seeing on whatever happens to be at hand (although they may prefer something else), Sutherland had to seek out a particular subject or come upon it unexpectedly, in order to set the creative process in motion.

Service as a war artist resulted in a number of memorable works, but in several respects its benefits were long-term, for the ending of the war left him somewhat at a loss. The element of urgency, the obligation to record without time for reflection, proved – as it did with some other war artists – disturbing in its immediate after-effects. (I recall Paul Nash, in the same situation, describing himself as 'a war artist without a war'.) Sutherland continued to paint landscapes, but compared with the earlier they seem summary and the outcome of less deeply felt experience. In a number of his thistle and thorn paintings and drawings there were overtones of cruelty. During these years he had been made uncertain of his direction, not only by the war but by his increasing attraction to Continenal art. From 1947 – when he visited the Picasso Museum at Antibes – he spent a part of every year in the south of France (and from 1956 he lived there almost entirely, although keeping his house at Trottis-cliffe).

Many of his paintings of the later 1940s show this temporary loss of direction by their formlessness, indeed their lack of significance of any kind. To take examples, *Estuary with Rocks* (1946), or *Chimère I* (1946) and *Chimère II* (1946–7), are confused in composition and unconvincing in theme. But an artist should not be judged by his failures. At the same time he painted a number of thorn trees which combined complexity and harmony in their design and brilliance in colour, and which sparkle with energy – paintings which can bear long scrutiny. Of these, which number among his finest works, *Thorn Tree* (1945) and *Thorn Trees* (1946), are outstanding.

Even by 1950 Sutherland had not entirely recovered from the effects of his service as a war artist and the relatively sudden impact of Continental art. His first visit to Paris did not take place until 1944, considerably later in life than most of his artist contemporaries, and the impact of Continental art was accordingly more deeply felt. Moore and Bacon had not yet won world acclaim (indeed, Bacon painted his first serious work only that year) nor had British art of both the nineteenth and twentieth centuries become the subject of inter-national interest, even in Paris, the capital city least responsive to its qualities. On the contrary, it was regarded, not least by many British artists and critics, as provincial and even negligible. In the 1940s and 1950s it was a far more disturbing experience for a British artist to

settle in a country which was still generally considered to be the creative centre of Western art than it would be today.

This, following the effects of the war, accounts, I believe, at least in part, for the disparate quality of Sutherland's creation. Even as late as 1950 he could paint *Armoured Form*, a confused pastiche of de Chirico, and the fine *Standing Form against a Hedge*, a massive enigmatic 'presence' (to use another of the artist's favourite expressions) standing against a background of bougainvillea. A more elaborate and complex and still more impressive painting, surely one of his best, is *Three Standing Forms in a Garden* (1952), composed from studies of roots, trees and hanging maize. In my opinion, paintings such as these two constitute the outstanding expressions of the artist's power of creating forms, part primitive, part sophisticated, based, however remotely, on objects observed.

Two developments mark his later work: a brightening of colour and, as already noted, a preoccupation with animate life. The glowing yet sombre colour of his Pembrokeshire and war pictures was replaced by colour of a lucid brilliance, due in part, no doubt, to residence in a clear-aired and sunlit region. On occasion he created compositions of an extraordinary although highly disciplined complexity, such as, for instance *Variation on a Theme II* (1953), or, to an only slightly lesser degree, *Thorn Cross* (1954).

It was in the 1940s that the intimations, usually tentative or oblique, of Sutherland's interest in the figure became explicit. This might eventually have happened as a consequence of innate impulse, but, as so often in the lives of artists, changes are precipitated by external circumstance. During this decade he accepted commissions to portray figures – both divine and human. The divine came first. In 1944 he was invited by Canon Walter Hussey – the highly discriminating patron of the arts – to paint an 'Agony in the Garden' for St Matthew's Church, Northampton, for which he had commissioned Henry Moore to carve a 'Madonna and Child'. Sutherland preferred the Crucifixion and Canon Hussey agreed. Between 1954 and 1957 he designed an immense tapestry, representing 'Christ in Glory in the Tetramorph', for the new Coventry Cathedral, and in 1960 he accepted the invitation of another of the few enlightened patrons of ecclesiastical art, Father James Ethrington, to paint a Crucifixion for St Aidan's Catholic Church, East Acton, London.

The execution of these three commissions caused Sutherland more stressful self-questioning than any other work. Before undertaking the first he had painted natural phenomena, creating 'equivalents' for these in response to their action on his imagination. His work as a war artist, he realized, must constitute a record of actual scenes, but, although he would have preferred longer periods of contemplation

than circumstances allowed, they caused him no undue anxiety. In brief, he had been, although not quite in the sense in which Constable used the term, a 'natural painter', not associated with any group or movement; clearly a 'contemporary' but untouched, for instance, by such influential movements as Cubism or Surrealism.

In accepting commissions to represent precise traditional subjects – already represented, century after century, by generations of painters and sculptors – he knew that he would be submitting himself to severe limitations; he knew, too, that his images were intended for specific places and specific purposes. And of course he was painfully aware of the growing, indeed all but absolute, alienation of the churches from serious art.

Before beginning work on all three undertakings, Sutherland studied the portrayals of the subjects by a number of old masters and made studies derived from them, in order, as he told a friend, 'to eliminate them from his mind' and leave him free of traditional conventions, in order to reinterpret them as though seen for the first time by an artist of the twentieth century.

All three were formidable tasks and Sutherland achieved them in a manner unmistakably his own, although in each case echoes of earlier masters are easy to identify: in both the Northampton and Acton paintings the spirit of Grünewald, for instance, is present, and the former reveals memories of the de Maistre *Crucifixion* of 1942–44, of which, indeed, he took some photographs. All three are images not easily forgotten. In the handling of such formidable undertakings it is perhaps inevitable that there should be features which invite criticism. In both the Northampton and Acton Crucifixions the head of Christ, without a neck, grows out of the upper part of his chest, leaving exposed, where the neck should be, a functionless curving ridge of flesh. In the Coventry tapestry the lower part of Christ's garment forms an almost featureless oval that distracts the spectator's attention from more significant features. This and other weaknesses are perhaps due in part to the great disparity in scale between the preliminary study and the completed tapestry. But how easy to discover weaknesses in the treatment of subjects which present such manifold difficulties! It is more relevant to be grateful to the authorities concerned that they commissioned an artist of Sutherland's gifts and gave him an almost entirely free hand, thereby proclaiming – although not, of course, for the first time – that the present alienation of the serious artist and the church is not inevitable.

Sutherland's portrayals of mortals were less complex. In the mid-1940s he painted a few heads, lacking in character, anatomical structure and, more serious still, evident purpose. There then occurred the external circumstance that made him a painter of portraits: in

1948 he received an invitation from Somerset Maugham, whom he had met occasionally at St Jean Cap Ferrat, and who enjoyed having himself painted and drawn, to paint his portrait. The invitation was eagerly accepted. It is rare for a portrait painter not to make his first portrait until he is in his mid-forties, and the portrait of Maugham was accordingly an adventure. 'As a person sits so I tend to accept him,' Sutherland wrote, and, instead of imposing a posture on his sitter, he waited until he or she assumed, perhaps unconsciously, the one most revealing of character.

The portrait was completed in March of the following year, after some two months' work, Maugham having given him about ten consecutive sittings of an hour a day, the artist making only drawings. While at work on the definitive portrait he also made a few oil studies. (The portrait was presented by Maugham to his daughter Lady John Hope, who two years later presented it to the Tate.)

Painters have criticized *Maugham* on the grounds that the emphatic modelling and the strong colour of the clothing distract interest from the head, and that the narrowness of the stool on which he sits gives the whole a top-heavy look. There is some justification for the first criticism, but the very narrowness of the stool surely draws the spectator's attention upwards to the prime focus of interest, the face. Unlike landscape or still-life, portraiture has a primary function: to achieve likeness. In *Maugham* Sutherland achieved a searching likeness: bone structure, expression and habitual pose are precisely as those who knew him remember them. It is, incidentally, as a first portrait, something of a feat, even for an experienced painter.

His second portrait, *Lord Beaverbrook* was commissioned because Beaverbrook liked the Maugham portrait and when the staff of his newspapers wished to present him with his own portrait on his seventy-fifth birthday, he asked Sutherland to undertake it. This is less penetrating as a likeness and somewhat coarse in execution, but these shortcomings are due, at least in part, to the sitter: unlike Maugham, Beaverbrook did not particularly care for being painted or drawn, and he was physically restless and, when he sat, he simply slumped into his chair. Sutherland, true to his belief that he should accept the pose which the sitter assumed, accepted this. But the difference in characterization constitutes the basic difference between these two portraits: Beaverbrook wears a characteristic but transitory expression, one, merely, of many. No portrait can reveal the whole of a man's nature, but Maugham's portrait reveals much more about him; there is something basic about his expression.

It is my belief – having known all three subjects – that Sutherland's most searching portrait is one of two he made of the Hon. Edward Sackville-West, namely that made in 1953–54. (The smaller prepara-

tory version, completed from memory in 1959 is marred by the exaggerated depth of the skull and the clumsy shoulders.) But the first-mentioned is a portrait of rare insight and, were it hung between the Beaverbrook and the Maugham, would highlight the coarseness of the first and give the second, fine although it is, a slightly over-emphatic, almost caricatural look. Sackville-West's intellectual dis-tinction, sensibility, pessimistic outlook on life, absence of personal ambition and even the withdrawal, over the immediately preceding years, from social life and from a number of his friends – are all shown with a lucid sympathy. It is surely an impressive portrait and, for anyone who had the privilege of friendship with its subject, a very moving one.

Until his death Sutherland painted a number of portraits which show a high degree of perception, but none, I suspect, with such understanding of his subject as his *Sackville-West*. However, in offering this opinion it is right to say that several of the subjects of his later portraits are unknown to me.

A fine example of his increasing preoccupation with animals is *Toad II* (1958–59), where the creature's character is observed with the same perception as the artist's human subjects.

From the early 1960s, Sutherland's subjects underwent no radical change or extension. Rocks, thornlike forms, the occasional portrait, animal, bird, still-life, but above all, landscape, remained his continu-ing preoccupations. Their treatment, however, underwent conspicu-ous changes. Instead of being held together by the tough thread of black cotton that Sackville-West wrote of, they are looser in construc-tion; the sharp outline tends to be replaced by one that is broken and easy, suggesting rather than defining. More radical still is the change in colour. With many exceptions – the *Thorn Trees* earlier referred to for one – the glowing sombreness that pervaded the painter's earlier work was replaced by a greatly heightened palette. These changes can be observed, for instance, by comparing such works as *Study Landscape 1968* with several of the Pembrokeshire landscapes made thirty years before, which in subject it closely resembles, but which, in drawing and colour, is very different indeed.

But Pembrokeshire, the place where Sutherland 'began to learn painting', remained a source of inspiration – where landscape is the principal source, as exemplified, for example, by *Tree with G-shaped Form*. Especially from the late 1960s he returned to Wales two or three times a year, twice spending Christmas there; indeed during his relatively infrequent visits to Britain, Wales saw him more often than Trottiscliffe. It was at Picton in Pembrokeshire that the Graham Sutherland Gallery was inaugurated in 1976.

Sutherland moved from a delicate, highly proficient discipleship of

Palmer to the exhilarating revelation of West Wales, through the disturbing yet fruitful experience of the war, through a period of experiment and reassessment resulting from this and the impact of Continental art, and emerged as an occasional portrait painter of exceptional insight at his best but, above all, as a landscape painter. Sutherland was awarded many honours, including, in 1960, the Order of Merit. A retrospective exhibition of his portraits was held at the National Gallery in 1977. He died in London on 17 February 1980.

ALBERT HOUTHUESEN
1903 – 1979

The frailty of his health compelled Albert Houthuesen to conserve all his energies for the practice of his art: his life was therefore unadventurous and marked by few noteworthy events, although he knew tragedy and privation. He was happily married and deeply attached to his Camberwell house, which he rarely left. However uneventful his personal life, his life as an artist was one of conspicuous strangeness. At the age of fourteen, for instance, before receiving any professional instruction, he painted several still-lifes so accomplished that were they hung in the company of any but the greatest of the seventeenth-century Dutch masters they would not be easy to distinguish. Yet it was not until he was fifty-eight years old that Houthuesen began to receive a measure of the recognition that he had for so long deserved.

Albertus Antonius Johannes Houthuesen was born on 3 October 1903, the eldest of the four children of Jean Charles Pierre Houthuesen and his wife Elizabeth Emma Petronella, born Wedemeyer, at 263 Albert Cuyp straat, Amsterdam. (Cuyp, it so happens, was a painter for whom he had a particular admiration.) He was baptized at the Catholic Church of St Willibrordus. Among his ancestors, both paternal and maternal, the Houthuesens, Wedemeyers, Houlliers and Wittenbergs have numbered artists and musicians active in Holland.

Albert's father was a pianist who, in the last ten years of his life, turned to painting. Such, it seems, was the innate artistic sensibility of the family that he painted pictures which offer no hint of the fact that he was self-taught. He was an able pianist but he had always aspired to be a painter. The family's capital, however, consisted of a legacy from his wife's maternal grandfather, the conductor Nicholas Wedemeyer. When Pierre Houthuesen on his marriage abandoned the piano in favour of painting, his wife responded resentfully, feeling that she had the right to object to his taking up a profession that offered such dubious material prospects. By 1911 Albert was painfully aware of rising tension between his parents. This erupted suddenly with tragic consequences for the family; for Albert these were radical and lasting.

One day in October that same year, when his father was giving

him a drawing lesson, his mother exclaimed angrily: 'Not *another* artist in the family!' 'He can do better than I,' his father answered. Albert had scarcely left the room when he heard anguished groans and rushed back, where he saw his father staggering and shouting: 'My head! My head!' It was plain that his mother had struck her husband with one of her shoes and its high heel had penetrated his temple. Presently he fell onto his bed and she seemed demented. Albert could neither move nor speak. 'Take this,' said his father to his wife, holding out his purse, 'I shall never need it again.' And to Albert: 'Look after your mother, sister and brothers.' After Albert had left the room agonized cries echoed through the house. On 5 November, aged thirty-three, his father died, without having been able to speak during the three weeks he spent in hospital. The following year the widow took her four children to London, where her mother lived and where they settled permanently, first at 7, later at 20 Constantine Road, Hampstead.

For Albert the effects of these events were almost catastrophic: unable to speak English he was entirely dependent on a mother whose guilt it was agony to recognize, and who insisted that it was while playing with Albert that her husband had struck his head against a chandelier.

While in Amsterdam he had enjoyed his father's ardent encouragement of his determination to be an artist, and the accessibility of innumerable paintings by the Dutch masters, of which he acquired a precocious knowledge. Suddenly, fatherless and exiled from a civilization of which he had been conscious of being a part, and from ubiquitous beauty, he was living in subjection to a mother whose fears impelled her to sever every link with the past, unable to speak with anyone except members of his immediate family and living in an environment of unredeemed drabness. (In order to make the break absolute, as soon as the children had learnt the rudiments of English they were discouraged from speaking Dutch.) The boarding house their mother kept was a failure and they became ever more abjectly poor. Every other morning Albert stood in the queue for stale bread before school, and every Friday he went with his mother to the pawnshop where all their possessions of any value were delivered, his father's watch among them, which, however, was redeemed. I heard him describe his years from eight until twenty-one as 'unmitigated hell'.

When he first attended Fleet Road, a London County Council school, to compensate for his inability to speak English to the other boys, Albert drew a thrush on a blackboard, which was applauded by his class. The teacher showed it to a colleague and he to the headmaster: all three admired it; the drawing was not erased for

several days. This was Albert's first recognition as an artist. But in spite of this auspicious welcome he was unhappy at school, horrified, in particular, by the savage canings of many boys by a sadistic master for trivial offences which the others were compelled to witness, and he feared for his own hands but was never caned. Nor did his mother's constant visits to voice a wide variety of complaints fail to intensify his unhappiness.

At fourteen he left school without prospects, but continued to work, as he had for the past two years, as a grocer's delivery boy. Later he served as an assistant to an engraver, a furniture decorator (mostly restoring red lacquer) and an architect. It is fortunate that he was unable to find the £25 he would have had to pay to be formally indentured to the engraver – Vintner, of Holborn – as this would have bound him for five years. However, the time he spent at the engraver's was not wasted, for he came to know and revere the engravings of Dürer, in particular his *Adam and Eve*, *Death on a Pale Horse* and *Melancholia*. In the meantime, as often as his circumstances allowed, he visited the National Gallery and the British Museum, and every evening from 1917 until 1923 he worked at the St Martin's School of Art. From here he made three yearly applications for a London County Council scholarship of £80 a year to the Royal College of Art; on each occasion it was rejected. Two students with whom he had become friends at St Martin's and who had gone on to the College, Barnett Freedman and Gerald Ososki, were deeply concerned by what had happened. Together they explained the situation to my father (at the time Principal of the College), saying that they believed he would be interested in their friend's work and expressing the hope that he would see the portfolio he had submitted in support of his application. My father immediately took a taxi to County Hall and, after looking through the portfolio, angrily insisted on Albert's being awarded the scholarship.

Accordingly he entered the College in 1923, where he remained for four years, becoming one of a group that included Henry Moore, Edward Burra, Charles Mahoney, Barbara Hepworth, Cecil Collins and Ceri Richards, as well as the two friends so largely responsible for his presence and a number of other members of an outstandingly gifted generation. Also Catherine Dean, to whom he became engaged in 1926 and married five years later. No marriage could have been more fortunate, for she was a painter of rare but reticent talent, able to sympathize wholeheartedly with Albert's aspirations.

At the Royal College, Albert's attitude was different from that of most of his fellow students, who were high spirited and often rowdy, due to his awareness of the privilege of being an artist: he had seen his father die for it and he himself had suffered exile and privation.

In spite of his highly developed sense of humour he never for a moment forgot the scarcely believable fact that at last he was free to devote all his time and energies to his chosen vocation.

Before he entered the College he had achieved a technical command which most students lack when they leave. This command is apparent in his three earliest surviving paintings. The first two, made when he was fourteen, are *Apple* and *Potatoes and Onion*, done on lids of his father's cigar-boxes brought from Holland, and *The Candlestick*. These and other paintings were made in secret in a bedroom that was only 'his' when unoccupied by a boarder. As the work of a schoolboy who, apart from lessons from a self-taught father, had received no instruction, they are remarkable not only for the skill they show, but for the knowledge of the Dutch masters. *Apple* and *Potatoes and Onion* are highly realistic, yet the blackness of their background is an intimation of the symbolism that was to be a cardinal element in Houthuesen's work: the blackness of the secrecy in which they were painted. In *The Candlestick* (which shows some resemblance to his father's work) symbolism is explicit: the candle is burning; its flame represents the gleam of hope which circumstances seemed so grimly to deny – but the last match has been struck. The painting bears the marks of the jabs of his mother's scissors: he caught her, just in time, in the act of destruction.

As though his circumstances were not sufficiently sombre, a further misfortune occurred in about 1920. One night Albert thought he saw a fire burning in the house next door; it quickly became apparent that this was the reflection of a fire in their own. The only accommodation he was allowed for his possessions was a single drawer in a table. Beneath stood a laundry basket; its contents had been set on fire by his mother, perhaps by accident, for she habitually carried a lighted taper. The table was damaged and all Albert's early drawings and a portrait drawing by his father were destroyed. Fragments of copies of an illuminated manuscript in the British Museum and some lettering by Edward Johnson were the only things to survive. After this occurrence Albert asked his mother to sit for him for a drawing. It was impossible for her to sit or for him to draw: neither could bear to look at the other.

At the Royal College he made the fullest use of the opportunities offered him by good teaching, official encouragement and exhilarating companionship – to what purpose may be seen in the two versions of his diploma painting, *The Supper at Emmaus* (1927).

They are not, like the two still-lifes of ten years before, virtuoso pieces. They show the same command of form and colour, but what impresses is the originality and intensity of the treatment of the subject: the risen Lord, followed by two disciples, enters by a narrow

gate a garden of a kind still to be seen in Hampstead (except that the house on the left with a step-gabled roof is reminiscent of Amsterdam) and approaches an ordinary table on which supper is being laid, but the chair on which He is about to sit is surrounded by an aura of gentle light, and wild roses blossom against the red-brick wall behind. The unearthly character of Christ and the chair are thrown into gentle relief by the convincing ordinariness of their setting – an ordinary garden, and serving-man, mildly surprised at the emergence of the haloed white-robed figure, who is not even noticed by the other manservant, who is concerned only whether the table is properly laid. Figure and chair are thrown into relief without in the least impairing the unity of the work as a whole or diminishing the credibility of the scene. One does not expect to see Jesus emerge from a garden door, but this painting persuades us that if He did, this is how the scene would present itself.

Houthuesen most ardently and continuously revered Rembrandt, and in this picture, as in a number of his other works, the influence of the master is apparent, for instance, in the treatment of the servants' sleeves. But here Rembrandt's influence is also revealed in deeper and more pervasive terms. Unlike many of his contemporaries and successors who placed the events of the New Testament in what was imagined to be, or in the case of Holman Hunt actually was, their true setting, Rembrandt did not concern himself with archeology or the actual appearances of the Holy Land. Instead he observed the people of the Bible as they went their ordinary way in the Jewish quarter in Amsterdam. Houthuesen set the event not, indeed, in Whitechapel, but in a pleasant English garden, contemporary but not aggressively 'modern' in the manner of certain religious painters of today who make their representations of comparable events look forced and artificial.

Life after leaving the College, in spite of the happiness of his marriage, was something of an anticlimax. At 20 Abbey Gardens, St John's Wood, where he and Catherine settled in 1931, the couple endured abject poverty and eventually debt. As an artist he suffered almost total neglect, and the Depression made work of any sort difficult to obtain. Every evening for nine years, however, he taught at the Mary Ward Settlement and later at the Working Men's College. Nine years of such a way of life resulted in prolonged and serious illness. They moved in 1938 to a studio in nearby 37 Greville Road, which was damaged two years later by a bomb and had to be abandoned. Kindly neighbours rescued Houthuesen's work and stored it in their house, but it was later moved by a maid into a damp cellar where it remained for three years and some forty canvases were destroyed. At the same time he was rejected for the armed forces on

medical grounds, and placed in category Grade IV. From 1940 until 1944 he worked as a tracer in the draughtsmen's office of the London & North Eastern Railway in Doncaster – when he lived for a short time in the village of Letwell, in Nottinghamshire, and a succession of lodgings near Doncaster – which resulted in his complete collapse. They returned to London in 1945 without money and still without prospects, and accepted the offer of three rooms in a vicarage at the Elephant and Castle at nominal rent, in return for acting as wardens to students billeted there. But their enforced and unhappy wanderings were almost ended; after living with friends in a house in Oxted, Surrey for two years, they went as tenants of part of a house in Camberwell, 5 Love Walk.

In spite of the harassments of ill-health and acute poverty, as well as the distress which the war brought to most of the inhabitants of these islands, Albert continued – almost miraculously – to paint daily, and, after the war, when not frustrated by illness. For some sixteen years, however, he worked in almost total obscurity. He had a few admiring friends, some of the fellow students at the Royal College (where his work had been held in high regard), friends he had made during his years in Yorkshire, and a handful of others. One of his Yorkshire friends, Lady Matthews, bought several examples of his work, and I persuaded the Leeds and Sheffield Art Galleries, when I was their Director, and later on the Tate, to buy or accept a handful – the two former a painting each, the latter four – but the chilly indifference of their respective governing bodies was undisguised. At Leeds, Houthuesen's painting was demoted to the cellar after my departure in 1933, where it remained, subject to constant disintegration, for thirty-six years (it was eventually repaired, with minimal success, on the initiative of the artist himself). I relate this circumstance not by way of reflection upon my successors – all men of quite exceptional ability who brought about radical improvements – but to illustrate the degree of Houthuesen's neglect.

This neglect he philosophically accepted; his fastidiousness would have forbidden the least attempt at self-promotion. Those who are strangers to the hardship of most artists' lives may not understand the temptation to try to attract public notice, which is no loss when their work has been done without the slightest concern for popular appeal. Even so respected an artist and honourable a man as Paul Nash praised his own work in reviews which he signed pseudonymously.

Houthuesen's existence as a painter might even now be scarcely recognized had it not been for the enterprise and perseverance of a lifelong friend in the late 1950s in interesting dealers in his work. The friend was Elizabeth, my wife. A meeting with Victor Wadding-

ton, who offered Houthuesen an exhibition of his sea paintings, led
to a discussion with Graham Reid which resulted in his first
exhibition of paintings and drawings in 1961. Its timing – entirely by
chance – was propitious. In the course of his forty-odd years as a
painter, his outlook had changed scarcely at all. It often happens,
with the passage of time, that a painter's brushwork becomes freer
and more fluent (Turner's and Corot's are conspicuous examples). Of
course the brushstrokes are as precisely controlled as ever, but they
can assume an audacious, spontaneous look. Such was the case with
Houthuesen's, and the effect was to bring his painting for the first
time into relationship with that of a number of his contemporaries.
In spite of his paintings being, as always, figurative, their seeming
audacity and spontaneity made it possible to see them in terms of
paint applied in a certain way and even to relate them, however
superficially, to those of certain 'action' painters. The resemblance,
entirely accidental although it was, obscured the fact that Houthuesen
was as solitary a figure as he had ever been. His command of resonant
and dramatic colour, as well as his impassioned brushstrokes,
impelled many who had not known or had discounted his work to
scrutinize it with close attention. A growing number recognized it as
the expression of a rare spirit: exalted, highly imaginative, yet
intimately conversant with the natural world.

The high praise with which this exhibition was received gave him
a wide measure of recognition. It also enabled him to subsist, and for
the first time, by his painting and drawing alone. For his friends, for
decades painfully aware of his almost total neglect and consequent
poverty, who happened to be present, the opening night was one of
those occasions when they were tempted to doubt the evidence of
their eyes and ears: the densely packed, attentive crowd; the infor-
mation that there was neither a painting nor a drawing left unsold.
A second exhibition was held at the Reid Gallery in 1963, and when
it closed the following year Houthuesen was taken on by Victor
Waddington.

In 1967 he transferred to the Mercury Gallery in Cork Street where
an exhibition was held that year, followed by two others in 1969. All
met with the same success. The Mercury also published a finely
produced book in a limited edition, illustrated mostly by recent work,
by way of tribute to an artist so long and so unjustly neglected. One
result of Houthuesen's success was that he and his wife were able to
buy the house in Love Walk, not long after the landlord had given
them notice. The interior of this house, although they had until the
1960s not pounds but shillings (and not always these) to spend on
furnishing and decorations, suggested Vermeer.

But in spite of his success – of recent years there have been

numerous collectors eager to buy any example of his work that might become available – his position has remained in one sense anomalous: the establishment still ignores him and nothing was acquired from these exhibitions for any public collection.

Ours is a time when many, possibly even most, artists are preoccupied exclusively with formal problems and relatively few consistently express an attitude to life. Their art is addressed to small groups of initiates and some is sheer soliloquy. Even Houthuesen's two earliest surviving still-lifes, already referred to, in spite of their look of objectivity, are expressions of nostalgia for the art of his native land and of the hopelessness of a miserable boy. Almost all, perhaps all, of his painting and drawing is the expression of a highly personal, passionate outlook. Were it possible to express this attitude precisely in words there would be no need to do so in paint or crayon. It may, however, be approximately defined as one of intense responsiveness to the beauties of the natural world, shadowed by an awareness, at times almost overwhelming, of their transitoriness and vulnerability. The theme to which he constantly reverted, implicitly or explicitly, is tragedy: the tragedy of disappointed hope; the destructive power of hurricanes, sea and jagged projecting rock; the chaos always threatening mankind, the transitoriness of everything precious, especially the fruits of creative effort. I recall his telling me that before beginning a painting or a drawing, he was often overcome by the awareness of their inevitable destruction, and saw canvas or paper as already disintegrated into dust. (He invariably did his utmost to delay the disintegration of his work by using the very best materials he could afford. In the later 1960s he began to use acryllic, the most durable paint available.) Tragedy, however, may be redeemed by its acceptance with sublime indifference or else by a gleam of hope, as in the early *Candle* – painted at a time of abject misery – for although the matchbox is empty, the candle is lit.

For Houthuesen there was no conflict between the pursuit of formal values and the expression of a theme, whether seen or imagined. Form, tone, colour and composition were never ends in themselves but, unless they were as perfectly realized as his dedication and technical command could make them, they could not effectively serve their purpose.

However radically his technical procedures changed, from the minutely articulated, minutely finished still-lifes of his boyhood to the audacious evocations of stormy sea, windswept landscape and sky, fierce sunlight and menacing rock, his outlook changed hardly at all.

The change in his methods is not easy, indeed impossible, to chart precisely, owing to his practice of resuming work on a painting or

drawing often after many years. 'If I go on with a drawing or painting,' he wrote to me, 'it means that it had not been carried as far as possible. Certain paintings I wouldn't dream of altering because it would be a lie to alter them.' He allowed no work to leave his studio unless he was convinced that he could carry it no further. *The Somnambulist*, for instance, a watercolour about which I will have more to say later, was reworked from 1943 over a period of twenty years.

Although difficult to trace in detail, the evolution of his working method from the smoothly finished (which he used on occasion until the 1930s) to the broadly audacious was fairly consistent. Nor did this evolution relate only to the application of paint. Earlier he made use of studies from life, but later, for figures, land- and seascapes, he drew upon memory or imagination and, for still-life, he had the subject on the table before him, constantly observing but freely interpreting what he saw. To quote from another letter: 'As one gains experience, so one understands how to use it and model it – freely – selectively.' Without preliminary studies he would paint straight onto the canvas, after putting in the chief features of his design with a few touches of blue.

After he left the Royal College, disillusioned by current tendencies in English painting, Houthuesen responded to the poetic earnestness of the Pre-Raphaelites, but this highly informed student of Van Eyck and Rembrandt was also conscious of their defects and the response was brief. I recall his saying that,

> So much of their painting is coloured drawing. The Pre-Raphaelites could admire Van Eyck, who also painted minutely, but unlike them, in tone. And he saw life naturally and as a whole, but with, say, Holman Hunt, life was *arranged*. One could walk around Van Eyck's 'Arnolfinis', but Hunt finished his 'Scapegoat' from the wretched animal tethered to a tray of salt, and what a world of difference there is between the two!

This transitory response, scarcely reflected in his work, was followed by the reassertion of the strongest and most lasting influence of his life: Rembrandt. Perceptible, as already noted, not only in the *Supper at Emmaus* but in a number of other pictures, it is more explicit and pervasive in, for instance, *The Butcher's Block* (1928), *Farm on Fire* (1931) and *Deserted Tin Miners' Cottages* (1931), made when the Pre-Raphaelite response was growing fainter.

Houthuesen studied Rembrandt not only in the original and in reproduction, but also his methods. (How, in his studio in his house in St Anthonies Breestraat, known as The Joden Breestraat, where he lived before his ruin, Rembrandt must have manoeuvred each of the four shutters of its high windows – one wide open, another almost

closed, the two lower closed entirely – until he had created the marvellous light he wanted, but with his own eyes shaded.) If with the passage of years the spell of Rembrandt became less evident, this was not because it diminished but because it was completely assimilated, pervading the spirit of Houthuesen's work rather than specific features.

There was another fructifying element which first took hold of his imagination as a child in Amsterdam, namely the sea. Memories of the Zuider Zee, the high long dyke, sea on one side, the roofs of houses on the other; of the sea at Sandvoort, at Scheveningen, remained with him all his life. One of his many sea pictures, an outstanding work, is *Rocks and Sea-spray II* (1960).

After recuperating from an illness at Birling Gap in 1931, years passed before he saw the sea again, other than briefly; but he and Catherine visited North Wales in 1932, staying with relatives in a cottage near Holywell, returning annually until 1938 and intermit-tently until ten years later. They also took holidays with relatives in Devon and on the Sussex coast. His visits to North Wales resulted in a series of landscape paintings and drawings. 'A wonderful landscape, wherever one looked,' he wrote in a letter to the Tate about *Maes Gwyn Stack Yard* (1935) which was presented to the Gallery in 1939. In some of these landscapes the influence of Rembrandt is apparent. One of them, *Windswept Tree and Cottage*, made in the mid-1930s, affords the first intimation of the violence that animates much of his later work, in particular the seascapes.

At Maes Gwyn farm, Llanasa, he did not paint only land- and seascapes: two or three miles from the coast is Point of Air colliery and he became fascinated by the colliers. He painted a portrait of the first collier he met. In another letter to the Tate he described the sitter of *Painted in a Welsh Village* (1933):

> One day I saw a really fantastic figure carrying a great bundle of wood on his back, and later this young man, Harry Jones, came to sit for the portrait you have . . . four times . . . A village funeral was a procession with the coffin on a farm wagon, but alone, quite alone and leading the way, in a long black overcoat and bowler hat, carrying a bunch of wild flowers which he had gathered from the hedges, was Harry Jones.

Allusion has already been made to Houthuesen's solitary position. This is due largely to his use of symbolism, never a common feature in British art and which has now virtually disappeared. The only others of comparable stature active today in whose art symbolism plays an integral part are David Jones and Cecil Collins.

Houthuesen's symbolism refers to some aspect of the manifold tragedy of the human lot, and its meaning is explicit, as in *The Wreck of the Early Hope* (1960), *Icarus* (1962–67) and *The World Upside Down*,

a series of drawings of the mid-1960s. *The Wreck* alludes immediately
to the wreck – by homicide and exile – of his early hope of a happy
initiation as a painter by a father to whom he was deeply attached,
and by the presence of works by the masters whom he most ardently
revered, in an environment of extraordinary beauty. The picture
refers, too, to the frustration of hope as a universal human experience.
Symbolic elements even less easy to interpret are the luminous
radiating outlines – reminders that, even among the wreckage, hope
still glimmers, however faintly. The theme of *Icarus* is also the
frustration of hope, but in a special, one might say in a professional,
context. Artists of exceptional talent, however modestly disposed, are
sufficiently perceptive to be aware of it; they are also aware of the
wide gulf that separates achievement from aspiration. *Icarus* suggests
that Houthuesen must have been painfully aware of such disparity,
for Icarus is the artist, attempting to fly to the sun, being burnt up,
his paintings and drawings falling with him to destruction. It carries
intimations, too, of Houthuesen's often expressed sense of the
vulnerability of what is precious to the destructive forces in nature.
The World Upside Down series, expressive of a world gone mad, still
emphasizes hope. They do indeed recall the misery of his boyhood
and youth (the boots which figure in one of them refer to those which,
as a schoolboy, he did not possess until a pair was given to him by
the London County Council; the folios of drawings to those of his
own destroyed by bombing; likewise the collapsing houses).

In spite of these and similar distresses and calamities, the artist –
in every one of the series – continued to work, representing the artist
in every man who continues, come what may, to create.

Sometimes his work was done at the prompting of impulses, more
obscure, and it is correspondingly more difficult to decipher; in a few
cases a clue from his life is necessary. But it always refers to specific
events or situations, experienced or observed. One such is *The
Somnambulist*, already mentioned, which was inspired by an incident
which took place during the war when for a time he had to walk daily
along a path of cinders leading from Letwell, the village where he
was living, to Langold coal tip. One day a stranger, walking the same
arid path in the opposite direction, made him a gift of roses. Another,
entirely incomprehensible and without a clue, is *A toute à l'heure*, a
work with a near-tragic genesis. In 1961 Houthuesen underwent an
operation. Lying in the anteroom of the operating theatre, he
overheard a conversation in French of which 'à toute à l'heure' were
the last words he heard before losing consciousness under the
anesthetic. After the operation he returned home and during a long
period of acute depression in convalescence he cut up several of his
pictures. This act afforded a release from tension and saved him from

suicide. Much later, again returning to his workroom, he found it thickly covered in dust. As he picked up the scattered fragments, each one left a clear silhouette on the floor or worktable. The sight inspired him to reassemble, rearrange and add to the fragments of one of the paintings he had cut up. As a title to the new work he gave those last words overheard. This oil and collage was not completed until six years afterwards. A similarly esoteric work, of which the symbolism, although obscure, is less difficult to make out, is *Here and Now* (1963), where a clown is represented as creator with tiny seeds – symbols of hope – which can just be seen scattering from his hand.

Clowns, artists and poets always had for Houthuesen a very close affinity, deriving perhaps partly from the fact that the mother of the celebrated Dutch comic actor, Johannes Busiau, was a Houthuesen. He was too young to see his professional acting but he remembers his clowning and happy laughter evoked by his presence in his parents' home.

Houthuesen's interest in clowns (of whom he had made his first drawings in Doncaster towards the end of the war) and the theatre was stimulated by his residence in the second half of the 1940s in the Elephant and Castle, where he often went to the theatre and made a number of drawings – some of them among his finest – of clowns, dancers and other performers. He continued to represent them after he had left the district. *Young Dancer and Old Clown* was not made until 1954 or 1956, and the much reworked *Song of the Cat* was not finished until 1960. His attitude towards clowns is suggested by some words he wrote on the back of a photograph of one of his oil paintings titled *Poet*: 'Poet clown: Clown poet'.

There is inevitably something sad, even tragic, about a clown, since his function is to make his fellow men momentarily forget their sorrows, and this element is marked in Houthuesen's clowns. The dancers he made at the Elephant and Castle, and the memories of his days there, like his still-lifes of fruit and flowers, are expressions of his delight in the beauties of the natural world.

For all his compassion Houthuesen, like Turner or Brueghel, viewed humanity from a distance, rather than, as Renoir or Van Gogh did, by close identification with it, and during the 1960s his chief preoccupation was with land, sea and sky rather than with his fellow men. One feature of his skies is notable: belonging inalienably to the North, he saw the sun not, as Mediterranean man does, as the source of intolerable heat, but as a visionary essence; not to be sheltered from but exultantly faced. Innumerable painters have shown the rising or setting sun, but relatively few, like Houthuesen, of the sun high in the heavens. In most he faces the source of light directly.

It is the continual beauty of the natural world that precludes

ultimate despair, and for Houthuesen this beauty was a symbol of hope. Response to the beauty of the natural world preceded his impulse to interpret it. He and Giacometti (they never met or communicated) expressed themselves to me, although in different languages, in terms strangely indentical:

> 'Do you know anything more repellent about an artist than his referring to "my art"? My own hope, given propitious circumstances, is to do justice to *my subject*.'

The painters who figure in these pages are, as painters, mostly solitaries, but none as solitary as Albert Houthuesen was: never a member of any group, or a participant in any 'movement', deeply grateful for what other artists taught him yet the disciple of none, going his own way, against the way of the world, the complex of ideas that dominated it. His way did not lead back to any tradition: he was as independent of the past, for all his reverence for Rembrandt, Van Eyck, Turner and other masters, as he was of the present. In spite of its wide variety of theme and treatment his work reflects a rare consistency of vision: humane, delicately perceptive, and above all tragic, yet offering its gleam, however faint, of hope.

After a long illness, Houthuesen died on 22 October 1979. Memorial exhibitions of his work were held at the South London Art Gallery from 27 March to 16 April 1981, and at the Kirkhaam Gallery, Kirkhaam, Amsterdam 3 December 1982 to 8 January 1983.

JOHN PIPER
born 1903

John Piper's early environment, unlike that of many artists, prepared him well for the pursuit of his chosen vocation, including one circumstance that threatened to prevent his becoming a professional artist at all, and in fact delayed it.

John Egerton Christmas Piper (the 'Egerton' was taken from Thackeray's *Newcomes* which his father particularly admired) was born on 13 December 1903, the youngest, by six years, of the three sons of Charles Alfred Piper and his wife, Mary Ellen, born Matthews. His birthplace was Alresford, a villa in Ashley Road, Epsom, Surrey, named after the town in Hampshire where the Piper family had lived for several generations. It was demolished, and a larger one, similarly named, was erected in its place, but this, too, was demolished. Charles Alfred Piper was a solicitor and partner in the firm of Piper, Smith & Piper, with offices in Vincent Square, Westminster. He was a visual man with wide-ranging interests and the author of an autobiography, *Sixty-Three: Not Out*, published in 1925. A man of strong convictions, he was disapproving, for instance, of boarding schools, and leaving his children to choose their own religion. His visual aspirations led him to attend art classes at St Mary's School, Vincent Square. 'My own special inclination,' he wrote, 'has been towards drawing and architectural work, and I made one or two attempts in this direction without success.'

Charles Piper's father had begun life as a bootmaker and eventually became a Westminster City Councillor; he was a militant radical. One of John's uncles was an amateur artist who made a set of architectural drawings and it was this that first evoked John's lifelong passion for architecture. For a time his family assumed that he would make it his profession, but his father, by taking him on frequent expeditions from his offices in Vincent Square to the nearby Tate Gallery, aroused a still more ardent passion in John to become a painter. In particular he was obsessed by Turner's watercolours. In the meantime, by taking walks and bicycling through Surrey and Sussex, he extended his knowledge of landscape, and in particular studied the architecture, sculpture and glass of parish churches.

While still at school at Epsom – where he was a day-boy from 1917

until 1921 – Piper became a local secretary of the Surrey Archeological Society. On his way to Switzerland, where the family used to spend their holidays, he visited the Louvre, and on a visit to Italy with his father in 1921 he made drawings in Venice, Siena, Volterra and San Gimignano. Revisiting the English parish churches he was able to study them with more sophisticated eyes. But 1922 seemed a year fatal to his hopes: his father, who had done so much to foster his enthusiasm for painting and drawing, decided that the life of an artist was too precarious to be risked and insisted on Piper studying law in his office as an articled clerk, with a view to his becoming a partner in the firm. There he remained for five years, leaving only in 1926 after his father's death. His law studies, however, were not so demanding as to prevent him from drawing and writing: he wrote verse, and a volume of it, *Wind in the Trees*, which he illustrated, was published in 1924.

These five years intensified Piper's already ardent desire to devote his life to painting and made him value the liberty to do so, when it came to him, far more than if he had merely graduated from an art school. Piper was twenty-three, an age when many students graduated, when he went to the Richmond School of Art. Here he studied painting under Raymond Coxon, a zestful Yorkshire intimate of Henry Moore. 'It was Coxon,' Piper says, 'who really taught me how to *look*.' It was at Richmond that he met Eileen Holding, a fellow student, whom he married in 1928, the same year that his mother had a house with a studio built for him at Betchworth in Surrey. Their marriage was dissolved five years later. In the meantime he entered the Royal College of Art, where he was introduced by Coxon to Henry Moore who taught there. Piper recalls with gratitude the sympathetic helpfulness of two fellow students, Charles Mahoney and Morris Kestelman, with a variety of technical problems; he learnt, he recalls, more from these and other students than from the College staff. He received no particular encouragement from my father, then Principal, who, however, praised one of his landscape studies as being 'like a Conder'. Piper confessed to my father that he was acutely bored by the lectures of one of the professors; he responded by giving him permission to make a copy of Cézanne's *Aix: Rocky Landscape*, which had just been given to the Tate by the Courtauld Trustees, instead of attending the lectures. At the Tate he met H. S. Ede, then working there as an assistant, who praised the copy and otherwise encouraged him, and the two became friends. One day Ede invited Piper to his home in Hampstead where, to his delight, he met Braque. In 1927, while still a student, Piper held an exhibition of wood-engravings with David Birch. Assiduously as he applied himself to the study of painting, drawing and engraving, his interests were not

confined to these: he attended concerts, the Diaghilev Ballet and played the piano in an amateur dance band at Epsom.

By the time he left the Royal College, Piper – already painter, draughtsman, engraver, archeologist, musician, poet and art critic – anticipated what he was shortly to become and has since remained: beyond comparison the most versatile British artist of his time, and, after Michael Ayrton, the most articulate. He wrote book reviews and notices of exhibitions for *The Nation* and *The Listener*, in which he gave discerning praise to such contemporaries, then little known, as Hitchens, Pasmore, Richards and Coldstream.

The paintings and drawings Piper made for the next five years also anticipate – clearly in their subjects and even in some degree in their treatment – his mature work. Landscape and seashores with lighthouses – many of them made at Dungeness and Littlehampton – were favourite subjects. By the early 1930s he had become increasingly identified with the abstract movement of which Ben Nicholson and Barbara Hepworth were the leading English exponents. In 1933, in the course of a visit to Paris, he met Hélion, Braque, Léger and Brancusi, which decisively confirmed his disposition towards abstraction. But his approach to abstraction differed from that of many of his associates: for them it was an art, dependent exclusively upon form and colour and entirely disassociated from theme – an autonomous art; for Piper it meant something different, namely the 'abstraction' of natural forms from what seemed to be accidental or superfluous; the stripping down to basic elements. So it is that a number of his paintings of the mid-1930s (several titled *Abstract Painting*), which at first glance appear to be strictly orthodox abstracts, in fact include such features as the surface of the sea or an expanse of sky. In any case, Piper continued to paint landscape – coasts, chapels and other favourite subjects – although in a formalized manner. At least one of these, *Newhaven 1936*, clearly shows the influence, although this was transitory and slight, of the Cornish 'primitive' Alfred Wallis, no doubt transmitted through Ben Nicholson, who, with Christopher Wood – whose own work Piper particularly admired – was responsible for his discovery. In short, Piper's abstracts, like Picasso's, have their point of departure in nature, from which he 'abstracted' but did not exclude.

Although from 1933 he was absorbed by abstraction for several years, he found it, as he said to me, 'interesting but not ultimate; for me not possibly the end'. His allegiance to the movement, however, was both strengthened and prolonged by his friendship with Myfanwy Evans (whom he married in 1935), the founder and editor of *Axis*, the pioneering quarterly review of abstract painting and sculpture – in fact the axis of English abstraction. (Assuming that its

title referred to the German-Italian alliance, the Italian Embassy sent for a copy in 1939.)

There are people who have the gift of winning, and for a time retaining, high reputations while possessing minimal gifts of any other kind. Myfanwy Piper has, on the contrary, preferred privacy, and with such consistency that her various achievements remain relatively unknown. After going down from Oxford she went to Paris in 1934 and met Brancusi, Kandinsky, Giacometti and Mondrian; this at a time when these men were almost unknown in London, and when they were known were apt to be suspect. Before long she was persuaded to found *Axis* (which was published at Fawley Bottom Farm House, near Henley-on-Thames, Oxfordshire, where Piper moved in 1935 and has remained ever since), which quickly established itself as an invaluable point of contact between the emerging English abstract movement and its Continental pioneers. She proved an invigorating influence as a person as well as an editor. In 1938, the year after *Axis* ceased publication, she edited *The Painter's Object*, an anthology of contributions by artists to the perennially engaging theme of the content of art. Since then she has written on painting, including a book on Frances Hodgkins, librettos for operas by Benjamin Britten, adapted a play from Kierkegaard's *Diary of a Seducer* and much else besides. To dine with the Pipers at Fawley and to listen to Myfanwy, standing before her cooking stove, saucepan in hand, discoursing upon the thought of Gissing or Henry James, was a memorable experience.

I do not suggest that Piper was unduly affected by his abstractionist friends, but unlike many artists who take up – at least after their first youth – attitudes of marked independence or even isolation, Piper, on the contrary, has always been disposed to collaborate with others in creative activities: he has illustrated books by other writers, designed eighteen stage sets, including six for operas by Benjamin Britten. Accordingly he entered with particular wholeheartedness into the vigorously emerging abstract movement. With such wholeheartedness that he was gently but admiringly admonished by Hugh Gorden Porteus in an article *Piper and Abstract Possibilities* published in *Axis* No. 4, 1935, for being too rigidly abstract. 'Piper has made himself an absolute master of the game he plays', it runs, 'I should like to see him loosen the restrictions he still imposes on himself', and refers to 'his still too purified forms'. Herta Wescher, in the same issue, refers to his 'straight lines, angles, rectangles, trapezes, semicircles, nothing but mathematical forms . . .' Piper was in fact regarded as both a highly accomplished and conformist member of the English abstract group. Accomplished although his abstract works, whether painting, drawings or collages, certainly are, they do

not express his deepest impulse as, for instance, those of Ben Nicholson and Barbara Hepworth – who have both made fine works of an unambiguously representational character – express theirs. Abstractions by these two (and of course a number of others) are creations in their chosen language and they have accordingly a character of finality about them that Piper's lack. These are statements – lucid, inventive, harmonious and sophisticated – but made, so to speak, in a language ably mastered but not innately his own. How little his own is even clearer from his occasional returns to near-abstraction, as for instance in some of his Pembrokeshire and Breton coast scenes of the early 1960s. These lack both the forthrightness of his abstractions of the 1930s and, of course, his rare sense of *genius loci*.

Although he was to practise abstraction for some more years, as early as 1935 Piper was plainly convinced that a strictly autonomous art subjected those who practised it to crippling limitations. In an interview, 'England's Climate', published in *Axis* No. 7 – surprisingly, considering this periodical's abstract orientation – he declared:

Any Constable, any Blake, any Turner has something an abstract or a surrealist painting cannot have. Hence, partly, the artist's pique about them now, and his terror of the National Gallery . . . Read Constable's letters, or a poem of Blake's, or look at an early glass painting. Each 'means' far more than itself alone. It 'means' the life of the artist – but beyond that, the life of his time . . . [his] whole existence and surroundings, and it fixes the whole passion of his age . . .

Two years later he contributed an article, 'Lost – A Valuable Object', to the anthology *The Painter's Object*, in which he voiced the same opinion at greater length and with sharper emphasis. Here are what seem to me its crucial paragraphs:

The trouble being that the Cubists had smashed the objects into fragments . . . The abstractionists who followed held their noses in the air, and said they'd never been interested in the object anyway. The Dadaists and later the Surrealists, all premeditatedly scatter-brained, looked for it and failed to find it – oblivion being one of the few places they don't visit. And they have been celebrating its death ever since. Surrealists, in fact, produce things they call *objects* – fetish-worship idols, in the image of the vanished god of painting. Abstractionists, of course, forbid themselves such irreligious games.

All the time activities have been going on that both the Surrealists and the abstract painters disapprove of and pretend do not exist. These range from the wonderful pattern-making in space of Matisse (who could so easily be ignored except for the misfortune that he is a genius) to the seaside toy-making of Christopher Wood.

Where is the object? One thing is certain . . . artists everywhere have done their best to find something to replace the object that Cubism destroyed . . . It all seems to me an attempt to *return* to the object . . .

> But the object must grow again; must reappear as the 'country' that
> inspires painting. It may, at the worst, turn out to be a night-bomber,
> or reappear as a birth-control poster – but it will grow again, somehow.

(The reference to the night-bomber shows an extraordinary prevision
of one of the most impressive 'objects' chosen by his friend Paul
Nash in the impending Second World War.)

So much for convictions about painters' urgent need to recover the
'object' – or the subject, as it is more generally called. The article ends
by describing two objects that he finds reappearing in his own art.
The second is a beach 'which might be Newhaven, or the Welsh coast,
or the Yorkshire coast, or Brittany . . . There is an absence of life, of
seagulls even: but a sense that life is ready to break in . . .' This
description also shows an element of prevision; for it is a far closer
verbal 'equivalent' of the coast scenes of his maturity than of the
relatively tame *Beach Collage* made the following year.

So Piper continued to make abstractions, although with diminish-
ing frequency, after he had become convinced that painting – and not
only his own – should have an 'object'. This dichotomy was resolved
decisively by the war, and in particular by the threat to the buildings
he had loved since childhood, and before long by the devastation of
many of them. His love was not confined to ancient cathedrals and
village churches; like that of his friend John Betjeman – with whom
he produced architectural guides to Buckinghamshire, Berkshire and
Shropshire and one, edited by Betjeman, on Oxfordshire – it embraced
a wide variety of buildings, many of them not previously considered
eligible for inclusion in a tourist guide: nonconformist chapels,
country railway stations, public houses, suburban villas and the like.
Among his wartime subjects were villas at Reading and Henley (1940
and 1941), *Micheldever Railway Station, Hampshire* (1944), *The Ship Inn,
Shoreham-by-Sea* (1943), *The Royal Adelaide, Windsor* (1939) and *Italian
Cheltenham* (1939) – to name a few of his widely varying subjects.

The sharp recoil from abstraction, the value of which he had already
questioned, provoked by the war, although it radically affected his
choice of subjects, did not at first affect his style. The *Reading Villa*,
just referred to, for instance, although it quite unambiguously
represents a villa, does so in terms of rectangles, planes parallel with
the picture surface and so on, closely resembling those of his abstract
works. Piper's return to his boyhood loves and his anxiety to record
them in case they were destroyed was too impulsive and whole-
hearted to impel him, at first, to trouble himself with the evolution of
a style that would enable him to describe them more fully than
arrangements of flat patterns.

For Piper the war years were crucial for the development of his art
and the establishment of his reputation. Not that he had not won

high respect in the London art world during the 1930s as a painter (his first exhibition was held at the London Gallery in 1938), as a designer for the theatre (the scenery and costumes for Stephen Spender's play *Trial of a Judge* in 1937) and, as already noted, as a critic. But the war enabled him to find the Valuable Object, whose loss he had ironically mourned and for whose rediscovery he had expressed ardent hope.

No events had demonstrated so forcibly the importance of the Valuable Object as the two world wars. In both the authorities in Britain showed surprising wisdom in their choice of war artists. The humanly significant themes offered by both wars evoked from several artists, among others Nevinson, Wyndham Lewis and Paul Nash, a number of their finest works. In 1940 Piper was appointed war artist to the Ministry of Information (to specialize in bomb damage) and to the Ministry of War; he was also employed by Recording Britain, a publishing project financed by the Pilgrim Trust. The opportunities which these assignments offered could not have been more propitious. Here was an artist who from his earliest years had been an impassioned student of architecture, who was horrified by the prospect of the destruction of many of the buildings that had been the objects of his study; an artist who possessed, too, to a rare degree, a sense of *place*. A tribute to Piper's acute awareness of *genius loci* came from an unexpected quarter – unexpected for an artist, whose associates included Nicholson, Hepworth, Calder, Hélion, Miró, Léger, and other notable abstract artists. In an introduction to a book by Piper entitled *Brighton Aquatints* (1939), a voice from the remote past, that of Lord Alfred Douglas, declared that from the perusal of them 'I discovered that the Brighton of my youth was still in existence and that nearly all the old landmarks remain exactly as they were.' Surely to be able to reveal to a perceptive resident the finest buildings in his own city shows a sense of place of a quite exceptional acuteness. It was a sense that was to increase in range and penetration.

In addition, Piper's intimate and bracing association with a number of the finest artists in Britain and the Continent, and preoccupation with abstraction, which enhanced his awareness of structure, of the basic forms of things, combined to prepare him in a way that could hardly have been bettered for his intensive work of the war years. His reception into the Church of England in 1939 served to identify him still more intimately with a wide range of buildings threatened with destruction. Like those of a number of other artists, the country's danger and the severance of all links with the Continent for the time being focused Piper's interests predominantly on English art and poetry. He renewed his study of Turner, Blake and Palmer; his *Hampshire Cottage*, a watercolour of 1941, is very close to Palmer in

spirit; and he read Wordsworth, Coleridge and Hopkins as well as writers on the picturesque. Besides their effect on his painting and drawing, these studies found expression in a short but informative and lively book, *British Romantic Artists* (1942) in a series *Britain in Pictures*, in which he traced the Romantic impulse in British art from a 'romantic' poem by 'the most august Augustan Pope' to Paul Nash and Frances Hodgkins and beyond. He even attempts to indicate, in the first sentence, one element of that most elusive of concepts: Romanticism.

> Romantic art deals with the particular . . . |It| is the result of a vision that can see in things something significant beyond ordinary signifi-cance: something that for a moment seems to contain the whole world; and, when the moment is past, carries over some comment on life or experience besides the comment on appearances.

By implication – for no theories are developed – Piper's own attitude to the arts is more clearly manifest in this essay than in any of his other writings. A friend pleased him by saying, 'I know it by heart.'

The admiration that Piper's work evoked during the war effected his method. Although as a person he seems self-confident, and easily wins the trust and friendship of those with whom and for whom he works, as well as many others, he was, before the war, diffident about his painting. Admiration gave him confidence to evolve, gradually, the more fluent and 'freer' brushstroke natural to him and which became, eventually, so conspicuous a feature of his work. Many will remember the praise of his paintings and watercolours of bomb devastation: *House of Commons, Aye Lobby* (1941) and a watercolour of the same date; those of Bath; *Interior of Coventry Cathedral* (1940); the eerie desertion of *Dead Resort: Kemp Town* (1939); *St Mary le Port, Bristol* (1940); *All Saints Chapel, Bath* (1942) and *Somerset Place, Bath* (1942). St Mary le Port was destroyed in a great raid on the night of 24 November 1940; according to a letter which he wrote to the Tate in 1958 'when he went there he found the ruins of two churches still smoking'. In the same letter he describes, with reference to the two Bath pictures, arriving four days after what used to be called a 'Baedeker raid', that is to say, particularly devised for the destruction of historic buildings, how 'the ruins were still smouldering and bodies were being dug out'.

Knowledge of architecture and of the early English topographers gave Piper so firm a grasp of his subjects that, moved though he was by the poignant spectacles he chose to represent – there was no time for recollection in tranquillity – his pictures of architectural catas-trophe are painted with a sure touch. They are, in effect, a series of grand and elaborate sketches, their absence of traditional 'finish'

conveying a moving sense of their having been made on the spot 'when the ruins were still smouldering and the bodies were being dug out'. Some of them, the more elaborate, were in fact made from studies made on the spot, and he is unable to work from photographs, or from subjects that do not engage his utmost interest. During the war, for instance, he was asked to make a drawing of an air raid precaution post, and he was unable to do so.

Preoccupation with architecture, threatened or destroyed, led him naturally, as a man with a strong historical sense, to the representation of architecture for its own sake. In 1941 he received a commission to make two series of watercolours of Windsor Castle from Queen Elizabeth, now the Queen Mother. This, and the commission during the same year from the late Sir Osbert Sitwell to make a longer series of paintings and watercolours of Renishaw Hall, his house in Derbyshire (and after the war of Montegufoni, his house near Florence), gave Piper's particular gifts the widest scope.

Piper's work as a war artist and the fulfilment of these two inspiring commissions further enhanced his understanding of architecture, of which he took the utmost advantage, making over the ensuing years paintings and watercolours of a wide variety of buildings. The result has been the most various and by far the most extensive record of the buildings of Britain by any artist of this century.

Over the years Piper's style has undergone little basic change. It has indeed become freer, swifter and lighter in colour, but the aura of romance with which he often suffuses his buildings involves no distortion of their structure. He regards even his most highly romanticized representations of buildings as essentially accurate. One day at Fawley he left me for a few minutes in his studio and on his return found me examining a watercolour of the château of Chambord in which the centre of the façade was hidden by a circular blaze, almost an explosion, of white light. 'Perhaps you think that light was invented,' he said, 'but look at this!' And he showed me a photograph he had taken after making the watercolour, which showed the light as no less intense.

Allusion has been made so far – the reference to Chambord apart – only to Piper's pictures of architecture in Britain, but he and his wife make regular tours by car to the Continent, and he has painted buildings in France and Italy; Rome and Venice offer themes which have for him a particularly strong appeal, *St Agnese and the Bernini Fountain of the Four Rivers* (1962) and *The Salute* (1960) being characteristic examples. Piper spends more time on the Continent than most artists resident in Britain. There are some who do so for the purpose of identifying their work with that of the 'Continental mainstream', although, on account of the diminished importance of

Paris, far fewer than was once the case. Piper, however, belongs so integrally to the English Romantic tradition that his work is not remotely affected by his Continental friendships or subjects. (This was, of course, not the case in the 1930s when abstract art had already been established for more than two decades and was far more highly evolved than that of its English pioneers, and he learnt much from Hélion, as well as Braque, Léger and others.) Besides buildings he also, although much less often, makes watercolours and oils of pure landscape. On account of their conspicuously structural conformation, the subjects best suited to him are mountains, the 'natural architecture' of Yorkshire and North Wales. I am thinking of *Gordale Scar* (1943) and *Rocky Outcrop, Snowdonia* (1948), for example.

In a note on her husband in the catalogue of his first exhibition at the Marlborough New London Gallery in 1963, Myfanwy referred to one of his 'preoccupations' during the years 1930–39 as 'an empty stage'. This 'preoccupation' of his seems to me to have far wider implications than she intended. A singular feature of Piper's art is that in almost the whole of his formidably large production the stage is empty: there are no human figures. Occasionally he makes a portrait or a nude from life, but these are relatively few in number and seem to have been done without the intense scrutiny and the technical insight that marks even the slightest of his landscapes, with or without buildings. This absence of human figures is singular in view of Piper's exceptionally lively interest in his fellow men, both as individuals and collectively, as its apparent from his readiness to undertake many exacting official duties. But except for his mountain scenes of Snowdonia, Yorkshire and elsewhere, all of his landscapes, by the introduction, almost invariably as the commanding feature, of a cathedral, village church or chapel, castle, country house, Venetian palace, lighthouse or the prospect of a town, indicate the presence of man their creator. The stage is empty but, as Robert Melville, in the introduction to the catalogue of a retrospective exhibition at the Marlborough in 1964 perceptively observed, Piper has 'salvaged the humanist scale and undepicted man remains in his work the measure of all things'. This aversion to representing the human figure in its environment is the more singular in view of the readiness with which Piper represents representations of it, of the statue, for instance, in *Juno in the Grotto, Montegufoni* (1948), to mention one of his many figures made from sculpture and stained glass.

Whatever merits posterity will attribute to his workmanlike and attractive abstractions of the 1930s, there can be no doubt that Piper's concentration upon pure form did much to prepare him for the formidable achievements of the next decade. Surely there can be no comparison between the empty and trivial *Beach Collage* (1938) and

such works as the best of the Windsor and Renishaw paintings, the bomb-devastated buildings, *Hovingham Hall* (1944), *Great Coxwell Tithe Barn* (1941), *Castle Howard* (1943) or *The Monument, Waldershare* (1947).

The evolution of Piper's vision, like that of many other painters, has been away from precise definition towards breadth and atmosphere, expressed in what someone described as 'marvellous rapid handwriting'. And from a predilection for sombre skies (I was told that King George VI exclaimed, on first seeing the Windsor series, 'I hadn't realized that our weather was so bad') he has become preoccupied with light. If a choice had to be made from the immense production of Piper's recent work, the finest and most characteristic are, I believe, the representations, in oil, watercolour and lithograph, of church towers, of which *Redenhall, Norfolk* (1963), and several church tower triptychs, for example, *Lexfield, Lavenham and Darsham* (1965) are radiant examples. The special qualities of *Redenhall* (and of others of similar character) are poetically described by Robert Melville: 'The colour is informed by mild moist English air. The line defines whilst confiding a diffident lyricism, like a song nearly lost as the singer turns away.'

Such works as these I have occasionally heard described, with a shade of condescension, as mere sketches. They do indeed lack the intensity and bony structure of those of such topographical predecessors as, say, Girtin or early Cotman, but the description, in its implication, is unjust. To 'sketch' – according to a definition in the *Oxford English Dictionary* – is to give the essential facts without going into details. Give the essential facts Piper certainly does, but he can do more than this at his best: in his representations of buildings he endows sculpture and other features with exhilarating life; often with audacity, sometimes with seemingly careless strokes and dashes of brush, pen or pencil, but with an effectiveness far beyond the powers of an artist without Piper's intimate knowledge of architecture. Sometimes he completes pictures on the spot, but more often makes small studies which, sooner or later, as he has said, have 'roused lively thoughts of further development as drawings or paintings'.

Nobody – least of all Piper himself – would contend that all of these many works are of anything approaching equal value, but as a whole they present a panoramic view of Western, in particular British, architecture. The best among them – and they are not few – represent an exhilarating combination of the romantic and the particular searchingly understood. No painter of his generation, and few, surely, of any, has studied and portrayed in England, Italy and France so wide a range of architecture with such sympathetic understanding.

These few pages give little indication of the range or extent of

Piper's activities and virtually none of those except painting. In 1921 he produced his first book of poems, *Wind in the Trees*, and three years later *The Gaudy Saint and Other Poems*, which he also illustrated. In the late 1920s and early 1930s, before his pictures began to sell, Piper reviewed art exhibitions, plays and concerts for *The Nation*, *The Athenaeum*, *New Statesman* and *The Listener*. He contributed to *Axis* and many articles to *The Architectural Review*, often illustrated by his own drawings and photographs. He was also a frequent and accomplished photographer. He was a founder member of the English Opera Group; in 1931 he supervised the design of the Battersea Pleasure Gardens; in 1954 he designed the scenery and costumes for Britten's *The Turn of the Screw* with a libretto by Myfanwy, staged at the Teatro la Fenica, Venice. In 1954 he was already collaborating with Patrick Reyntiens, the glassmaker, and designed and made the East windows of Oundel School Chapel. In 1955, with Reyntiens, he arranged the Aldeburgh Festival exhibition, 'Anthology of Modern Stained Glass'. Two years later he was commissioned to design and make the Astor Memorial window at St Andrews Church, Plymouth and began designs for the baptistry window at Coventry Cathedral.

These were followed over the years by the design of a number of stained glass windows for a number of other buildings, including eight for Eton College Chapel, Liverpool Roman Catholic Cathedral (with Reyntiens), Coventry Cathedral, St George's Chapel, Windsor, St Margaret's, Westminster, the Cathedral, Washington, D.C. and St Mary's, Fawley. In 1959 he designed mosaics for St Paul's Church, Harlow New Town, and for the entrance hall of the BBC Television Centre, and in 1961 for the Birmingham Chamber of Commerce. In 1960 he designed the library of the Orient liner *Oriana*. In 1961 he directed the conversion of a loft into a chapel at Nuffield College, Oxford, designing the altar and stained glass. In 1962, after completing designs for the baptistry window of Coventry Cathedral, he also designed new vestments. But I will mention no more: his activities are continuous.

For every decade of Piper's working life there have been held more exhibitions of his work than most artists have in their entire lifetimes. Two, however, have been outstanding: 'John Piper: 50 years of Work, Painting, Drawings and Photographs 1929–1979', at the Museum of Modern Art, Oxford, May–June 1979, gave an evocative impression of the wide range of his creative activities. The second, at the Tate in December 1983, covered his creative activities with rare completeness, throughout nine galleries. As though the numerous exhibits were not sufficient, photographs of other works were shown. For its range, variety and accomplishment it was a memorable event.

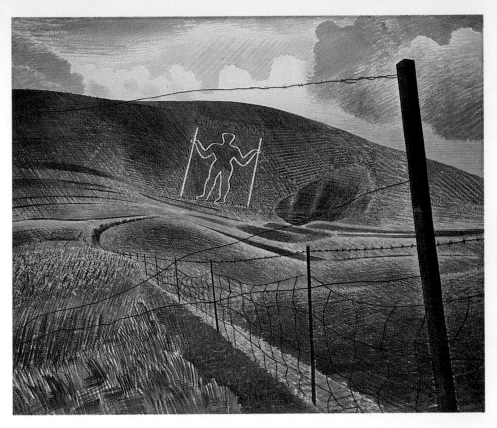

1. ERIC RAVILIOUS: *The Wilmington Giant* (1939).
Watercolour, 17⅝ × 21⅛ in (44·4 × 53·4 cm).
The Victoria and Albert Museum, London.

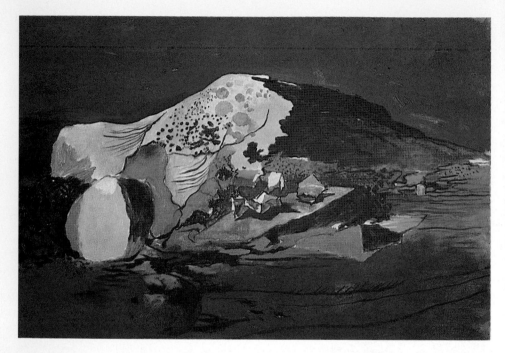

2. GRAHAM SUTHERLAND: *Red Landscape* (1942).
Oil, 26¾ × 39¼ in (68 × 99·8 cm). Southampton Art Gallery.

3. ALBERT HOUTHEUSEN: *A tout à l'heure* (1961).
Oil and collage, 48 × 60 in (120 × 150 cm).
Coll. of Richard Nathanson, London.

4. JOHN PIPER: *Castle Howard* (1943).
Oil on board, 25 × 30 in (62·5 × 75 cm). Private collection.

CATHERINE DEAN
1904 – 1983

Some years ago when I was writing a book (as yet unpublished) on Albert Houthuesen, to whom the subject of this essay was married, I made an egregious error for which I cannot forgive myself. At the time I was paying regular visits to their house in Camberwell; Albert was gravely ill, so I used to exchange only a few words with him, but Catherine afforded me the utmost help, recalling biographical facts and aspects of his art and character and showing me numerous examples of his painting and drawing.

On one such visit, while I was waiting for her in a room packed with paintings and drawings while she was attending to some need of Albert's, I noticed with admiration paintings of a broken loaf and of a plate of grapes in front of a large dish. When she came back I observed that they were uncharacteristic of Albert. 'But they're not by Albert, they're *mine*.' I immediately asked whether I might see some of her other paintings. What she showed me filled me with admiration – and shame at my ignorance of the range of the achievements of so old a friend. Had I been wholly unaware of her gifts, that would have been shameful enough, but what I had done was yet worse, for I was not unaware of them. In 1940, I had begged Dean's *Cat Asleep in a High-Backed Chair* for the Tate from our common friend Lady Matthews, who generously presented it. Another, *Sheep's Skull and Ferns* always hung in the Houthuesen's house, and I never looked at it without admiration. Ineptly I assumed, in view of the weight of Catherine's exacting and varying responsibilities and the absence of the slightest allusion on her part to her own painting, that she had practised it only on the rarest occasions and years earlier. I had regarded *Cat Asleep in a High-Backed Chair* a splendid expression of a talent frustrated and long inhibited by circumstance. For my obtuseness I felt the worse since we had been friends all her adult life, ever since she became a student of my father's at The Royal College.

My self-reproach was deserved, but circumstances made its cause explicable. During Houthuesen's long periods of serious illness, Catherine had devoted herself so completely to his care, the management of his professional affairs and of their household, that over

many years she had scarcely a moment for painting. I hope that I will now make some amends.

Catherine Mary Dean was born on 16 October 1905 at 1 St John's Road, Fazakerley, Liverpool, her mother's only child by her marriage, in 1903, to James Harold Dean, a marine engineer. Both his family and his wife's, the Gatcliffes, were long-established in Liverpool. Her great grandfather, Samuel Petit-Leather, according to unchecked family tradition, was the architect responsible for the design of several notable Liverpool buildings, including the Philharmonic Hall, which was destroyed in the Second World War, and the Picton Library; he was also an engraver and etcher.

The Dean's house at Fazakerley was the first of six situated in a large field, in which grew a variety of wild plants. This was a perfect playground for the children of the houses and excited Catherine's lifelong delight in the countryside and particularly in flowers.

She became devoted to her two half-brothers – who were aged fourteen and twelve when she was born – particularly Eric because he studied at home and played with her, and it was he who first encouraged her to draw and paint. He himself drew and painted and was musical. Catherine always remembered sitting on the carpet at the foot of the music stool, listening while he practised piano for hours – Chopin, Mendelsohn, Tchaikovsky, among other classical composers – and how he delighted in stimulating his half-sister's fascination by the visual arts. When the war came both brothers immediately enlisted. While leading his platoon 'over the top' at Arras on 23 April 1917, Eric was killed. 'This tragedy,' Catherine said to me, 'has darkened my whole life. Whether one is born with deep pessimism, or whether such a tragedy gives it one for ever, I don't know. Certainly I have it – and have been a pessimist at heart ever since.' After his death their mother could not bear to hear Catherine's juvenile piano practising; her musical education, so far as playing an instrument went, accordingly ceased.

In spite of the happy relations with her family, especially with Eric, Catherine became independent and solitary early in life. The fact that she was the only child of parents who were nearing forty when she was born, was exceptionally shy, delighted in music and landscape, but above all in the visual arts, all combined to foster her detachment.

From 1912 until 1920 she attended a small private school, but her own inclination and the memory of Eric's encouragement caused her to decide to become a painter. In 1921 she won a scholarship to the Liverpool School of Art, where she remained for five years, and in 1926 she was awarded an £80 travel grant by the Liverpool Education Committee, which allowed her to meet her expenses at the Royal College of Art, which she had entered that year. The grant, however,

was insufficient to maintain her all year in London, and so she went home during the holidays, doing a variety of work such as painting banners for Masonic Lodges and an occasional portrait of a friend.

Having left school at fifteen and subsequently struggling to win the scholarships necessary to enable her to study at Liverpool School of Art and the Royal College imbued Catherine with the perseverance which lasted throughout her life.

Not long after her arrival at the College she happened to see a list of students who had earned special awards posted on a notice board, including one name which aroused her curiosity: Albertus Antonius Johannes Houthuesen. Some time later her attention was attracted by a painting, *The Supper at Emmaus*, hanging at the head of the staircase leading to the Life Room and another to the adjacent Victoria and Albert Museum. Her first sight of Houthuesen was of him running, flush-faced, towards the College along the cinder track between the students' common room and the sculpture department (then housed in old army huts) and Exhibition Road. The running figure looked tense and highly strung, with thick blond hair, metal-rimmed spectacles and a black pin-striped suit. She asked a fellow student who the strange figure was, to be told 'Woodhouse', the name he then preferred to be known by, being the exact English translation of his surname.

Not long afterwards they met; Houthuesen had noticed Catherine alone, drawing, and was immediately attracted to her. It so happened that, like most attractive female students, she had been pursued by some male students, whom she disliked, and was apt to be 'spoilt'. Accordingly she was prejudiced and snubbed Albert. But he was not discouraged and before long they became friends and used to sit together under the tall trees in the quadrangle of the Victoria and Albert, or go into the Museum, which he had long known well and where he drew her attention to special treasures.

Before long they became more intimate. 'It was a wonderfully happy time after the unfortunate beginning of our friendship,' she said to me, 'which I suppose I've been trying to make up for ever since.' Among other places, their wanderings took them to my parents' house, 13 Airlie Gardens, Kensington, which was open to students of the College every Sunday evening during term, partly to enable them to meet artists, writers and others who might be of help or interest. We had no notion of the trouble which Catherine (and other students) went to to prepare for these occasions. Catherine used to make dresses, for instance, out of cotton curtains that her mother had sent her, which she then dyed in a bath, using a sewing machine which an aunt had lent her the money to buy. This she would also use to turn Albert's cuffs and shirt collars when they were worn out

or make new ones from pieces cut from a shirt tail. When particularly depressed by their poverty, she used to comfort herself by reading the account in the diary of Dostoevsky's wife of the time when they were reduced to utter poverty because of his gambling.

Catherine remembered meeting at my parents' house several visitors whose work she admired: Ralph Hodgson, James and Cynthia Stephens and Max and Florence Beerbohm. Also, shortly after Hardy's funeral, Florence, his widow, was very distressed and tearful. My mother introduced Catherine to Mrs Hardy who reminded me how hard she and I tried, without success, to comfort her. She met these guests only once, but she became friendly with Sidney Schiff and Violet, his wife. They corresponded; she was excited at knowing someone who had met Proust and who gave her a copy of *Time Regained*, which he had translated. Her extreme enthusiasm evoked a temporary distaste for Proust in Albert; but later he gave her a volume of Proust's letters.

Albert left the College in 1928 at the end of the summer term, when Catherine also took her diploma before completing the customary four years, afraid that the annual £80 grant would be discontinued. In the event it was extended for another year, which enabled her to devote herself to painting and to Albert.

Shortly after he had left the College his second version of *Supper at Emmaus* was bought for £80. This gave Albert confidence, and one evening, walking to her rooms in South Kensington, he proposed to her. They decided to marry as soon as possible.

When Catherine left the College in 1929, unable to find work in London, she taught art at Withington School for Girls in Manchester, where she respected the staff but not the children, many of whom arrived in chauffeur-driven cars and were apt to behave offensively to the younger teachers. Albert's letters saved her from despair.

In order to be nearer to him she taught briefly at a school in Nuneaton, leaving when she had secured a part-time post at a London County Council Training College as a teacher of crafts and needlework and later taking classes for teachers at the Blackheath and the Camberwell Schools of Art.

To both Albert and Catherine their engagement seemed very long, but 3 October 1931 – his birthday – they were married at St Emmanuel's, Fazakerly, the church where she was christened, Albert wearing 'the black suit' in which she first saw him four years before.

They rented the two upper floors of a small terrace house, 20 Abbey Gardens, in St John's Wood, determined to make it as happy a place as they possibly could. Their landlord, a grocer and a Sunday painter, was a very amiable man whose wife used to say that 'artists always like St John's Wood because the North light comes straight down'.

The early years of their marriage were happy: they delighted in their visits to the theatre, circus and ballet, denying themselves meals in order to afford seats or standing room in the gallery. Among many other performances they saw Massine in *The Three-Cornered Hat* with the original Picasso costumes, sets and curtains.

They enjoyed these years in spite of their poverty, which was acute, for Albert's teaching was poorly paid and Catherine was unable to obtain any teaching post at all. Eventually, however, she obtained a two-day-a-week position at Honor Oak Girls' School as a teacher in the art department (which she enjoyed and held for six years) her time later being increased to four days, although she had to teach English as well as crafts. But the salary was insufficient to meet their needs and she had, accordingly, to teach evening classes at art schools as remote as Blackheath, Camberwell, Islington and Stoke Newington. Her life was hard: she was rarely able to get home before ten, having left at half-past seven in the morning.

Two of Catherine's aunts shared a cottage at Berthengam near Holywell in North Wales. She and Albert took intermittent holidays with them, sometimes staying for three months in summer, a week or two over Easter and at Christmas. Albert was deeply attached to North Wales. Catherine was able to draw and paint, but such times were rare indeed, and remained so for many years. Throughout her life she drew and painted, but only intermittently during school holidays. Her work was either given to friends or sold for scarcely more than nominal sums.

In 1936 Albert was seriously ill and was compelled to give up teaching in the evenings, so their poverty became yet more acute. By March 1938 they were no longer able to afford the two floors in Abbey Gardens, and they moved into a small studio at not far distant 37b Greville Road. It was of architectural interest, its design, by Basil Spence for the sculptor Alfred Hardiman, was based on that of an old stable. Albert was delighted with it. To celebrate their move they gave an evening party of some fifty guests, to which we brought Stanley Spencer.

A few months before the beginning of the war they were in Yorkshire, and we introduced them to some close friends, Sir Ronald and Lady Matthews, who lived at Aston Hall, Sheffield, with whom they stayed. Shortly afterwards Catherine was appointed the most rewarding post she had held, as lecturer in art at St Gabriel's Teacher Training College in Camberwell. The opening of the College for the autumn term was postponed on account of the war, pending decision by the authorities as to whether it would be advisable to evacuate the students. Accordingly Catherine was able to remain at Letwell at a cottage of the Matthews's, receiving, for the only time in her life, a

month's salary without working for it. At the end of October she went to London and assumed her duties, visiting Albert for Christmas at Letwell.

In the spring of the following year Albert returned to their Greville Road studio, he working there and she going daily to the College, staying beyond the end of the 'phoney war'. In the autumn when the bombing began they shared the air-raid shelter of Sir William Goscombe John, the sculptor and a friendly neighbour, who lived opposite at number 24. Fortunately they were away for a weekend in North Wales before St Gabriel's autumn term began when a bomb fell in St John's Wood, completely destroying their neighbour's studio and seriously damaging theirs. On their return they salvaged most of their possessions – a few had been damaged or stolen – including some furniture and forty of Albert's paintings.

Having nowhere to live in London, and as St Gabriel's was also bombed, Catherine and Albert returned to her aunts in North Wales, from where they saw the bombings of Liverpool where her parents lived across the Mersey estuary.

During their years in the North they lived mostly in Tickhill in uncomfortable rooms, but moved eventually to a pleasant half-cottage. It was not far from Doncaster, to which St Gabriel's had been evacuated after a period in Coventry, where Catherine had also served.

When the war was over Catherine and Albert returned to London. Happening to meet Catherine, I urged them to rent a studio, then easy to secure, as quickly as possible since rents would shortly be very high. Although we had exchanged letters from time to time, owing to their stoicism I had no notion of their circumstances, their utter poverty, or his serious ill-health which had made it impossible, over the past two years for him to earn a salary. Her pay at Doncaster was minimal. Unless she had been able to buy vegetables cheaply in Tickhill they would barely have avoided starvation. They had nothing in the bank.

Fortunately, St Gabriel's College was reopening and plans were in hand for the repair and reconstruction of its war-damaged building. But in the meantime hostels for the students within comparatively easy reach had to be found. The College being a church of England foundation, the authorities were able to make available disused vicarages, and a part of that at Lady Margaret's Chatham Street, Elephant and Castle, was offered to Catherine and Albert at a rent of £25 a year on condition that she, who was appointed warden and senior lecturer, looked after the fifteen young women who were to live there. The church was used occasionally, but there was no vicar. Not having alternative prospects, they accepted and were allocated

three rooms on the ground floor for a year – and remained for five. Here, remote from any place with which they were familiar, they immediately felt at home; remote, yet relatively accessible to Kensington, Chelsea and Hampstead, where many of their friends lived, as well as the West End.

Although their quarters were, as so often, cramped, Albert and Catherine were exhilarated by their return to London and their escape from the outskirts of Doncaster, especially to a region of London imbued with an element of fantasy. Both were fascinated by their strange neighbours – many 'originals', many known or suspected criminals – and by the old-fashioned corner shops (almost all now destroyed by developers). While waiting in a shop to be served, it was not unusual to hear animated talk between a 'regular' and a 'new-looking customer' (a prisoner just released from jail), who might be overheard to say such things as, 'It's not bad at first, yer know, then it's bleedin' awful.'

The St Gabriel's students were always watchful for some exciting happening, and those occupying the top rooms with good views of the streets below were always ready to alert Catherine and Albert when someone was doing a midnight 'flit' or carrying anything suspicious.

Sometimes there would be dramatic celebrations in the neighbourhood – a wedding, a funeral or a jail release – at which time benches would be borrowed from the local British Legion and placed round some small room in the host's house, from which all other furniture would be removed. Dancing would then begin which would be accompanied by terrific rhythmical stamping by all those sitting on the benches.

When several other hostels suffered disciplinary disorders, Catherine, assiduously helped by Albert, kept admirably cheerful order among the students. In fact they were even suspect by the College bursar because they never had occasion to fine a student. There was one circumstance that made discipline easier than it might otherwise have been, namely that the neighbourhood was so dangerous that the students were frightened of staying out after the statutory hour of eleven; like most rules it was sometimes broken. The housekeepers varied from former Eton Dames to a missionary from deepest Africa, who was remembered for her bizarre sayings. To a student who was painting a Crucifixion she remarked, 'That's all very well, Miss, but Our Lord never had legs like that.' The ending of the war added to the general liveliness, troops being demobilized and streets hung with welcoming flags, and parties held for every new arrival home.

The evenings of their last years at the Elephant and Castle were devoted more and more to visits to music halls and theatres, especially

to Covent Garden, always in the gallery, 'standing room only'.
Although their life there was more interesting and enjoyable than at
any time, after five years they were restless and in need of change. In
any case their circumstances had altered. The College was closing the
outlying hostels and Catherine's two benevolent aunts from Berthen-
gam had died, leaving her almost three hundred pounds. To them
this was a fortune, and they decided to leave the Elephant and Castle.

At Doncaster during the war Catherine and Albert had become
close friends with John Acheson, later Earl of Gosford, and his wife
Francesca, an Italian-American by birth. He was a group captain
stationed at an RAF base near by. In the North they rarely met anyone
interested in the arts, and Lady Acheson not only drew but was an
active craftswoman. She allowed Catherine, during her brief periods
of leisure between her duties at St Gabriel's and responsibilities to
Albert, to paint in the office she shared for voluntary war work.
Catherine and Albert stayed with them when they were living near
York, and she painted a small portrait of their son Charles when he
was eighteen months old. Lady Acheson obtained for Catherine
several commissions to paint portraits of the wives and children of
officers stationed in York.

After several moves, in 1950 the Achesons took Stone Hall, near
Oxted in Surrey. It was a very large, rambling, bomb-blasted house,
long deserted and disintegrating with dry rot, consisting of some
forty rooms, several of which they intended to turn into flats to let. It
was surrounded by neglected gardens and decaying outbuildings. In
November of that year they encouraged Catherine and Albert to settle
there at a rent of three guineas a week, which they could scarcely
afford. Their accommodation consisted of a huge billiard-room with
a big West and a circular East window, which they used as a studio.
Here she painted several versions of *Naboth's Vineyard*, and *Family at
Stone-Hall* and *From the Studio Window, Stone Hall*.

Compared with the bleakness of the war years in the North and the
rich variety of those at the Elephant and Castle, the two spent at
Oxted were serene and uneventful. The spare rooms were never let
and eventually they were troubled by the house's eerie silence. They
longed, moreover, for a home of their own. As the Acheson's plans
were changing they had, in any case, to move yet again.

Catherine and Albert longed for a permanent home in London, and
for more than two years she searched widely, tirelessly scrutinizing
advertisements. At last, in 1952, in a South London newspaper, she
found one which described a house at 5 Love Walk, Camberwell; it
seemed ideally suited to their needs, and it was for sale. But they had
no capital and her salary at St Gabriel's barely enabled them to exist.
It offered endless possibilities, but the landlord refused to let it and

they said goodbye to all their hopes. One morning, however, in July 1952, when she was in the College studios a maid announced 'A gent to see you', and in walked the apparently intractable landlord. He simply said that arrangements could be made for them to rent it for £4 a week. Finally feeling secure, they settled happily into their first real home after eleven moves, mostly forced on them since the bombing of the Greville Road studio twelve years before. They hoped never to move again. But on a quiet Sunday morning some two years later the landlord returned to announce that it had been decided to sell the house after all, and he gave them the required three months' notice. They were deeply distressed, for they had not saved a penny.

Then a fortunate event occurred: a new principal of St Gabriel's was appointed, who, shortly after taking up her post, appointed Catherine principal lecturer with an accompanying rise in salary. She promptly consulted her bank manager, and arrangements were made to enable her to buy the house freehold. Over the next years she suffered constant anxiety regarding the heavy financial obligations that this involved, but the secure possession of the house they loved so much brought Catherine and Albert intense happiness. Three doors away was the house built for Ruskin's secretary; not far was Ruskin's own house, finally demolished during the war.

Both Catherine and Albert made notable contributions to the assembly of the collection of works of art for St Gabriel's, which received, in 1940, a bequest in memory of Victoria Morris, Catherine's immediate predecessor as lecturer. Among Catherine's contributions is a German Bible of 1640, and, in addition, four artists presented examples of their work, Catherine *Head from Pishawr* and Albert *The Love Letter*.

A long letter I received from the distinguished theatrical producer-actor Douglas Wilmer following the exhibition of Albert's work in May–June 1961 recalls his friendship with Albert and Catherine. It concludes:

> . . . Cath, without whom A could not have been, I believe. Her incredible devotion, self-denial – self-effacement and strength of character and counting of small blessings – her willingness to 'enter the lists' in so many incongenial fields, such as the law, nursing, accountancy, tax difficulties: to protect Albert – and above all, her love and kindness for all about her – all these and other qualities without number make her a shaming example to me (of myself). I hope very much that she will look after her own shaky health and continue to exercise her *own* great gifts as a painter – increasingly.

Their first sixteen years at Love Walk, in spite of Albert's declining health and sight and the ever-increasing demands it involved on Catherine's care – were the happiest in their lives. But from 1970 the

decline in his health accelerated and this inevitably had tragic effects on both their lives. She would spend all day and most of the night – often some twenty hours – not only nursing him and helping him to paint and also attending to sometimes complex professional and legal problems.

On 22 October 1979 Albert died. For more than two years she devoted herself, with rare dedication, to securing for his art much of the recognition that was so unjustly withheld during his lifetime. But with characteristic wisdom she eventually decided that she had done all she should, and in a letter to me dated 14 April 1982 she wrote: '... more and more I am coming round to the opinion that I've pushed all I really can, and his work will eventually look after itself – it cannot fail, knowing as we do what is really in it'.

Catherine also devoted herself to her own art, which, in none of her previous years – except those as a student – had she had more than the rarest opportunities to practise. Her talent had revealed itself early in her life. In a shadowed corner of a room in Love Walk hung a small painting of a seated boy. It was her first, an oil made in 1922, done, as she says, before she 'learnt' to paint at the Liverpool School of Art, and completed in an hour. It has nothing of the creation of an 'infant prodigy'; it is a sober, traditional and very competent work for an untaught seventeen-year-old. Of somewhat similar character is *Portrait of Scottie* (1928), made at the Royal College of Art, but its more confident modelling clearly reveals the value of the instruction she had received. *The Entombment* of the following year is very different; it shows that her imagination had been stirred by her study of other painters, in particular Stanley Spencer; also a command of complex composition. By the next decade she had reached full maturity, apparent in the Tate's *Sheep's Skull and Ferns*, painted in Trelogan, Flintshire, North Wales, in composition still more complex yet completely lucid – and a work of rare poetic insight. Of yet greater complexity and lucidity is *Still-Life of Spring Flowers* (1944). If it lacks the varied, poetic aura of *Sheep's Skull and Ferns* it is, nevertheless, an outstanding example of her accomplishment, with every petal and every leaf precisely realized.

Catherine painted a number of flower pieces – most of them commissioned – over a period of forty years or so. One of them, which I have not seen since it was painted in 1941, remains vividly in my memory. Its subject is a bunch of flowers in partly unwrapped tissue paper. The transparent wrapping, reflecting clear light from several angles, encloses flowers represented with understanding and technical skill. I had the good fortune to buy the painting for the Contemporary Art Society.

Catherine's ability to represent subjects such as flowers and leaves,

especially those close to the eye and flat, imparting a character to each, was a rare one. Her work shows, however, that she had little feeling for distance, as is evident in most of her Letwell and Tickhill landscapes, or for movement; she was apt to be at her best when she represented subjects that were near and still. This, however, is not invariably the case, as seen, for instance, in *Naboth's Vineyard*, a complex woodland depicted with delicate perception. It also indicates her sense of character: three figures – Lady Acheson in the foreground busily gathering primroses, her two young daughters close to her, her son Charles wandering dreamily apart – are all distinct. Technically she was at her least impressive when she painted 'freely', as, for instance, *Living Room in a Cottage at Letwell*, *Snowy Morning from our Cottage at Tickhill* (both 1943), or *Stone Hall, Oxted* (1942).

Her subjects during the war years – apart from flowers – were not such as she would have chosen in less unfavourable circumstances. In any case the ever-increasing need to devote herself to Albert's health, as well as her duties at St Gabriel's, allowed her scarcely any time for painting. But even while lecturer at St Gabriel's and attentive of Albert's ever-declining health she was able to paint – just. A notable and strange achievement is *Attic Table with Bees* (1962–66). Its subject is a table with its top turned upright. As the title tells us, there are two bees, both enfolded in an aura. The top is elaborately inlaid and it too has a narrow white aura around and close against it. The subject is not quite, but fairly 'ordinary': in an antique shop it would attract no undue notice, but this precise, intense representation of it does. Looking at it I am reminded of Albert's words: 'If you can explain the subject of a picture there would be no need to paint it.'

Although Catherine's art is far from wide-ranging either in subject or treatment, it has a degree of variety (apart from the landscapes which I doubt whether she would have undertaken had circumstances been otherwise), for example *Broken Brown Loaf* (1958) in particular, *Unburnt Loaf in Studio* and *Burnt Loaf in Studio* (both 1981), all of which are 'freer' and far more 'painterly' than *Attic Table*, indeed more than most of her other work.

After Albert's death, together with all that she achieved towards the recognition of his painting, she was able to practise her own painting with unprecedented regularity. And to what purpose was manifest in her first one-woman exhibition, held at the Mercury Gallery in January–February 1982. It was not only widely praised but highly successful; of the forty-three works exhibited, all but five were sold. Included were two perceptive portraits, *Freesia* (1978), and *Uglie* (1979), besides a number of other subjects. But the most memorable subject, to which she constantly returned, were flowers, such as *Pool with Waterlily*, and most conspicuously *Fatsia Japonica and Three Cats*

(1981) – the cats only just perceptible peering through the foliage – and several others of almost identical subjects. Like many of her best works these are imbued with delicate, affectionate and serene humour.

In light of her always heavy responsibilities and the grievous circumstances of more recent times, until the last three years prior to her death she had found it possible to paint only at odd hours, often at night or very early in the morning, and usually between longish intervals. Her achievement is thus a very rare one. Its most remarkable feature is negative, namely that her art was in no way affected by the intimate association of more than fifty years with an artist of rare and highly individual talent, and one whose work she always so deeply revered. Yet at no time was her own painting influenced by his. Her *Entombment* (1928) depicts a crown of thorns resting on a slab of stone. This does, indeed, closely resemble the treatment of the same subject in certain of Albert's, but anticipates it by a number of years; not that Catherine's painting ever remotely influenced Albert's: *Entombment* represents a chance crossing of their ways.

To someone who wrote of her exhibition with admiration, Catherine replied 'I'm glad if there appears to be any sunlight in my work, for I do not wish to pass on personal troubles to anyone. Perhaps it has been my defence against the horrors and trials of life to escape when possible among pleasant, everyday things.'

During the 1970s, never at any time robust, she was grievously afflicted by several ailments, including cancer. She died on 25th January 1983.

EDWARD BURRA
1905 – 1976

In his fourteenth year Edward Burra's prospects for the successful pursuit of any vocation must have seemed negligible; indeed, his fitness for any vocation at all could readily have been called in question. Never robust, he was subject to a combined attack of anemia and rheumatic fever of such severity that he never fully recovered from its consequences. At the age of thirteen his constitution was gravely impaired and he was compelled to leave school with minimal education. (I once referred to his uncertain health, and he replied 'Nonsense: I have the constitution of a mule; otherwise how could I have made it for so *long*?')

These seemingly catastrophic circumstances combined, however, to enable him to become an artist. Unfit to prepare for a regular profession, he became free to devote his acute and original mind, his prematurely penetrating observation and his entire time to his chosen vocation. He was spared the accumulation of knowledge irrelevant to an artist; moreover his parents, and not only because of their anxiety about his health, welcomed an interest in the arts and fostered his choice of vocation, however uncertain the prospects it offered.

The artists of the past owed much of their technical resource to prolonged apprenticeship. At the age when students of today begin their education, their early predecessors had at least mastered the elements of their art and often considerably more. In this respect Burra resembled them, for from the age of fourteen he was able to draw, paint, observe and enlarge his imaginative experience without opposition or distraction. The continuing precariousness of his health required him to dedicate all of his energies to the pursuit of his art; he had little extra for conventional pleasures and none for the politics of art. Even his personal relations were of a special kind: he felt, I believe, particular affection for and even dependence on his small circle of old friends, but it was almost invariably they who would have to take the initiative when meetings were concerned. Were they to fail to do so, the friendship would languish. But they did not fail, and he was warmly responsive. 'I have been meaning to write but never have of course' is a sentence that recurred in his letters. When he wrote he wrote very fluently, although the premature ending of

his formal education is evident in the casualness of his spelling: Herbert Read is 'Herbert Reed', foreigners are 'foriengers' and so on, and his handwriting, although not as childlike as Lucian Freud's, developed little since his schooldays. At times his letters revealed the same characteristics as his paintings, a preoccupation with the macabre and, particarly in the earlier, with the shoddy.

As a man he seems to have suffered from a languor, even an exhaustion, so acute as to suggest that he was incapable of action of any kind. Incapable of standing for long periods, he once said to me 'I must sit down most of the time; if I could work lying down I'd do so.' Even in his student days he put me in mind of an inactive, almost run-down being, so near to exhaustion did his reserves of energy seem. There was little about Burra's presence to suggest that he was shortly to show himself to be an artist of astonishing originality, and to be the creator, over some fifty years, of a long series of highly finished paintings.

Edward John Burra was the eldest child but one (who died young) of Henry Curteis Burra JP, and his wife Ermentrude Anne, born Robertson Luxford. He was born on 29 March 1905 at his grand-mother's town house, 31 Elvaston Place, South Kensington. The school which he had to leave prematurely on account of the collapse of his health was Northaw Place, Potters Bar. 'There were a great many strange scholars there,' he said, describing the school, and manifesting his preoccupation, even as a boy, with the quality of strangeness of which he was later to give such masterly expression.

After leaving Northaw Place he drew and painted at home in Rye until 1921, when he spent two years at the Chelsea Polytechnic. Here he became friends with the future theatrical director, William Chap-pell; the fact that they were younger than most of the other students first brought them together, but this friendship – as with others formed in his early years – flourished until his death. Chappell remembered Burra's addiction to squalid subjects with sinister overtones. Looking at some of his drawings of hags screaming at each other in Casey's Court, a slum street, one of the masters asked him why, for a change, he didn't draw some smart people. He did so, and the smart people looked more frightful than the hags.

In 1923 he transferred to the Royal College of Art, remaining there for a year. At the College, where I first became acquainted with him, he was regarded as something of a strange scholar, partly on account of occasional eccentricities, but far more for his extraordinary sophis-tication. The life drawings he made there show that he was already an extremely accomplished draughtsman. During the years when his fellow students had been applying their attention listlessly to the binomial theorem – subjects with little relevance or none at all to the

nourishment of artistic talent – Burra had been charging his imagin-
ation with precisely the ideas and the imagery that it most required.
With the literature, for instance, of the cosmopolitan world centred in
Montparnasse – Blaise Cendrars, Francis Carco, Pierre Macorlan and
Daniel Fuchs. But he was also widely read in earlier writers, in
particular the Elizabethans Tourneur and Marston, whose *Scourge of
Villainie* was a favourite, as well as Walpole's *Castle of Otranto* and
Harrison Ainsworth's *Tower of London*. With *Oliver Twist*, too, he was
familiar. Although such works treat a wide variety of subjects, they
offer an indication of the two subjects that obsessively preoccupied
Burra and accordingly contributed to the enhancement of his creative
energy and to the sense of purpose which young artists are often
slow to discover. These two subjects were the Latin South, especially
its underworld, and the sinister and menacing aspects of life in
general. 'I've never been even faintly curious about any northern
country, but I've wanted, for as long as I can remember, to go to
Mexico and Venice,' I heard him declare. In later life, however, he
became attracted by the North of England, especially Yorkshire, also
by Ireland.

About Burra's representation of evil there is a quality that distin-
guishes him from the satirist; from, for example, George Grosz, whose
work he particularly admired. Grosz exposed, with grim ridicule, the
brutish callousness and greed, the arrogrance and capacity for hatred
of his early German profiteer type of subject; Burra created manifes-
tations of evil of various kinds, but without ridicule or censure.
Burra's evil is shown simply as evil, without comment. Since the
artist will be personally unknown to the large majority of readers,
this description of him is meant only to make clear that his depiction
of evil was in no way an expression of his character – far from it. It is
simply that evil – which he regarded with an obsessive horror tinged
with amusement – happened to be the particular aspect of life to
which his attention was habitually drawn.

It was characteristic of Burra that he did not wait until he visited
the Continent to portray with a profusion of detail the various aspects
of its low-life that was to be his chosen theme for some fifteen years.
By the time of his arrival at the Royal College, Burra's knowledge of
painting was as wide as it was of literature. Caran d'Ache and Doré
were early favourites, but El Greco, Zurbaran, and, in particular, Goya
were more enduring influences. From Signorelli he learnt the effec-
tiveness of hard, simple modelling and of the taut pose for conveying
suggestions of restrained violence. Among other contemporaries and
near-contemporaries those he studied to most purpose were, Grosz,
Beardsley, Dulac, Walter Crane, Chirico, Wyndham Lewis, Dali and
the now all but forgotten Covarrubias. As the number and variousness

of the artists suggest, Burra was the disciple of none, but, like a magpie, picked up what he fancied. And what he took he assimilated into an art that had become, by his mid-twenties, one that did not remotely resemble that of anyone else: lucid, audacious, fantastic, and often conveying overtones of menace and corruption.

There was something bizarre in the contrast between the delicate young man who, although at times 'a strange scholar', was homeloving, and the products of his imagination: nocturnal encounters in the red-light districts of Continental cities, scenes set in the waterside cafés and sailors' brothels of Mediterranean ports. These places were represented with meticulous correctness, for Burra was not only acquainted with picturesque literature in more than one language but, like Utrillo, he made extensive use of picture postcards.

From the mid-1920s, when he made fairly frequent visits to the Continent, his use of postcards diminished, and he came to rely increasingly on his extraordinary memory – a memory so precisely retentive that he had no need even to make sketches and returned from tours or expeditions with his mind charged with a wide range of images exactly envisaged. When he was driven in a car he appeared to look at nothing in particular; just to stare straight ahead.

Not long after leaving the College, he and Chappell, 'chaperoned' by the Henry Rushburys, visited Paris. A year or so later the two of them spent some time in Cassis, a town that delighted him; also, with several other friends, in Toulon. One of them, Beatrice Dawson, remembers that when the others enjoyed themselves on the beach (where he was never seen) Burra sat in a back room of the hotel, painting and eating ice-cream. He later adapted a fountain in Toulon for the drop-curtain in his setting for the ballet *Rio Grande* He was seen off by another group of his friends, who noticed that his luggage consisted of no more than one small suitcase containing some papers and a spare pair of trousers.

Allusion has been made to his friends. Between him and them a very special relationship subsisted. Burra was a friendly person, ready, for instance, to strike up an acquaintance with someone met by chance in, say, a pub, but his intimates were mostly among those who were fellow students at the Chelsea Polytechnic or the Royal College, or both. These were William Chappell, Beatrice Dawson, Barbara Ker-Seymer, Frederick Ashton, John Banting, Basil Taylor and Georgiana Hodgkins. They were drawn together by a common interest in films and ballet, as well as painting. Unlike so many student friendships, they not only survived but grew closer. A chief friend of a later date was Gerald Corcoran (formerly married to Beatrice Dawson), director of the Lefevre Gallery, where he had shown for many years.

In 1930 he made a journey through France under the guidance of
Paul Nash which took him again to visit a number of his favourite
subjects, sailors' bars and the like.

Apart from his three student years Burra lived all of his life in Rye,
which provided a small, although of late years, a slightly increasing,
proportion of his repertory of subjects. Travel, however, was a
necessity to him, both as a spur to his imagination and as a means of
extending his repertory. Besides the Continent he visited the United
States and Mexico, where he became seriously ill, and going to
Boston, spent weeks recovering in a basement room. Although his
health required that he preserve almost all his energies for his art, in
life he occasionally behaved like one of his own creations 'Which
reminds me somehow,' Paul Nash wrote to a friend in the summer of
1934 (I quote from Anthony Bertram's *Paul Nash*),

> 'of a lovely story [Conrad Aiken] told me of Ed's arrival in New York.
> Conrad met him at the Customs displaying the most awful mess of
> Woolworth underwear mixed up with paints and French and Spanish
> novelettes which was passed by the customs officer, an enormous Irish
> Yank. But as Ed stooped to close up his bag a large bulge in his hip
> pocket betrayed a considerable bottle of whisky. The officer leaned over
> and without a word tapped the bottle with a pencil. Conrad began to
> feel anxious and I'm sure did a lot of scratching behind his ear. But Ed
> didn't even straighten up, he leered round at the cop and said in that
> withering voice of his *'it's a growth.'* Conrad said the chap was
> completely broken, he just got very red and wandered away looking at
> other things.'

In any case Burra did not allow his precarious health to inhibit
entirely his innate disposition to pursue, although fitfully, an inde-
pendent way of life. There was a story current among his friends that
one afternoon he walked out without a word. When night fell he had
not come in, nor was there any sign of him for some three months.
One evening he strolled back casually, thin as a skeleton. It appeared
that he had been to Mexico and lived in New York, making drawings
and watercolours of life in Harlem. When I questioned him he
admitted that the story was not entirely apocryphal. It related,
probably, to the expedition of 1933–1934. One of these watercolours,
dated 1934 and entitled *Harlem* was bought five years later by the
Tate.

Unlike that of most artists of the present century, Burra's style
changed little: the clearly outlined, suavely modelled forms, usually
near the paper's surface, the minutely observed detail, the absence of
atmosphere ('I don't believe I *see* atmosphere,' he said to me) all
remained virtually unchanged. Later in his life, when he painted
landscape observed rather than imagined, English and Irish weather
being what it is, he had to 'see' atmosphere, but even in such an

outstanding example as *Low Tide, Rye* (1963), although mist-covered mud flats are represented, the artist's primary interest was focused on the eerie formation of the trees in the foreground, leafless, almost twigless, and the way they related to the chilly unruffled surface of the sea. The atmosphere is scarcely more than a backdrop, rather than something to be represented more, as it would have been by Turner, Constable or an Impressionist, for its own sake. 'Indistinctness is my forte,' as Turner is supposed to have said: Burra's forte was the near, the sharply defined, the minutely observed, yet represented in terms of large, audacious and unexpected form. But if his style evolved little, the informing spirit underwent two changes, one of them radical.

From his student years until the mid-1930s his principal preoccupation remained the low-life of the Mediterranean port, the sailors' café or brothel, exemplified by such works as *Rossi* (1930), showing a French sailor eating by himself in a café with eight white, red pompommed caps disposed upon a hat-rack like strange, delicate insects, contrasting with the huge Rossi bottle in the foreground; or *The Cafe* (1932), in which a young man sits in slyly smiling meditation upon some unlawful pleasure or nefarious plot, the foreground dominated not by a bottle, but by his companion's huge cloth cap. One feature of Burra's art of those years was a preoccupation with the cheap. What other artist has caught so inexorably the exuberant cut and the fibrous texture of cheap clothes? In rather the same way as Francis Bacon, a member of an 'old' family, is disposed to magnify the good qualities of proletarians, Burra, brought up in prosperous upper-middle-class surroundings, was fascinated by the meretricious. Although he looked occasionally through *The Times*, the 'popular' newspapers were his preferred reading, from which, however, he managed to be extremely well-informed about the major issues confronting the world, as well as many comic and bizarre happenings that would elude an exclusive reader of *The Times*. This fascination diminished as a consequence of the radical change that affected his art from the mid-1930s – a change reflected in a gravity of outlook rarely perceptible before. The change was, however, not instantaneous. It is anticipated, for instance, in the sinister and enigmatic *John Deth* (1932), surely among his finest pictures. In it is portrayed the scythe-bearing figure of Death intruding upon a party of dancers, striking the guests with terror, which sometimes expresses itself with tragic absurdity, as in the expression of the coarse-featured man wearing a paper hat who, in the act of embracing a woman, suddenly perceives Death kissing another woman paralysed by fear.

'Original' is a term apt to be too comprehensively applied, but it perfectly fits *John Deth*. However, the radical change, in part tempera-

mental and in part, perhaps predominantly, due to the ubiquitous signs of imminent catastrophe, came a few years later. The Nazi's assumption of power warned the world – although many were long reluctant to face the issue – that people had to submit to a slavery of the most degraded character and to arbitrary massacre or else fight for their liberty, or even their survival. The issue was brought more sharply into focus by the Spanish Civil War. This terrible event seized the imagination of a world unable to foresee the far greater catastrophes immediately ahead. Just before the beginning of the war Burra happened to be in Madrid. 'One day when I was lunching with some Spanish friends,' he told me, 'smoke kept blowing by the restaurant window. I asked where it came from. "Oh, it's nothing," someone answered with a gesture of impatience, "it's only a church being burnt." That made me feel sick. It was terrifying: constant strikes, churches on fire, and pent-up hatred everywhere. Everybody knew that something appalling was about to happen.'

Burra spoke to me on several occasions of the Spanish Civil War, but he gave little indication of partisanship. To him the all-pervasive element of tragedy seemed to preclude it: he was overwhelmed by the cruelty, destruction, hatred and death. It was a tragedy in which all concerned, however culpable, were in the last analysis victims. I say little indication of partisanship rather than none at all because horror at the burning of churches inclined him to identify the Franco party with civic stability, but I never heard him express even the most oblique approval of fascist ideas.

The war had for Burra a special significance as an artist as well as a man. For several years earlier he had been under the spell of Spanish civilization and had studied, with intense excitement, the great Spanish painters, as well as the luxuriantly dramatic (and in England, then little-known) architecture and sculpture of the Jesuit-commissioned baroque churches of Mexico. He could also be stirred to enthusiasm by lesser artists. 'Have you heard of a Spanish painter Gutierrez-Solana?' he asked me in a letter of 11 October 1942; 'they are very remarkable, but not "well known" as Spaniards are not so good at advertising themselves as the French.' He taught himself Spanish which he read with ease, also French, although he was reluctant to speak it.

No artist personally known to me led a more sequestered life. Although he held one-man exhibitions fairly regularly, he found them an ordeal: 'they make me quite ill,' he wrote to me. On six occasions, however, work in a different medium brought him before a larger public than was aware of his paintings, namely designs for five ballets and an opera. These were *Rio Grande* (originally entitled *A Day in a Southern Port*), music by Constant Lambert and choreogra-

phy by Frederick Ashton, in which Markova and Lopokova performed, produced by the Carmargo Society in 1931; *Barabau* (originally produced by Diaghilev with settings by Utrillo and choreography by Balanchine), produced by Ninette de Valois and performed by the Sadler's Wells Company in 1936; *Miracle in the Gorbals* performed by the same company in 1944; *Carmen* in 1947; the following year *Don Juan*, music by Richard Strauss and choreography by Ashton; and, in 1950, *Don Quixote*, with music by Roberto Gerhard and choreography by Nintette de Valois. The last three were performed at Covent Garden.

I myself saw none of these and know only of a few of their settings from photographs, and designs, but in the January 1949 issue of *Ballet and Opera* Richard Buckle, under the pseudonym 'Dorothy Crossley', paid him this tribute:

> In our century it was Diaghilev who first persuaded 'easel painters' to work for the stage. He employed the greatest artists of the School of Paris. In England the Sadler's Wells Ballet and now Covent Garden Opera have wisely enlisted artists outside the ranks of the small band of the accepted theatrical decorators. Of these perhaps Burra has been the most successful and shown most feeling for the stage.

In the same article he wrote of his front curtain for *Miracle in the Gorbals* that 'the prow of a great half-built liner in the Dockyards was grandly conceived', and of his costumes as 'cunning simplifications of contemporary cheap clothes to be seen in the backstreets of any industrial town.' These performances brought Burra into favourable public notice, but after each one he disappeared from view.

In spite of his dislike for showing his work, it was exhibited regularly: at the Leicester Galleries in 1929, 1932, 1947, 1949, at the Redfern in 1942, at the Hamet Gallery in 1970 and 1971, at the Postan Gallery in 1972, at the Lefevre in 1952, and there from 1955 biennially. 'I am a biennial,' said Ivy Compton-Burnett of her production of books, and Burra might have said the same with reference to his exhibitions over the past years. These were received with respect and on occasion with wholehearted admiration, but until quite recently Burra's work has not been favoured by the establishment, never accorded, for instance, an officially sponsored exhibition, by the Arts Council, the British Council, even the Whitechapel, whose former director, Bryan Robertson, is an ardent admirer, or, until 1973, the Tate (although the trustees did purchase seven of the eight examples of his work the Gallery possesses). Not that he ever lacked admirers: Paul Nash – a close friend – and Wyndham Lewis both told me that they considered him to be one of the finest British painters. And his work sold sufficiently well to have enabled him to live in modest comfort.

I do not know whether others share my sense of shame at the
discovery of their ignorance about aspects of the lives of friends,
whom they suppose they know well, and of acquaintances when
significant circumstances about them – tragedies, interests, achieve-
ments and other crucial matters – are revealed in their obituaries, or
in tributes when they are the recipients of honours or other distinc-
tions – or most acutely when one has occasion to write about them.
This I felt when Kenneth Clark, aware of my particular admiration for
Burra, invited me in 1942 to contribute the small volume on his work
in the Penguin Modern Painters series, of which he was editor. This
undertaking involved a closer association with Burra, bringing a
wider knowledge of his art and character.

My first visit to Springfield, the Burra house in Rye, was an
occasion I shall not forget. The house was wide-eaved, William IV or
early Victorian. Its four-square solidity, the tweed coats and caps
hanging in the hall, fishing tackle, shotguns and the like, reflected a
certain conventionality, no less than that of Edward's father, a widely
read and cultivated man who encouraged his young children to look
at Caran d'Ache and Doré. He greeted me in formal but friendly
fashion, and took me for a stroll round the garden. When I had
climbed the stairs, adorned mostly by Victorian watercolours, to
Edward's studio the contrast was startling – a contrast resoundingly
proclaimed by a framed close-up photograph of a face far gone in
leprosy. In a book devoted to Unit One, the distinguished but
shortlived association of artists gathered in 1933 by Paul Nash (the
only group, I believe, that Burra ever belonged to), there are photo-
graphs of its members' studios. That of Burra's suggests that it was
tidy and bare. The book was published the following year but I do not
know when the photograph was taken. No room could have been
more unlike it than the studio I visited eight years later.

Photographs were pinned up almost completely covering the walls:
paintings by Tiepolo (one of the artists he most admired, but of whom
I see no reflection in his work), Signorelli, Magnasco, a wide variety
of Spanish masters, pictures clipped from popular newspapers and
periodicals (mostly representing dramatic incidents, often with
figures in violent motion). Covering his record-player, radio, chairs
and areas of the floor were hundreds of books, newspapers and
periodicals, novels in English, Spanish, French and Italian, glossy
South American picture magazines, Victorian scrapbooks. And scat-
tered among them scores of records, for he listened to music while he
worked, Berlioz having been his favourite composer. (Beneath a
similar profusion in nearby Springfield Cottage to which he even-
tually moved were discovered, in 1971, five wood-blocks, engraved
in 1928–29, but never pulled and long forgotten by him and unknown

to his friends. Their discoverer was the journalist, Barrie Penrose; the blocks themselves now belong to the Tate.) Constituting a top layer above this profusion were scattered long, white paper cylinders: his own drawings and watercolours, curled up (owing to his feeble health he prefered watercolour, which required less physical effort, to oil paint, which he rarely used from the 1920s). None of his own works were hung, but a few, returned from exhibitions, leaned framed against the walls. A small work table stood close to a window, the light falling from the left. 'There never seems to be light enough,' he complained, 'and I can't work by electric light.' Since the installation of a 'daylight strip' at Springfield Cottage some years ago he was able to work at any time of night. I recall this complaint because another visitor described a sheet hung from a corner of the window frame to protect him from the afternoon sun and to shut out the view of Rye. I saw none but ordinary curtains but whether the observation about the sheet is accurate or not, the reference to shutting out the view of Rye has relevance. Burra spent almost all his life there (in three different houses) and lived there until his death, but it never engaged his affection; indeed indifference sharpened into positive dislike for what he sometimes called 'Tinkerbell Town'. It is curious, considering he could afford to live elsewhere, that he should not have left it. Lowry had no deep general sentiment for the Salford area, only for certain streets of poor houses, Oldham Road and other areas immediately adjacent to it, from which he drew the essential nourishment for his art, and needed accordingly to remain nearby. Although he occasionally talked of leaving South Lancashire, he never did so. Burra made a number of landscapes of Rye and the country round about, which not surprisingly reveal a special perceptiveness, but had he moved elsewhere his art would not have been in the least degree affected, nor, I think – apart from the acute discomfort of picking up roots, even from an unloved place – would his way of life.

After I had looked through all his work he suggested we should go into the garden. The gentle movement – we spent several hours perambulating there – seemed to stimulate him. He spoke of the artists he admired, particularly of Paul Nash and Wyndham Lewis; of his being haunted by the Spanish Civil War, and obsessed by Spanish civilization.

There was a picture that I especially wished to see again. 'A big picture of conquistadors' was how I described it: Edward looked puzzled and we recovered the painting I had in mind, which represented a group of soldiers of somewhat sixteenth century aspect, wearing scarlet masks appropriate to a Venetian carnival. 'Oh! *That* was the one you wanted, was it?' he said; 'but it's of *this* war: those are *British* soldiers just outside Rye.' Shortly after my visit *The Studio*

offered to present a picture to the Tate and the trustees readily
accepted this splendid work, charged with the energy apparently so
lacking in the artist himself, and of a sinister strangeness. Concerned,
I think, that its subject should not again be mistaken, he changed its
title from *Soldiers* (under which it was first shown at the Redfern
Gallery towards the end of the year) to *Soldiers at Rye*.

Although all his pictures represent specific themes, Burra did not
give them titles until they were to be exhibited. 'Then somebody
comes along,' he explained, 'and stamps them with my signature
with a rubber stamp, and presses me to invent titles for them.' Indeed
there was an element of the unconscious about his procedures. 'Bring
in a psychiatrist,' he replied to an enquiry as to the meaning of one
of his pictures, 'and we'll find out.'

The character of Burra's evolution is clear; the Second World War
intensified the sense of tragedy evoked by the Spanish Civil War.
One seemed to him to be the logical culmination of the other. The
themes often drawn from the Mediterranean brothel or sailors' bar
were no longer adequate to express his agonized awareness of the
dark tide of savagery that was transforming the world as he had
known it. At a certain level artists must enjoy what they represent. I
remember artists in both World Wars being distressed by the
dichotomy set up in their minds between their exhilaration by the
spectacle of devastation and their utter abhorrence of its cause. The
vein of sardonic humour with which Burra viewed the war is implicit
in the sentences which follow in a letter dated 1 October 1942:

> About 2 days or so after you left a bomb or so fell round the cinema
> suddenly turned into one of its own news reels. I came on a very
> *romantic* scene, "improved" into the lovelist ruin with a crowd of
> picturesquely dressed figurents poking about in the yellowish dust.
> Many more bombs and ye antiente towne really won't have a whole
> window left let alone a ceiling up – a very pretty little late eighteenth
> or early nineteenth Wesleyan Chappell went as well in the hubbub. I
> now notice an anti-aircraft gun outside the door.

(When the family moved from Springfield after the war their new
house was built on the site of the ruined chapel, hence its name
Chapel House.)

The same spirit animates – more vividly – passages in an undated
letter to other friends evidently written about the same time:

> Christmas night, the night before Christmas as a matter of fact the fun
> was so fast and furious in ye antiente towne that a Canadian was kicked
> to death and all the dances closed down by the military police on new
> year the Canadians came back all ripe for a revenge but found the
> midgets from Rochdale here shut up in their tumble down residences
> glaring behind broken panes with military police parading up and
> down . . . the days pass with many a jest and quip. Also as I was about

to approach the level crossing I heard what I thought was machine gun practice, but oh dear me, it was nothing of the kind. It was the real thing . . . they did it again last Friday. Always when I'm going down to buy cigarettes . . . An American citizen now he is – with a special "pardon" for a murder he committed in that state or an attempted one I'm not sure – but of course in a nice way – it was for the party . . .

The heightened sense of tragedy evoked by the Spanish Civil War was expressed not only in paintings with military themes, such as *Soldiers at Rye, Silence* (1936) – representing a macabre figure smiling at a bomb-devastated street – *War in the Sun* (1948) or *Camouflage*, of the same year, but in religious pictures, such as *Holy Week, Seville*, *Mexican Church* and *The Vision of St Theresa*, all of 1938, a particularly productive year. Religious subjects – although Burra was not a practising member of a Christian church – continued to preoccupy him from time to time. In his 1952 exhibition at the Lefevre Gallery he showed *Christ Mocked, The Expulsion of the Money-Lenders, The Entry into Jerusalem, The Coronation of the Virgin, The Pool of Bethesda* and *Joseph of Arimathea*.

Parallel with the growth of his tragic sense of life was his perception of the elements of strangeness in everyday things. From his earliest days he was obsessed by the quality of strangeness, but then he expressed it mainly by the depiction of themes strange in themselves, of which *John Deth*, although a conspicuous example, is only one among many. But from the 1950s his work shows this heightened awareness of the strangeness in everyday things. In, for instance, *Owl and Quinces* or *Bottles in a Landscape* (both 1955) it is as though he had seen, for the very first time, the stuffed owl and the four pieces of fruit at the foot of its mounting and the ten bottles standing on a path with houses and telegraph poles in the distance. The conviction and the skill with which he conveyed his astonishment at the sheer strangeness of these objects compel us to share it. We are seeing a stuffed owl and bottles as though we had never suspected that such objects existed. But here again the suddenness of this preoccupation must not be exaggerated: the coffee-machine (and its reflection) in an early work, *French Sailors*, the big bottle in the foreground of *Rossi* earlier referred to, the buildings in *Harlem* (1934), are examples of it selected at random; while his perception of the various qualities of cheap textiles was always acute. Earlier, however, owing to the bizarre or nightmare character of his subjects, this strangeness was less conspicuous. Later, enhanced and applied to everyday objects in isolation, it became one of the most impressive characteristics of his work.

Burra's art underwent a further change. Until the later 1940s almost all of it represented people in their environment (occasionally strange

nonhuman beings in theirs), but there was then a gradual shift of interest away from man to landscape and to inanimate objects. He confessed, as an artist, to a diminished interest in people, and more in his surroundings. He made landscapes near his home in Rye and other regions which he visited, occasionally with his sister, in Yorkshire (where they stayed with friends in Harrogate) and in Ireland. He made no sketches on the spot but returned to Rye with his memory charged with subjects remembered selectively but in the utmost detail. 'There is a time-lag between my seeing a landscape,' he explained to me, 'and coming to the boil, so to speak, but when I go back there, I'm always puzzled by what I've left out.'

As was inevitable, with the diminution, although far from extinction, of his interest in his fellow men, the satirical tone of his art underwent a parallel decline. Discussing this development, I recalled that David Low had said to me that something of its former satiric bite had gone out of Burra's caricature, and that the cause was clear, namely that the world had become so horrific a place that much was beyond the reach of satire. 'What,' he had asked me, 'can a satirist do with Auschwitz?' 'I entirely agree with Low,' Burra said; 'so many appalling things happen that eventually one's response diminishes. I didn't *feel*, physically, for instance, the shock of Kennedy's assassination as I would have done before the war.'

If Burra became less concerned with subjects inherently dramatic and sinister, he was able to imbue a stuffed owl, a few bottles or even a bunch of flowers with a dramatic and sinister ambience. This ability, this compulsion sprung not from fancy or transient mood, but from a consistent attitude to life. '*Everything*,' he said to me, '*looks* menacing; I'm *always* expecting something calamitous to happen.'

The diminution of his interest in people and the drama of their situations is reflected by their replacement, frequent by the 1960s, by sculpture, which enabled him to represent the human figure without concerning himself with its personality. So highly evolved did his power of endowing inanimate objects with the quality of mysterious threat become that human beings became less and less necessary features of his art.

Burra's imagery – the solid figures unmoving, unblinking, charged with nameless menace, yet animated by touches, here and there, of schoolboyish humour as, for instance, in *It's All Boiling Up* (1948); landscapes, motorcars, lorries, excavators, flowers too, with obscure, disturbing overtones – constitutes, in T. S. Eliot's phrase, 'a more significant and disciplined kind of dreaming', although it often had more of the character of a nightmare than a dream.

Edward Burra was an essentially private person – who took pride

in never 'giving anything away' about himself; so I will not intrude much upon this expression of privacy.

He was without ambition of any kind, either professional or personal. John Banting, who was with him when the offer of a CBE arrived, wrote, he told me, the letter of acceptance on his behalf in case Burra should forget to do so. Invited to become an Associate of the Royal Academy, he did not even reply. If his work sold, he was mildly pleased; if it did not, he was indifferent; he required only sufficient income to keep up Springfield Cottage (where he lived from 1968), to afford his biweekly visits to London and his occasional expeditions with his sister, but it almost always sold well. He rarely read reviews of his exhibitions.

The extraordinary strength of his will compensated amply for the weakness of his constitution and gave him untiring energy. He would walk long distances, stay up late, required no more than five hours' sleep, and worked every day from eight or eight-thirty; rested for an hour or so in the afternoon in order to read (he was a voracious reader in Spanish, French, as well as English, of everything from the classics to science-fiction) and resumed work later on.

There is one respect in which artists may be divided into two categories: those for whom the creation of a work of art is an extension of themselves to be, if possible, retained or else in some way safeguarded, and those for whom such creation is an act of parturition. Stanley Spencer, to take a conspicuous example, even at times of extreme poverty, never parted with his work without reluctance (aside from landscapes, which he painted specifically for sale) and never at all – so far as I am aware – with any of his sketchbooks. It remained intimately, obsessively, a part of himself. Francis Bacon, on the contrary, would not object (although he might be surprised) if the purchaser of one of his paintings promptly destroyed it. Burra in this respect resembled Bacon: he lost his work and often forgot it. If a friend showed him a lost or forgotten work he would look at it with relish or dismissal, just as though it had been made by someone else, in particular laughing at any feature of it that struck him as comic or absurd.

However indifferent the general public, his work, even routine life drawings made as a student, has always been treasured by his circle of intimates as well as a slowly growing number of others. It is my own long-held conviction that posterity will share the admiration of his friends rather than the indifference of the general public.

TRISTRAM HILLIER
1905 – 1983

Of several of the painters who figure in this book, even perhaps of most, it can be said that their energies were almost exclusively dedicated to their work and that their lives were uneventful. Their vision, its vicissitudes, their attempts to realize it as fully as lay in their power, these things constituted the drama of their lives. I am thinking in particular of Houthuesen, Burra, Collins and Richards. The lives of Bacon, Freud and Colquhoun, on the other hand, could provide, independently of their art, subjects for biography or fiction. Bacon, for one, has long been a legendary figure. But the interest even in them derives from the audacity and intensity with which they have lived lives in outward circumstances not very different from those of their fellow artists. Tristram Hillier, on the other hand, led a life which, in spite of his dedication to painting of meticulous finish and elaborate composition, was almost Byronic in its variety and drama.

The circumstances of his birth and upbringing were unusual; still more so those in which he inherited his religion. His father, manager of the Hong Kong and Shanghai Bank in Peking, went blind at the age of thirty, and planned to shoot himself. When he confided his intention to a friend, he said, 'Why not become a Roman Catholic instead?' This he did, with far-reaching consequences for his second son.

Tristram Paul Hillier was born on 11 April 1905 in Peking, the youngest of the four children of Edward Guy Hillier and his wife, born Ada Everett. The Hilliers were of Huguenot descent, their name being originally St Hellaire, settling in England in the middle of the seventeenth century, shortly before the revocation of the Edict of Nantes. They were always connected with the sea, first as shipbuilders on the Thames and later, for several generations, as officers in the Royal Navy.

The Hilliers lived for a time in Pa-Li-Chuang, a temple in the Western Hills outside Peking, after their town house was burnt in 1900 in the Boxer Rebellion. Journeys in China and across Russia by the trans-Siberian railway accustomed Tristram to travel.

Life, however various and interesting, was not happy for Tristram:

his father was aloof and usually absent in China and his mother was
an invalid dying slowly of cancer, and he felt little affection for her.
Some twenty years after his mother's death in 1917 he suffered a
nervous breakdown, which the doctor who was treating him attrib-
uted to the insecurity of his early years and the horrifying impression
made by his last visit to his mother's deathbed.

In short, his childhood and boyhood were lonely and loveless. He
began to draw in the nursery but the Hilliers were a family without
the slightest connection with the arts and it did not occur to him until
much later to make a profession of a delightful diversion.

At the age of nine he went to Downside, remaining there for eight
years. 'Religion was not in any way forced upon one,' he wrote in his
autobiography, *Leda and the Goose* (1954), 'but the Benedictine ritual
had become so familiar a part of my life that I absorbed without
thought the strong influence that it was bound to exert upon an
impressionable youth'.

At first the influence, I suppose, was primarily aesthetic (unless
otherwise indicated all quotations in this chapter are taken from the
artist's autobiography):

> I had begun to serve Masses at the High Altar of the Abbey, elaborate
> ceremonies which were conducted by priests clothed in vestments of
> scarlet, azure and cloth of gold, with a score of serving boys in
> attendance. The pageantry, the colour and the grave rhythm of
> movement against a background of delicate Gothic pillars affected me
> profoundly.

But by the age of seventeen, spiritual had reinforced aesthetic
influences: he considered whether he had not a vocation for the
monastic life, and with this end in view his curriculum was altered
to give more time to theology and Latin. His life was to take a very
different course, but his sense of religious vocation was so strong
that he could write: 'Even after the passage of thirty years I feel today
that my youthful intuition may well have been the light I should have
followed.' In his last months at Downside, with the encouragement
of the drawing master and the headmaster, he devoted time to
drawing as well as theology and Latin.

In order to consult his father about his vocation he revisited Peking.
He also went for advice to the Trappist house in the Valley of the
Monks in Mongolia, but during the few weeks he spent there,
Tristram became, he tells us, 'alarmed beyond measure by the rigours
of the Trappist order, which finally extinguished the few poor embers
of that spiritual blaze which had been kindled by my Benedictine
schooling'.

This circumstance, and the fascination aroused in him by the
landscape of China, indicate that aesthetic aspirations had by then

far superseded monastic. Instead of returning to the novitiate he went to Cambridge. The two years he spent there, 1922 until 1924, he described as 'a waste of time' and dismissed them in half a dozen lines, in which he does not even refer to his college (Christ's) by name. In one respect, however, these years were highly important: for it was then that he began to paint seriously. But in spite of his absorption in this pursuit it did not even then occur to him to adopt painting as a profession; he was not yet sufficiently emancipated from the tradition of a family which would have regarded such a choice as morally indecent and materially insane.

The decisive impulse came from the unlikeliest quarter. After a holiday in Turkey and Rumania he joined a London firm of chartered accountants, as an apprentice. There he did little but 'doodle': every morning a virgin pad of blotting paper would be placed on his desk and by evening it would be covered with drawings. One day a cashier told him that he had kept all these drawings and that his wife had wrapped them in tissue and placed them in a drawer.

> 'Now, Mr Hillier, I'm an old man and you mustn't take offence if I speak my mind. You'll never make a chartered accountant, nor any sort of business man . . . you ain't got no 'eart for it. I says to my Missus last night 'e's an artist, that's what 'e is.' 'Course 'e is', says she, 'and you ought to tell 'im so.' 'It's a wicked waste . . . you go off and have some paintin' lessons . . . and one day you might be paintin' the portrait of the Lord Mayor of London.'

Hillier never saw his unlikely mentor again but he remembers him with gratitude. Taking his advice he relinquished his apprenticeship and found his way to the Slade, where he quickly became aware of the emptiness of his previous existence. Oppressed by the sense of time wasted he found the hours of work at the Slade – ten until five – too short, and he attended evening classes at the Westminster School of Art, under Randolph Schwabe; also Bernard Meninsky who, although a former Slade student, had little respect for the austere academic teaching of Henry Tonks.

The passionate response among the younger generation to the revolutionaries who had rejected the academic tradition – Picasso and Braque (especially their Cubist works), Matisse, Wyndham Lewis, as well as certain of their predecessors, Van Gogh, Gauguin and most of all Cézanne – provoked in Tonks, as in many of his generation, a bitter defensiveness. Outstandingly effective teacher although he remained, many of his students suffered from this. 'Obscene nonsense' was how he described Cubism to Hillier. Although he took Meninsky's advice to move to Paris after eighteen months at the Slade, Hillier owed much to Tonks's instruction in draughtsmanship in the classical tradition.

By way of Lake Como and Marseilles he went to Paris, working under André Lhote at the Atelier Colarossi and the Grande Chaumière. He met many of the most illustrious painters, including Picasso and Matisse, and new worlds of vision were discovered to him: Cubism, Fauvism, Surrealism and a host of more ephemeral movements:

> Through this tornado of influences I steered an erratic course, veering first this way and then that, but leaving further behind me all the time the classic shores of my early training – to which, many years later, I was nevertheless destined to return.

Such paintings from his early years in France as I have seen fully bear out this account: they are derivative – sometimes feebly – from Cézanne, Picasso, Braque, Chirico and a dozen others, as well as Lhote. None of them, strangely enough, gives any intimation of the extremely personal style Hillier was to evolve not much more than a decade after his arrival in Paris – a style that subsequently underwent little change.

Within a few months of finding himself in 'this tornado of influences', Hillier's outlook was transformed: the sober instruction at the Slade was rejected as a remote irrelevance; he had become hostile to the church to whose service he had so recently determined to devote his life; and as for England, he had decided never to return.

Before he had given himself time to assimilate in a systematic fashion any of these multifarious influences, a romance caused him to leave Paris. At the Ritz bar he met a young woman to whom he was violently and instantly attracted; his feelings were reciprocated and they went away together, settling in a cottage at La Gaude, a village near Nice, where they remained for about a year. The Provençal landscape evoked a passion for Cézanne, but the four surviving canvases from the period suggest that passion was not accompanied by illumination. They are no better than the average Cézannesque schoolpieces mass-produced by generations of British artists, ever since Fry, with scholarship and sober eloquence, had established Cézanne as a 'tribal god'. But the volume of the work Tristram produced testified to his rare powers of concentration, for his relationship with Jill was tempestuous.

One incident will serve to indicate its climate (no less Jill's spontaneity and indifference to convention). Not long after their return to Paris Tristram happened to be stepping into his bath when she appeared, also naked, claiming the right to have her bath first, which he disputed. Their altercation culminated in violence: she struck him with a soap-rack and he fell bleeding to the floor. Horrified, and still naked, she descended in the lift to an apartment in which

some Spanish friends were giving a party. A friend present described the entrance of Jill as the most dramatic he had ever seen: the double doors were suddenly pushed open, and there stood a naked Greek goddess announcing, 'I have just killed Tristram.' His injuries, however, were superficial, and they settled once again in Provence, but before long she left him.

On this sojourn, expeditions in the sailing-boat of his friend the Greek artist Varda enhanced a passion for the sea and for the shore, the subjects of many of his paintings a few years later. But again his concentration on his art was to be similarly tested. Landing from Varda's boat in Toulon harbour after a narrow escape in a storm, dirty, bearded, spray-soaked, barefooted, wearing only patched trousers and a singlet, he and Varda were instantly invited to join a party of friends. There he again fell at sight in love with a beautiful girl. She was engaged to be married but within twenty-four hours he had persuaded her to remain with him. On returning to London, her philosophic betrothed observed, 'At Victoria I lost my umbrella, at Toulon my fiancée, at Monte Carlo my money and on the return journey my ticket.'

Hillier bought, for the proverbial song, a large, almost ruined, fourteenth-century castle, Mansencome near the Pyrenees. 'Wuthering Heights must have been positively cosy compared with that,' exclaimed the girl on her first sight of it, but shortly decided that it should be their home. At night bats circled and owls flew hooting through its immense vaulted chambers; but in the sunlight, with bees humming among its ruins, it was a place of enchantment. Here Hillier worked unremittingly and she gave birth to twin sons, having reluctantly agreed 'to conform to this archaic survival', for such was her opinion of marriage. The ceremony took place in 1931, and the marriage was dissolved four years later.

Hillier held his first London exhibition at the Reid and Lefevre Gallery in 1931 (he had earlier held a smaller one in Paris), and this was amiably received. He and his wife remained at Mansencome, where life assumed a peaceful rhythm of painting and, with the help of their Cossack servant, of gardening and rearing the children.

One August, with Roland Penrose and Darsie Japp, another painter, he walked across the Pyrenees into Spain. He was immediately aware, he told me, of his profound affinity with Spain: 'No grass, no trees, but only rock and tawny earth that stretched away to the shimmering horizon like a lion's pelt.' 'A country I came to love above all other countries . . . The translucent light is comparable with that of Greece, which had so fascinated me,' he wrote, 'with the addition of a dramatic quality both noble and cruel, with which the land as well as the people are invested.'

To Spain he returned in 1935, remaining there until the outbreak of the Civil War. During this time he became a close friend of André Masson with whom he lived and worked for weeks at a time and from whom he received much encouragement and help. Subsequently he travelled in Belgium, Holland, Hungary, Greece, including Crete, and a leper island. At last by 1936 his all but insatiable need to travel was almost satisfied and, returning to London, he settled in a studio in an alley off World's End in Chelsea. Circumstances were slowly combining to bring – eventually – a stability both to his vision as a painter and to his domestic life. On a holiday in Austria he met Leda Millicent Hardcastle – the 'Leda' of his autobiography – to whom he was married early in 1937 in Vienna. 'Her values were those I had known as a child,' he wrote, 'against a background of country life, and they seemed sane and comforting after the turmoil of my existence since those early days.'

Through events far beyond his control Hillier's desire for a settled way of life was frustrated, for the Second World War was casting its dark anticipatory shadow – particularly apparent to him and Leda, who left Austria only 'a very few hours before . . . the entry of the Führer and his gangsters'. (Hillier's talk was wide-ranging, but to my knowledge his only allusions to politics were expressions of loathing for nazism and fascism.) Although the war delayed their extablishing a harmonious way of life, his rediscovered values and his long and various apprenticeships culminated in the formation of a syle precisely suited to convey his vision of chosen aspects of his environment. He thus describes this development:

> Here [near Vence] during the next few months I started to paint landscape again, not in my earlier manner *au plein air*, but attempting to construct my pictures, from rough drawings which I would elaborate in the studio, in the style of the Flemish and Italian masters whose work I had recently had so much opportunity of studying. This was the beginning of my ultimate phase in painting, and became the manner in which I have worked ever since. There's a picture of mine, 'La Route des Alpes', dating from this time (1937) which now hangs in the Tate Gallery and illustrates fairly well, although I do not care for it, this period of transition from abstraction and surrealism to representational painting.

Although prior to the mid-1930s Hillier had indeed tried and discarded various manners, the ideas which were to fructify in his own 'ultimate phase' were taking shape. A paragraph from a brief essay which he contributed to *Unit 1*—the book published in 1934 devoted to the short-lived but highly talented group of that name formed by Paul Nash early in the previous year – indicates Hillier's

5. EDWARD BURRA: *John Deth* (1932).
Watercolour, 22 × 30 in (57·2 × 75 cm).
Whitworth Art Gallery, Manchester.

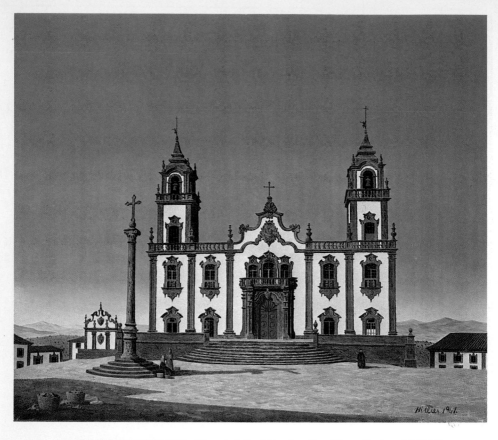

6. TRISTRAM HILLIER: *Chapel of the Misericordia, Viseu, Portugal* (1947).
Oil on panel, 10 × 11½ in (254 × 292 cm). Southampton Art Gallery.

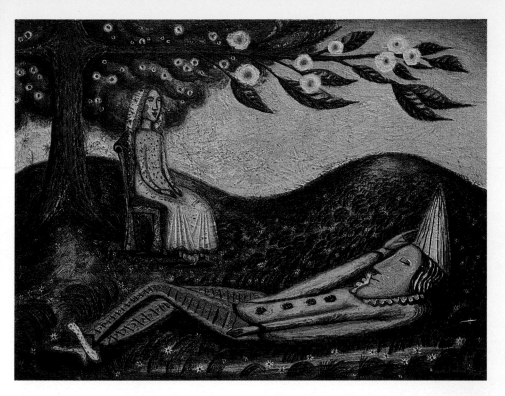

7. CECIL COLLINS: *The Sleeping Fool* (1943).
Oil, 11¾ × 15¾ (29·3 × 39·3 cm). The Tate Gallery, London.

8. VICTOR PASMORE: *Spiral Motif in Green, Violet, Blue and Gold:*
The Coast of the Inland Sea (1950).
Oil, 32 × 39½ in (81·2 × 100 cm). The Tate Gallery, London.

preoccupation with the problems of composition so precisely solved in the best of his later work:

> For the design of my pictures I rely on my natural sense of balance and not, as has been suggested, upon numerical proportions; for the essence of what we understand as art lies in that order which is the outcome of assymmetry . . . it is only in the free sphere of irregularity that a man can build an homogeneous arrangement of tones, colours and shapes which achieve an equilibrium not of balancing volumes but in their relative intensities and mutual complement.

In the same essay, too, he refers to his 'deliberate distortion of perspective' 'in order to emphasize the rhythm' he feels – a consistent feature of his 'ultimate phase'.

By this time the special qualities that were to distinguish his work were already apparent. In a foreword to his exhibition at Reid and Lefevre held in 1933, his friend Roy Campbell wrote:

> Round all Hillier's work is that linear Pythagorean harmony which appears to be the dress and outline of all ideas, but is really their essence . . . The painter's passion and his lyricism are not less powerful for being like a kite when it is pulling its hardest, almost motionless.

The artist's indifference to *La Route des Alpes* (1937) is understandable, but although this painting does not stand comparison with his best, it does exemplify with particular clarity the combination of qualities that mark the work of his 'ultimate phase': the austere, the static, the precisely calculated image, its cold sparkle and the almost total indifference to atmosphere.

Ever since the late 1920s he had been susceptible, too, to the dream-like quality inherent in Surrealist art and had made paintings designed to capture this quality by the use of the prevailing formula of juxtaposing incongruous objects. But in the later paintings, realistic landscape, architecture and, to a lesser degree, still-life, are invested with an aura of strangeness without diminution of their credibility. Surrealism thus transmuted continued to play a pervasive part in his paintings.

Although *La Route des Alpes* is a relatively minor performance, when it was first shown at the Arthur Tooth Gallery in 1943 I well remember the clear, decisive, minutely calculated chord it struck, and how pleased I was to be able to buy it for the Contemporary Art Society, which presented it the following year to the Tate.

Edward Wadsworth, a friend and a visitor in the mid-1930s to a furnished villa that the Hilliers rented at Etretat on the coast of Normandy, helped him towards the evolution of his final style. The two painters had certain tastes in common: for the sea and the shore; for boats and lighthouses; for cranes, netting, coils of rope and chain and other impedimenta of deck, dock and pebbled beach, and for all

these seen in sharpest focus. In one respect, however, they differed. 'I have always used oil paint,' Hillier wrote to me on 21 May 1970, 'but I take a deal of trouble preparing my canvas, which accounts for the very smooth quality of the paint. Wadsworth tried for years to persuade me to try tempera – of which he was a master – but I never cared for it.'

But his full employment of the style he had evolved was delayed by the war. Just before its outbreak his father-in-law bought them a stylish eighteenth-century house, L'Ormerie, near the village of Criquetot L'Esteval, in Normandy, which they intended to make their home. But they were swept away in the vast and harrowing exodus of the population before the German advance. After an adventurous journey they escaped from St Malo to Southampton. From 1940 until 1944 Hillier served in the Royal Naval Volunteer Reserve, being invalided out with the rank of lieutenant. After the war had ended they returned to Normandy, but to their sorrow they found L'Ormerie an almost irretrievable wreck, at least for people in their straitened circumstances.

Hillier's pictures, however, were saved, and since they constituted a large proportion of their assets, he applied to the Board of Trade for permission to import them, with farcical consequences that I well remember, as the lady bureaucrat concerned gently explained to him:

> We are facing a period which demands from all of us a standard of living if the economic structure of this country is to survive. Sir Stafford Cripps [President of the Board of Trade] has endeavoured constantly to impress upon the people that they must learn for the time being to forego luxuries. If I were to give you permission to import your paintings there would be people, no doubt, who would be tempted to buy them, and Art, after all, is a frivolity which we simply cannot afford just now.

When he told me of this homily, in praise of a policy which excluded national assets from the country (exportable assets incidentally) and which threatened an artist (also an ex-service man) with bankruptcy by denying him effective posession of his own work, I joined several of his other friends in attempting to reverse this decision, as unjust as it was contrary to the national interest, but with no more than partial success. A licence was eventually granted, but to import only pictures painted before the war and excluding any that he might have done since his return to Normandy, and this subject to the condition that he take up permanent residence in Britain.

Tristram and Leda, like almost everybody in France, found living conditions desperate; they also found that the country itself had undergone disillusioning spiritual and intellectual changes, and they no longer wished to live there. In the spring of 1946 they accordingly returned to England and explored the only part of it, aside from

London, with which he was in some degree familiar from his years at Downside and a visit towards the end of the war, namely Somerset. Here they eventually settled. 'I have found my happiness and my home at last,' he wrote, 'in Leda and in England.'

Hillier's return to England was marked by another return: to the communion of the Catholic Church. This act was marked with the same meticulousness as his painting. Determined to be sure that his decision was not the result of sentimentality he discussed the matter thoroughly with several noted theologians at nearby Downside.

Between 1941 and 1944 he had scarcely been able to paint, but in Somerset during the last months of the war he worked during every daylight hour (he never painted at night.) Service with the navy, however, had not entirely prevented him from working. It is strange that the shattering events of the war and almost three years of enforced cessation of painting, far from impairing, conspicuously enhanced his creative powers. This can be seen at a glance by comparing *La Route des Alpes*, with *Harness*, painted in Somerset seven years later, or with the slightly earlier companion picture *The Bridle*. The first looks mechanical and contrived and its impact is less forcible than that of either of the others or of the fine; *Trinity Wharf* (1945), in which a rhythmic poetry is extracted from a lighthouse and a dock on which repose anchor, rope, a rowing-boat: all the maritime miscellanea that he and Wadsworth had represented with such zest a few years before.

But of a different order from these are those Hillier painted in Spain and Portugal. There are painters who delight in what is damp, soft, atmospheric, unsusceptible of sharp definition, such as Ivon Hitchens's *Damp Autumn* and *Waterfall, Terwick Mill*, which perfectly exemplify such preferences. There are also painters of precisely opposite preferences – for what is dry, hard, clear and susceptible of the sharpest definition – such as Wyndham Lewis and Edward Burra. But not even they showed quite the passion for these qualities as Hillier. This disposition may have been fostered by the austere landscape of certain parts of China, as was suggested by his fervent response to it when he revisited the country for the first time as an adult; perhaps, too, by his almost exclusive familiarity with Chinese painting in childhood and adolescence. The fact that he was so long and so intimately identified with the Mediterranean world led to his intense interest in Van Eyck and other early Netherlandish painters being overlooked. These he assiduously studied in Dutch and Belgian museums, delighting expecially in their lucidity and mastery of detail. Brueghal and Bosch are among the painters whom he most fervently admired.

Precision and clarity – besides its other-worldness and strangeness – were among the qualities of Surrealism that held a particular appeal

for him. But what decisively confirmed these various preferences was his long and passionate association with the Iberian peninsula. From 1947 he spent several months of every year in Spain and Portugal. As he related to me:

> There is hardly a corner of Spain that I don't know. I have painted all over the country and in much of Portugal as well. The region of Spain that I most love is Estremadura, which is still little visited by foreigners. Beside my own affinity with Spain when I first went there, I was aware of an affinity between the landscape of Spain and that of China. Sometimes I find Spain so emotionally disturbing that I take refuge in Portugal, that 'paradise of flowers and gentleness'. Yes, after a week in Spain I can be absolutely whacked from emotional exhaustion: by its starkness, its cruelty, its nobility.

There is no cruelty in Hillier's painting, beyond an intimation in some of the black high-prowed Portuguese fishing boats like fierce primeval monsters stretched out on the beach, but there is much stark nobility. At first glance his paintings appear to be literal representations. Further scrutiny reveals in them marked imaginative, even dramatic elements. The painter was too long under the spell of Surrealism ever to be tempted into supine acceptance of the scene before him. Or, more precisely, of what he saw when making his preparatory pencil studies. All his later paintings were made in his studio in Somerset. As already indicated, he distorted perspective, sometimes radically, in the interests of drama, lucidity or some other quality he was attempting to achieve. Discussing a painting of a street in a Spanish town, in which the perspective appears entirely credible, he pointed out that two of the architectural features depicted could not, in reality, be seen simultaneously. The subjects, then, were carefully modified or even rearranged; likewise their illumination and colour – but never to the extent of impairing, to the least degree, their credibility. In his pictures the paint scarcely 'tells' as paint at all; its qualities are as seriously disciplined in the interests of the representation of his subjects as they are in those of Ingres. No artist of his generation was more remote – to define the character of his art in negative terms – from 'action' painting than Hillier.

Establishment in Somerset faced him with one serious problem, posed by his preference for what was dry, hard, clear, and susceptible of the sharpest definition. For Somerset has none of these characteristics. There are occasions when, in his landscapes of his neighbourhood – he lived at East Pennard, near Shepton Mallet – he imposed the qualities of his preference on a subject which is conspicuously characterized by their opposites. There are, however, other occasions when the very persistence of the struggle to overcome temperamental preferences in the interests of the most searching representation of his

subject resulted in high achievements. I am thinking, for example, of such as *January Landscape, Somerset* (1962), and *Landscape with a Stream on Godney Moor* (1967). But there can, I believe, be no denying that his highest achievements were reached in response to subjects invested by the qualities which he loved with the austere passion so profoundly appropriate to them; the landscapes of Spain and Portugal. Here the toll of high achievement is far longer. Among what I believe to be his finest paintings are *Tornada, Igredia de Misericordia*, and *Portuguese Fishing Craft* (all 1947); *Viseu* (1948); *Salamanca* (1961); *El Convento de San Esteban, Salamanca* (1963); and *Cevera, Aragon* (1964).

'If it were not for Leda's devotion to Somerset,' he told me, 'I'd live in Spain.' When I objected that were he to do so the exhilarating emotional disturbance he experienced on his visits would be likely to diminish, a look of happiness lit up his face; he agreed that the intensity of his response to Iberia could best be preserved by spending most of his time in misty, gentle Somerset.

In the course of our desultory correspondence I asked him whether he thought that what he himself referred to as his 'ultimate style' was in fact ultimate, or whether he was likely to any degree to experience the evolution common to many painters towards a greater freedom and apparent spontaneity of brushstroke. He wrote in reply (11 June 1970):

> I would like to think that my present form of painting does not represent my ultimate phase and that I shall eventually be able to express myself with a more free brushstroke and a richer use of paint. But I think this is unlikely for after so many years of working in this meticulous manner, I have become the slave of my own style – which I suppose happens to every painter of my age. In my recent work, however, I have been using a much rougher texture – painting often with a palette knife in my landscapes and skies, and simplifying my architectural forms. It is true that my masters are the Flemish and Dutch painters, but this does not lessen my love for painting of a very different kind. When I look at a Courbet or even a Turner, it is with envy that they can use paint in such a rich and luscious way. It could never be my way, and I learned very many years ago the lesson which every painter has to learn sooner or later – that one must know one's limitations and seek to perfect one's technique within these limitations.

Fortunately he retained his 'ultimate style' – his poetic perception of his subjects, realized with the rarest precision, yet at his best of an unexpected character – until the end. And he was often at his best; an impressive feature of 'A Timeless Journey', his retrospective exhibition in Bradford, at the Royal Academy and in Hull and Preston was held shortly after his death on 18 January 1983.

CECIL COLLINS
born 1908

In the introduction to the catalogue of his 1965 exhibition at the Arthur Tooth Gallery, Kathleen Raine wrote of Cecil Collins's paintings that they 'seem not so much separate wholes as each an aspect of a single world'. This observation seems to me to touch the very essence of his work. His life has been dedicated to the discovery and the depiction of another world – a world governed by many of the same laws as our own, gravity, perspective and the like – yet entirely different. 'The Lost Paradise' is how Kathleen Raine defined it. It is a world which – although it took him long to discover, explore and represent – he was aware of even as a child. Awareness of the existence of another world and of his own affinity with it gave Collins a sense of acute loneliness. Had this world been a child's fairyland it might have served as a refuge from loneliness, but he understood, however vaguely, that it was a real and universal although a hidden world that imposed its own special duties and responsibilities, and that art (he regarded himself as an artist from childhood) was not a private but an essentially communal pursuit. Of course neither the Lost Paradise nor the nature of art were present to his mind in quite such definite terms, but they afford an indication of the direction of his thought and feeling.

Cecil James Henry Collins was born on 23 March 1908 at 2 Bayswater Terrace in Plymouth, son of Henry Collins, an engineer, and his wife Mary, born Bowie. Both his parents were Cornish and of predominantly Celtic blood.

From at least the age of six Cecil drew with considerable facility, his earliest enthusiasm being for landscape, but his father opposed his ambition to become an artist, and compelled him to train as an engineer and apprenticed him to a firm in Plymouth. His father's opposition, however misplaced, was understandable, for ruined as a consequence of the First World War, he was reduced to working as a navvy on roads, and the family lived in one room in a Plymouth slum. Cecil, at the time aged fourteen, bored by engineering and repelled by the brutality with which the firm was conducted, ran away and refused to return.

Collins's persistence won him a scholarship at the Plymouth School

of Art in 1924. Here he received precisely what he required: a
rigorous training in realistic draughtmanship. In his determination
to be an artist he was encouraged by a local Catholic priest. In 1927
he was awarded a scholarship at the Royal College of Art, where he
worked for four years. Recalling many years later Albert Houthuesen's
Supper at Emmaus at the College, he said he felt that the artist 'had
touched a mystical stream, a manifestation of a higher form of
consciousness'.

Inevitably our talk turned one day on the relation between himself
as a student and my father as Principal, after he told me that he had
been awarded the William Rothenstein Prize for Life Drawing. 'For
me, coming from Plymouth, where I was taught, and well taught, by
teachers,' he said, 'your father's was an exciting presence as the *artist*,
a man who was himself part of a magical world. And he put up
benevolently with my eccentricities.'

In the meantime his ideas steadily clarified and he became ever
more aware of the transitoriness of our life and convinced of the
existence of another world, which he has many times described, once
in conversation, as 'the continuum of consciousness, which permeates
this world as perfume does a fabric'.

In 1931, before taking his diploma, he married Elisabeth Ramsden,
a fellow student at the College who worked under Henry Moore when
he was an instructor there. Elisabeth is the eldest daughter of Clifford
Ramsden, and his American wife Nellie, born Ward, of Hollins,
Luddenden, Yorkshire. The family is well known in the West Riding.
Their connection with the local newspaper, *The Halifax Courier and
Guardian*, has extended over four generations.

Until he came to the College, Collins was primarily a draughtsman;
but from the late 1920s he turned to painting, becoming more and
more conscious of the evocative power of colour. In the light of his
determination to state his often highly complex message with the
utmost lucidity, it is to be expected that his art, for all its beauties of
colour, should be essentially a draughtsman's. In fact, at the very
time of his enhanced awareness of the potentialities of colour,
familiarity with the drawings of Klee released a vein of fantasy in
him that has remained a recurrent element in his work.

It seemed to him, in the mid-1930s, that Surrealism could bring
him nearer to that 'other world' by which he was becoming ever
more obsessed but which he had not yet 'seen plain'. 'This,' said Sir
Herbert Read at the opening of the Surrealist exhibition in London
in 1936 (in which Cecil was represented), 'is the dawn of a new
world.' Collins was present, and, already troubled by doubts about
the movement's validity, reflected that 'the occasion was not a dawn
but a sunset.' He therefore quickly rejected Surrealism and what he

called its 'psychic furniture'. 'I do not believe in Surrealism,' he wrote in his basic affirmation of faith, *The Vision of the Fool* (1947), 'precisely because I do believe in a surreality, universal and external, above and beyond the world of the intellect and the senses; but not beyond the reach of the humility and hunger of the human heart.'

I do not pretend to be able to trace the precise steps which led from his rejection of Surrealism in the late 1930s to the mature formulation of his philosophy of art and life in the early 1940s. This evolution owed something to Eric Gill, whom he saw often from 1933 until 1936, when they were neighbours in Buckinghamshire. Gill's logical mind, his constant preoccupation with ideas, expressed not only in his art and writings but in his conversation, a bracing blend of the challenging and the humane, no doubt stimulated Collins to clarify his ideas. Far more influential than Gill's own ideas were those of Maritain, to which Gill introduced him. These gave him his first contact with traditional philosophy. Although he owes much to Maritain, he was eventually repelled by his Aristotelian and Thomistic orientation, his own being innately Platonic. It was to Gill, too, that he owed his introduction to David Jones, an artist and writer whom he particularly admires. Perhaps the strongest and most lasting influence was that of Mark Tobey whom he met two years after he moved, in 1936, from Speen in Buckinghamshire to Totnes in Devon. Tobey, who was teaching at Dartington, evoked his interest in the art and philosophy of the Far East. (More than thirty years later I noticed, on Collins's reading desk in his workroom in Chelsea, prayerbooks and works of meditation of the Ba'hai religion, in which Tobey was a believer. 'I'm studying Ba'hai at the moment,' he said, and opening the book showed me some of the prayers.) Later on, when he was working there, another teacher at Dartington, Rudolph Laban, interested him in dance theory, which increased his awareness of the importance of the rhythmic aspects of pictorial composition.

Whatever the influences – and Collins is widely read, especially in the mystics – Blake became a paramount source of inspiration – it is clear that, by the early 1940s, his philosophy of life and art was fully evolved, and both succinctly and eloquently expressed in *The Vision of the Fool*. In essence it is an elaboration of the injunction in St Paul's First Epistle to the Corinthians: 'If any man among you seemeth to be wise in this world let him become a fool that he may be wise.' To quote some key passages:

> Modern society has succeeded very well in rendering poetic imagination, Art and Religion, the three magical representatives of life, and heresy; and the living symbol of that heresy is the Fool. The Fool is the poetic imagination of life . . . The greatest fool in history was Christ. This Divine Fool, whose immortal compassion and holy folly placed a

light in the dark hands of the world |a world in which| Art, Poetry and
Religion are not so difficult or important that they can be made
mediocre, it only needs education |in which| A great spiritual betrayal
is on – it is the betrayal of the love and worship of life by the dominance
of the scientific technical view of life in practically all the fields of
human experience |and by| the mechanization of contemporary society
and by the teaching of the norm of the ordinary man, 'the man in the
street' . . . the philosophy of mediocrity, into which, with a sigh of
relief, the heavy inert mass of mankind desires to sink.

The concluding sentences are these:

The Saint, the artist, the poet, and the Fool, are one. They are the
eternal virginity of spirit, which, in the dark winter of the world,
continually proclaims the existence of a new life, gives faithful promise
of the spring of an invisible kingdom, and the coming of light.

At the beginning of the essay Collins asserts that paintings and
drawings cannot be explained, but the concluding sentences at least
indicate the subject which his own represent. In the case of a painter
for whom subject is integral to his art this indication has great value
for the understanding of it. In a later piece of writing – some 'Notes'
in the catalogue of the retrospective exhibition of his paintings,
drawings and tapestries from 1926 held at the Whitechapel Gallery in
1959 – he is rather more specific about the nature of his subject:

Beneath the tyranny and captivity of the mediocre culture of political
dictatorships and their mechanical systems, and beneath our commer-
cial traveller's civilizations, there still runs the living river of human
consciousness, within which is concentrated in continuity the life of
the kingdoms of life, animals, plants, stars, the earth and the sea, and
the life of our ancestors, the flowing generations of men and women,
as they flower in their brief and tragic beauty. And the artist is the
vehicle of the continuity of that life, and its guardian, and his
instrument is the myth, and the archetypal image.

To Collins that 'living river', although perceptible only by the
imagination, is also an objective entity, as is suggested by his
preoccupation with the angel, the archetypal messenger between our
world and another, who figures in many religions. 'We cannot yet
bear to come in touch with the external world,' he said to me, 'so the
angel is its mediator.' 'With this world,' he added, 'I make contact
when I paint. It is a world that Plato mentions, and Dante wrote the
Divine Comedy in order to raise man from a state of wretchedness to
a state of blessedness.'

Collins is well aware, despite such contacts, of the mysterious and
elusive nature of this other world. But it does not in the least trouble
him. 'I detest ambiguity,' he said, 'ambiguity is something ordinary
made obscure. Mystery is the hallmark of all canonical art.'

Because of its clarity and reflection of a hidden world, Collins, who

as a student admired John and Greco and later Klee and the Sur-
realists, has come to prefer the arts of the ancient world: Buddhist
and early Greek sculpture, Byzantine painting and Italian painting
before Duccio. His admiration for Picasso is qualified by the melan-
choly reflection: 'He was a genius born outside a civilized context.
Imagine what he would have done in a great culture!' The only
modern painter of whom I have heard him express unqualified praise
is Rousseau.

It is William Blake's paintings, drawings and poems – expressions
of his 'Visions of Eternity' – that have most deeply affected Collins.
Blake, on painting, wrote:

> Shall painting be confined to the sordid drudgery of facsimile repre-
> sentations of merely mortal and perishing substances and not be, as
> poetry and music are, elevated to its proper sphere of invention and
> visionary conception? No, it shall not be! Painting, as well as poetry
> and music, exists and exults in immortal thoughts. I assert to myself
> that I do not behold the outward Creation and that to me it is hindrance
> and not Action; it is the dirt under my feet, No part of Me. 'What,' it
> will be questioned, 'When the sun rises, do you not see a round disk of
> fire somewhat like a guinea?' O no, no, I see an Innumerable company
> of the Heavenly host crying, 'Holy, Holy, Holy is the Lord God
> Almighty'.

In a formal sense, Collins's paintings and drawings, his elongated
and sometimes skeletonless figures, reveal Blake's influence, but no
more than the most superficial aspects of it. He does not in any
specific sense share many of Blake's obscure, and in any case
changing, doctrines, but it is from the example of Blake that he
derives the courage to be a visionary painter: to act and act constantly
upon the intimations he receives from his other world, his Lost
Paradise. He does not, however, derive from Blake only the concep-
tion of the incompatibility between innocence, the visionary sense of
the infinite, the religion of the spirit, and materialism, conventional
morality, and science. There is much else in *The Vision of the Fool* that
echoes Blake. 'The ideal of our education,' for example, 'is the clever
scientific technician (which) dominates all other approaches to the
mystery of life, including those ancient and eternal ways of percep-
tion, Art and Religion.' He even uses the word 'innocence' in the
Blakean sense: '. . . this ancient element of the eternal Adam still
exists deep inside a man . . . That holds converse with the essence of
life. Spiritual joy, that is essential joy, arises from innocence . . .', and
this by way of contrast to 'the element of the insect, of the mechanical
in man, which degrades man into . . . a sterile state of efficiency.'
Although Collins's visionary spirit is akin to Blake's, his painting, in
spite of the occasional superficial resemblance, is very different.

Blake's forms were largely based upon late Renaissance works highly influential during his time, as well as Gothic, while Collins's are more hieratic, and influenced by the arts of far earlier civilizations.

On a different level Collins derived something, too, from the lyricism of Samuel Palmer. No one ignorant of his Shoreham landscapes could have made *The Field of Corn* or *The Invocation* (both 1944).

Collins's return to his native Devon in 1936 had two other consequences besides his significant association with Mark Tobey. The rounded hills and the forests near Totnes, perhaps because they revived memories of scenes of his childhood, stimulated his imagination. And by an accident of war he adopted a new, although secondary profession.

Cecil and Elisabeth attended Mark Tobey's classes at Dartington, but he returned within a few months of their meeting in 1938 to the United States. Just before the Second World War an art school was established at Dartington, staffed mostly by Germans and Czechs, who in the course of it were imprisoned or interned. In 1939, unexpectedly, Collins was appointed director of studies, and taught painting and drawing at the school's studio workshop. His duties did not seriously interrupt his own painting, and in that same year, among other pictures, he completed a large oil of himself and his wife. They are seated at a small dining table, and through the window behind them is a hieratic Byzantinesque landscape with Palmeresque overtones. It is a dignified, serious painting, but it shows little of the imaginative fantasy that was shortly to characterize his work and had already occasionally revealed itself, for instance in *The Quest*, another large painting made the previous year, which represents a king and three others in a small boat skirting a rocky shore of lunar aridity. *The Artist and his Wife* are ensconced firmly in Totnes, but in *The Quest* we are shown 'the other world', although hardly a Lost Paradise. The aura of this painting – apart from the fact that the boat is proceeding at a brisk pace without visible means of propulsion – makes it clear that we are remote from even the wilder shores of the terrestrial globe.

Collins enjoyed teaching at Dartington (where he had his own studio) and living in a community, staying there for four years. He resumed teaching in 1956 at the Central School of Arts and Crafts in London. Being something of a prophet, teaching is for him a natural function and, although he evolved a philosophy of art and life relatively early, he finds that discussion with his students further clarifies his own ideas. For him painting and drawing are a form of meditation, but he regards the function of the artist as being essentially public. Convinced as he is that art is a form of knowledge,

he was delighted when his students, after an interlude during which they demanded entire freedom of action, suddenly asked to have the model back and demanded to be taught. The rejection by many students today of standards of morality of any kind, even though Collins himself has always been opposed to conformist morals, greatly troubles him. 'Do you realize,' he asked me, 'that owing to the absence of moral standards the student of today can't even *sin*?'

Collins held his first one-man exhibition in 1935 at the Bloomsbury Gallery, and although he contributed to at least three wartime exhibitions ('New Movements in Art', at the London Museum, 'Imaginative Art since 1939', at the Leicester Galleries, and the British Council's 'Contemporary British Art', shown at the Museum at Toledo, Ohio, and elsewhere in the United States) he nevertheless became averse to showing his work publicly. But in 1943, the year when he returned to London from Devon, he acceded to the urgent advice of a friend and decided to hold an exhibition. For a time he lodged in Carlton Mews off Trafalgar Square. At his invitation I called to see him and a considerable accumulation of his work. We had known each other when he was a student at the Royal College of Art, but I must confess to my discredit that I had underrated his work (although there had been few opportunities of seeing it); also the man and his ideas. But my experience at Carlton Mews transformed my attitude: I intensely admired the best of his work and formed an enhanced liking and respect for the man. Like his master, Blake, he is an uneven artist but at his best he has a high place among the small company of imaginative artists active today. Having a wide range of his work to choose from I bought, on behalf of the Contemporary Art Society, *The Sleeping Fool* (accepted by the Tate in 1951), an unforgettable combination of naivety and sophistication, and a painting that has remained as vividly present to me as any picture on our own walls.

This painting is one of a series begun three years before, originally titled *The Holy Fools*, but later, to accord with his essay, altered to *The Vision of the Fool* – a series he has constantly added to but never shown in its entirety. The essay, although I think even more highly of it now than I did at the time, completed the experience of Carlton Mews: Cecil, Elisabeth, Elizabeth and I became friends, and although for geographical reasons we have not met frequently our friendship has, I believe, flourished.

But it was one thing for a friend to urge Collins to show his work and very much another to achieve this purpose. Packing as many paintings and drawings as it would hold into a large suitcase, he trudged wearily along the streets where the commercial galleries are located, unpacked his work and showed it. It was rejected by all. At

the Lefevre Gallery, McNeill Reid said, after giving one of the paintings a cursory glance, 'It's no good. All this Surrealism is *over*.' By this time Collins was too exhausted to carry the suitcase any further, and he asked whether he might leave it at the gallery. Being a kindly man, Mr Reid readily agreed and undertook to look at the work at leisure. Two days later he returned, to be told that 'there has not been time to look at it'. Still exhausted, Collins asked if he might leave the suitcase for one day more. Next morning he was greeted by Duncan Macdonald, one of the partners in the firm who had just returned from New York, with the words, 'The work you've left here is very important. If you'll allow me I'll visit you in Devon and see more.' The result was Collins's first one-man exhibition for nine years which was held early in 1944. It was well-received and there were a number of sales. In the course of the exhibition Collins and Elisabeth went to stay with her parents at Luddenden, near Halifax. News reached them there that the Lefevre Gallery had been hit by a bomb. As his exhibition represented some ten years' work Cecil compulsively telephoned to the gallery, although scarcely expecting any response. To his astonishment his call was answered. 'Yes, I'm still here,' a member of the staff said, 'your pictures were all blown off the walls and are among the wreckage on the floor, but I've examined them, and all but two are unharmed.' Among the unharmed was *The Sleeping Fool*. The following year Collins had another exhibition at the Lefevre which was even more successful than its predecessor, and a third in 1948.

Collins has never had a strong constitution, and his happy married life has not, I believe, been marked by dramatic external events. Like Albert Houthuesen and Edward Burra he has to conserve all his energies for his art. Much of his life, in any case, is passed in his other world, 'in the living river of human consciousness' unseen by the ordinary eye, 'The Lost Paradise'. But until they settled in Selwyn Gardens, Cambridge, in the summer of 1947, and a workroom flat in London, the Collinses were often on the move. Besides the moves already mentioned they spent some time in Oxford in 1946, where he met Paul Nash, who thought so highly of his perceptiveness that he invited him to write a book on his painting; as well as Conrad Senat who sponsored the first book on his work, *Cecil Collins, Paintings and Drawings (1935–45)*. There are times when he regrets not having settled in Oxford. Later, staying with us, he said, 'Cambridge is so *hygienic*; Oxford is redolent of evil. I think I could really *work* here.' After a brief sojourn in Chelsea he returned to Luddenden to live with Elisabeth's parents. Apart from visits during the years 1950–54 to Italy, France, Germany, and one to Greece, he has moved rarely since his establishment on his Cambridge–London axis, although

eventually making a more permanent home in London, at 47 Paultons Square, Chelsea. The visit to Greece was especially memorable. Seferis, the revered Greek poet-ambassador in London, suggested to him in 1962 that he hold an exhibition in Athens. 'I found myself en route for Greece with a suitcase full of watercolours,' he told me. The exhibition at the Zyghoe Gallery was welcomed and four works were bought by the Greek National Gallery.

Collins has held a dozen one-man exhibitions besides receiving the accolade of his retrospective at the Whitechapel Gallery in 1959 which included two hundred and twenty-seven oils, gouaches, watercolours, pen and chalk drawings, lithographs, monotypes and tapestry. The exhibition was received with marked respect. In the same year he designed a huge curtain with Shakespearian themes for the British Embassy in Washington D.C., made by the Edinburgh Weavers. (He had designed his first tapestry ten years before.) But in spite of the general respect for his work and a circle of ardent admirers, he is far from being accorded the place which his talents deserve. Like Roy de Maistre, Edward Burra and Albert Houthuesen, Collins was never favoured by the establishment. When I brought examples of their work before the Tate trustees they invariably treated my admiration for it as a symptom of personal idiosyncrasy, to be treated sometimes with tolerance, at others with tight-lipped reserve. Indeed in the trustees' report, published the year after my retirement, friendly reference is made to my sponsorship of 'less popular kinds of painting . . . good examples (were acquired) of the work of men such as Burra, Houthuesen, Cecil Collins and Roy de Maistre'. Since the Tate was never associated with the acquisition of works which were 'popular' in the sense generally understood, in this particular context the expression 'less popular' is a synonym for 'less popular with "progressive" establishment taste'.

The most singular aspect of such taste is its double standard. Until quite recently, when there has been a blurring of all criteria, it was dominated by the abstract idea. Abstract artists of the most modest talent were readily accorded the status of significant figures, and in considerable numbers; their work was selected to represent their countries in international exhibitions and the like. For figurative artists to achieve a comparable status the conditions were far more rigorous. Had he not been the author of In Parenthesis and Anathemata, it is legitimate to doubt whether David Jones would have attained his present eminence; Henry Moore and Francis Bacon are figures whose stature is not easy to ignore, and Henry Moore in any case is the maker of a number of abstract and near-abstract works. But compared with the practitioners of abstraction how few figurative artists were included among the elect! It is as though there had been an unwritten

veto on their recognition. Collins, for example, received a number of letters from Sir Herbert Read expressing high admiration for his work, yet in his voluminous writings on his artist contemporaries it is never referred to.

Of the four painters referred to as rated below their merits by the establishment, Collins has given particular grounds for suspicion. While de Maistre (except as a very young man in Australia), Houthuesen and Burra did not express their convictions publicly, Collins has, explicitly and at length. Although written as long ago as 1914 and without specific reference to abstraction, Clive Bell's characteristically uncompromising words remain the clearest statement of the attitude that culminated in abstraction:

> To appreciate a work of art we need bring with us nothing from life, no knowledge of its ideas and affairs, no familiarity with its emotions. Art transports us from the world of man's activity to a world of aesthetic exaltation.

In *Notes by the Artist*, Collins wrote:

> I am not very interested in what is called 'pure painting' . . . If the subject is unimportant in a picture we may well ask: unimportant to whom? The subject of the Crucifixion unimportant to Grünewald? to Fra Angelico? The themes on the front of Chartres Cathedral unimportant to its builders? The subject unimportant to Rembrandt, to Goya? . . . It is not sufficiently realized how a subject functions in a picture. A subject is thematic energy, the theme in art is a focus or canalization of visual energy, hence the emotions and associations of the theme are inseparable from the forms and colours in a picture . . . The terms 'pure painting,' 'pure art' seem to me to be meaningless. All my pictures are based upon a theme, and the theme is the cause of all form and the colour harmonies and no colour or line exists for its own sake.

In this connection he repeated with evident amusement an account given him by Arthur Waley (who was present) of a lecture by Roger Fry in Cambridge, in the course of which, showing a slide of a painting by an old master, he had said, 'I would like to draw your attention to the large mass in the centre of the composition.' The 'large mass' was the crucified Christ, which he did not otherwise describe.

At the Royal College of Art, fellow students sometimes ridiculed Collins's ideas – admittedly less lucidly formulated than they since became – and even *The Vision of the Fool* was treated by some of its readers, including a few of his friends, as an extravaganza bearing no relation to the actual condition of society. They were mistaken: this essay, in particular its emphatic and repeated contention that poetic imagination and human liberty are entirely incompatible with our materialistic, technologically orientated civilization; in which the

'plain and ordinary man' has made the philosophy of mediocrity a power; and that this philosophy has an army, armed with guns, bombs, gas, atomic rockets, and other effective instruments for the destruction of the human race, clearly predicted some of the issues that have provoked the almost world wide revolutionary ferment among recent student generations. Collins is far from regarding this ferment – however justified – with approval. Discussing this subject he said, 'In the great cultures man's imagination was protected by the idea of the sacred; today his imagination is open to all forces, and often their victim.'

The Vision of the Fool reads in fact as though it had been written in California in the 1960s rather than in England in the 1940s. It is no accident that it is quoted by students in California and elsewhere in the United States, and in a book entitled *The Holy Barbarians* by the Californian writer Henry Lipton.

Collins's writings have been quoted at some length not because his philosophy is as important as his painting and drawing, nor because it explains them, but because it offers so clear a reflection of his outlook on our world and also upon that far less tangible entity, the world of his imaginative apprehension. As he has written, 'Paintings and drawings cannot be explained', but his writings help us to share his vision of this archetypal world. It is, however, a world which he himself is not always able to keep in focus. At such times he ceases to draw and paint, as in 1959 when he ceased for the better part of a year. There are other times when, seeing his subject imperfectly or scarcely at all, he begins simply to apply paint and the process stimulates his creativity, enabling him to give it a clearly defined form. But it is more usual for him to envisage a picture in detail before he puts brush or pen to wood, hardboard or paper. The actual process of applying paint, then, evokes an increasing exhilaration and involvement, but on account of his method the work proceeds slowly. He applies successive layers of transparent glazes, each of which is allowed to dry before another is laid on. This method enables him to give his images the appearance of being at different depths: some submerged deep beneath several subtly toned transparent layers, hovering in mysterious darkness, others floating on the surface. 'The paintings and drawings distil inside me and when they are ready they burst out – complete, for I have long since ceased to make preliminary studies. At the moment,' he told me in 1969, 'I have four visionary pictures in my mind, three clearly, but when at peace I can call them all up.' A big painting – often the essence of experience accumulated over years – takes him from three to four months to complete. From the early 1950s his favoured medium has been oil on wood or hardboard, which has a solid icon-like character

that pleases him. There is something trancelike in his state of mind while he is painting, as he expressed to me in a letter of 30 July 1970:

> I am not aware of the qualities of my painting while I am doing it, but I am aware only of the absence of that Reality, that Beauty, so that the process of creating it is for me mostly absence, and the pain of absence, and yet in this process, this state, I am highly critical, my critical faculty is not suspended. Out there is nothingness, and into that nothingness I make an act of faith, and it is only sometime after the painting is done that its Beauty and Reality are revealed to me, so that I can see the qualities that my friends and others find there.
>
> In a word the painting and the vision come to fruition by themselves, but the experience of that fruition is the pain of absence.

It is perhaps inevitable that an artist whose subjects belong to a visionary world, whose eyes are lifted always to the heights of his experience, should be uneven. Failure to attain exalted ideals (like-wise failure to realize high ambitions) is always conspicuous in a way that failure to perform some routine undertaking is not. Many artists evolve a series of formulae which they follow with mechanical proficiency throughout their working lives, and the better results are no more successes than the worse are failures, for a failure must bear some relation to a standard, and artists of this sort – and they are legion – have none worth taking account of. An artist with exalted aspirations whose subjects are visionary, Collins is unable, at moments of flagging inspiration – unlike artists whose subject is present before them – to revive it by the contemplation of its form and colour or by an attempt to represent it. The artist dependent on his imagination alone has no such resource: the act of creation is for him a uniquely exacting ordeal, and the results of moments of flagging inspiration, still more of its failure, are conspicuous to a special degree. At such moments, like Blake's, Collins's work is marred by want of clarity, when paint coagulates awkwardly, or by oversimplification or even emptiness of form. But it is by his best – and only by his best – that an artist should be judged. Collins paints pictures in which splendours of form and colour combine to give us an insight into a radiant, unknown world. Such are *The Voice* (1938); *The Greeting* (1943); *Christ Before the Judge* (1954); *The Sleeping Fool*, already mentioned; *Hymn to Death* (1953); *The Golden Wheel* (1958); *An Angel*, painted in 1969 for a room of meditation in the south of France, or *The Wounded Angel* (1969). These and a number of other paintings, watercolours and prints, as well as such a tapestry as *The Fools of Summer* (1954), all reflect the vision of an artist who has preserved a rare originality, and in spite of his highly sophisticated mind and eye, a moving innocence of spirit. Cecil Collins would not be an incongruous inhabitant of his own Lost Paradise.

VICTOR PASMORE
born 1908

There is one respect in which Victor Pasmore closely resembles Whistler: both possessed, and sedulously cultivated, a power of achieving the most compelling resemblance to nature, while at the same time being deeply convinced that the qualities most worth striving for were the purely formal qualities: form, colour, tone. Whistler's assertion that his celebrated portrait of his mother should be seen as an *Arrangement in Gray and Black No. I* is well known; perhaps less so are his still more emphatic words about Japanese art, which, as he wrote in *The Gentle Art of Making Enemies* (1890), 'is not merely the incomparable achievement of certain harmonies in colour; *it is* [the italics are his] *the negation, the immolation, the annihilation of everything else'*. Much of Pasmore's early work resembles Whistler's in its delicate romanticism. All of the later, however logically it accords with Whistler's ideals, he would probably have refused to recognize as art at all. Whistler shared with the many advocates of 'significant form' (which included colour) – of whom the most influential were Roger Fry and Clive Bell – a curious obliviousness to the logical conclusion to which it would lead, although, unlike these two distinguished critics, he died almost a decade before the emergence of abstract art.

Among its most austerely logical practitioners, as well as teachers, is Victor Pasmore. His work, which at first reflected that of Turner, the Impressionists, Vuillard, Bonnard, as well as Whistler, by a predominantly intellectual evolution eventually became autonomous form and colour: 'the negation, the immolation, the annihilation of everything else'.

The development of many artists (Henry Moore, for instance, and Pasmore's friend and one-time close associate William Coldstream) represents a readily comprehensible, almost organic growth – of course stimulated, diverted and arrested by influences met with on the way, or reactions from influences, and the like – and this growth has the quality of naturalness comparable with the growth of a plant. But there are other kinds of development, which, guided by logic, discipleship of a stronger personality, the prevailing artistic or social climate, or ambition, result in radical change. It was primarily

ambition, for instance, that transformed Millais from the painter of *Lorenzo and Isabella*, *Christ in the Carpenter's Shop* and *The Blind Girl* to the painter of *Bubbles*. In the case of Pasmore the change in his development – more radical than that of any British painter of the present century – was due to a change of intellectual convictions, the result of tenacious study and prolonged reflection. In his book on Pasmore, Clive Bell describes his artistic temper as

> that of one who paints as a bird sings rather than as an architect builds. So joyfully, so unscientifically, so digressively even does he pursue his theme that he seems never to come up with it till the last moment – and not always then . . . and manifestly his nature rebels against theory and dogma. Essentially that nature is conservative . . .

Pasmore was only thirty-seven when it was published, and on the evidence of his work up to that time it seems a fair description, but it is in fact a description of a temper the precise opposite of Pasmore's.

Edwin John Victor Pasmore was born on 3 December 1908 in Warlingham, Surrey, the eldest of the three children of Dr Edwin S. Pasmore and his wife Gertrude, born Screech. The family was originally West Country on both sides, the Pasmores being from Devon and the Screeches from Somerset. E. S. Pasmore was a respected mental specialist, who at the time of Victor's birth was attached to Chelsham Hospital.

From as early as he can remember Victor wished to be an artist. He went to Summerfield, then to Harrow – where he won drawing prizes – remaining there from 1922 until 1926, and it was assumed that on leaving he would go to an art school. But as the result of the premature death of his father the family could not afford the expense. They moved to Hammersmith, living just off Brook Green, and from 1927 until 1938 Victor was a clerk in London County Council's Health Department at County Hall. Still determined to be a painter, Pasmore attended evening classes at the London County Council's Central School of Arts and Crafts from 1927 until 1931 under A. S. Hartrick, whose teaching he found invaluable, as well as painting whenever opportunity allowed. In 1931 he took a studio in Devonshire Street, off Theobald's Road, Finsbury Park; three years later he joined the London Artists' Association, through which he met William Coldstream and Claude Rogers and which sponsored his first exhibition at the Cooling Galleries in 1933.

Although still at County Hall and very much an amateur, he was elected a member of the London Group in 1934 and contributed to the 'Objective Abstractions' exhibition at the Zwemmer Gallery, in which several of the exhibits proclaimed the autonomy of paint and brush in a way that anticipated the abstract expressionism of twenty

years later. About the same time he also saw abstract paintings at an exhibition of the Seven-and-Five Group.

Like many young painters during the present century, Pasmore was confused. I described Bell's statement that he 'paints as a bird sings rather than as an architect builds' as the opposite of the fact, because Pasmore is, more than any other painter in this book, a theorist. During his earliest years as a painter, however, he had no intellectual convictions about his art; not only had he never attended an art school full-time, but he had read scarcely any books about painting. So he was susceptible to every wind that blew: the late Turner at the Tate, Whistler, the Impressionists, Matisse, Picasso, Braque and other Cubists, Bonnard, various old masters, including Chardin, Japanese prints; and he tried to imitate a number of them. He also made Fauve and abstract paintings. However, little of his work from before the 1930s survives. But he was getting nowhere with these imitations, which he was unable to finish. It was not that he lacked talent, as his *Church in Spring* (1926), painted when he was still at Harrow, clearly shows. Characteristically he adopted a logical point of departure.

Pasmore, although more talented than most of his contemporaries, was less informed, more aimless and less consistently instructed, in spite of his perceptive art masters at Harrow, Maurice Clarke and John Holmes, who interested him in Impressionism and encouraged him to read Leonardo's *Notebooks*, and his fruitful evening classes with Hartrick. This absence of aim, and dissatisfaction with the prevailing geometric style resulted in a development that was important in its creative results as well as giving Pasmore the point of departure he was looking for. However, this development was not the work of Pasmore alone, for, as Sickert used to say, 'these things are done by gangs'.

Geometrical abstraction was being pursued from the mid-1930s with conspicuous success by Ben Nicholson, Barbara Hepworth, John Piper and others whose practice and theory emerged from the pages of *Axis*, the quarterly review of abstract painting and sculpture. Of the particular 'gang' concerned, the other leading members were William Coldstream and Claude Rogers. All strongly shared, however, a sense of the severe limitations imposed by geometric abstraction, exemplified by the work of some of them shown at the 'Objective Abstraction' exhibition which had led nowhere, and they were deeply attracted by the ideal of a return to nature – 'straight painting' as they called it – yet they were unmoved, in spite of their admiration for Sickert, by the 'straight painting' practised by a number of their seniors. None had anything approaching 'primitive' tendencies and they realized that 'straight painting' must have a point of departure

in some tradition. After much reflection and discussion it was accepted that French painting between David and Cézanne had created a tradition which in particular fostered an intimate understanding of natural appearances, a tradition that succeeding generations for some mysterious reason had failed to develop. So they established a school of drawing and painting at 12 Fitzroy Street in 1937, and moved later that year to 316 Euston Road, where they were joined by Graham Bell; they were a group of painters who were close friends sharing basic ideas about painting, and also an art school. Both were known as the Euston Road School (a detailed study of this group-school is long overdue). It had affiliations with the literary world; Coldstream, for instance, was friendly with Auden and Spender and painted their portraits.

The rejection of the strongly emerging geometric abstraction called for courage, for young men of such intelligence and talent did not reject the 'progressive' in favour of the 'traditional' without misgivings. Their state of mind was perceptively summed up by Coldstream in an article entitled 'How I Paint', which appeared in the 15 September 1939 issue of *The Listener*:

> I belonged to a set of about a dozen friends, all painters who had just left the Slade. We read Clive Bell and Roger Fry, and spent a great deal of time discussing aesthetics. All the more intelligent books on art which we read taught us to regard subject-matter merely as an excuse for good painting. Our discussions were usually on the question of which modern style was best and most progressive . . . When we were influenced by Picasso and Braque we were troubled by a suspicion that we should be as far in advance of them as they were in advance of Cézanne.

Their inability to be 'in advance of Picasso and Braque' and their preoccupation with natural appearances seemed less perverse after the economic slump of 1930, which fostered strong left-wing political attitudes which in turn made abstract art – as unattuned to 'the people' – appear exotic, 'the people' requiring an art 'that had to do with life'. The Bloomsbury group, feeling their neighbours in Euston Road to be their natural successors, gave them support; they felt the need of successors, as the failure or defection of many of their protegés left Duncan Grant, their star, in an isolated position.

I will not dwell at length on the Euston Road School, which in any case was as promptly extinguished by the Second World War as Vorticism was by the First. Moreover, the theories that pervaded its practice did not affect Pasmore deeply. It was invaluable to him, as it was to everyone associated with it, as a highly perceptive introduction to a tradition, but a tradition followed, however faithfully, with independence. But he was not yet the theorist he was to become:

although an active teacher at the School, he was primarily an impassioned student. Uninterested in left-wing politics, the war in Spain or any other public issue, he studied painting, its techniques, its history, the theories that had affected it; he read and experimented endlessly.

The late 1930s and early 1940s were frustrating years for those artists who were not officially employed as war artists. But Pasmore was freer than most: through the generosity of Kenneth Clark he was able to afford to resign from County Hall in 1938, when he moved from his Howland Mews studio and his quarters over the then-celebrated meeting-place of artists and writers, the Eiffel Tower Restaurant, to the studio at 8 Fitzroy Street, earlier occupied by Duncan Grant, Sickert and Whistler. In June 1940 he held his first one-man exhibition, married Wendy Blood and settled in Ebury Street. I well remember the terms in which he formulated his attitude towards painting when I spent some time early the following year in the by then badly bombed studio. While Wendy, he and I sat on the bed eating a snack lunch Victor emphatically declared: 'Surrealism, abstraction and the rest of the contemporary movements I look on as aberrations. As *aberrations*, do you see? Now we've got to go back to Degas and the Impressionists – they represent the real tradition – as soon as possible. We must begin again at the point where the tradition deviated.' And I remember, as I looked round at his paintings of Wendy, of roses, of bottles, of the seashore, all so delicately lovely in colour and tone, I marvelled that this searching mind, with its forceful apprehension of the problems of painters of his own generation, should be content to tread so well-trodden a path – for his work reminded me not only of the Impressionists but of Bonnard, Whistler and even of Conder. The path was none the worse for being well-trodden, but Pasmore seemed to me an incongruous figure to be treading it.

Over the next decade Pasmore's outlook underwent a change which at its culmination seemed apocalyptic. Seen in retrospect, although it was clearly radical, it was less apocalyptic, less unheralded, than appeared at the time. In the early 1940s he was determined to 'go back to Degas and the Impressionists'; to help to reanimate the realistic tradition at the point before which he, and a number of his friends, believed that it had begun to decline. However, by the late 1940s he had decisively rejected that tradition in favour of the abstraction which he had tentatively practised in the mid-1930s. There was, of course, nothing original about this rejection of tradition: it had been rejected by Kandinsky, Mondrian, and others; the *Realistic Manifesto*, the work mainly of Naum Gabo and issued in Moscow in 1920, had declared: 'The attempts of the Cubists and Futurists to lift

the visual arts from the bogs of the past have led only to new delusions . . . The past we are leaving behind as carrion.' As Pasmore explained to me:

> . . . 1947 was no traumatic experience. It was the logical result of my professional evolution. I had no interest in rebellion; I never tried to do anything new. I learnt from Moore and Nicholson, but I never wanted to be a Mondrian, in fact I don't care a button for him. I explored all possibilities; I'm not interested in my 'style'. I'm not even against subject, but it's not for me: I believe that abstraction is the logical culmination of painting since the Renaissance. No one could follow Picasso, for instance, in his realism. But I was very much moved by his work at the big Picasso-Matisse exhibition held just after the war (even though I didn't like it). I felt that Picasso was the man whom earlier artists, Cézanne and Van Gogh for instance, had been implicitly talking about . . .

for certain of the ideas they expressed seemed to Pasmore to be far in advance of their own practice.

Pasmore's evolution during the 1940s, although admittedly less 'traumatic' than it once appeared, was nevertheless an extraordinary phenomenon, to which I can recall no parallel. In certain of his flower paintings, such as *Chrysanthemums* (1943) and his Thameside land-scapes, such as *The Quiet River* (1943–44), *Chiswick Reach* (1943), *A Winter Morning* (1944) or *The Gardens of Hammersmith* (1944), as well as *The Wave* (1939–44), Pasmore showed a power of evoking a gentle, radiant, misty vision of nature unapproached either for acuteness of perception or for sheer poetry by any of his own gifted generation. They invite comparison with Whistler's Thames paintings of the 1870s: the two painters shared a love for similar aspects of nature and an absorption with the underlying geometry of their composi-tions. In all the paintings referred to, except *Chiswick Reach*, sharp linear outlines appearing here and there can be perceived – by hindsight – as presaging, however discreetly, the pure abstraction only a few years ahead.

Nevertheless for Pasmore the 1940s were strange years: he was a painter with a rare and growing command of the natural world, especially of its delicately romantic aspects, yet all the while troubled by doubts about the validity of traditional naturalism and by a sense of its impending disintegration. These culminated in a conviction that it had, in fact, already disintegrated. Many years later he described his conclusion in 'What is Abstract Art?' in *The Sunday Times*, 5 February 1961:

> The solid and spatial world of traditional naturalism, once it was flattened by the Fauvists, atomised and disintegrated by the Cubists, could no longer serve as an objective foundation. Having reached this point the painter was confronted with an abyss from which he had

either to retreat or leap over and start on a new plane. The new plane
is 'abstract art'.

Characteristically, Victor Pasmore leaped.

The arrival of traditional naturalism at the abyss he regards as no
more unheralded than his own, and he has described, in the article
quoted and elsewhere, how it was approached from the later nine-
teenth century. Turner's 'free development of colour', the 'art for art's
sake' movement, Cézanne, Van Gogh, Gauguin all played their part
and, as already noted, the Fauves and Cubists. His conception of
abstraction, the art on the far side of the abyss, is orthodox: 'an
evolution without precedent in the visual arts . . . altogether inde-
pendent of imitative techniques, literary associations and decorative
functions' and manifesting 'complete autonomy of form'.

In 1947 he moved away from the Thameside where he had painted
most of his finest landscapes, while living at 2 Riverside, Chiswick
Mall, for about a year from 1942 (on his discharge from the army after
a year's service) and at 16 Hammersmith Terrace from about a year
later, settling at 12 St Germans Place, a spacious Georgian house in
Blackheath. This has remained the family's London base, although in
1970 he bought another house in Gudja, Malta, where he spends the
greater part of the year. From 1947 Pasmore systematically began to
study abstract art as well as to practise it.

It was characteristic of him that in making his new beginning he
should scrutinize the writings of Kandinsky, Mondrian, Arp and
other abstract painters, as in 1943–44 he had studied – largely in the
excellent library at Biddesden, the house of the Hon. Bryan Guinness,
now Lord Moyne – those of Cézanne, Gauguin and Van Gogh before
the Picasso-Mattisse exhibition had confirmed his determination to
explore the implications of their ideas.

Pasmore's decision to become an abstract painter and his wide
reading about abstract art did not lead immediately to an evolution
of a personal style. For instance, *Square Motif in Brown, White, Blue and
Ochre* (1949–53) owes much to Cubism, and several painted reliefs of
the same period are echoes of earlier works by other artists, and less
original than those made by Ceri Richards in the same medium in the
1930s. But this is no cause for surprise: to explore various possibilities
was in accord with Pasmore's character and this innate disposition
was stimulated by intensive study of abstract practice and theory of
many kinds. (He even compiled an anthology entitled *Abstract Art:
Comments by Some Artists and Critics*, printed privately in 1949 at the
Camberwell School of Art.) The effects of the encouragement he
received from Ben Nicholson – who had evolved a highly personal
form of abstraction by the mid-1930s – are apparent in Pasmore's

early abstraction. He visited Nicholson and Barbara Hepworth in St Ives in 1950 and exhibited with them at the Penwith Society, which assembled the first exclusively abstract exhibition held in Britain since the war.

For a painter widely honoured as a traditional master, who had developed implications in the work of certain of the Impressionists and of Whistler in such a way as to give his own work a strong appeal not only to those with traditional inclinations, but to those sensitive to art of various kinds characteristic of their own day, to transform himself with apparent suddenness into an abstract painter provoked astonished shock. Indeed I cannot recall an effect caused by a change in outlook in a British artist of anything approaching comparable intensity. Its most significant result was to persuade a number of serious artists, particularly Pasmore's friends and former students, to reconsider their own basic convictions, including Kenneth Martin, Adrian Heath and Terry Frost. The fact that Pasmore's change was seen, even by his friends, as 'apocalyptic' instead of the culmination of a steady evolution over several years is not surprising. I do not believe, however, that this evolution could be traced with any degree of precision, even by his intimates, until his major retrospective exhibition held at the Tate Gallery in 1965.

The first abstract paintings which were quite unmistakably Pasmore's own were a number of whirling forms made in the early 1950s. These are not abstract in the severest, most exclusive sense and their titles indeed show his awareness of their affinities with the world of natural appearances, for instance *Spiral Motif: The Wave* (1949–50), or *The Snowstorm: Spiral Motif in Black and White* (1950–51). Their allusion is not so much to water and to snow as to the forces by which they are animated. As he stated clearly in an article in *Art News and Review*, 24 February 1951:

> The spiral movement which can be discerned throughout nature, in many different forms, is reduced to its single denomination . . . the act of drawing a spiral in a variety of ways will evoke emotions similar to those associated with the spiral movement of nature.

Pasmore's is a wholeheartedly logical nature and, as could have been predicted, he abandoned the spiral motif series because they inevitably evoked images of the natural world. The last he made was probably '*Spiral Motif in White, Green, Maroon and Indigo*, completed in 1952. The previous year he made several painted reliefs, *Relief Painting in White, Black and Indian Red* and *White Relief* being the first.

The reasons for his preoccupation with reliefs included an admiration for those made by his friend Ben Nicholson – to which his own earliest have some resemblance, although they are less sophisticated

and indeed have a 'homemade' look – and an increasing recoil from all imitation of nature, however oblique, which disposed him to create, instead of suggesting, form and space. This development was accelerated by reading Charles Biederman's *Art as the Evolution of Visual Knowledge*, lent to him in 1951 by Ceri Richards, which emphasized the significance of relief. The two reliefs referred to were tentative beginnings. Characteristically, Pasmore carried this development towards a logical conclusion by boldly projecting form and its accompanying deep space. It was an attempt to create space in front of the picture surface instead of, as in traditional painting, behind. The character of many resulting reliefs is suggested by the title which he gave to several of them, namely, *Projection Relief*.

Pasmore differs radically in at least two respects from the generality of 'geometric' abstract artists. To them their work constitutes a language more or less private, understood by a perceptive few, and these mostly fellow artists, and it is characterized by something less easy to define, a certain impersonality, often evident in the look of being the product not of the hand but of a machine. (This look is not, of course, the exclusive mark of the work of 'geometric' abstract artists.) Pasmore's contrary 'public' preoccupation found the widest scope through his long association with the small town of Peterlee in Durham, conceived by Peter Lee during the Depression as a 'dream town' for miners. Lubetkin was the chief architect but Pasmore was appointed in 1955 as consulting architectural designer for the Peterlee Development Corporation. Here, under the direction of the general manager, A. V. Williams, and in association with Lubetkin and other architects, Pasmore has been concerned with the South West housing area. It gave him 'an opportunity,' he said to me, 'to bring abstract art directly to the public – right outside the range of the museum.' (It was not his first opportunity, which was a relief-mural – his first relief – made for the drivers' and conductors' canteen at Kingston, Surrey, in 1950, but it was beyond comparison his most far-reaching.) Although not formally trained as an architect, Pasmore had studied, with his customary diligence and zest, the work of Corbusier, Gropius and others.

The culmination of his work at Peterlee was the design of a pavilion which serves as an urban centre – as a church would were a new village to be built in Malta. But unlike a church the pavilion, an integration of architecture and painting, has no function except to give pleasure and a sense of focus, to be, as he put it, 'an emotional centre', an essential urban feature, and one so often lacking in modern urban development. Pasmore regards this massive, harmonious, partly painted, concrete structure, each aspect of which differs from the others, as his best work.

The pavilion is closely related to his linear abstractions in both two and three dimensions. But Pasmore is very much aware of the danger that exclusively 'geometric' art may become mechanical, and he has accordingly practised an art which, although no less abstract, is of a different and even a contrary order. He builds up a composition, at first only vaguely envisaged, from dots and dashes almost arbitrarily applied; in brief, he allows the picture to make itself. No artists could differ more from Pasmore (or from each other) than Jack Yeats and Francis Bacon, but all three have in common a reliance, at certain times, upon the paint 'to take over' and complete the work. Such a procedure has, of course, a long history in Britain going back at least as far as Alexander Cozens. Even Aubrey Beardsley, a meticulously precise draughtsman, said to W. B. Yeats, 'I make a blot upon the paper and I begin to shake the ink about and something happens.' One example of many, but perhaps the first, of a Pasmore painting which evolved in this way is *Black Abstract* (1963); another is *Blue Development No. I* (1965–66). Having explored many of the possibilities offered by the relief, Pasmore has devoted most of his recent years to two-dimensional painting. His use of the word 'development' in the titles of a number of his works testifies to his continued preoccupation with the possibilities, to use another of his own expressions, 'of the picture making itself'.

No artist of Pasmore's generation has been so wide-ranging: he has evolved from being a painter of delicate poetic landscape to a painter of autonomous forms, who then felt impelled to move from the two-dimensional medium of painting to the actual three-dimensional world of 'construction' (*Relief Construction in White, Black and Indian Red*, [1965–67]), or pure 'architecture', and returned to painting with every move impelled by a zestful logic largely his own. A writer for whom I have a high respect has maintained that Pasmore's work has an underlying unity. I see him as an adventurous spirit pressing forward, following up the implications of every idea he has realized. His method of evolution indeed has unity, but not, surely, the work. What could be more different than *The Wave* or *Chiswick Reach*, suffused with a delicate romantic radiance, and the massive concrete pavilion at Peterlee?

MICHAEL ROTHENSTEIN
born 1908

Painter in acrylic and watercolour, maker of reliefs and collages – but over the last decade increasingly dedicated to the making of prints of a wide technical variety – William Michael Francis Rothenstein was born on 19th March 1908 at 11 Oakhill Park, Hampstead, the younger son of William Rothenstein and Alice Mary, eldest child of the minor Pre-Raphaelite, Walter John Knewstub.

In the introduction to the catalogue of a recent exhibition of his work, he wrote that:

> I do remember as a child looking at things like cockerels rushing about the farmyard. I started drawing when I was very young – about four I should think . . . But what I do remember is that if I drew something like a lion I used to jump down on the floor and growl and bounce about – I would act a lion. I had a rich uncle who gave me some of those really marvellous cast lead soldiers from Germany, with plumed helmets riding on wonderful horses! I used to draw these knights fighting each other and I would draw one of these chaps falling off his horse, being sliced right through with an axe, with all this blood! You know, I loved red; I loved mixing up all this red and I would groan and roar as this pathetic chap was slashed in half.

Michael early decided to become an artist. In 1923 he attended evening classes at the Chelsea School of Art, where he formed a warm though brief friendship with Edward Burra, a fellow student. They would meet from time to time and paint watercolours together. In 1924 he went on to the Central School of Art for two to three days a week, attending life-classes conducted by Bernard Meninsky, whom he remembers as an able teacher but a melancholy man who used to spend his spare time in a brokendown easy chair with half its stuffing on the floor, reading Dostoyevsky and other Russian classics.

At the Central, Michael received encouragement from A. S. Hartrick, another teacher there, who used to talk to him about Van Gogh. One summer, he told Michael, he lent a studio he rented in Paris to Van Gogh – a room with whitewashed walls and a window overlooking a busy street. When Hartrick returned he found the walls covered with an extraordinary mural consisting of red and blue pictures of everything that Van Gogh had seen in the street. He had begun by

drawing on both sides of the window, then above and below it.
Before he left, Van Gogh put all the paintings he had made that
summer along a wall and asked Hartrick to accept one in lieu of rent,
among them a version of *The Sunflowers*. Hartrick declined the offer,
admitting that at the time he did not admire the artist's work. Van
Gogh, he said, was an impulsive recorder of anything that triggered
his excitement – and almost everything did – drawing on table tops,
newspapers, indeed anything to hand, and using bits of red and blue
crayons which he made himself and always carried in his pockets.

Michael's earliest commission came from Harold Munro, who ran
The Poetry Bookshop, a place of substantial repute in the 1920s. Our
father showed several of his drawings to Munro, who commissioned
him to make an alphabet for Eleanor Farjeon's *Country Child's Alphabet*
(1924) (for her *Town Child's Alphabet* he commissioned David Jones).

Michael became friendly with several students, all his seniors, who
were at the Royal College of Art, among them Houthuesen, Horton,
Mahoney and Freedman, whom he used to visit at his studio in
Howland Street. ('Friends like coming here;' Freedman said, 'they
know they can spit on the floor'.) The central figure among their
heroes was Cézanne, and Zwemmer's publication of the first little
paperbacks on Picasso, Rousseau, Gauguin and others aroused
intense excitement in a generation too young to have seen Roger
Fry's Post-Impressionist exhibitions.

As Michael's elder brother and preoccupied as I was with the visual
arts, I might accordingly be assumed to have had exceptional
opportunities of becoming familiar with his work. (I remember being
attracted briefly by the idea of becoming an artist myself and I
mentioned it to our father, who responded in an amiable fashion but
concluded 'but remember, John, that Billy', as Michael was called in
his early years, 'has far more talent than you'.) The circumstances of
both our lives, however, have long made this difficult. When we lived
nominally under the same roof at our parent's house in Kensington,
my time was mostly spent at school, university and in the United
States, while Michael remained at home. He was often in what
seemed a melancholy state of mind. I recall passing his room on the
staircase and seeing him through the open door sitting motionless on
a sofa, his expression sometimes tragic. The cause of these periods of
melancholy nobody knew. They did not prevent him from working,
except at intervals, and his talent early revealed itself. Work done at
this time reflects an intense and introspective state of mind. The most
striking is a pencil and wash drawing, done in great detail, of figures
swimming and scrambling through a surreal and tortured landscape.

The cause of Michael's long and frequent spells of acute melancholy
– which he suffered from the age of eighteen until his early thirties

– was mixadema, a malfunction of the thyroid gland. None of the family realized that he was ill for he showed no physical symptoms to suggest it. 'These early years', he wrote in a letter to me, 'were a living hell of anxiety and nervous exhaustion. I haven't got binocular vision and one of the effects of my trouble has been left-eye vision. Very uncomfortable when one is drawing!!' By 1930, however, recovery was in sight, although this was not complete until the mid-1940s.

Michael's first exhibition – a show of romantic watercolours largely based on themes drawn from folklore and poetry – was held at the Warren Gallery in 1930. It met with success and most of the works were sold. Over the next few years he made a number of drawings, with which, however, he became increasingly dissatisfied, and once, in a fury, burnt several hundred. Of the events of those unhappy years he remembers little, but by 1938 he was well on his way to recovery and began to draw with conviction, producing work which evoked admiration. The following year Michael began drawing landscapes. Having met Stanley Spencer at our parents' house, the two stayed at a Cotswold inn at Leonards Stanley (Spencer arrived carrying a paper shopping bag containing only pyjamas and a palette), he drawing and Spencer painting landscapes.

In 1940 he worked mainly making drawings and watercolours for the Pilgrim Trust, in Northamptonshire, Gloucestershire and Yorkshire – 'quite a life-raft for me, not being fully recovered', he said. He also made a few drawings for the War Artists Committee. In that year he settled in Essex – which, although he travels widely, has remained his home ever since – first in Great Bardfield and later in Stisted, where he built a house and a studio in 1970. Also in 1940, an exhibition of his work, mainly watercolours, was held at the Redfern Gallery. These again were romantic, and bear some relation to the English romantic movement of the 1840s. It is in these works that the cockerel motive first appeared; although most of the images were of farmyards. Michael's treatment of the black and white geometry of the tarred and plastered farm buildings were the first indications of a move towards abstraction.

About Michael's early works I have said nothing, having seen very few, and he is apt to treat them with reserve. Among these, however, are several which evoke my admiration: *Crucifixion* (1934); *Reposing Figure Beneath a Tree* (1934); *Farm House* (1939); *Sawn Log* (1942); and *Stoke-on-Trent Coaling Plant* (1943); the last four all being watercolours. To someone unaware of the various directions in which his work was shortly to develop, the difference between the first three and the last of these watercolours would appear far from radical, yet it does afford a gentle intimation of radical change from the static to the animated,

from the relatively simple to the complex. Nothing in the three earlier works affords any intimation of the lively complexity of the fourth.

In the course of our correspondence about these and other changes in his impending work, he wrote:

> With the opening up of one's spirit resulting from recovery from prolonged illness I began to look outwards, to be aware of what was happening . . . It was largely the climate of the New Romanticism that gave one some life-holds on the use of more cogent figuration as far as the English scene was concerned. The 'Stoke-on-Trent Coaling Plant' referred to is an instance of this. A driving interest in Picasso, Braque, and Cubist radicalism, was, of course, the larger backdrop to the little English scene.

It was not, however, until the late 1950s that he underwent an experience which radically affected his outlook. He found life in Essex satisfying and accordingly his handling of watercolours became bolder and more varied. A large watercolour depicting the rooftops of an Essex village is one example. It was in the course of those few years, however, that he worked with William Hayter at his studio, Atelier 17, in Paris. In a recent letter to me he described the effects of this experience:

> This was something entirely to my taste: he opened a doorway to a large and wide-horizoned place of glittering vitality. For me it came at exactly the right moment and enabled me to turn my back, to turn fully around, away from the constraints of in-turned provincial life and gave me the energy to make a belated farewell to the horrors of earlier years. I do not know if Hayter realized that a few brief visits to Atelier 17 offered a dramatic rebirth. I was a man reborn and immediately set about building the studio-workshop at the Bardfield House.

Through Hayter, Michael made a revelatory discovery of the world of printmaking which propelled him into protracted research into its techniques. Finding it difficult to get his work printed in England and expensive to go to Paris, he set up a studio at home, buying a relief printing press at an auction, for which he paid £5, and an etching press which had once belonged to Mark Tobey, and made wood- and lino-cuts, although he soon abandoned etching. One of his first lino-engravings, *Turkey on Farm Machine* (1954) won the Giles Prize, the first of several awards he received for printmaking.

Michael evolved new techniques adapted to his ever-increasing visual vocabulary – by the 1960s so varied that he ceased to use such terms as 'lithographer' or 'etcher', but called himself simply a 'printmaker'. To quote from Silvie Turner's excellent introduction to the catalogue of his exhibition, 'Works on Paper':

> He printed from every form of found material, no matter what shape or size; from naturally weathered elements to those physically changed by

man, each selected piece having a particular identity and individual history. He utilized the character of the material as directly as possible, combining separated and isolated elements together in single work, contrasting the found elements with his own sculptural gougings into wood and gestural brushmarks onto etched lino.

Such images as *Black Bar* (1963), among several, is an example. 'Up to that time', to quote from another letter to me, 'I had used only smooth, faceless surfaces; I wanted to uncover the skin on organic surfaces. A rough plank of elm wood, a rusted metal fragment, a gear wheel picked up on the roadside'. Thus, through the excitement of finding out on *what* he could print, he became closely involved with the 'found' object – involving himself directly with shapes and artifacts drawn from nature, from the 'outside world'. This led to the use of nonreferential forms and brought him eventually to his very personal style of quasi-abstraction. It offered a way of using organic shapes – such as the crosscut of a tree – without involving the act of drawing, and at this period work, apart from prints, meant either collage or the very free use of more or less nonrepresentational marks. It was collages on paper of this character that were shown in his exhibition at the Hamilton Galleries, held in October 1962.

At this time Michael had several opportunities of exhibiting abroad. A show that gave particular satisfaction was 'Hommage à Josef Albers et Michael Rothenstein' organized by Xylon in the Kongresshalle, Berlin in 1969. Others were held in the United States, Canada and Scandinavia. It was through his friendship with Waldemar Stabbell that Michael's work was first introduced to Norway where three major exhibitions have been held, one listing over two hundred watercolours, drawings and prints.

Another circumstance that impelled him towards abstraction was the growing awareness of the ever-increasing influence of the camera:

> As a child I saw the world through my own pair of eyes . . . As I grew up that intimate feel of the objects one saw – the flowers, the butterfly, the tree – was slowly changed. That private world was gradually invaded by other, more public images: films, magazines, newspapers, better illustrated books, posters along the street. And later, television, and now video with its power of image-recall, fixed-frame, slow motion and the rest. From possessing one pair of eyes I felt – and feel – I have grown thousands upon thousands; eyes that are lent me through the other man's camera!

As Michael's work became ever more hieratic and wide-ranging in scale and subject, so did his techniques. For instance he designed and printed on the walls at Eltham Park School in South London work which extended for some eighty feet (twenty-four metres). Besides traditional tools he came to use drills with brush attachments,

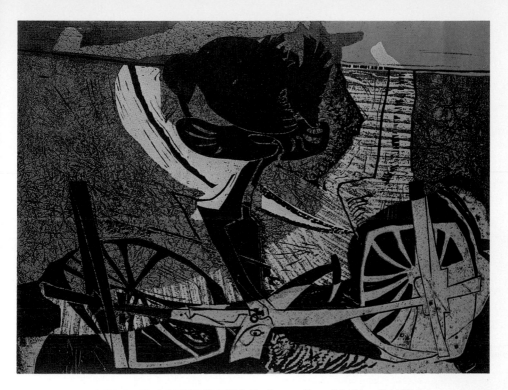

9. MICHAEL ROTHENSTEIN: *Turkey on Farm Machine II* (1954).
Colour linocut, 15¾ × 21 in (40 × 53·3 cm).
The Victoria and Albert Museum, London.

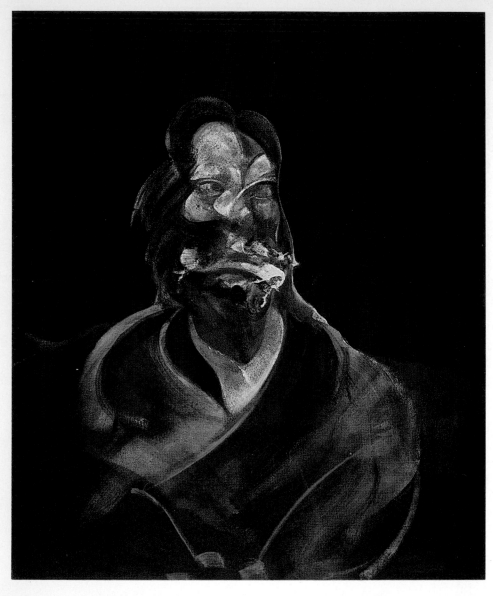

10. FRANCIS BACON: *Portrait of Isabel Rawsthorne* (1966).
Oil, 32 × 27 in (80 × 67·5 cm). The Tate Gallery, London.

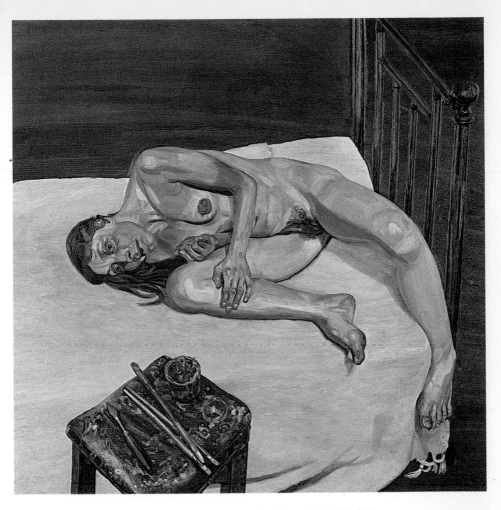

11. LUCIAN FREUD: *Naked Portrait* (1972–73).
Oil, 24 × 24 in (61 × 61 cm). The Tate Gallery, London.

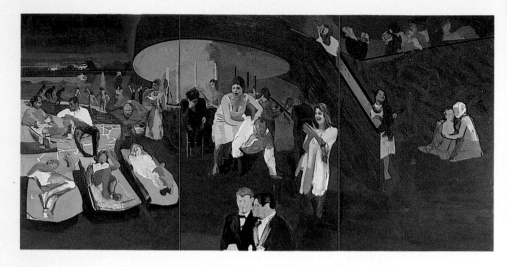

12. MICHAEL ANDREWS: *All Night Long* (1963–64).
Oil on board, 3 panels, each 72 × 48⅛ in (182·8 × 121·9 cm).
Reproduced by permission of The National Gallery of Victoria, Melbourne.

electric jigsaws, tinman's snips and flexible driving shafts with cutting heads. His images, as he expressed it, 'liberated from the tyranny of the rectangle', were worked on a wide variety of shapes as well as surfaces. In the March 1967 issue of *Art and Artists* appeared an article entitled 'Look No Hands', in which Michael describes with insight the nature of the ideas which motivated what he terms 'the current print explosion'. There follow some informative extracts:

> There is an awareness of a new kind of print – the photo-aided print, where photographic, or partly photographic, means have been used in producing the image. The use of more or less mechanical aids may be said to have brought on a 'crisis' in evaluating the future role of hand gesture in printmaking – and has thus called into question traditional attitudes to originality.
>
> Unquestioningly we have accepted that artists' prints were made from hand-worked blocks or plates, and now, quite suddenly, the printmaker is using ways of work which partly, or wholly avoid the direct intervention of the human hand. Rauschenberg, Dine and Paolozzi, to name only three, take images from industrial catalogues, seaside postcards, glossy weeklies or daily newspapers, and have them reproduced photographically. They are then enlarged or reduced and thus fitted, in scale, to the scheme of their design. The artist's final image may also be editioned with photographic aids, quite often by silkscreen, sometimes by photolithography, apart from the presence of these received materials.
>
> Are such images original? And if we so consider them, how are their qualities of originality to be measured against images taken from manually executed blocks or plates? To a marked extent the conflict between a manual and photo-aided statement is a conflict between the old and the new, between past and present, between the agrarian culture that produced the woodcut and the world of technology that produced sophisticated photo-aids. A Matisse linocut, a Gauguin woodcut, relates to a very ancient line of human activity. Hand-engraved prints have been honoured and valued uniquely, until the advent of photo-processes, as the only known form of repeatable image . . . The tool is the extension of the hand: the machine in its turn is the extension of the tool. Today the printmaker's plate is seen as taking shape at the far end of a camera lens as well as beneath the hand of the artist. Indeed the love of hand gesture in art for its own sake may show an unattractive attachment to the past; to a half-acknowledged image of a bearded craftsman, back bent over a block of wood or metal plate, the well-worn graver lovingly held in work-worn hands.

When the retrospective exhibition of Michael's work was held in Norway in 1975, an eminent Norwegian critic wrote a very appreciative review, but in the piece pointed out the unusual divergences of style between Michael's middle abstract period and the earlier and later work. This comment evoked Michael's conviction that:

> . . . one should always 'roll with the punch'. That one must go along

with experience, take it the whole way, unqualified by the concept of a consistent personal style – drive out into the storm however tattered the sails . . . the artist doesn't live by establishing a style, and by practising that style all his life . . . The earlier work and the mature work I see as intersecting arches each springing from a different area of possibility . . . When you see the work together you can see it is all done by the same chap . . .

Before long he had resumed a relatively objective imagery; much of his recent work accordingly expresses increasing concern with subject. A strong preoccupation with male/female relationships, such as the 1982 'Paris Pullman' series, both watercolours and woodcuts, where a clothed male stands beside a nude woman with lights from the cinema entrance behind. In other images metaphors for sexuality are used: the cock, the cat, the clown, an upturned umbrella; but a substructure of quasi-abstract geometry is present, an inheritance from the period of abstraction. This change was accelerated by an increasing doubt as to the existence of an avant-garde relevant to the present time. He did not for a moment doubt its power of evoking decisive creativity at particular times; but not the present. He shared the feelings expressed by Philip Guston before he died: 'How glorious to be free of the avant-gardes.'

Michael's visits to the United States had a highly stimulating effect. About them he wrote me a letter which reads, in part:

> There was a marvellous feeling of cultural cleanness. Deep down I felt able to straighten my back and to feel the overload of old admiration slip away. It gave me a freedom I had never known – something you must have experienced on your early visits.

> It was an exciting time; through friends – fine American artists, such as Breverman, Cassill, and Broner, I found the universities were open and generous in their support. Then again with the new focus on the New York School there was the driving thrust of challenge. Rauschenberg, Oldenburg and Jasper Johns in particular were a source of intense interest. I loved the wonderful directness of statement, the courage in the clean confrontation in regard to their ideas and feelings – something uncluttered; free of the aesthetic historicism of so much of Europe . . .

> That chord goes on vibrating: the work I'm doing now, the drawings, watercolours and prints, all very much about *immediate* experience – an attitude one's travelled a long way to attain. Such as the image of a man and woman sitting on a London Underground station with the powerful glare of travel and cinema posters behind. In one a Samson-figure confronts a leaping lion drawn from the posters advertising the film 'The Beastmaker'. But childhood influences cannot be discounted.

In a recent taped conversation Michael said:

> I find many connections with childhood. One is a Christmas tree. When we were kids we would be brought in on Christmas Eve and there was this Christmas tree. It was trancendentally wonderful: the coloured

lights and the coloured presents against the black boughs of the pine tree. It was a kind of magic thing that seemed to be quite detached from the brown-bread-and-butter of practical life. The other thing was my father had a very marvellous collection of Rajput miniatures; these are the most brilliant images with a Chinese vermillion background, blue figures, black trees, wonderful orange and purple ornaments . . . Images return in different works and may have some sort of obsessional character. But they aren't always what they seem. This isn't a rainbow, for example, it is an arch of colour – it is half a circle of colour, not a rainbow and well the cockerel we've talked about. Shall we say I am playing a very solemn game with factors that have haunted me and interested me over a period of many, many years.

Even when deeply involved with the abstract and quasi-abstract, Michael remained absorbed by photographs. This began almost by accident: one day he was with his wife at a local butcher's where she was buying a joint. To wrap it the butcher pulled down a sheet of newspaper from a hook on the ceiling. As he did so Michael caught sight of a photograph of an eye with a camera reflected in it. He was so excited that he shouted 'I want that newspaper!' The butcher looked at him in surprise and handed him the page. This evoked a fascination with news photographs; his abstract work, with its use of found materials, had a parallel expression with that of his fascination with them.

He had collected photographs for many years, both prints and reproductions, with no particular purpose in mind – simply because he liked them. Both his abstract work and the photographs were 'found' imagery, and both were disconnected from the practice of drawing, which he for a time abandoned. With this development he had to start again from the beginning because the use of photographs involved methods which he had never previously used. It was several years before he was able to make an effective image, such as *The Running Dog* (1975), one of his best screen prints. After a year or two he resumed drawing, although only occasionally, his prints being based on photographed drawings. Later, however, he resumed drawing regularly, and also painting, always in watercolour. He now paints more than he has for twenty years. He also draws directly on the wood blocks on which he carves his lines.

Like a number of others of his generation in Britain, the United States and elsewhere, Michael began as a realist. This was followed by the difficult acquisition of more or less abstract forms of expression, and then the eventful return to plausible, nature-based imagery. As he and others who have experienced it will know, such complex evolution imposes a heavy psychic strain.

Michael's output has been very extensive. This has been largely due to this extraordinarily wide variety of his work. To distinguish

clearly between an artist's vision of his subjects and the techniques by which he gives it expression is rarely simple: in Michael's case it is particularly difficult. Serious painters in a single medium find that it is difficult to master; even one of Monet's stature frequently expressed distress at the difficulties and technical problems of using oil paint. But Michael's radical technical evolutions, involving the acquisition, even the discovery, of new procedures imposed, as already noted, a heavy psychic strain. He is exceptionally self-critical, yet his complex evolutions have meant constant trial and error. A contemporary, such as Eric Ravilious, who early in his career evolved his perception and methods of its realization, would destroy works whenever he judged them to have fallen short of either. (This he frequently did and it accounts for a substantial portion of his output). Michael, on the contrary, whose perception underwent several radical changes, and his technical procedures many more, remains frankly evolutionary. He distinguishes clearly between his successes, intermediates and failures, but regards his failures as steps, however halting, towards the realization of his widely differing objectives. A pioneer anticipates falling short; nevertheless, for Michael these works constitute steps towards the realization of his changing aims, and as such call for preservation, sometimes exhibition and reproduction. I have had occasion elsewhere to stress the crucial fact that artists should be judged only by their best work.

Recognition of his highly varied achievements have been far more marked abroad than at home. Until I began to assemble material for this brief chapter I had little idea of the extent of the recognition abroad of his versatile creativity. The many awards Michael has won include the Gold Medal at the 1970 Buenos Aires Print Bienniale and the Grand Prix at the Norwegian International Print Bienniale, 1976.

FRANCIS BACON
born 1909

In 1962 the Tate Gallery brought together the first officially sponsored
retrospective exhibition of the paintings of Francis Bacon, containing
ninety-one examples – nearly half of those that had survived his own
self-critical iconoclasm.

It fell to me as Director to write the introduction to the catalogue of
the work of a painter which I had immensely admired since it was
first shown seventeen years before: 'at times it seems to me that I
have it all in focus; then suddenly the collective image fades and I
have to begin again, and by looking at the paintings, at photographs
of them, to recapture what has been lost.'

Many years have passed and I have, of course, seen much more of
Bacon's work and read much of what has been written about it, yet
its elusiveness has scarcely diminished. This is curious, for the highly
informed intelligence of the painter, manifest in all his work, has
evoked an extremely perceptive body of criticism. None of his
contemporaries, in fact, has been the subject of criticism of so
consistently high an order. Writings on Henry Moore, for instance,
have often been sheer adulation, while many other artists' outstand-
ing merits have often been ignored or dismissed, at least until late in
their working lives. Thérèse Lessore, Robert Melville, John Russell,
Lawrence Gowing and David Sylvester (and others, both in Britain
and abroad) have contributed substantially to our understanding of
Bacon. David Sylvester, moreover, persuaded him to give a highly
illuminating interview in which he talked at length about his complex
art with the candour and sophisticated intelligence expected of him.
And yet, even with access to so much fact and perceptive interpreta-
tion, as well as Bacon's own answers to adroitly devised questions,
and my own talks with him, much remains, for me, deeply enigmatic
about his art. There is, too, something enigmatic about Bacon himself.
He moves freely in several societies, exchanges ideas lucidly and
without reserve, yet he is less well known than Picasso, whose
privacy was strictly guarded, who rarely left the house to which few
were admitted (and some of these far less frequently than they would
have wished) and who expressed himself with circumspection to all
but his few intimates.

In earlier centuries artists were often nurtured, for instance, by the practice or patronage of the arts by members of their family. Today this is rarely the case. Of the subjects treated in this series only one, S. W. Hayter, was an artist's son. In fact, many, if not the majority, of the most serious artists of modern times emerge from environments such that it is surprising that they ever became aware of their vocation. One such was Bacon. The only discernible favourable characteristic of his early life was a high degree of mobility that left all options open.

Francis Bacon was born in 28 October 1909, in Dublin at 63 Lower Baggot Street, one of the five children of Edward Anthony Mortimer Bacon, and his wife Christine Winifred, born Firth. His father was a collateral descendant of Francis's illustrious Elizabethan namesake. (Queen Victoria had urged his grandfather to assume the lapsed title of Lord Oxford, which he refused to do on the grounds that he lacked the means to 'live up to it'.) Edward Bacon also suffered from a lack of means and often gambled, and Francis remembers being sent to the post office to place bets by telegram. After serving in the army he lived by training and breeding race-horses. Bacon's mother, almost twenty years his father's junior, was as lively and sociable as he was censorious and moralistic.

During the First World War, Edward Bacon worked in the War Office and the family moved to London, but travelled often between England and Ireland, never establishing a permanent home. For a short time Francis attended Dean Close School, Cheltenham, from which he ran away. Long-standing tension between his father and himself culminated in an incident, in itself trivial, which entirely transformed his way of living. In his book on the artist, John Russell writes that Bacon told him how he had tried on his mother's underwear which seemed to his father a grave breach of the rather puritanical tone which he set in the house. The result was that in 1926 Francis was sent away from home. With his mother and her family his relations were happier. Among them the habit prevailed of frequent and lavish entertainment. 'I read almost nothing as a child,' he told me; 'as for pictures I was hardly aware that they existed.' The first he saw in a domestic context were paintings by the Pre-Raphaelites and some of their followers at Jesmond Towers, the Northumberland mansion of one of his mother's relatives. Apart from his uncompleted term at Dean Close and some tutoring by the local parson, he received no education at all.

When he left home he was without ambition or objectives of any kind; he wished simply to do nothing, but worked in an office in London, then spent some time in Berlin and rather longer in Paris.

He responded wholeheartedly to both the erotic, anarchic society of the one and the perceptive passion for the arts of the other. In Paris he carried out some commissions for interior decoration and made a number of drawings and watercolours.

The circumstances of Bacon's early life have been briefly recalled because they contributed more to the formation of his outlook and to his way of life than is sometimes supposed; for he is apt to be thought of as a phenomenon quite unrelated to his background. Certainly this extraordinary painter and man seems to owe little to his father, except, perhaps, the vein of austerity which enables him, when working at full stretch, to dispense with the society of his friends and the other pleasures that he so zestfully enjoys; to sleep and eat little, foregoing alcoholic drink and scarcely leaving his studio. But the freedom of all the societies he had known in Ireland, Berlin and Paris, their tolerance of individual idiosyncrasies, and his lack of formal education, of 'formation' of any sort, gave this highly individual boy a prevailing sense of the openness of the choices before him – a sense he has preserved even after making the most crucial choice of all: to become a painter.

The approach to painting of one who was to become so quintessentially a painter was slow, hesitant, and for long periods distracted by other preoccupations – gambling for one. (Most painters – certainly nearly all the others who figure in this volume, showed a consistent determination to adopt their vocation from a very early age. Utrillo, encouraged by his mother to paint as a distraction from heavy drinking, is one of the rare exceptions.) Bacon had, however, been fascinated by reproductions of paintings ever since he left home.

When Bacon settled in London in 1928 in a converted garage at 7 Queensbury Mews he began to paint in a desultory way, trying out various styles, among them one derived from Lurçat and Sourverbie, portraying dead, pale trees in landscape. But he was chiefly occupied with designing furniture, rugs and interior decoration, and it was with these, which he showed in his studio in 1929, that he began to make a modest reputation. There appeared in the August 1930 issue of *The Studio* an article entitled 'The 1930 Look in British Decoration' with illustrations of the furniture and rugs he designed and the interior of his studio (the first occasion when his work was noticed by the press). The windows were described as 'curtained with white rubber sheeting that hangs in sculptural folds'. The general impression the article conveys is that Bacon's work was of a self-conscious modernity. It is worth noting that the tubular base of one of his glass and metal tables foreshadowed the railings that sometimes enclosed the papal, politician-executive figures and the portraits in his paintings of later decades. The rugs hanging on the facing wall had

abstract designs. Among his occasional commissions was one to design furnishings for the dining-room in the house in Smith Square, Westminster, belonging to R. A. (later Lord) Butler; these, however, were bought by Patrick White, the Australian novelist

Gradually, however, Bacon's concern with decoration – largely sustained as a means of making a living – dwindled to extinction, and he became determined to paint. But how? He had never attended an art class, nor even learnt the most elementary drawing during his single term at school. Help came to him from the far side of the world, from 'down under', to be precise. About the same time as Bacon, Roy de Maistre arrived in London. De Maistre, a man fifteen years his senior, had had a thorough training at two art schools in Sydney, and won a travelling scholarship which had enabled him to study in Paris, where he had exhibited at the Salon. The previous year in Sydney he had held a one-man exhibition, and was shortly to hold another in London. The two met and immediately a close and lasting friendship grew up between them. Bacon confided to him his ambition to paint and his benevolent friend gave him all the help in his power. Years later de Maistre told me that Bacon, despite his perceptive scrutiny of reproductions, knew nothing whatsoever about the technical side of painting and had scarcely drawn at all. De Maistre was amused to hear a man of such rare intelligence, who showed an acute understanding of a 1927 exhibition of paintings by Picasso, ask questions that a schoolchild might have answered.

Although a man of outstanding determination, to whom few say 'no', Bacon's beginnings as a painter were extremely tentative. The Picasso exhibition evidently had a crucial effect; Diana Watson, his second cousin and close friend, told me that before seeing it she had never heard him speak of becoming a painter. For a time Bacon painted diluted Picassos, such as that on the left in de Maistre's *Francis Bacon's Studio* (1933). The studio was in 71 Royal Hospital Road, Chelsea, one of several he occupied in his earliest years in London; there were others in the Fulham and Cromwell Roads and at 1 Glebe Place, Chelsea. In the first, in Queensbury Mews, he and de Maistre held a small exhibition together in the winter of 1929–30 in which Bacon showed a few watercolours and pieces of furniture. Derivative and tentative as his early work was by comparison with that of his maturity – to judge by the very few examples to survive his consistent iconoclasm – there were about it faint intimations of the qualities which emerged in the mid-1940s with such explosive force, apparent to a few men of particular sensibility. Sir Michael Sadler – the first purchaser of Bacon's work who was not a member of his family or a friend – after buying *The Crucifixion* (1932) sent him a photograph of his skull with a commission to paint his portrait.

Another *Crucifixion*, in which Bacon incorporated the skull, painted in 1933, was reproduced as *Composition* in Sir Herbert Read's *Art Now*, published the same year, when Bacon also showed single works in two exhibitions at the Mayor Gallery.

After these signs of recognition he suffered a setback. In 1934 he arranged an exhibition of seven of his oils and five or six gouaches in the basement of Sunderland House, Curzon Street, which he called the Transition Gallery. This failed utterly: it was scarcely attended and nothing was sold. Deeply discouraged, he painted little over the next two years, and between 1936 and 1944 scarcely at all. In his despondency he turned to gambling instead. Resumption of painting became more difficult because of the war, during which he served in the Air Raid Precaution Service until discharged on account of the asthma from which he suffers still. However, one painting of these near-barren years, made in 1936 and now destroyed, entitled *Abstraction*, clearly anticipated the central panel of his first major work.

Francis Bacon is surely a phenomenon unique among painters of this century. He had had no instruction at all – apart from some friendly advice from de Maistre; had painted little for two years after a failure; then for eight years had almost ceased to paint at all. And what he had painted, although of sufficient interest to a few perceptive connoisseurs, would have been quickly forgotten.

Bacon himself regards his early work with contempt. But it was not destined to stand by itself; suddenly in 1944 he knew that his time had come and concentrated the whole of his formidable powers on painting. These earlier works were the prelude to a long succession of paintings ever more widely acclaimed as the work of a master.

In early April 1945, in an exhibition at the Lefevre Gallery, which included works by Moore, Matthew Smith and several others of the most admired British artists, was also hung a painting by Bacon that created a sensation: it was the object of ridicule, astonishment or outright horror – and, by a very few, of cautious admiration. The painting was a large triptych, made the previous year and called *Three Figures at the Base of a Crucifixion*. Each panel represents a horrific creature, half human and half animal. That on the left is tensely bowed as though for beheading; that in the centre, a defeathered ostrich, with a mouth in place of a head, emerging from a bandage; and that on the right, a long-necked creature with a huge open mouth, screaming, with ears but faceless, yet voracious, infinitely malignant. Bacon had long been obsessed by the central figure, which closely resembles the destroyed *Abstraction* painted some eight years before. 'I began,' he said to me, 'with the *Three Figures at the Base of a Crucifixion*.' In the same exhibition was another work by Bacon, painted shortly before its opening, entitled *Figure in a Landscape*, and

it differs sharply from the other in both spirit and execution. The *Three Figures* is frankly horrific and is in essence a vividly coloured drawing. The *Figure in a Landscape*, is the first of his pictures to anticipate the sheer mastery of paint, so integral a feature of the work of his maturity. Distinct from the character of its companion, it suggests the impending calamity that was to characterize many of Bacon's paintings during the next decades. It is also the first of his several portrayals of figures beneath umbrellas. The partially delineated figure is vaguely suggestive of a dead man with a machine-gun, but it was painted from a photograph of a friend asleep in a chair in Hyde Park. The friend was Eric Hall, who presented the *Three Figures at the Base of a Crucifixion* to the Tate Gallery in 1953.

Less than a year later, in February 1946, again at the Lefevre Gallery, Bacon showed two paintings which confirmed the belief of the few admirers of the *Three Figures* that it was no accident. These were *Figure Study II* (formerly known as *The Magdalen* but the artist repudiated this title) and *Study for the Human Figure at the Cross II* (also known as *Figure Study I*). Both were completed shortly before the exhibition opened, the latter first. This shows a hat and coat which evoke the presence of a mourning figure. *Figure Study II* shows a similar preoccupation with the expressive possibilities of clothes. This splendid painting – by comparison the *Three Figures* is the work of an amateur of genius – is pervaded by a sinister ambience not less powerful for being, by comparison, suggested rather than proclaimed. It combines grandeur of design with a subdued resonance of colour. Nothing more clearly indicates the long-persisting caution of Bacon's admirers than the fact that this painting, one of his finest, was bought by the enterprising Contemporary Art Society from the Lefevre exhibition, and was available as a gift to almost any public collection; yet six years passed before it found a home in the Bagshawe Art Gallery in Batley, Yorkshire, one of the most obscure in Britain. Instead of denigrating his work, as many unfriendly writers had the *Three Figures*, as a grotesque freak, critics saw that it must be treated a little more seriously, and it was explained accordingly as a revival of late eighteenth-century Gothic 'painting of horror', and Bacon as a latter-day Fuseli. But denigration continued. One critic voiced the opinion of a number of his colleagues when he wrote of Bacon's 'fast-dating Grand Guignol' and his 'creaking melodrama'.

That same year he painted another masterpiece, *Painting 1946*, representing a sinister figure, faintly reminiscent of Mussolini, seated beneath an umbrella with carcases of beef suspended just behind him and enclosed by a fence of metal tubing which, with blinds with swinging cords, were to become recurrent accessories of his back-grounds. In the course of a discussion about it Bacon said, 'I began

that particular figure with the intention of representing a bird of prey alighting on a ploughed field. The carcass? When I was a boy I was fascinated by butchers' shops.' The painting reflects a procedure the exact contrary of that followed in the *Three Figures*. The existence of a photograph of the destroyed *Abstraction 1936*, from which the central figure in the *Three Figures* has clearly derived, shows that this image had been in Bacon's mind for at least eight years. In *Painting 1946* he was clearly working under the effects of chance. It was a procedure that was to dominate his future course. There was an indication of it in *Figure in a Landscape* in which a seated figure is transformed, but there is nevertheless a relation, however remote, between the photograph which provided its point of departure and the completed picture. In *Painting 1946* there was no such relation between completed picture and original image. Two years later, Alfred Barr bought *Painting 1946* for the Museum of Modern Art, New York – the first purchase of one of Bacon's works by a museum. It was shortly followed by another painting of somewhat similar character, *Study of a Man with Microphones* (also representing a figure beneath an umbrella), which the artist destroyed.

Because of the horrific and on occasion sensationally horrific nature of Bacon's themes; his reliance on what he calls 'accident'; his startling originality; the derivation of much of his work from photographs and film stills, it was not understood that Bacon's painting is an integral development of the European tradition. Many artists disguise their indebtedness to the example of others; Bacon is candid about his own, whether to Velazquez or Rembrandt or anyone else. Of one of his *Crucifixions* he said to David Sylvester, 'Without all the paintings that have been done in the past of the Crucifixion, I would not have been able to do it.' He studies the old masters not panoramically but intensively, in terms of the works that he admires most deeply. Besides those already mentioned are Cimabue, Grüne-wald, Poussin, Constable (especially his *Leaping Horse* at the Victoria and Albert Museum, conveniently near to where he lives), Degas (especially *Après le bain, femme s'essuyant* at the National Gallery), Van Gogh, and among contemporaries Matthew Smith, Duchamp and Giacometti. I well remember his visits to the Tate when I was Director: he would arrive, usually, in midmorning, and, after a glance round each room, would quickly decide on what he wished to see, then scrutinize a few pictures intently and at length, ignoring the rest. Occasionally he looked at almost everything – for example, the Daumier exhibition.

Bacon's relation to traditional painting has been succinctly and precisely summarized by John Russell: his 'ambition is to take "shocking" or "unheard-of" material and deliver it in the European

grand manner. People often imagine that any recrudescence of that manner must be accompanied by a certain rigidity, a defensive keeping out of subject matter that is too much of our own time. Bacon's view is the opposite of this. "If only people were free enough to let *everything* in, something extraordinary might come of it . . . The difficult thing is to keep open the line to ancestral European painting while producing something that comes across as entirely new." '

There is another sense in which Bacon it traditional. Today many painters are experimenting with or adopting new media and often regard oil paint as an anachronism, the possibilities of which have long since been exhausted. 'The empty canvas,' announced a prominent constructivist, 'symbolized the fact that this medium can have no more to offer in our times.' Bacon remains, steadfastly, an oilpainter; in fact much of his power of taking advantage of what he calls 'accident' derives from his understanding of the unique potentialities of oil paint.

Although he belongs integrally to the European tradition, he believes that traditional forms, for the moment, are entirely played out. 'What modern man wants,' he said to me, quoting Valéry, 'is the grin without the cat; that is, the sensation without the boredom of its conveyance.' By this he means the traditional all-over elaboration, especially of subjects better represented by the camera. This is apparent, for instance, in the way in which, after completing a head which seems to him to be 'illustration', he will sweep away a part of it with a bold, deft stroke of the brush, or even sweater or sock. The likeness remains, but conveyed in terms entirely different from that of a photograph.

At the same time, Bacon is fascinated by photographs, in particular by the work of one of the most masterly of all photographers, Edward James Muybridge. The principal aim of Muybridge was to show 'actions incidental to everyday life'; human and animal movement as they are in reality and not as derived from tradition and as taught in art schools. Before Muybridge, the precise nature of movement was not known. In order to establish it he took sequential photographs by setting up twenty-four cameras facing a horse's course – the horse was his first subject – and as it passed the cameras it broke a series of threads which set them in action. Each exposure was two-thousandth of a second. Before he could afford to buy Muybridge's two classic volumes *The Human Figure in Motion* and *Animals in Motion*, Bacon used to study them in the Victoria and Albert Museum's library. These two remarkable books show nude men, women and animals in every conceivable movement; Bacon is able, in an instant, to find any one of the thousands of reproductions of photographs they contain. Fascinated as he is by Muybridge, Bacon was far from being the first

painter to learn from his work. Thomas Eakins both learnt from and sponsored him; he also collaborated with him in the invention of a camera – and was photographed running naked. Artists as remote from one another as Meissonier and Seurat benefited from Muybridge's discoveries. Bacon also studies photographs clipped from popular magazines, of which he has a very large collection, most of them showing figures in motion. The effect upon him of 'Nurse screaming', the celebrated still from the film *Battleship Potemkin*, has long been known. He has never, he told me, taken a photograph himself.

Just as works by the old masters suggest certain of his themes, although they are usually radically, more often wholly, transformed in the process of his own painting, so do photographs. They are not, however, always transformed beyond recognition: Valazquez's *Innocent X* is the recognizable point of departure for a number of Bacon's popes, as are the features of the nurse for the 1957 *Study for the Nurse in the Film 'Battleship Potemkin'*.

The photograph has had another effect on Bacon's art besides providing points of departure for his imagery. In the traditional portrait there is a direct relation between the painter and his subject: sometimes they look at each other; sometimes the subject looks elsewhere, but he or she is aware of the presence of the painter and, however informally, is posing for him. The modern photographer – the earlier worked under the influence of painting – catches people when they are unaware of his presence; off balance, when they are not in the poses which they think most dignified and attractive, nor wearing their 'Sunday best'. Photography of this order has done much to foster in Bacon his predilection for portraying people as though they were alone, unaware of any other presence. To take an extreme example, in *Three Figures in a Room* (1964) the figure on the left sits naked on a lavatory.

In Bacon's portraits and figure paintings his subjects are in fact not even in his presence; he does not have them in his studio when he paints them. Naturally he is aware of the frequent ferocity of his distortions. 'But who can I tear to pieces,' he asks, 'if not my friends?' 'If I like them I don't want to practise the injury that I do them in my work before them,' he said to David Sylvester. 'I would rather practise the injury in private by which I think I can record the facts of them more clearly.' Accordingly he works mainly from memory but sometimes with the aid of photographs. I asked him why, if he believed he was practising an injury on his friends, he took his friends almost exclusively for his subjects. 'The answer is simple,' he replied. 'It is because I *know* my friends, and I need that knowledge in order to paint them. You see I know them by heart.' Yet although

he is a constant and generous friend, in his portraits of them there are no signs of benevolence.

It is not surprising that Bacon should paint his friends *in absentia*, for no painter of the natural world active today observes it, directly, so little. He prefers to study it in photographs. As it did Blake, nature 'puts him out' and when in earlier days he had to accept an occasional commission for a portrait, he painted laboriously. On one of the rare occasions when he has painted an uncommissioned subject from life, that of David Sylvester, entitled *Man Drinking* (c.1954), the sitter told me that Bacon scarcely looked at him as he sat at a table with a mug before him, which he was not invited to raise to his lips. On another occasion when he sat for him, the portrait became that of a pope and Bacon ignored his model in favour of a big-game photograph because, he said, the animal's texture engaged his interest. Bacon often carries his preference for indirect vision so far as to prefer, even in cases of the old masters, a reproduction to the original. He has bought many books on Velazquez from which he cuts out and preserves his *Innocent X*, the painting that he perhaps admires the most, yet he told me that when in Rome he has never been to see it.

Bacon's attitude to life has not changed, but in two important respects his art has. The undisguised horrific subjects of many of his earlier paintings, most conspicuous of all in the *Three Figures*, have on the whole been replaced by subjects not intrinsically horrific but imbued with his obsession with human cruelty, vulnerability, lone-liness and the pitiful indignity of men, and occasionally women, in solitude, unobserved. There are, however, a number of exceptions: *Lying Figure with a Hypodermic Syringe* (1963), *Three Studies for a Crucifixion* (1962), *After Muybridge: Woman Emptying a Bowl of Water and Paralytic Child on All Fours:* (1965), and *Triptych: Inspired by T. S. Eliot's 'Sweeney Agonistes'* (1967). But far more radical than the modifications of Bacon's subjects has been the evolution of his attitude towards his medium, oil paint, and its potentialities.

The *Three Figures*, however sensational its subject and the treatment of it, from a purely technical point of view is not a revolutionary work. It had been long pondered, as we know from the preliminary study for the central panel made eight years earlier. It is, in fact, a triptych of drawings whose outlines are filled in with more or less uniform areas of colour. In an interview with David Sylvester in *The Sunday Times*, 14 July 1963, Bacon said:

> You know in my case all painting – and the older I get the more it becomes so – is an accident. I foresee it, yet I hardly ever carry it out as I foresee it. It transforms itself by the actual paint. I don't in fact know very often what the paint will do, and it does many things which are very much better than I could make it do. Perhaps one could say it's not

an accident, because it becomes a selective process what part of the accident one chooses to preserve . . . Can you analyse the difference, in fact, between paint which conveys directly, and paint which conveys through illustration? It's a very close and difficult thing to know why some paint comes across directly on to the nervous system and other paint tells you the story in a long diatribe through the brain.

The interview in which these sentences occur is long and informative, but they seem to me to be crucial, for they illuminate a basic dichotomy in Bacon, but one which does not weaken his art but instead creates a continual and exhilarating tension.

Bacon is a man with intense, wide-ranging interests. The reading and rereading of classics of many kinds extends the reach and strengthens the grasp of his formidable intelligence. I remember seeing piled high on his bedside table volumes of Aeschylus, Pascal, Montaigne, Baudelaire, Nietzsche, and Shakespeare, as well as critical works on several of them. He is fascinated by his fellow humans and in particular by his friends. 'I have always been more interested in what is called "behaviour" and "life" than in art,' he says – and this, from a man with his knowledge of art and reverence for certain works by many old masters, is a significant confession. In particular he is obsessed by human cruelty, behaviour to fellow men, to animals. He has studied photographs of animals who know they are about to be slaughtered. His Crucifixions are representations not of an historic event – for he is a nonbeliever – but 'of an act of man's behaviour to another'. Here, then, is a man profoundly and consistently obsessed by great art, great literature and many aspects of human behaviour. How far are these obsessions related to his painting? In an age less complex than our own, with an authoritative, widely accepted tradition of painting, in an age when the camera had not been invented, many of Bacon's obsessions could have found direct, unequivocal expression in his painting. But this is a highly complex age, with a tradition of painting, like many others, that has withered and in which the camera plays a part which no figurative painter of sensibility can ignore.

Bacon is not a revolutionary, and his belief that traditional forms are for the time being entirely played out does not in the least impair his strong sense of belonging to the tradition of European painting, and he is well aware that the work of those who have done most to revitalize it, such as that of Van Gogh, invariably appeared to their contemporaries as destructive of tradition, especially to the self-appointed academic 'guardians' of it. What such men never see is that these 'madmen' rediscover forgotten elements in tradition's infinitely rich and complex legacy. 'I could never disassociate myself,' he says, 'from the great European images of the past.' But just as

tradition could not afford to reject the discoveries of the past –
perspective, for example, or Turner's or the Impressionists' ways of
achieving an enhanced brilliance of light – so Bacon is convinced that
the eroded tradition of today cannot afford to neglect the most
influential discovery of our age: the camera. Its effects upon Bacon
are threefold: first he sees, as have many other artists, that the camera
has superseded the paintbrush as a medium for recording facts. At
the very beginning of the interview with David Sylvester Bacon says:

> One thing that has never been really worked out is how photography
> has completely altered figurative painting. I think Velazquez believed
> he was *recording* the court at that time and certain people at that
> time . . . But a really good artist today . . . knows that that particular
> thing could be recorded on film; so this side of his activity has been
> taken over by something else.

Second, as already mentioned, he knows that the camera has revealed
the realities of human and animal movement unknown to, undreamed
of even, by painters prior to its invention. Third, he finds in photo-
graphs – as in certain paintings by old masters – images 'that breed
other images for me'. The threefold effect is that Bacon rigorously
avoids recording what he calls a 'story', which the camera could record
better. He takes advantage of the photographs of Muybridge and
others with the vastly extended repertory they afford of humans and
animals in motion or unobserved repose; likewise of 'unheard of'
material drawn from contemporary life, often suggested by photo-
graphs from popular magazines and stills, which he presents in his
original projection of the European grand manner. But in one import-
ant respect his painting differs from that of any of his predecessors.
 Before the invention of the camera, painters portrayed definite
subjects, the meaning of which could be scrutinized, analyzed and
enjoyed in detail. Their subjects were integral to their work. But the
existence of a machine that can represent subjects more accurately,
which has caused innumerable artists to turn to abstraction – which
Bacon dismisses as 'decoration' – has affected him in an entirely
different way. He is determined to subordinate the subject to the
paint, 'to make the paint,' I heard him say, 'speak louder than the
story'. It is ironical that this should be the situation of an artist who
first made his reputation by the horrific character of his subjects.
There has been an inclination among a few recent writers to discount
Bacon's preoccupation with the horrific, but his visits to medical
bookshops – he was at one time interested in the diseases of the
mouth – to butchers' shops and to Scotland Yard's Black Museum
surely confirms it; as he says, 'When I was younger, I needed extreme
subject matter. Now I don't.' This is not invariably the case, but
'extreme subjects' are far rarer than they were.

The element of violence – 'violence' does not convey my meaning precisely but I can think of no better word – manifests itself in two other ways. One of them, already referred to, 'the tearing of his friends to pieces', is the less important. The other is the element of violence – again not the precise description – so often manifest in his treatment of the paint itself. Just as in the painting of, say, Ingres, the paint, simply applied, plays a minimal part, in that of Bacon it is of its very essence. He has emphasized many times the crucial part played by accident in his art, and the creative effects of the paint itself. In fact, no figurative painter has ever gone so far in making an equal, even at times a senior, partner of his medium. Bacon's procedure is complex and ambiguous, but roughly speaking an image lodges in his imagination, is suggested by the memory of an old master or a blurred photograph from some popular magazine; he begins to paint, then, as he says. 'This is the thing that can only probably happen in oil paint, because it is so subtle that one tone, one piece of paint, that moves one thing into another completely changes the implications of the image. But the image is not allowed to clarify beyond a certain point – that point being when the paint becomes subservient to it. 'What I really love,' he has said 'is the way paint makes things. The way I work now is accidental. The moment the story' – that is to say the subject – 'talks louder than the paint boredom sets in' and 'painting is the pattern of one's own nervous system projected onto canvas . . . an attempt to make a certain type of feeling visual.

I know no clearer statement of his attitude than something he wrote not about his own painting but that of a friend. In 1953 we brought together a reprospective exhibition of the work of Matthew Smith at the Tate, and Bacon accepted our invitation to contribute to the catalogue. It remains his only published writing. Thus runs his 'Painter's Tribute':

> Because I very much admire Matthew Smith, I am delighted to have been asked to write something about him, although I know I will not be able to do him justice. He seems to me to be one of the very few English painters since Constable and Turner to be concerned with painting – that is, with attempting to make idea and technique inseparable. Painting in this sense tends towards a complete interlocking of image and paint, so that the image is the paint and vice versa. Here the brushstroke creates the form and does not merely fill it in. Consequently, every movement of the brush on the canvas alters the shape and implications of the image. That is why real painting is a mysterious and continuous struggle with chance – mysterious because the very substance of the paint, when used in this way, can make such a direct assault upon the nervous system; continuous because the medium is so fluid and subtle that every change that is made loses what is already there in the hope of making a fresh gain.

I think that painting today is pure intuition and luck and taking
advantage of what happens when you splash the stuff down, and in
this game of chance Matthew Smith seems to have the gods on his
side.

Bacon's friends have often heard him define the objective of his
painting in these and similar ways; likewise express his repugnance
for 'story' – a synonym for 'illustration' – by which I understand him
to mean a subject completely and explicitly realized. In fact, Bacon is
preoccupied, and preoccupied deeply, with his subject. Showing me
some of his large collection of photographs, mostly clippings from
magazines, and pointing to one of those he values most, a crowd
dispersing in panic across a square in St Petersburg during the
Revolution, he said something that illuminates the relation between
photography and his own art: 'Not one of these hundreds of figures
looks remotely like a conventional figure; each one, caught in violent
motion, is stranger and at first sight less intelligible than one could
have imagined it. Could anything,' he asked, indicating an off-
balanced L-shaped form in the foreground, 'be more utterly unlike
the conventional concept of a man running?' The observation helps
us to understand the dichotomy in the art of this man, so deeply
interested by many aspects of the physical world – although very
little by landscape, sky or water – and by philosophy and literature,
besides, of course, painting; that is why he is so imperiously
determined not to depict any facet of this world so that 'it would
speak louder than the paint'. However intense his concern with his
subject, his determination to subordinate it to the paint sets up a
tension from which he derives his prime motive force.

Wide though his interests are, his subjects have remained similar:
mostly single figures, usually male, sometimes lying in agony or even
dead, crouching or else simply sitting. Even though a number of these
are triptychs, they still represent, in effect, single figures in that they
are mostly oblivious of one another's presence.

There is another dichotomy in Bacon's art: the 'accidents' to which
he often alludes, the 'speaking' of the paint, its 'impact on the nervous
system', relate only to his figures; their background and accessories
– beds, clothes, curtains, carpets, umbrellas, newspapers and the like
– tend to the portrayed with little or no distortion. His interest is
focused on the figures, but their environment and accessories also
have their part to play, at times by suggesting, by their claustrophobic
intimations, the loneliness, although not the privacy, of the figures in
their cell-like rooms at others by directing the spectator's attention
upon them.

Bacon regards portraiture as the most difficult kind of painting.
Nor is this surprising, for to subordinate the likeness of a specific

individual, one intimately known to him, to 'the paint' must be more difficult than an anonymous figure in which 'accident' is untramelled by the need to approximate, however freely, to the likeness of the subject. In his portraits he plays a particularly complex game with what he has called 'the perilous onset of likeness' without help from the process integral to his other paintings of 'one image breeding another'. Although in his portraits his freedom of action is not absolute, he relies, nevertheless, as in his other paintings, on suggestions produced by the paint itself. 'This head I painted a few days ago,' he said to David Sylvester, 'I was trying to paint a specific person. I used a very big brush and a great deal of paint, and I put it on very freely, and I simply did not know in the end what I was doing, and suddenly the thing clicked, and became exactly the image I was trying to record.' Inevitably an artist who works in such a way is uneven, but his desire to achieve the perfect image impels him to destroy not so much his outright failures as those which fall just short of his hopes, more especially those which, beginning well, lose their qualities. 'How,' he asks, 'can I recreate an accident?' There is, too, a technical reason for his difficulty in restoring lost qualities: he uses both thick and thin paint, working on unprimed surfaces, which means that the addition of more paint to thickly worked areas causes clogging, which is difficult to remedy.

Because of this ruthless self-criticism, not only his failures but many paintings which fall just short of success are destroyed. Most of those permitted to survive reveal the majestic although ambivalent character of his art, in which the paint is not the servant of the subject, but the subject is wrested from the paint and is seen as though he had never seen it before: thus from *Figure Study II* and *Painting 1946*, through *Two Figures* (1953) and *Study after Velazquez, Portrait of Pope Innocent X* (1953); up to *Portrait of Isabel Rawsthorne* (1966), *Study of Isabel Rawsthorne* (1966), *Portrait of George Dyer, crouching* (1966), *Three Studies of Lucian Freud* (1969); to *Triptych* (1970), *Study for Portrait of Lucian Freud – sideways* (1971) and *Figures on Beds* (centre panel 1972) – to mention a few among a much larger number.

The compelling power of Bacon's vision, once ridiculed as schoolboy obscenity, derogated as an affront to decent people, and so forth, has imposed itself on the public imagination, not only of Britain but of the western world. In the awkward strangeness of his figures unobserved we recognize ourselves; in his 'affronts to decent people' we recognize understatements about our own age, the age of Auschwitz, Stalin, Hiroshima, Bangladesh, and about much that goes on beneath – although not far beneath – the surface of our own society. So completely, in fact, has it imposed itself that to some among the younger generation it has become almost commonplace. This

untaught painter has become, by the audacity of his vision, by his dedication, his rare understanding of paint and its mysterious potentialities, a master. The interview several times quoted here was titled 'The Art of the Impossible'; it is a measure of Bacon's stature that he so often achieves it.

ROBERT COLQUHOUN
1914 – 1962

Robert Colquhoun, a sombre, introspective presence, appeared, except for his dark and piercingly observant eyes, to lack energy. No impression could have been more misleading: he had a rare power of concentration and in a noisy gathering of friends and hangers-on he could work as fast and as surely as if he were alone. It was a power that enabled him to produce – in a short working life – a body of work impressive both in quality and volume: paintings, drawings, prints, as well as designs for the décor and costumes of a ballet and a play, while leading a life which would have frustrated an artist without rare gifts and a rare capacity for giving them full scope in often highly inauspicious circumstances.

Robert Colquhoun was born on 20 December 1914 in Kirktonholm Place, Kilmarnock, Ayrshire, Scotland, the eldest of two sons and a daughter, of Robert Colquhoun, an engineering fitter and his wife, born Janet Stewart Candlish. About ten years later the family moved to New Mill Road.

After attending Loanhead School in 1926, he entered the Kilmarnock Academy where he showed himself proficient in all subjects, but art was his main preoccupation. From 1929 until 1932 he specialized in drawing and painting under the head art teacher, James Lyle, a man who was to play a crucial part in his becoming an artist. He painted and drew continuously from a very early age, almost everything around him, especially, and in detail, the interiors of the homes of his relations. In 1929 the economic depression caused Colquhoun, like many others, to leave school or college to help his family to survive. Accordingly he was apprenticed to an engineering concern, but his absence from his class was immediately noticed with consternation by James Lyle, who was convinced that the fifteen-year-old student possessed talent of a rare order. This purposeful man, after obtaining the agreement of Colquhoun's parents, solicited the help, readily forthcoming, of a perceptive local patron of the arts, Sir Alexander Walker and of the Revd James Hamilton, thereby making it possible for Colquhoun to resume his studies. This he did to such purpose that in 1932 he won a scholarship at the Glasgow School of Art. Besides the high quality of the teaching at the School,

165

Colquhoun benefited from Glasgow's fine tradition of painting, its great collections, and in particular from the opportunity of visiting an exhibition which enabled him to study works by Manet, Degas, Cézanne and Picasso.

It was at the Glasgow School that he formed a friendship with a fellow student of the same year – a friendship so intimate that one of their closest friends said to me, 'they were one person'. Their mutual devotion was to be lifelong. The fellow student was Robert MacBryde. MacBryde had a far less auspicious start, having to work for five years in a factory before he was able to go to the Glasgow School, where, like Colquhoun, he studied for five years. Both benefited greatly from the teaching, especially that of Ian Fleming, who was quick to recognize their exceptional talent, although there was no doubt in his mind or in that of others with whom they came in touch that Colquhoun's was the more considerable. Fleming commemorated Colquhoun's and MacBryde's intimacy and his own regard for them in a double portrait. The two students are shown in a corner of one of the School's studios. The relationship between them is perceptively expressed: MacBryde is standing in the right foreground; Colquhoun on the left, farther back and seated. By his emphasis on MacBryde's face and by bringing him forward towards the spectator, Fleming suggests his outgoing temperament and his protective attitude towards his friend; his posture is erect, his expression vital. Colquhoun's face, on the other hand, is somewhat veiled, in harmony with his loose, almost slumped posture, indicative of his withdrawn, almost passive, relaxation. Fleming, who so clearly shows his insight into their relationship, which never changed, did much to establish the reputation of 'the Roberts' – as they were called in Glasgow and throughout their lives. They spoke of him with respect and affection, as a man to whom they were indebted, and when they established themselves in London he used to stay with them. They owed much, also, to the teaching of Hugh Crawford.

Colquhoun and MacBryde were happy at the Glasgow School and believed that their time there was well spent. They kept themselves somewhat apart from the main body of students, especially those intending to become teachers, but both, in particular Colquhoun, were much admired. Both won prizes for drawing and Colquhoun a post-diploma award which enabled him to spend an extra year there, and both won scholarships which enabled them to travel widely in Europe together, visiting Rome, Venice, Florence, Paris, Aix, Avignon, Orange and a number of other places. At the end of 1939 Colquhoun, with MacBryde, returned to his native Ayrshire, both working in a studio-hut at his grandparents' home at Netherton, besides painting and drawing in various parts of Ayrshire. The

following year Colquhoun was called up, serving in the Royal Army Medical Corps as an ambulance driver in Edinburgh – where Mac-Bryde brought him special food – and Leeds, where in 1941 he was invalided out after collapsing from cardiac trouble, about which MacBryde was also helpful. McBryde, being tubercular, was exempt from service.

Later that same year, after a brief visit to Ayrshire, both settled in London and their lives underwent radical changes of several kinds. They stayed first with the enlightened patron of art and literature and publisher of *Horizon*, Peter Watson, in his flat in Prince's Gate, later taking a small studio behind Barker's shop in Kensington High Street. During the day Colquhoun drove an ambulance as a member of the Civil Defence corps, and often painted at night.

Colquhoun's earliest paintings were mostly landscapes, lucid in design, solid in construction and reflecting the strong colours of parts of his native county. Gradually his sympathetic obsession with his fellow men and even more with his fellow women came to dominate his art. But frequent travel and war service had discouraged continuous work. In London his qualities as a painter were recognized, and his presence, magnetic in spite of his sombre silences and proneness to aggressive behaviour (which increased with the years), quickly won him a special place – both as a painter and as a man – in a circle of artists and writers of exceptional talent, and the attention of several perceptive collectors.

The time of his arrival was propitious. The response of British artists to the shock of war and the resulting isolation from the Continent was to focus their attention on their own predecessors, such as Blake and Palmer, rather than on their most creative contemporaries. (Colquhoun was not entirely immune from the prevailing influence of Palmer, which is clearly apparent in his *Marrowfield, Worcestershire* (1941), but paintings in this spirit were not many.) Colquhoun, who had little interest in earlier English painting and had so recently spent much time travelling abroad, appeared a conspicuously attractive cosmopolitan figure. Not that he regarded himself as 'progressive', but rather, like Kokoschka, as someone who hoped to help revivify the great European tradition which he revered. There was, however, one British painter by whom he was radically affected. This was Wyndham Lewis, whose writings he read and reread, and the clarity and logic of whose paintings he admired and kept in mind while at work. As a student he had studied his portrait of Mrs Lewis in the Glasgow Art Gallery. Colquhoun's admiration was reciprocated. In a letter to Keidrych Rhys (9 October 1948) Lewis refers to Ceri Richards as 'far and away the best of the younger painters – with, perhaps, Colquhoun'. The year before, writing with

more deliberation and at greater length in *The Listener* of 13 February, he expressed the opinion that Colquhoun 'is generally recognized as one of the best – perhaps the best – of the young artists. That opinion I cordially endorse.'

Late in 1941 Colquhoun settled in a spacious studio which he shared with MacBryde, and for a short time with John Minton, at 77 Bedford Gardens, Campden Hill. At a time when the traditional social structure of London was disrupted by the war – even 'bohemia' had had such a structure, even though of a more transient kind – the studio became for a time a unique meeting place for artists and writers of the emerging generation: Michael Ayrton, Keith Vaughan, Dylan Thomas, Benny Creme, Prunella Clough and John Craxton were frequent visitors, and Francis Bacon called from time to time. They occasionally met Wyndham Lewis, a near neighbour. Two years later Jankel Adler – whom they particularly admired – arrived from Glasgow (where he had come after service with the Polish army and where they had known him) and settled in the studio immediately above. Adler's work, although it had little in common with Lewis's, did share its deliberation and clarity and this, especially after they became friends and neighbours, impressed Colquhoun.

Adler was not the only link 'the Roberts' maintained with Glasgow. Not long before David Archer had founded an informal centre where artists met and worked called Sandiford Place (just off Sauchiehall Street) which contained seven or eight rooms that he gave rent-free as studios. Besides Adler, Sandiford Place was frequented by Helen Biggar, sculptor and stage-designer, the poets W. S. Graham and Ian Hamilton Finlay, and the painter Robert Frame. All became friendly with 'the Roberts'. Finlay and Frame hitchhiked to London and became still closer friends. All these were visitors, some regular and others occasional, at Bedford Gardens. One evening in the same year Colquhoun and MacBryde walked into a Soho pub where they met another friend, the writer Paul Potts who, handing his companion a Pimm's No. 1, said to him, 'I want you to meet two remarkable men.' The companion was George Baker the poet. They became friends immediately (even though MacBryde crushed a small wineglass in his right hand which cut Barker's as they shook hands). The friendship formed that evening between 'the Roberts' and Baker was the closest of their lives and ended only with the artists' deaths.

Colquhoun's relatively wide travels and his acutely perceptive eye enabled him to learn from many painters, and it is not difficult to identify features in his work drawn from artists as remote from one another as Picasso and Palmer, Wyndham Lewis, Assyrian sculptors, Celtic carvers and illuminators and many others besides. But all these borrowings effected very minor contributions to a vision of the rarest

originality. In Lewis's appreciation of Colquhoun in *The Listener* (already quoted) he continued, 'Perhaps I should have said Colquhoun and MacBryde, for they work together, and they can be regarded almost as one artistic organism. Usually we say "Colquhoun" when we speak of it.' Because Colquhoun was the more imaginative and the finer draughtsman, their work, although it had at times close similarities, was in fact scarcely 'one artistic organism' and the recognition of Colquhoun's superiority – which MacBryde himself consistently proclaimed – has led to MacBryde's unjust neglect.

The two were so close that it is impossible, even for those who knew them best, to envisage MacBryde's art if he had never known his friend's; whereas Colquhoun's, it is not unreasonable to assume, would not have been very different. But MacBryde often showed a more resonant sense of colour. Colquhoun's figures at first glance appear grotesques. It is part of the mysterious character of his art that on closer scrutiny these figures, in particular the faces, represent so movingly the artist's preoccupation with tragic aspects of the human lot. In his preface to the splendid retrospective, consisting of two hundred and fifty-one paintings and prints which he brought together at the Whitechapel Gallery in 1958, Bryan Robertson contends that Colquhoun's vision 'was in no way pessimistic'. Wyndham Lewis was surely nearer the truth when he said, 'There is a grave dug behind all his canvases of a certain kind', namely behind those canvases in which he conveys most explicitly his tragic vision of life: mostly in terms of old or elderly women, poor, bloodless, grieving and without purpose. They are perhaps in part expressions of memories of his own childhood. Certainly they are emanations of the Celtic world, of his native Scotland and of Ireland where he spent two months in 1946 in Cork and Crosshaven. (As a rule he worked from imagination or memory, but in Ireland direct from his subjects.) An intimate of 'the Roberts' gave me a hint of an interpretation of the paintings and monotypes in which these women, who appear together, are also obscure personifications of Colquhoun and Mac-Bryde themselves, and allusions to the situations precipitated by their complex intimacy.

It was in the mid-1940s that Colquhoun reached the height of his creative power. Comparison between two paintings, made only two years apart, reveals the difference between high promise and sure achievement: *The Two Sisters* and *The Fortune Teller*, earlier titled *Women Talking*. The first, made in 1944, is loose and summary, weak in construction: the sister on the far side of the table, for instance, scarcely holds together. These are matters of means only; there are many paintings in which the means, viewed in isolation, are unimpressive and the finished work the very reverse (such as a

number of Lowry's). But *The Two Sisters*, whatever its intimations of interest, falls, so to say, with a dull thud. *The Fortune Teller*, made in 1946, grips, and retains, the viewer's interest. (Mine at any rate. How, in the writing of the work of contemporaries, can one speak for anyone but oneself, when all judgments, even those which seem most secure, are liable to radical modification or else outright reversal?) The painting has so humane, so elegiac a poetry, that one thinks only about the effect, but the means will withstand severe critical examination. A few of the substantial number of paintings of comparable quality are *Seated Woman with Cat* (1946), *Woman with a Birdcage* (1946), and, although not of quite the same sureness, the Tate's *Woman with Leaping Cat* (1945–46).

These paintings and a number of monotypes of similar character, such as *Women Talking* (1945–46), represent Colquhoun's *annus mirabilis*, the high point of his achievement. His reputation appeared to be firmly established; he had won the respect and admiration of fellow artists, of a number of collectors, and held exhibitions, well received, at the Lefevre Gallery in 1943, 1944 and 1947. In 1948 he and MacBryde were approached by Leonide Massine with a view to their designing costumes and décor for a Scottish ballet. The year following they and George Barker went to Italy to see the puppet-plays at Modena and the Palio at Siena, which Colquhoun used later in a series of paintings and prints (and perhaps to attune himself to theatrical design); and to illustrate a book on Italy that Barker was projecting, but neither text nor illustrations were completed. They also visited Rome, Venice, Florence, Verona and Settignano. Being interested in the extent to which painters study their predecessors, I asked Barker how much time Colquhoun spent in museums. 'About one day a fortnight', was the answer.

The new Scottish ballet for which Colquhoun and MacBryde had designed costumes and décor, entitled *Donald of the Burthens*, was produced in 1951 at Covent Garden; Beryl Grey and Alexander Grant danced the principal roles, the music was by Ian White and the choreography by Massine. I saw neither this ballet nor *King Lear*, produced at Stratford two years later by George Devine (Michael Redgrave played Lear, Marius Goring the Fool and Yvonne Mitchell Cordelia, with music by John Gardiner), but experienced judges regarded the first as amateurish and the second as impressive.

Colquhoun continued to make paintings, drawings and prints of a high order until near the end of his life, and even those of lesser merit are almost always marked by a dignified humanity – a humanity not confined to human beings. Many of his drawings and prints of animals, especially of horses, are masterly in their understanding of both movement and repose, expressed with the utmost economy.

However, in spite of his continued, if less consistent, command of exceptional powers, his close friends were increasingly distressed by signs of decline in both the man and the artist – a decline no less evident in MacBryde. It was the subject of frequent discussion between them, but there was no consensus about the causes of the gradual but, to intimates, painfully apparent symptoms of disintegration. Although its basic cause eluded them they were agreed that it was accelerated by three events, which exacerbated some deeper malaise.

By the mid-1940s Colquhoun and MacBryde were the focus of an admiring and congenial group of friends, and 77 Bedford Gardens had become their home. From this they were ejected in 1947 by the landlord, who said that it was intended for working in by day, not for 'drunken orgies' by night. After this, one of their closest friends said to me, their lives 'began to fall apart'. When they first came from Glasgow the two young artists did not touch alcoholic drink, or scarcely at all, but in the paradoxically exhilarating atmosphere of wartime London, finding themselves at the centre of a circle of high-spirited young artists and writers, they began to drink heavily, almost nightly, frequenting for long hours such Soho resorts as The Black Horse, 'The French Pub', the Caves de France and the Gargoyle Club, often meeting Dylan Thomas, Roderigo Moynihan, John Craxton, Keith Vaughan, John Minton, George Baker and others. Being hospitable when they had the means, they also accumulated numerous hangers-on. But, excessively as they drank, it did not appear to affect them until they lost the studio where they had won their reputations, made lifelong friends and formed the habit of regular work. Regular, indeed, in a special sense: both required the incentive of an impending exhibition or of a probable sale to impel them to work at full stretch. Both, especially Colquhoun, could paint and draw at exceptionally high speed; he could complete three prints in a morning, not in the least deterred by a noisy talk in their studio, in conditions in which most artists could hardly even think. With MacBryde it was otherwise: he needed quiet and very few ever saw him at work.

Bedford Gardens was their home and they suffered permanent distress from their expulsion from it, even though two sisters, Frances Byng Stamper and Caroline Lucas, who lived at Lewes, Sussex, lent them a studio where they lived for nearly two years, and commissioned Colquhoun to make many lithographs and drawings for Miller's Press, which the sisters owned and ran. Here Colquhoun also made colour lithographs for *Poems of Sleep and Dream*, edited by W. J. Turner and Sheila Shannon and selected by Carol Stewart.

It was after their return from their Italian journey with George

Barker in 1949 that they suffered a further blow to their confidence. Duncan Macdonald, a director of the Lefevre Gallery and long a friend and ardent supporter of their work, died. The Gallery had not only given Colquhoun three exhibitions but acted as a sort of banker for him and MacBryde. It in fact gave him a fourth exhibition in 1951, but with Macdonald's death the intimate link between the artists and the gallery was broken. This was a shock to Colquhoun's dignity: he never troubled to find another dealer.

George Barker, the most devoted and loyal of their friends, and his wife, invited them to live at their home, Tilty Mill, near Dunmow in Essex, which, like Bedford Gardens, was a resort of writers and artists. Here 'the Roberts' remained for four years. Elizabeth Barker, quite simply, kept them. In return they looked after the children when she was away working in London. But eventually serious and continuous tension prevailed at Tilty, which led, in 1954, to their return to London. Shortly afterwards Tilty was sold. Whatever the cause for the progressive disintegration of 'the Roberts' its results increasingly alarmed their friends. Of these the most obvious was their increased addiction to drink. At Tilty they went to the local pub as soon as it opened in the morning and remained until it closed. They drank on credit and when they left Elizabeth Barker settled their enormous bill. In spite of these tensions and their results George Barker remained as devoted a friend as ever: 'I have never known more fascinating men,' he said to me, 'and this was true of many besides myself.'

In most respects 'the Roberts' could not have been more different. They had indeed a few qualities in common – besides their extreme addiction to alcohol. Both were deeply conscious of their Scottish heritage. They could sing: MacBryde had the better voice and a wide repertory of Scottish songs which was a joy to their friends to listen to. In spite of their liability to use such expressions as 'the English Occupation of Scotland', these were no more than weapons of aggression. None of their friends who have spoken about them to me remember their advocating the separation of their country from England; indeed they seemed to have few if any serious political preoccupations. Colquhoun had a romanticized vision of the artist as an antisocial being derived originally, perhaps, from Rimbaud.

Colquhoun's professed Scottish nationalism is indicative of an ambivalence in his character, for after 1946 he never visited Scotland, and never again saw his parents. Apart from a very occasional letter or telephone call he deliberately severed all links with Kilmarnock. This ambivalence was not confined to his native city to which he owed so such. Devoted although he was to his friends, after leaving the Kilmarnock Academy in 1932 he never visited – or I believe

communicated with – James Lyle, to whose confidence in his powers and persistent and effective help he owed the opportunity to become an artist.

The two also shared a self-respect with regard to their appearance, in the case of MacBryde amounting to vanity, on Colquhoun's behalf as well as his own. One evening Colquhoun, whose sight troubled him at times, put on a pair of spectacles. MacBryde snatched them off his face and crushed them angrily under his heel. Before going out for a night MacBryde would iron their trousers with the utmost care and Lucian Freud once saw him ironing one of Colquhoun's shirts with a teaspoon.

They also shared a sensitiveness which, especially under the effects of alcohol, took the form of deliberate, aggressive rudeness towards those whom they met for the first time, as a test. If the victim responded with good nature, after ten minutes or so they might become friendly. It was a test which I unhappily failed to pass. One night, as a guest of Francis Bacon, at a late dinner at the Gargoyle Club, I and other members of the party were accosted by two men unknown to me (fellow guests, it shortly appeared) with truculent demands for whisky, as they assembled and took their places at the table. My response – to my regret – was curt, and I accordingly never came to know these two remarkable men.

In other respects they might be regarded as opposites, or else as contrary but complementary aspects of the single person they almost were. Colquhoun was inward-turning, withdrawn, prone to long periods of silence, when he could sit, hour after hour, staring. He read widely but without discrimination; anything at hand, whether a classic, a detective story, or even lists of racehorses or objects for sale. The sight of this immensely creative man just reading for days on end, simply to pass the time, continually surprised his friends, even though they knew that when he worked he worked surely and fast. Colquhoun was, strangely, at once the dominant yet in several respects the passive member of the couple. When he talked – he rarely mentioned painters or painting – he showed, according to George Barker, 'a natural, a beautiful intelligence'.

MacBryde, on the other hand, was an extrovert, expressing himself freely and with ease, although reticent and modest about himself. He looked after all the practical aspects of their life: he did the cooking, the shopping, maintained contacts with dealers and replied to most of their letters. He used to declare his pride in being 'the servant of the great master' and in having sacrificed his own career to further that of Colquhoun. Without Colquhoun's inhibitions and reserve, he made friends easily. But Colquhoun was liable to an emotional susceptibility towards men that could stir jealousy in MacBryde.

The relation between them was so strange that I doubt whether it was fully understood even by their closest friends. Its strangeness has never been more evocatively described to me than by George Barker's son Sebastian. When 'the Roberts' were living at Tilty Mill he was a boy – eight when they left. They were delightful companions to the children, he said, entering wholeheartedly into whatever they were doing, gentle, humorous and sympathetic, incredibly dexterous manually, making bows and arrows and inventing original games. When the children became too demanding they had ingenious – and sometimes macabre – ways of getting rid of them, for instance by sending them in search of an allegedly crashed aeroplane. The evenings were idyllic: amusing talk, sitting round the dinner table, varied by the beautiful singing of Scottish songs. The idyllic evening would end and, when all had retired to their bedrooms, from 'the Roberts' would suddenly be heard a variety of sounds: fist-fights, crashes and screams. On one occasion their double bed was set on fire, but the flames were promptly put out. Next morning, although black eyes and cuts were evidence that these sounds were not emanations of nightmare, 'the Roberts' were as gentle and sympathetic as before, and any damage to furniture or anything else had been skilfully repaired.

The failure of the Barkers' attempt to provide peaceful working conditions for 'the Roberts' at Tilty Mill aggravated their susceptibility to despair that their expulsion from Bedford Gardens and the death of Duncan Macdonald had exacerbated. The result was the decline of all their faculties. But such was Colquhoun's talent and resilience that he was still able to work well, although less impressively and consistently than before. Even so intense and monumental a painting as *Woman Ironing* (one of five completed at high speed specially for his Whitechapel retrospective in 1958) has passages in which a summary breadth of form is the result of loss of the application so evident in the best of his earlier works. (Francis Bacon, always conscious of the crucial part played by impulse generated by the actual process of applying paint and also by sheer chance, deplored Colquhoun's 'destruction of his art by his gradual enslavement to a constrictive style'.) But whatever the shortcomings of his later work, it shows, almost invariably, strains of nobility.

There was something about the character of 'the Roberts' that survived the general decline of their faculties; nothing showed this more clearly than the undiminished affection and loyalty of their friends. I had met them only rarely but on every occasion they had been extremely drunk and behaved unpleasantly to all within earshot. Early in April 1958, the ninth to be precise, I went to the Colquhoun retrospective at the Whitechapel. Although I had long admired his

work – we had bought *The Woman with the Leaping Cat* for the Tate four years before – I realized that I had not recognized his full stature. There I met Colquhoun and MacBryde, for the first time sober. When I spoke to Colquhoun of the deep impression his assembled work made on me, he made no reply but simply looked at me gravely and I could see tears in his eyes which said as clearly as any words that if he and circumstances had been different he might have achieved infinitely more. A moment later he seemed serene and happy; we had a long talk and I formed an immediate liking for him and for MacBryde; they spoke with enthusiasm of plans for starting a new life in Sudbury, Suffolk. Of all Bryan Robertson's notable achievements at Whitechapel, none was finer than this great tribute to a noble but now wasting talent.

In spite of the obvious delight that the exhibition gave Colquhoun, his last years were bleak and restless. After returning from Spain – where 'the Roberts' went on the proceeds of the exhibition – they were without a home, living in rooms in 47 Gibson Square, Islington, 9 Westbourne Terrace, 8 Norland Square and elsewhere, declining in health and confidence – but according to their friends never in courage. 'I never knew men more courageous, less afraid', I heard one of them declare.

On 20 September 1962 Colquhoun died of heart disease, while at work on a drawing of a man in space, dying – a drawing, in effect, of his own death. George Barker travelled to Kilmarnock for his funeral and wrote this poem:

FUNERAL EULOGY FOR ROBERT COLQUHOUN
inscribed to Robert MacBryde

It was at four in the morning at work on his sketch of Death
He felt on his shoulder the tip of that twisting wraith,
He had at least etched on the negative of his life.

As the flying Scotsman to the landscapes of the Pennine Chain
Or the Flying Dutchman to all illusions of the Ocean
So was Colquhoun to those through whom his devotion drove him.

What we saw was a winged engine illuminated with flame
Or the skeletal hull loom through the fog of our time
As he dominated and dogged the heart marked X.

I shall know him again by the self-graven epitaph in his face
When, as he may, he chooses to revisit this place
That gave him, as haven, little more than a grave.

Tenderest of men in the morning before the ravening ghouls
Swept out of his holyrood conscience like lost souls,
In the evening we heard him howling in their chains.

All things were, to this man, a sort of structural

Crucifixion, like the god of the straining pectoral
Brought down to the flayed stoat nailed to a tree.

II

By moonlight I see a stallion of Stubbs-Uccello
Gaunt, long-barrelled, yellow, lifting its head
Proudly out of a bunch of fallow thistle

Which is the Knoxian conception of Scottish
responsibility. And now this proud man is dead.
This Highlander, this skinny Aryan, this, yes, British

Mountaineer of spiritual violence
This draftsman who was not so much a painter
As the graphologist of our dying conscience,

Elected to go home to cold Kilmarnock
And render those he left behind a mere remainder,
For what he wanted lay north of Cape Wrath and the rock.

In the ferocious exhibition bout he conducted
With himself both Jacob and the Angel, we, the audience,
Had at last become superfluous. We were subtracted.

I have to believe that, having contested the issue
With his own passion, he now resumes it in regions
To which neither our love nor our grief shall ever have ingress.

Intensity of spirit, that energy with which
Energy creates itself, is indestructible.
Now where is the wrestler Jacob meeting his match?

And supernaturally, why? To that rigorous
Calvinist of the Image, canvassing the invisible
Icon in colours seemed at heart futile and frivolous.

What, I think, broke this horsebreaker of a man
Was the knowledge that not in things but in their distances –
Yes, there the love that kills them always began.

Such a hero – and by this I mean
A heart that acknowledges the glory of consequences –
Foresees that the love that generates between

All things must in its own turn destroy them
Like rubbing hands of wood. What possible pretences
Existed for such a man? How could he employ them

In the already burning theatre of his spirit?
The consolation that pacifies those ashes
Is his. It is not ours. We cannot share it.

So let him lie now near the rock and the cold loch
Not to awaken again till Cape Wrath one day dashes
The last wave over that long grave in Kilmarnock.

The other Robert could not long survive. He lived in what was
scarcely more than a cupboard, declining quickly from cleanliness to

13. ALAN REYNOLDS: *The Keeper of the Dark Copse II* (1951–52).
Oil on board 30 × 42 in (76·2 × 106·6 cm). The Tate Gallery, London.

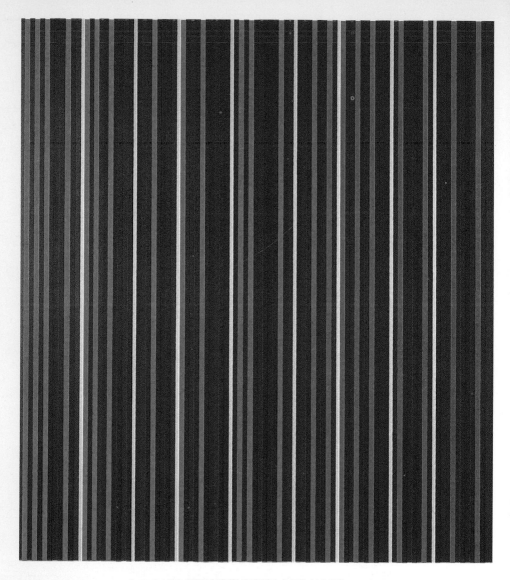

14. BRIDGET RILEY: *Midi* (1983).
Oil on linen, 83½ × 73 in (209 × 182·5 cm).
Collection of Sutherland-Hawes Design.

Opposite
15. EUAN UGLOW: *Nude, from twelve regular positions from the eye* (1967).
Oil on board. 95 × 36 in (241·3 × 91·4 cm).
University of Liverpool Art Gallery.

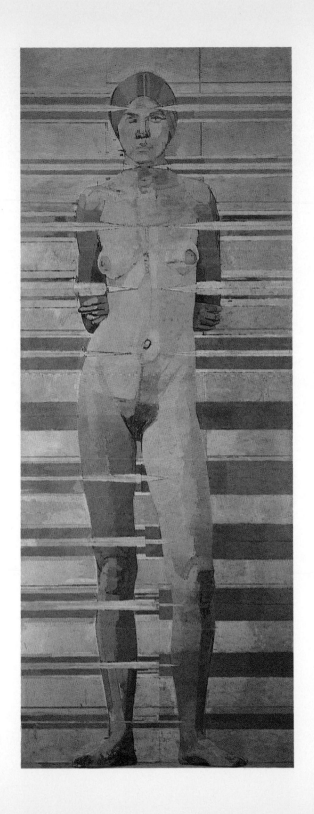

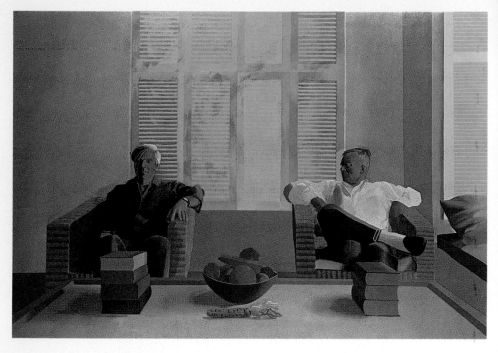

16. DAVID HOCKNEY: *Christopher Isherwood and Don Bachardy* (1968). Acrylic, 83½ × 119½ in (212 × 304 cm). Private collection, London.

abject filth. Then, in Dublin on 15 May 1966, after a night's drinking,
he was run over by a car and killed – Robert MacBryde, who had said
to George Barker, 'We must be certain to create our legends before we
die.' That legend he failed to create, but George Barker, also wrote:

IN MEMORY OF ROBERT MACBRYDE

It is midnight. The moon is high
and staring down with a white eye

on Dublin where she saw you die
knows how black her magic was

when you met Nothing face to face.
How can I think, dear Robert dead,

you are not here, but lie instead
under every stone I tread?

How can a shovelful of dirt
lie so heavy on your heart

that I too feel some living part
of me lies there, and always will?

When that huge room at Notting Hill
on Sunday nights began to fill

with those whom you loved all too well,
then I and each one was the most

devoted, O intemperate ghost,
of all the lovers you have lost.

And bluer days in Italy
when, footloose around Fiesole,

Colquhoun and you, and she and I
wove like a tartan or like dances

Love into all circumstances
not caring that the grave advances

and that of our four, too soon, three
would sleep so far from Italy

and further from what used to be.
My memory is that pearled room

high over Florence in the gloom
of a March evening. There you, whom

too often I waited for, you three
return, and perhaps smiling, we

rise and take hands silently
as the sun through the French window

turns on Florence far below,
leaving us in a great shadow.

Or I hear, now growing softer
the mocking birds of your laughter

I follow, a sleepwalker, after;
as, fitfully, from the town below

those sleepers of so long ago
rise from the bed of the Arno.

And once again, well-washed, we are
standing against that little bar

in the Piazza Signoria,
happy, silly, a bit mellow,

joking with a cyclist fellow
named – you remember? – Donatello.

Now even that March sun is gone.
The night divides, for everyone

Sleeps, dear Robert, like you, alone.

LUCIAN FREUD
born 1922

At least three of the painters discussed in this volume – Burra, Houthuesen and Collins – have been accorded by the establishment far less recognition than their achievements merit. Although still subject to official neglect, Houthuesen and Burra had sufficient recognition from private collectors to have lived in modest comfort, and Collins still does. The case of Lucian Freud is different: the establishment, owing to the fact that he has many highly influential friends (Francis Bacon is an intimate and an ardent supporter), has always been aware of his existence and, particularly when he was in his twenties, of his precocious talent. However, although a few members of the establishment have bought an occasional example of his work, in the main its attitude has been one of lack of interest and he is meagrely represented in British public collections; but it is only fair to recall the smallness of his production. Freud reciprocates this lack of interest: when it was one of my duties to attend official receptions and the like he was never present. It would be untrue to suggest that official indifference towards him is complete: he was awarded an Arts Council Prize in the 1951 Festival of Britain Exhibition, and three years later a group of his works was shown in the British Pavilion at the Venice Biennale. The Tate trustees responded warmly to my proposals in 1952 for the purchase of *Girl with a White Dog*, a painting completed the previous year, and *Portrait of Francis Bacon*, and in 1964 they even exercised their prerogative of taking over any work falling within the scope of the collection bought by a member of the staff at the price paid for it, claiming his *Self-Portrait*, a painting of 1946, which my daughter bought at Sotheby's on my behalf for £120. He is also represented in the Museum of Modern Art, New York.

Freud holds himself aloof not only from official life but from conventional social life as well. This is due largely to his determination to preserve the utmost possible independence, but even more because he needs an exceptional measure of freedom from distraction in order to work. His talk is an easy and wide-ranging expression of a sophisticated and well-stocked mind and I, and no doubt other friends, on first coming to know him was surprised at the intense difficulty he

179

finds in drawing and painting. This difficulty in expressing himself other than by the spoken word is also apparent in his handwriting, which is almost childlike. This was in part due to his having to learn Roman script when he had been brought up to use Gothic, and in part to his being badly taught at his English school, but had this difficulty not been innate a man of Freud's talent would have easily overcome it. Spontaneous expression comes to him unsought, but deliberate expression is a different matter. He has disciplined himself in the effective use of brush, pen or pencil, but as he has no aspirations to write, except as a means of ordinary communication, he has barely troubled to master its elements.

Freud is, in fact, an anomalous figure, a socially sought-after solitary with a seemingly facile mind to whom the pursuit of his vocation is a sombre ordeal daily renewed, a seemingly material temperament, who, like Francis Bacon, beyond needing ready cash in his pocket, is without the acquisitive urge, and whose successive studios would be rejected as unfit to live in by the student of today.

Lucian Michael Freud was born on 8 December 1922 in Berlin, the second of the three sons of Ernst Freud, the architect and younger son of Sigmund Freud, and his wife Lucie Brasch. At the age of nine he was brought to England by his parents, where he has lived ever since. In 1939 he became a naturalized British subject. He often saw his illustrious grandfather, Sigmund Freud, who lived at Maresfield Gardens, Hampstead, and he enjoyed his jokes and his prevailing good humour – and the gifts of money he used to send him when he was at school.

For as long as he can remember Lucian has drawn and painted; it had always been assumed by himself and his family that he would be an artist. In the mid-1930s he spent three years at school at Dartington, where his predilection for drawing and painting was frustrated by the artiness of the art master (he was accordingly tempted to become a jockey instead of an artist), followed by a few terms at Bryanston, where for a time he took up sculpture and sometimes considers making more. After leaving school in 1939 he studied at the Central School of Arts and Crafts, with Cedric Morris at his school at Dedham, and, in 1942, drew part-time at Goldsmiths' College. In the meantime, by visits to art galleries and the study of reproductions, he gained a wide knowledge of European painting, that of the present century in particular. One of the most ambitious of his early paintings, *The Refugees* (1941), shows, for instance, familiarity with the work of Grosz and Dix. The satiric spirit of the former was a source of lively pleasure to him, but his form seemed to him superficial; he was more deeply impressed by Chinese art, the engravings of Dürer and the paintings of Van Gogh.

In December 1939 he and a friend, David Kentish, rented a miner's cottage at Capel Curig at the foot of Snowdon. They were joined by Stephen Spender, who had become a friend of Freud's the previous year: here he wrote *The Backward Son*, and, stirred by Freud's example, briefly tried his hand at painting. Together they compiled *The Freud-Schuster Book* (Spender's mother was a Schuster). The illustrations are by Freud and both contributed some lively but disconnected text, abounding, like the illustrations, in esoteric allusions and jokes. The themes of the drawings, many of them in ink and wash, some in watercolour, are extremely various. There are portraits (several of them of Spender, Kentish and the artist himself); horses (Lucian, having learnt to ride at Dartington, has had a particular affection for horses ever since); Welsh landscapes and interiors, and many expressions of fantasy, recollections of dreams, of paintings, surrealist concepts and other ideas. A few of them were made after Freud had left Wales. The book took over two months to finish, although 'finish' is a term not strictly applicable to a work which, although replete with wit, acute observation and vision, is without coherent form. Had circumstances been favourable it might have been in progress for two years as readily as two months.

To those familiar with Freud's paintings, the illustrations in *The Freud-Schuster Book* (never published or exhibited and not even seen by many of the artist's friends) offer a surprise due to the contrast between them. The paintings, especially the early ones, are marked by extreme deliberation and precision; the drawings by a playful spontaneity. Freud gave the book to Sir Colin Anderson, a helpful friend and supporter, who, in 1968, returned it to him, inscribed with an amusing poem of his own composition.

At Capel Curig, Freud worked almost continuously, all day and far into the night, although little of what he did survives. (He still works as well by artificial light as by sunlight – and almost always on several paintings at the same time.) The war, however, interrupted the work of all British artists except those employed by the War Artists' Advisory Committee and others advanced in years, and Lucian served for six months in 1941 in the merchant marines. (My own first meeting with him was at the Café Royal just after he had been invalided out; he was still wearing a striped sailor's jersey and was suffering from an injury inflicted in the course of a fight with a fellow-member of the crew.) Lucian began to paint shortly after his discharge, producing *The Refugees* already referred to; *Man with a Feather* (1942), *Still Life with Chelsea Buns* (1942–43), and *Quince on a Blue Plate* (1944).

By the mid-1940s, able to dispense with anything approaching the degree of reliance on other artists apparent in *The Refugees*, Freud

entered upon the first phase of his creativity as a mature artist when he made a number of paintings and drawings that won him a place among the foremost artists of his generation. These are surrealist in spirit but entirely independent of such surrealist devices as torpedo-like clouds, drawers projecting from torsos, liquefied watches and the like. They are suffused with the dreamworld strangeness of the best surrealist art, yet their subjects are entirely credible and belong unambiguously to the world of natural appearances. Among such works was *Dead Heron* (1946), which is worthy of comparison with the superb painting of the same subject made by G. F. Watts at the age of twenty. Freud was amazed, he told me, by its resemblance to Watts's painting when he saw it, nineteen years later, reproduced on the cover of the issue of *The Masters* (of which I was editor) devoted to the Victorian master. There followed *Still Life with Aloe Plant* (1948) and *Dead Monkey* (1950). The time when Freud entered upon his maturity may be dated fairly precisely as about 1946. *The Woman with a Daffodil* (1945) is a naive, almost primitive work in comparison with *Dead Heron* and *John Craxton*, both made the following year.

The fascinated unblinking stare with which Freud fixed his subjects enabled him to represent them in a manner that makes it impossible for the spectator (for this spectator at least) ever to look at them casually: the eye is compelled to see them, down to the smallest detail, with something of the intensity with which he saw them himself. I believe that these quasi-surrealist paintings and drawings will be found deserving of posterity's interest and admiration.

This first phase of maturity lasted but a few years, and by the early 1950s Freud's work showed intimations of a change that was, in less than a decade, virtually to transform it. In this early work, original, poetic, lucid, in which sophistication is tempered by a strain of naivety, some of Lucian's friends supposed him to have evolved a language that would serve him for many years, and they were critical of his modification and eventual abandonment of it. Of course it must be a matter for regret that a phase in an artist's development, when he made works of such unusual beauty, should be of brief duration, but a harder look than those friends gave at the nature of the work and the temperament of the artist would have warned them it was a phase unlikely to be prolonged. For these paintings and drawings are the visual equivalents of lyric poetry and of a poetry of youth, and Freud is the last person to prolong any phase of his art beyond its natural term. In any case increasing skill and sophistication inevitably excluded their strain of naivety. But a far more decisive factor was making itself ever more imperatively felt. This was the conviction that his was a painter's rather than a draughtsman's temperament, which could not find lasting satisfaction in a language that was

predominantly linear. A tendency to abandon detail in favour of broader treatment is often an observable phenomenon, as was noted in relation to a comparable change in Houthuesen's work.

It was perhaps a tendency also innate in Freud, a predestined feature of his evolution. However that may be, it was fostered by at least one outside circumstance. Francis Bacon had been a close friend since 1945 and Lucian's admiration for him was intense. Lucian was one of the smallish number of Francis's friends privileged to watch him at work and in the early 1950s he marvelled at the evocative power of his friend's handling of paint. Until then he himself had drawn constantly, confident that the pen or pencil could fully express his ideas. But this experience made him aware, as never before, of his need to represent *volume*, more naturally fulfilled by the brush than the pencil. In order to stimulate his urge to paint, he told me, he denied himself the delight of drawing. His paintings of the early 1950s show a delicate balance between the linear and the painterly, inclining gradually yet perceptibly towards the latter. This progressive change is charted in the following portraits: *John Craxton* and the Tate's *Self-Portrait* of the same year; *Girl with Roses* (1947–48); *Girl with White Dog* (1950–51); *Francis Bacon* (1952); *John Minton* (1952); *Head of a Woman* (1953) and *Woman Smiling* (1958–60). During the twelve to fourteen years after 1946 the evolution from the linear to the painterly, from emphasis on one-dimensional pattern to emphasis on volume, seemed virtually complete. In the following years, however, all trace of the linear was lost through preoccupation with volume and, increasingly, with paint as a medium, exemplified by such a portrait as *John Deakin* (1965) or *Mike Andrews and June* (1965–66). At first glance the first and last of these portraits might be attributed to two hands as unrelated as those of Ingres and Courbet.

Freud's earlier and later work, however widely different in both vision and technical procedures, are linked by a highly significant attribute of his character: his intense preoccupation with the familiar and the near. Many artists are drawn to depict the exotic, the remote, the imagined, the out-of-focus. Not Freud: he is obsessed by his friends and other familiars, by his immediate environment, a shabby and untidy workroom flat, and its neighbourhood. It is significant of this love of the familiar that since settling in Paddington in 1941 he has never moved away and even his moves within its boundaries – from 20 to 4 Delano Terrace, and thence to 124 Clarendon Crescent and again to 227 Gloucester Terrace – have been dictated by circumstance rather than preference. His devotion to this district has grown stronger with the years, and one of the most impressive of his paintings is *Waste Ground with Houses, Paddington* (1971–72), which

expresses a perception of the particular character of the place in which he lives which puts one in mind of Lowry or even Constable.

Attachment to familiar surroundings does not preclude occasional expeditions abroad. He has made two expeditions to Greece, in 1946 and 1967, and I met him by chance in Paris (which he has frequently visited) in 1953 when he was at work on *The Hotel Room*. This has an element of drama usually absent from his painting, representing the artist standing in near silhouette against the window and his golden-haired companion lying in bed.

Freud observes all of his subjects, human and environmental, minutely and at close range. Yet his vision has nothing of the warmth, the affection, that we usually associate with *intimistes*. On the contrary, it is cold, and with the years has grown as responsive to blemishes as to beauties. On several occasions, when studying nudes as coldly seen as they are intimately depicted, I have recognized them with a start of surprise as friends for whom he entertains a particular affection.

The prime focus of Freud's ceaselessly probing mind are aspects of human personality. When he depicts a cactus, a window, a mattress, his purpose is to provide a setting for the man, woman or child under his unblinking scrutiny – which has issued in portraits (those earlier mentioned prominent among them) which bear comparison with the best portraits of the time. The *Francis Bacon* for its psychological insight, its formal perfection and its aura of a magical strangeness, is a masterpiece.

It was logical that Freud's absorption in quintessential personality should have led him frequently to represent his subjects without clothes. For most painters the unclothed body is a 'nude' – a more or less impersonal figure. Freud's nudes are all portraits, in the widest sense, the absence of clothes giving the fullest opportunity for achieving the likeness of a total personality. The naked body, represented with searching detached candour, is surmounted by a highly characterized head. The impact of a nude by Freud is sometimes startling, for the spectator may find himself unprepared for confrontation not with a 'nude' in the traditional sense but with a naked individual. Although the face is, beyond comparison, a person's most expressive feature, a naked portrait by Freud reminds the spectator that all a body's features contribute, some to a greater, others to a lesser degree, to our understanding of a person. Such a portrait prompts the realization that the 'face-painting' of tradition can offer only a partial view. This realization, of course, serves little practical purpose, for those willing to be portrayed stripped of all protective disguise (especially by a brush at the service of a remorse-less eye) are very few and are unlikely, even in our 'permissive'

society, to become appreciably more numerous. We should be grateful to Freud (and his models) for combining to give us such impressive examples of a very rare kind of portraiture. The most characteristic as well as the most impressive of the group is *Nude* (1965).

It is a sad reflection on the present state of patronage that this impassioned portrait painter has been compelled to accept, in the entire course of his life, commissions far fewer than one would have thought conceivable – those referred to in these pages are of wives (he has been married to Kathleen, daughter of Sir Jacob Epstein, and to Lady Caroline Temple Blackwood) or of friends – and this at a time when serious portrait painters have never been so few. But then, as T. S. Eliot said, human beings can't stand much reality.

Lucian Freud is not a man to develop a style not subject to evolution; his mind is too exploratory and too probing to make permanence likely. His earliest mature style was largely innate: he always worked hard, but it was as though, at first, he was reaping a harvest, gathering something already sown. That severely linear style, suffused with a naive, sometimes surrealist poetry, he determinedly abandoned in favour of a painterly style, adapted to the portrayal of his subjects in terms of volume, which was accompanied by, and perhaps even fostered, a down-to-earth, prose attitude towards them. Nothing could be more different – apart from the informing purpose, the intense probing of a human personality – than the *Craxton* or the *Bacon* portraits on the one hand, and the *John Deakin, Mike Andrews and June* and *Head of a Man* (1968) on the other; than the hieratic idealization of the first two and the focusing upon the 'earthiest' aspects of the subjects of the others.

The change in his vision of his subjects has been accompanied by a change of method. In his earlier work he made no preliminary studies; his paintings and drawings – to quote his own words to me – 'often surprised me by the way they developed'. In his later years he draws in charcoal on the canvas, sometimes for hours, to prove to himself 'that the picture could be done'; this does not preclude his making changes in his designs, however elaborately worked out beforehand. I mention this paradoxical circumstance because it is the earlier work that looks precisely calculated and the later spontaneous.

It is as though the challenge of paint and volume and the quality of the down-to-earth having at last been successfully met, there has been some easing of his determination to exclude every vestige of the poetry of his earlier work. When I visited his studio in 1969 he had just completed *Large Interior, Paddington* which – for me at least – held intimations that the element of poetic strangeness, still an integral part of his vision, is once more, although within severe limitations, beginning to reassert itself.

MICHAEL ANDREWS
born 1920

Somebody once wrote of Michael Andrews that he was in danger of being taken for a rumour rather than a person. Several of the painters who are the subjects of this book are not widely known to the public at large but none is so elusive a figure as he, however ardently admired by several of his most illustrious fellow painters, or perceptively praised by several critics on the rare occasions when he exhibits.

Only two years after he had left the Slade, for instance, he was described in *The Times* (14 October 1955) as 'perhaps the most imaginative and serious young painter we have' – yet he remains elusive and paradoxically little known as both a painter and a man. This is partly due to his being something of a recluse, spending his leisure with his wife and child, shunning public occasions and meeting even his friends comparatively rarely. One of them, of several years' standing and a particularly ardent admirer, told me that he had never seen his studio. His telephone is exdirectory. But his relative obscurity as a painter is due to a greater degree to the paucity and character of his art. Although a hard and able worker, his production is very small indeed, owing to the degree to which each painting is the expression of some deeply felt experience. For Andrews, aims are more important than means. This is an over-simplification, and I will try to clarify their relation later on, but because every painting represents some unique experience, Andrews has not, so far, evolved a consistent or a readily recognizable style. If someone were to come upon a Christopher Wood, a Piper, a Bacon or a Hockney, for example, in an environment entirely improbable, they would nevertheless be able to identify it instantly. With Andrews it is otherwise: I believe that if on the far side of a crowded and noisy nightclub one saw even his most celebrated painting, one would be unlikely immediately to exclaim, 'A Michael Andrews *here*; how strange!' Closer examination would of course evoke a clear recognition – but that is a different matter.

Michael James Andrews was born on 30 October 1928 at Brunswick Road Hospital, Norwich, the second of the three children of Thomas Victor Andrews and his wife Gertrude Emma, born Green. Their

home was at 142 Glebe Road. Thomas Andrews's family were East
Anglian, although his maternal grandmother was Dutch. The Greens
were from Derbyshire. The Andrews family had only one artistic
connection, and that remote: Thomas Breeze, the watercolourist, was
a second cousin of Michael's father.

While at the City of Norwich School, which he attended from 1940
until 1947, he worked during his last year at the Norwich School of
Art. Michael, who felt the artistic impulse for as long as he could
remember, told me that he 'was quite good at art at school, although
more imaginative than skilful'. He was fortunate in the encourage-
ment his parents gave to his ambition to be an artist and in the
proximity of the Castle Museum, with its splendid collection of works
of the East Anglian school; those of Crome and Cotman particularly
compelled his attention.

Michael's parents were devout Methodists whose lives revolved
round their church, but early in life, 'kicking against it', he became an
agnostic, which he has since remained.

After leaving school Andrews served for two years in the Royal
Army Ordnance Corps, nineteen months of it in the vast camp at Tel-
el-Kebir. Discipline was strict, and he was able to see little of Egypt,
but it was there that he made a number of watercolours that he
regards as his first adult works. In the meantime Randolph Schwabe,
the Slade Professor, saw a few of his sixth-form drawings and,
discerning something of promise, kept a place for him at the School.
William Coldstream, Schwabe's successor, confirmed Andrews's
admission, and he studied there from 1949 until 1953 when he was
awarded a Rome Scholarship, tenable for two years. The award
pleased him, but he accepted it with misgiving because he had
become extremely fond of London, and felt that if he left it he would
be renouncing a necessary, comprehensible and glamorous way of
life. Accordingly he remained in Rome, and briefly in Anticoli, only
for five months. On his return he found London as enjoyable as ever.
At the Slade he owed much to the encouragement of Coldstream, the
first eminent painter whom he came to know. After his return from
Italy he taught for four years at Norwich at various times, at Chelsea
from 1962 until 1964, and the Slade from 1963 until 1966.

Andrews also acted in two films, both made by Lorenza Mazzetti,
one in 1953 when they were fellow students at the Slade, called
Metamorphosis, based on a story by Kafka, the other, in 1954, called
Together, based on Carson McCullers's *The Heart is a Lonely Hunter*, in
which Eduardo Paolozzi had a part.

In the meantime he began the slow succession of paintings which
won him the whole-hearted admiration of a still small but steadily
growing number of collectors and critics, but most conspicuously of

fellow painters. The first of these, done while the artist was still a student and, so far as I was concerned, not even a 'rumour', was *The Man Who Suddenly Fell Over*. This I happened to see at the Slade while on a visit to Coldstream just after its completion in 1952, described with enthusiasm to my wife – and forgot. Delightedly reminded of it when it was shown at Andrews's first one-man exhibition at the Beaux-Arts Gallery in January 1958, we bought it for the Tate. Coldstream, who remains a warm admirer of Andrews and owns a drawing of the woman's head in this particular painting, was at the time one of the Tate's trustees. Although in certain respects, in, comparison with his later works, it is technically naive, it clearly exemplifies the intense and complex ideas which almost all of Andrews's painting expresses. On 16 July 1958 he wrote to the Tate:

> About the picture. I didn't see it happen as far as I can remember though I have seen big people fall down. It's a catastrophe and as stunning and bewildering as the fable of the sky falling always seemed to be. It's about the complete upsetting of someone's apparently secure equilibrium and about their almost immediate efforts at recovery and their attempts to conceal that they *have* perhaps been badly hurt or upset which would only be allowed to show if they were by themselves.

A painting of the following year – the only one he made in Rome while on his scholarship – is *Lorenza Mazzetti in Italy*, which shows her in Piazza di Spagna (also included in his first exhibition at the Beaux-Arts Gallery). While it also gives an intimation of his powers, it shows little of the intellectual and emotional impulses by which its predecessor and the more significant of its successors are inspired. Technically it is a tentative work in which the sober, tonal, painterly handling deriving from the example of Coldstream combines with a clarity of composition indicative of his study of early Renaissance Italian masters.

Andrews works very slowly, producing at most two or three big paintings a year, and rather more small ones which he regards not as complete works but as experimental preliminaries. (Until he saw how much faster other Slade students worked he was unaware of his own slowness.) Usually he works only on one painting at a time, but in the process, particularly near its end, he realizes that it has given him ideas for its successor, and that, although this may not be readily apparent, there is accordingly some degree of continuity in his work.

It was not until the mid-1950s that he began fully to understand the real potentialities of his gifts, as shown, for instance, in a painting such as *Four People Sunbathing* (1955), in which one characteristic that was to mark his work is apparent, namely figures informal in posture and disposition but formally related to one another and with the utmost care, likewise to their environment. When this painting was

shown at the Institute of Contemporary Arts in 1955 (characteristically his was a single contribution to an exhibition 'Eight Painters'; one of the others showed ten) his note on it concluded that the people sunbathing 'were supposed to have plumped themselves down unceremoniously – but formally with respect to their surroundings'. Not all the figures in his future paintings are 'plumped down', although they are often seated or recumbent, but this sentence indicates Andrews's preoccupation with representing the casual subject in formal terms. But the representation in formal terms of figures casually posed is in itself, of course, no innovation; this is precisely what Seurat – to cite a conspicuous example – so consistently did.

Andrews is a highly complex painter. He belongs, unequivocally, to the 'modern' movement. In a conversation he referred to some of those by whom he was affected: 'Auerbach, Bacon, Tim Behrens, Harry Cohen, Uglow, Freud . . . Kitaj.' Talking with me about Duchamp and Klee, he said, 'In the light of Duchamp I can do without Klee.' Yet in spite of his intimate 'modern' affiliations, his subjects are in one important respect traditional: they are often groups of people – sometimes large groups – in landscape or interiors, some-times a combination of both. One reason why Andrews's work evokes such intense interest in those – not yet very numerous – who know it, is the way in which he uses contemporary means to represent such conventional themes as people sunning themselves in a field, a family sitting in their garden, people in night resorts and the like.

It is clear that he could not represent traditional subjects in a traditional manner without inviting the acute boredom of the spec-tator. The fact that traditional realism, which reached such inspiring heights in the seventeenth, eighteenth and nineteenth centuries, now appears to have exhausted its potentialities, and that the photograph would in any case have deprived it of the magic it earlier exercised, compels those few painters who still represent complex traditional subjects to evolve entirely new approaches. This, cautiously and at times haltingly, is what Andrews has done, and what he had in mind when in *Notes & Preoccupations* (*Volume One*, 1959–62) he wrote, by themselves, the two words 'Mysterious conventionality'.

More original, although at first sight more conventional – having, for instance, no exaggerated feature, such as the elongated leg of the central figure in the early *Four People Sunbathing* – is the very large *Family in the Garden* of his own family made during the summers of 1961 and 1962. As his family were not easily persuaded to sit for the requisite length of time, he worked closely from studies made while the painting was in progress, which he transferred to the canvas, even using photographs as additional guides. This painting of his

family having tea in their garden – it would be difficult to name a more conventionally English subject – nevertheless has overtones of strangeness, persistent if not obvious. But in the year of its completion, Andrews painted another which represented a deviation from his belief that, difficult although it is to distinguish them, ends are more important than means, namely *The Colony Room* (in which Francis Bacon and Lucian Freud figure in a group of friends in this celebrated night resort); Andrews has told us quite simply that 'technique had become an aesthetic and this wasn't appropriate to what I wanted to do'. This is more evident in the first of his major works, *The Deer Park*, inspired by Norman Mailer's novel of that name.

Gradually the procedure of making drawings, small studies and of drawing on the canvas came to be supplemented and even superseded by photographs, many clipped from newspapers and magazines of which he has a large number tacked on to the walls of his studio; of works of art, of heads and figures by Giacometti (for whom he has a particular admiration), of historical events (one, for instance, of a group of settlers taken during the Matabele Revolt); others of cities, London and New York by night, with hundreds of lighted windows; of balloons and scores of other subjects.

The photographs taken for his *Family in the Garden* were primarily substitutes for drawings, because of his difficulty in persuading his relations to sit, but in *The Deer Park* it was otherwise. For this he did indeed make a few preliminary drawings but it was photographs that played the integral part in its composition. *The Deer Park* was immediately followed by *All Night Long*, an even larger canvas which is based entirely on photographs, some of which he acquired while working on *The Deer Park* (one of them, suggesting the central group, played a crucial part).

I shall not forget my own first sight of it. Andrews was personally unknown to me. A considerable time had passed since I had seen any of his work, when Tilly Dower, a painter of talent, the daughter of our neighbour in Oxfordshire, took me to his studio. At that time – it was 1964 – he was living at 3 Duncan Terrace, Islington. *All Night Long*, almost completed, would have dominated a much larger room. Its huge scale, panoramic character, brilliant colour, and its nightclub themes compelled my prolonged attention and seemed an amusingly improbable production for the slight, apparently shy and unworldly young man who welcomed us in so friendly a fashion. The gentleness of his manner does, however, mask a strong will.

It is a painting that exemplifies 'mysterious conventionality'. A panoramic view of numerous figures in a waterside resort on a hot night: a distressed woman trying to support a drunken man, a couple making love, a group of naked intruding bathers going towards a

swimming pool or sea inlet, several in bathing clothes lying on chaises longues, people talking and drinking, a man playing a saxophone, among others. The setting, like that of *The Deer Park*, is part interior and part landscape. Every group or individual figure, he has told us, was based, directly or with modifications, rarely radical, on a photograph. Again, as in *The Deer Park*, the spectator is introduced as though he were a familiar, who feels free to wander about in this exotic panorama. Anything approaching *la belle peinture* is systematically avoided – the brushwork at various points indeed looks deliberately casual, as though this huge painting were merely a preparatory study, but the composition is highly professional and gives the whole an air of grandeur. It is marked by an astonishing variety: elements of orgy, forced cheerfulness, genuine enjoyment, indifference, boredom, acute loneliness and much else are to be discerned among the figures in their tawdry, pseudo-luxurious setting. Just as Rembrandt could ennoble the head of an ugly old man, so has Andrews given this scene of vulgar pleasure-seeking an aura of dreamlike beauty.

Being at the time of this visit Director of the Tate, I asked the artist whether I might bring it before our trustees with a view to its purchase. 'I wish you could,' he said, 'but the Felton Bequest have just bought it for Melbourne.' Another of his major paintings, a triptych completed after three years' intensive work in 1968, is cryptically titled *Good and Bad at Games*.

In the conversation with Victor Willing already quoted from, Andrews said, 'I think a painting should be clear. It worries me when I look at other people's paintings if I haven't the slightest idea of what they're about.' However easy it may be to understand the meaning of a number of his earlier paintings – nothing could be more comprehensible than his block of *Flats* (1959) in his second exhibition – it would be difficult to think of a contemporary painting more difficult to have 'an idea of what it's about' than *Good and Bad at Games*, his series of the large oil paintings just mentioned. It has nothing whatever to do with games and only peripherally with good and bad. It is set, to use his own words to me, 'in the sort of place parties might be given in'. 'Good' and 'Bad' refer not to athletic skill and very remotely to moral qualities, although it is relevant to recall his statement (in his *Notes*) that 'Every aesthetic adjustment reflects an ethical preference'. It is a painting primarily symbolizing the ascendency of the positive qualities – intelligence, vitality, strength, creativity – over their opposites in terms of social behaviour; a complicated social game in which the success of those possessing some or all of the first qualities is shown by their growing larger as

the series progresses, and those who do not diminishing. Alluding to the series in a letter to me (17 February 1973) he wrote:

> I was thinking about the variable effect a number of people (initially a group of ten) had on each other. The chosen conventional occasion was a party at which people noticeably behave in one way or another. – This might range from, or change gradually from, stage fright to indifference or boredom, or someone's composure or agitation might remain almost unchanged. At any rate I was trying for a definition of how these fluctuations of self-consciousness showed.

Both heads and figures reveal Andrews's ardent admiration for Giacometti, and several of them closely resemble certain of those in a photograph of a group of his sculptures on the studio wall. What differentiates *Good and Bad at Games* from its predecessors is its dreamlike, even at certain points nightmarish, quality. In my opinion it is, with *All Night Long*, his finest work.

In the later paintings Andrews's use of photographs is far more radical; in the earlier he used photographs as he might have used studies, but in *Good and Bad at Games* photographs were silk-screened onto the canvas, then worked on, and modified, with oil paint.

Speaking with specific reference to *Good and Bad at Games* but with much of his work in mind, he said to me: 'My vision is clear when I start, then it becomes obscured, then suddenly something happens to bring it into focus again – but I invariably think I will finish it more quickly than I do.'

His *Lights III: the Black Balloon* (1973), the last of a series of three of the same subject, was carried out not with a brush and oil paint but with a spray-gun and acrylic (which he had never used before the balloon paintings). It is as suave and highly finished as its predecessors are the opposite: as someone wrote of him, 'his stylelessness is almost doctrinaire'.

'All my paintings have a psychological significance,' he wrote to me. 'My greatest satisfaction is to have defined something I really mean.' The balloon paintings – suggested by photographs of balloons which he had clipped from newspapers and tacked to his studio wall – are for him highly symbolic, the balloon being an 'ego symbol', subject, like a person, to inflation, deflation – and accident; 'its buoyancy or well-being' (to quote from the same letter) 'is affected, or noticeably changed, by circumstances.' Discussing his identification of the balloon with a person, he showed me the following quotation from Alan Watts: 'the prevalent sensation of oneself as a separate ego enclosed in a bag of skin', which he said precisely expressed the sensation which impelled him to paint his balloon pictures.

Andrews reads widely and, as he paints, slowly but intensely:

Conrad, Proust, detective stories, but most of all Kierkegaard ('his ideas,' he said to me, 'fall over me like fructifying rain').

To say that an artist's work is an expression of his intimate self is a commonplace. Yet it is also true that the work of some artists is a more intimate, a more personal expression than that of others. Some professional portrait painters, for instance, away from their subjects, travelling, hunting, fishing or just walking about, may not, for the time being, be deeply involved with their art. But virtually nothing experienced by Andrews is not, directly or by oblique allusion, expressed in his painting. And not only visual experiences. In his *Notes and Preoccupations* he wrote: 'The most vivid visualization [is] sometimes prompted by something written or spoken'; and, 'The painting episode is a real situation imagined'; and, 'To feel I am placing the brush on the place, on the real thing'. I am not an intimate of Andrews's, and to pretend to be able to discern all or even many of the experiences expressed in his work would be presumptuous, but I know no artist – in spite of the smallness of his production – who includes in his art so wide a range of deeply felt personal experience, whether of his environment, the companionship of others, of his thoughts, profound or casual, or of his reading.

ALAN REYNOLDS
born 1926

Many of the most talented artists have no family associations with the arts, nor special opportunities of seeing works of art. One notable example is the subject of this chapter.

Alan Munro Reynolds was born on 27 April 1926 at 11 Stanley Road, Newmarket, of a family of four, two boys, of whom Alan was the younger, and two girls. Their father, George Munro Reynolds, was of Scottish origin and a stableman. His mother was Margaret, born Holloway, at Newmarket. Although born in a town, Reynolds became, and has remained, a countryman. The surrounding country was largely enclosed for horse breeding, shooting and angling, and so he quickly learned to be an astute tresspasser. His delight at being able to exchange fishing rods he had made for a biscuit tin filled with old tubes of oil paint expressed his dedication.

After leaving school in 1940 he worked as a labourer and later as a fitter with the Royal Electrical & Mechanical Engineers in motor vehicle workshops, where he was sufficiently well paid to enable him to devote some four months to drawing and painting; this without having received any tuition. During the later war years he served with the Suffolk regiment, the Highland Light Infantry (he welcomed, owing to his closeness to his father, being with a Scottish regiment), and when his territorial battalion was disbanded, was transferred to the Wiltshire Regiment. He spent five months in the Front Line in Holland and Germany.

Three years with the Army were highly conducive to his development as an artist. When the war ended, being too young for immediate demobilization, he studied art at Göttingen University, where the army had established a department of education, also of music and teaching. It was there that he received his first instruction in drawing and painting, and was allowed to draw in a plaster-cast room at night. In Hanover he served as an instructor in visual education; at the Landes Museum he was able to visit and revisit an exhibition of modern art condemned by the Nazis, which included works by Der Blaue Reiter, Die Brücke and the K. Hannover Groups. At about this time he also studied the art and writings of Paul Klee, from which he derived intense and abiding stimulus. Accordingly he returned to

194

England familiar with, besides the art of Klee, that of Mondrian, Schwitters, Bucholtz, Dexel, Albers and a number of other members of these groups. Along with Klee, the most decisive influence was Sophie Taeuber-Arp, who, with Hans Arp, her husband, was a versatile and experimental early abstractionist.

After his demobilization in 1947 Reynolds was accorded a government grant which enabled him to become a full-time student at the Woolwich Polytechnic School of Art, where he remained from 1948 until 1952, when he was awarded a scholarship at the Royal College of Art, studying there for a year. Not caring for the prevalent gregariousness, he spent as much time as he was able in the Victoria and Albert Museum studying the watercolours of Turner, Blake and Palmer. But not all his time, however, for in his first year he was awarded the medal for painting.

Reynold's deepest interest remained the artists whom he had studied in Germany, but their influence and those of the other Continental artists referred to was not, in a radical sense, immediate, although it did indeed imbue his early work with an aura of cosmopolitan sophistication. It was not until some years later that this fully asserted itself. The extent of its effect on his earlier work may be assessed by comparing it with that of Palmer, a master he particularly admired. It belonged indeed to a different age and was the creation of one with wider experience, but it expresses a similar dedication to a poetic, local vision of landscape. Indeed, visiting his fourth exhibition, 'The Four Seasons' in 1956 at the Redfern Gallery – where his first was held in 1952 – and hearing it discussed by perceptive visitors, I recall no references to Continental affinities. The exhibition was a conspicuous success.

Such success was amply deserved, for these Shoreham Valley landscapes – it was his love for the work of Palmer that drew Reynolds to this region – are rare achievements, revealing the realistic, penetrating perception of a countryman imbued with an original poetic vision. Their combination of delicate foreground detail with vast and varied expanses of radiant sky is expressed in, for instance, *Autumn*; and of a sinister darkness in *Winter*. The dense rows of hop-poles are realistically portrayed, yet they have the fascination of the complexities of imaginative forms in a fine abstract work. These paintings, once seen, are not easily forgotten.

The catalogue of the exhibition was a luxurious publication with four large colour reproductions and a substantial text. The exhibition was sufficiently successful to encourage the same gallery to publish, only two years later, another almost equally luxurious catalogue to accompany Reynolds's second one-man exhibition. That same year his first New York one-man exhibition was held at the Durttacher

Gallery and he was also represented at the Pittsburgh International. In 1953 the Tate Gallery accepted the gift of his *Keeper of the Dark Copse II* (1952), which had been included in the first Redfern exhibition, and I cannot recall any objection on the part of the trustees, nor to the acceptance of *Summer: Young September's Cornfield* (1954).

It seems at this point relevant to note that Reynolds was never a careerist: had his work not brought him success he would never have modified its character. He avoided social contacts with other than his friends and, student years apart, he never lived in London but always, during the time when he painted landscape, in places with the deepest appeal. These were Belvedere, near Erith, Kent, from 1947 until 1954; Blackheath, 1954 until 1957; Sevenoaks, Kent, 1957 until 1958. Only in that last year when his work was becoming abstract did he settle in Cranbrook, Kent, with his wife Vona, born Darby, whom he had married on 8 March the previous year.

In his earlier years especially Reynolds delighted in poetry and was an avid reader of Coleridge, Blake, Hardy and some of his own contemporaries, Dylan Thomas among them. But poetry – after painting – was never the art that moved him most deeply. 'Music', he wrote to me, 'has always come first. From childhood it has been a dominant influence on my work and my life. It has helped me amongst other things to think in terms of form and its clarification. More important I feel is that music has the power to sustain and develop one's spiritual growth or development. I enjoy most music but especially that of Bach and Mozart, the first and second Viennese schools and, of course, the composers of our own century. Since I always seem to be working on my own things I tend to play music a good deal whilst working'. Among other composers he has spoken of are the early Italians and Elizabethans and, among contemporaries, Mahler, Nielsen, Ravel, Boulez and Stravinsky.

But painting remains Reynolds's most passionate preoccupation, and on the walls of his house hang reproductions after Dürer, Rembrandt, Palmer and Klee, as well as originals. 'Over the years' he said, 'I have got together a little collection of prints and drawings – some the work of artist friends or students acquired often by exchanging works with them – I shudder to think of being in a house without pictures!'

Oddly, this intensely creative man, so deeply concerned with his own work and so responsive to painting, music and poetry, enjoys teaching, although he finds it arduous, and he taught at the Central School of Arts and Crafts from 1954 until 1961, and since then for three days a week at the St Martin's School of Art.

Over the years his own art has evolved steadily and eventually

radically. Someone familiar only with his *Four Seasons* and similar works or the numerous plant studies he made about the same time might intelligently assume that he is a traditional realist, although of a highly individual character. Yet the more closely these are scrutinized the more apparent it becomes that his romantic landscapes – and a number are highly romantic – have about them an austere structural equilibrium. The structure of Reynolds's paintings is predominately based on the relation between the horizontal and the vertical. The work contemporary with, or even earlier than, *The Four Seasons*, and others of a similar romanticism, feature conspicuously structural elements, for instance: *Moth Barn* (1952), *The Fir Tree* (1952), *Keeper of the Dark Copse II*, to name a few among a considerable number. While in *Seeding in Winter* (1953), the structural elements are so dominant that for a moment it is difficult even to identify the subject. In other works of the same years the horizontal and vertical are conspicuous in the picture's division into four or more rectangular parts, each one complete in itself.

By 1958 the abstract had asserted itself in Reynolds's work, as, for instance, in *Lyric Abstract Kent*. From the following year the abstract had become – and has remained – entirely dominant; the 'subject' is no longer featured.

The process was a strange one. The immense appeal of the Blaue Reiter group, in particular of Klee, remained, but in his early years Reynolds was not sufficiently comprehending of the basic motives which inspired them – hardly surprising in so young and aesthetically inexperienced a man – but as the years passed his comprehension increased. It is fortunate that the process was a slow one: otherwise his poetic landscapes might never have been painted.

It may seem paradoxical, but the most radical change came about so suddenly that he felt he was becoming repetitious – the shock of abandoning the subject, primarily landscape, which had so deeply moved him, although entirely voluntary, must have played its part, and in 1958–59 he destroyed some thirty of the paintings he had made during those two years. Five, however, he preserved. For the next half dozen years or so he continued to make oils and watercolours, with increasing emphasis on the horizontal and the vertical. 'Work', he once called it, 'of an improvisatory nature'. I think his judgment was correct. He had abandoned landscape, and these tentative early abstracts, made when his art was undergoing a radical change from highly poetic landscape towards abstraction, are the least impressive of his career. This period, marked by an element of uncertainty, ended during 1969 with a group of three-layer reliefs of painted woods. Curvilinear in form, they were influenced by the work of Sophie Taeuber-Arp; or, as he terms it, of 'intuitive structure'.

In the mid-1970s Reynolds turned to a more austere, more emphat-
ically rational approach, making constructional reliefs, sometimes
based on standardized blocks of wood or wood and card. 'The
subsidiary forms', he says, were 'finalized' through intuitive decision-
making. From 1976 he also made free-standing constructions of
painted wood, partly of standardized components but basically
improvisatory. The most expressive, it seems to me, of the spirit in
which he now works are his painted, (usually in black and white) low
or three-layered reliefs, mostly on wood, for instance *Small Structure
II* and *Trio* (both 1975), *Construction 3×3 (B)* (1977), and *Structures-
Group II (B)* (1979).

Characteristic, too, are the austere, three-dimensional, free-stand-
ing constructions of white-painted blocks of various shapes and
dimensions, such as *Vertical Construction III* (1977), *Modular Construc-
tion* (1978) and *Modular Construction 1980*. But the most austere of his
recent works are pencil drawings on paper, several composed of
sixteen squares of equal size, but varying in shading from light to
dark, such as *Modular Study, K & N* (1980).

Reynolds's abstract works combine basic mathematical principles
with his own imagination. All are of an extreme austerity, but he
abhors the idea that they are in any sense mechanical, which indeed
they are not. A letter to me of 8 August 1981, relating to some notes
on his later work concludes, 'I feel this sounds too matter of fact, but
the *spirit* behind the will to form I cannot define, or for that matter
one's need to address the *spirit*'.

Reynolds's early and late work could hardly differ more radically
(I omit the years of change) except that both manifest his integrity
and his rare technical accomplishment. This transformation brings to
mind that undergone by Victor Pasmore a few years before – from a
radiant yet acutely perceptive power of evoking particular Thameside
landscapes, to an absorption with the underlying geometry of his
subjects' composition. These qualities were shared by Reynolds,
whose chosen subjects were certain areas of Kentish landscape. There
was, of course, nothing original about the rejection of traditional
realism, but the cause in the case of these two painters was different.
'I believe that abstraction', Pasmore explained to me, 'is the logical
culmination of painting since the Renaissance'. Reynolds, even while
he was painting his Kentish landscapes, still felt much of his early
fascination with Klee, Taeuber-Arp, Mondrian and many of their
contemporaries. Abstraction was accordingly already in his blood,
and once he had represented his chosen landscapes with such
completeness, such poetic insight, he had achieved a specific aim,
and his ever-present youthful fascination suddenly asserted itself,
except in work 'of an improvisatory nature' and work of the late

1950s to the late 1960s, when he was feeling his way towards the expression of certain of these artists' ideas which had moved him so deeply.

Apart from his work of these years Reynolds always expressed himself with an impressive conviction and accomplishment, whether in his imaginative, highly complex Kentish landscapes or the works from which they differed most radically, for instance the austere, geometric, three-dimensional constructions of the late 1970s and the 1980s. However radical this difference – and it could hardly be more conspicuous – they were not arbitrarily arrived at, but expressions of an outlook undergoing logical changes. But who among the visitors to 'The Four Seasons' exhibition would have believed that Reynolds, only twenty-odd years later, would be making the *Modular Constructions*? Yet in spite of the wide variety of his work, his rare talent and the consistency with which he had followed the guidance of the *spirit* behind the will to form', Reynolds has made a lasting impression on his many admirers.

ELISABETH FRINK
born 1930

Many sculptors have experienced uncertainties and difficulties in beginning their careers. Reg Butler and Lynn Chadwick, for instance, were originally trained as architects, Joe Tilson as a carpenter, Robert Adams worked at an engineer's, a timberyard and a printer's and was only able to study sculpture at night school, while John Hoskin, Kenneth Martin and his wife Mary began as painters. Yet sculptors – and sculptors of attainment – they all eventually became.

Elisabeth Frink was fortunate in that she became a sculptor at an exhilarating moment when sculpture, through Henry Moore, had become a focus of unprecedented interest in the British art world, and the work of Europeans – Giacommetti, Manzù, Richier and Greco – was, with the ending of the war, becoming familiar.

Elisabeth Frink was born on 14 November 1930 at The Grange, Thurlow, Suffolk, the elder of the two children of Herbert Ralph Frink and his wife Jean Kathleen, born Conway-Gordon. They had met and married in India. He was an army officer of partly Dutch and partly Huguenot family established in Canada. There, however, Herbert Frink's father was unhappy; he went to Peterhouse, Cambridge, and settled in England. The Conway-Gordons were also of partly Huguenot descent but Jean was a Catholic. Elisabeth attended the Convent of the Holy Family at Exmouth in Devon, where between the ages of twelve and thirteen she began to draw with sufficient promise to be given extra lessons. She went on, in 1947, to the Guildford School of Art where her interest in painting declined and, immensely stimulated by her discovery of Rodin, she determined to be a sculptor. In 1949 she transferred to the Chelsea School of Art where Henry Moore was a visiting professor; her contacts with him, although brief and infrequent, were important. Her most influential teachers were Bernard Meadowes (who had been one of Moore's assistants before the war) and Willi Soukop, a Viennese by birth and training, who broadened her awareness of Continental art.

At Chelsea, Frink's ability as a sculptor began to win recognition and in 1953 she was appointed a member of the staff, a post she held for some ten years. She also taught at St Martin's and was appointed a visiting instructor in 1964 at the Royal College of Art. She began to

exhibit, with two other sculptors, at the Beaux-Arts Gallery in 1952 (from which the Tate Gallery bought, the following year, her *Bird* [1952]). I recall my admiration and astonishment that a work of such sophisticated power should be made by a woman of only twenty-two.

From the mid-1950s Frink's growing reputation won her public commissions. The first was a large concrete *Wild Boar* for Harlow New Town and *Blind Man and His Dog* for a new housing estate in Bethnal Green, both completed in 1957. Five years later she made a lectern in the form of an eagle for Coventry Cathedral. Other commissions followed: the façade of the Carlton Tower Hotel in 1959; *Winged Figure* for Manchester Airport and *Kennedy Memorial* in Dallas (both 1963); *Horse and Rider* (1975) for Piccadilly; an altar cross for Liverpool Catholic Cathedral (1968); a *Group* (1975) for Paternoster Square; an occasional portrait, including *Sir William Walton* (1975) for the Festival Hall and *Sir John Pope-Hennessey* (1976) for the British Museum. In 1955 she held a one-woman exhibition at St George's Gallery and in 1958 joined the Waddington Galleries, nine exhibitions of her work being held there between 1959 and 1976.

In 1955 Frink married Michel Jammet, eldest son of the proprietor of the celebrated Dublin restaurant of that name. The marriage ended in 1963 and she married Edward Pool and settled in France, living in the South, not far from the Camargue, but retaining her studio in Park Walk, Chelsea, later taking a larger one in the same street. They returned to London in 1965, settling in Putney. The marriage was dissolved in 1974 and she married Alexander Csaky and they settled in Westminster in 1977, she having worked since 1973 in a converted warehouse in Lant Street, Southwark.

In comparison with contemporary sculptors, Frink early realized the nature of her basic aims, and the principal changes in her work have related closely to her technical procedures. Her sculpture is built up by successive operations in plaster (she dislikes clay). In earlier years it was rough, or, to use her own term, 'spiky' in finish. In this respect it was no doubt affected by the contemporary sculptors whom she most admired – Giacometti, Armitage and Chadwick. In fact, fast, rough finish frequently marked the work of her immediate seniors, for example Armitage's *People in a Wind* (1956) and Chadwick's *Winged Figures* (1955). The 'spiky' finish is perhaps most conspicuous in her *Dead Hens* (1953, 1957) and *Dead Cat* (1956) which, reflecting her remorseless preoccupation with suffering, are stiffly twisted in the agony in which they died. Another aspect of her work, exemplified by the more ambitious *Blind Beggar and Dog* (1957), showing an alert dog and his helplessly dependent owner, expresses a moving humanity. Something of the same pathos is expressed, although more

obliquely, in *Dead King* (1963). But the emotion Frink expressed most often, and I believe most successfully, was aggression, an aggression impelled not by gratuitous cruelty but by predatory instinct, as expressed in her many birds, winged beasts and boars.

There is one creature, however, that Frink represents as neither pitiful nor aggressive: the horse. Her father was a cavalry officer, serving in the Dragoon Guards and eventually commanding the 25th in Burma. She was familiar therefore with horses and learnt to ride in early childhood and accordingly represents horses with rare and gentle insight. Three of her most impressive are *Lying Down Horse* (1971), *Sleeping Horse* and *Larger Rolling Over Horse*, (both 1972). 'Rolling over' in this context refers not to the horse's posture but to the fact that it can be seen equally well however placed or held). I know of no contemporary portrayal of horses that excels them. Those of Marino Marini, impressive for their energy, show less anatomical observation; their legs, for instance, are formal by comparison.

In one respect, Frink's sculpture has undergone a substantial change in technical procedure. In her earlier years artists were apt to regard the material in which they worked almost as a partner. Moore, for instance, held that 'the material can take its part in the shaping of an idea. Stone, for example, is hard . . . and should not be falsified to look like soft flesh . . .'; and Francis Bacon said, '. . . I don't in fact know very often what the paint will do, and it does things which are very much better than I could make it do . . .'

This sense was widely shared by Frink's contemporaries and her earlier works show that she felt the same. Frink's use of material, however, has undergone a steady but continuous evolution. Her rough-surfaced birds and warriors won her a place among the outstanding sculptors of her generation. This roughness resulted from the roughness of her handling of wet plaster, slapping it on, smoothing it, letting it dry, then breaking it up. She early had an ambition to carve, but the speed with which her ideas developed as she worked made plaster a far more appropriate medium; also because the bronze cast preserved the surface of her fierce modelling. For a number of years she continued to produce fiercely modelled works, side by side with others of smoother, sometimes very smooth, finish, expressive of a serenity of outlook. The character of several of her subjects, in particular the heads of soldiers, became smoother in finish as they became less aggressive, sometimes, indeed, positively serene in character.

Many, perhaps most, serious artists today tend, to a greater or lesser degree, to be realistic in their early years and as they develop incline to formalization or abstraction. Frink's evolution has been in the contrary direction: from a rather fantastic realism towards a more

traditional realism – a realism not remotely inconsistent with her formidable originality. An early expression of this evolution is titled, appropriately enough, *First Man* (1964): massive, smooth-surfaced and lifelike. Similar in treatment are the *Boars* (1969) and the *Small Boar* (1971). These are rather less smooth, but a boar's coat is less smooth than a man's skin. But the smooth, lifelike character is most conspicuous in *Horse and Rider* (1969), in Piccadilly. It is not often that the influence of others' work is apparent in her work, but the eagerly extended horse's head in *Horse and Rider* resembles fairly closely that in Marino Marini's *Horseman* (1947). Frink's *Heads* have undergone a somewhat similar transformation, as is evident by comparing the *Goggle Heads* and others of the late 1960s with *Tribute*, a group of four heads of some ten years later.

The evolution from the early works – rough in texture and remote in varying degrees from 'life' – was not uninterrupted. As late as 1967 Frink produced four works – *Mirage Bird*, *Mirage I*, *Mirage II*, *Mirage* – which are neither birds nor mirages but creatures of extraordinary fantasy: bodyless, wingless, huge, wide-mouthed heads on long, elegant legs. These reveal her mastery of anatomy and, however fantastic, they are wholly convincing.

One of the anomalies of Frink's subjects is that her birds are often wingless, or virtually so, and standing, whereas a number of her men have wings. In the series of four *Homme Libelluls* (1965), for example, they are literally in flight: *Horizontal Bird Man* (1962) and *Flying Figure* (1966), to cite two among a number; several, such as *Fallen Bird Man* (1961), have not the slightest intimation of wings.

Until recent years Frink's human subjects – a few portraits apart – were men. Complicated explanations have been given, but I believe the fact is simple: Frink preferred gaunt figures. *First Man* is rounded, almost rotund, but he is among the few exceptions. The male body suited her preference for the straight, elongated figure, as it did Giacometti's. However, since 1964 her male figures have again become massive and rounded. Frink rarely sculpted women, except in a few instances to carry out commissions, until quite recent years, although on occasion notably. An early example is *Tribute to Human Rights* (1970), but outstanding is *Walking Madonna* (1980), a large bronze figure of Our Lady, who is now striding purposefully across the lawn outside Salisbury Cathedral – a figure of rare nobility.

Frink has a wide-ranging knowledge of the work of her contemporaries, and since her student days has had an ardent admiration for Rodin. Among earlier artists she has an affinity with Grünewald, especially with his gaunt Christ in the Isenheim Crucifixion at Colmar. A sculptor of rare power, her knowledge of the work of other artists has never compromised her own tough independence.

I have written of Frink only as a sculptor, but 'drawing', she said to me, 'is as important as sculpture: one goes with the other'. In her drawings she nevertheless reveals markedly different qualities. Some she uses as the bases for sculpture, although she does not look at them while she sculpts. She is fortunate in having an almost photographic memory, and recalls how irritated she was at art school when told to 'bring your sketchbook', for she has never needed to keep one. All the drawings she makes, whether for sculpture or for their own sake, are complete. They differ from her sculpture to a far greater degree than those imposed by differences in media. Moore's drawings, although they are marked by different characteristics, are obviously by the same hand. Frink's are not; indeed, they are often conspicuously different. In her drawings she uses a sharply pointed pencil to depict subjects that are hardly possible in sculpture. For instance, in *The Lioness*, one of her illustrations for *Aesop's Fables*, the delicacy of the eyes and nose, the suggestion of fur around the nose and jaw, are expressive of the extraordinary acuteness of her observation and the retentive precision of her memory, as well as of the animal's massiveness and formidable strength.

Aesop's Fables, containing reproductions of forty-six of Frink's drawings, was published in 1968. The animals, in particular those depicted in 'The Hare and the Hound', 'The Monkey and the Dolphin' and 'The Lioness', represent their subjects with original, delicate poetry and an impressive economy and appear to be adaptations of Greek vase paintings. However, the human figures in, for instance, 'Venus and the Cat' and 'The Man and the Satyr', lack the originality of the animals.

Four years later, Chaucer's *Canterbury Tales* appeared, illustrated by nineteen of Frink's etchings drawn directly on copper plate. It is an impressive achievement. Although the prints admirably interpret the varied humour and drama of the *Tales*, they lack the linear subtlety of her illustrations for the *Fables*. A feature of both volumes is the use of delicate shading to emphasize certain figures. In the *Tales* figures and objects are often in silhouette, which conveys, it seems to me, Frink's vision less well than the purely or almost purely linear technique of the best in *Aesop*.

Two other books which include Frink's illustrations are *The Odyssey* (1974) and *The Iliad* (1975). In one respect they differ from the earlier volumes in that the figures and other features are either purely linear or else completely coloured. Both books are impressive productions.

Although slight and sketchy, certain of Frink's lithographs of birds and animals are notable. *Owl*, *Wild Dog* (both 1967), and *Horse and Rider IV* (1971), besides being highly accomplished drawings, show exceptional understanding of the character of bird and horse.

Strangely, these are markedly superior to her etched illustrations, for example Chaucer's *Canterbury Tales* or *Sir Topaz*, which include lifeless silhouettes drawn with a bored hand. In whatever medium, the work of this outstandingly accomplished artist is all of a serious quality, but there are inevitably differences of degree. Frink is at her finest as a sculptress, in particular, in her earlier years, with menacing, predatory subjects, whether birds, animals or men, also with horses, although these show no intimation of either characteristic – but less so with men without purpose, passive figures, such as the several *Spinning Men* (1960), or *Fallen Bird Men* (1961). I find the significance of such works as these elusive. Discussing these she spoke of them as 'committed to space' and of their 'acceptance of the elements'; of her own dreams of 'falling through space'; of the impression made on her by Valentin (the French bird man) before he jumped to his death. But the later bird men which appear to have evolved from them, flying even though wingless, such as *Horizontal Bird Man* (1964), or *Small Bird Man* (1964), on the point of flight, suggest perhaps that she recognized that the earlier were too passive.

The *Spinning Men* and *Bird Men* are not the only category which eluded me. The other is the series of massive, shallow-featured heads of 1967–69, several wearing dark spectacles. 'I was in France', she explained when we were discussing them, 'when the Ben Barka case was being tried. Temporarily my interest became political, and I attempted to represent some of the hideous people involved in the prosecution. Many wore these dark glasses. So mine are "political heads".' The heads of 1975–76, the group of five men's heads exhibited in the latter year at the Waddington and Tooth Galleries, are marked by an element of pathos: they have the look not of persecutors but of victims.

At her best – and she is often at her best – Frink is an outstanding draughtsman as well as one of the outstanding sculptors at work today. 'I think my sculpture,' she said – she might have added drawings and prints – 'are about what a human being or an animal feels like, not necessarily what they look like. I use anatomy to create the essence of human and animal forms'.

The recognition that Frink's work, however original, and her personality, however fiercely independent, now receives, provides an illuminating comment on the changed attitude of the official world towards originality and women. The evolution of her art towards a realism that has enhanced its originality; her detachment – her earliest years apart – from any 'movement' apt to be favoured by critics, has earned her an exceptional degree of official response, highly unlikely a few decades ago.

In 1969 Elisabeth Frink was awarded a CBE and a DBE in 1982.

She was appointed a trustee of the British Museum in 1976, a member of the Royal Fine Art Commission in 1977, elected an ARA in 1972, and a full member in 1977. All this, even though she is an artist of outstanding independence, imbued with ambition only for the perfection of her work.

BRIDGET RILEY
born 1931

Since about 1910 the most pervasive idea among artists has been that subject, at least the subject drawn from the external world, should either be strictly subordinated to form or else excluded altogether. In Britain in the 1920s and 1930s, for instance, subject for many painters was no more than the occasion for the creation of 'significant form'. Apples, sanctified by their frequent depiction by Cézanne, were favoured, but most other subjects would have served as well. Even before the period of the widespread subordination of the subject to its treatment, there briefly emerged an abstract movement. In the second issue of *Blast* Wyndham Lewis wrote, 'There should be a bill passed in Parliament at once FORBIDDING ANY IMAGE OR RECOGNIZABLE SHAPE TO BE STUCK UP IN ANY PUBLIC PLACE.' Kandinsky exhibited in London in 1911, 1912 and 1913. Vorticism, the term coined by Ezra Pound for the London practitioners of abstraction or near-abstraction (for several of them occasionally allowed machinery as a subject), established in 1913, was virtually brought to an end two years later by the war. Among the small group of young painters associated with the movement were Gaudier-Brzeska, Bomberg, Wadsworth, Roberts, as well as Lewis himself. The outstanding originality and energy of their Vorticist works has been, until recently, unjustly neglected, and is even now not recognized at its true worth.

A few of those associated with the movement, such as Lawrence Atkinson and Cuthbert Hamilton, continued until around 1920 to pursue its ideas. By then the movement was extinct, and it was not until the mid-1930s, with Ben Nicholson, Barbara Hepworth and a small group of their friends, that abstraction re-emerged. Although its influence was temporarily circumscribed by the impending war, it reasserted itself with the coming of peace and before long became the most powerful and pervasive force in British painting and sculpture, as it had been in that of the Continent for several decades.

Abstract art exercises a powerful hold, partly because it is in close accord with the high degree of specialization, with the division of labour, by which industrial societies function. The artist accordingly attempts to do what he believes cannot be done better by the camera or any other means, namely the creation of autonomous form and

colour. Nothing better illustrates the pervasiveness of abstraction today than the fact that the president of the institution which, far more militantly than any other, has upheld inherited conventional values and opposed innovation, often innovation of a very discreet character, namely the Royal Academy, should have been, at the time that I wrote this essay, an abstract painter.

The pressure upon artists to practise abstraction is therefore often difficult to withstand. Why, a critical reader may ask, should the withstanding of it be referred to at all? The answer is that only a small minority of abstract artists are fit by temperament to pursue the kind of art they practise. Most, if born in Victorian times, probably would have painted puppies in baskets and the like. To practise abstraction by spraying a board with a uniform colour, for instance, or by ordering a metal cube from a foundry over the telephone, is one of the most facile pursuits an artist can engage in – painting puppies in baskets well is far more exacting. The serious practice of abstraction, however, can be infinitely exacting. A portrait or a landscape painter, when feeling dull, may easily find stimulus in the subject before him or memories of it in the contemplation of preliminary studies, but an abstract artist has no comparable resources: he must rely wholly on his imagination. It is a practice so exacting that the innately abstract artist, the artist whose essential self is expressed in the language of abstraction, is a very rare person indeed. Of course such an artist may portray subjects from the world of appearances, as did Ben Nicholson, for instance, but the results, however admirable, are peripheral to his major preoccupation.

One of these rare persons is Bridget Riley. Although no work could be more radically exclusive of the world of appearances than that of Victor Pasmore since the late 1940s, after his brilliant maturity with his romantic paintings of riverside landscapes and figures, he revolutionized his art only when convinced that he had been working in a tradition in which everything significant that could be said had been said already. With Riley it was otherwise. Although her early drawings and paintings give indications of her talent, she could not express her essential self until she discovered that abstraction was her language – her only language. The process of discovery was long and at times painful; how long and painful would surprise anyone who met for the first time, after the completion of the process, the extremely assured and successful Riley of the last decade.

Bridget Louise Riley was born on 25 April 1931 in South London, the elder of the two daughters of John Fisher Riley, a commercial printer, and his wife Bessie Louise, born Gladstone, whose father, a distant relative of the prime minister, worked with Edison on the discovery of the electric light bulb. His brother was a founder-member

of the Fabian Society. Bridget's mother had an aunt, Ruth, who had been a governess at the Russian Imperial Court and, incidentally, served as a model for the heroine of James Hilton's *Goodbye Mr Chips*. Bridget Riley spent part of her childhood in Lincolnshire but the war years near Padstow in Cornwall with her mother, sister and an aunt, Bertha Joyce, who had studied art at Goldsmiths' College, and who first aroused her interest in the arts. In the meanwhile her father, who served in the Royal Artillery, was taken prisoner in the battle of Singapore and forced to work on 'the railway of death'.

Riley spent from 1944 until 1946 at St Stephen's Convent at Taplow, and then entered Cheltenham Ladies' College, where her growing interest in the arts was fostered by the art master Colin Hayes, the former Euston Road painter, who made her aware of the history of his subject and encouraged her to draw from life at the local art school. In 1949 a copy of Van Eyck's *The Man in a Red Turban*, made from a reproduction, gained her admission to Goldsmiths' College where she remained for four years, concentrating exclusively on drawing, encouraged by Sam Rabin, who held life classes. She owed much to Rabin for his perceptive teaching of drawing and for directing her interest to the drawings of Ingres. Their precise, linear, almost impersonal quality may well have evoked her first faint recognition of a quality that she wished to characterize as her own. But the attainment of anything that might be truly described as 'her own' was still a very long way off. The years at Goldsmiths', spent exclusively in drawing, were put to excellent use, but eventually, for two reasons, she wished to learn to paint, and in spite of the intelligence and sympathy of Rabin she was oppressed by a sense of remoteness from the centre of things, of ignorance of what the liveliest members of her generation were doing and thinking. In 1952 she accordingly transferred to the Royal College of Art, remaining there for three years. Although she learnt the elements of painting and met several painters, including Frank Auerbach, Peter Blake and Richard Smith (all shortly to win high reputations), she made no constructive friendships such as that with Rabin at Goldsmiths', and left feeling directionless and frustrated. Partly on account of her state of mind and partly through devoting much time to nursing her father, after a serious car accident she suffered a nervous breakdown and for more than two years scarcely drew or painted. When she returned to London in 1956 she was an out- and in-patient at Middlesex Hospital, where she was allowed to sell glass at an antique shop. In 1957–58 she taught art at the Convent of the Sacred Heart in Harrow and in 1958–59 she was employed by the J. Walter Thompson advertising agency, where she was engaged in photorealist illustration of a kind entirely unrelated to her interests as a painter.

Her obsession with her art, however little she was able to paint or draw, was undiminished; indeed it was further stimulated by the exhibition 'Modern Art in the United States: a Selection from the Collections of the Museum of Modern Art, New York' held at the Tate Gallery at the beginning of 1956, and by the ideas of Victor Pasmore and Harry Thubron, exemplified in 'The Developing Process', an exhibition held at the Institute of Contemporary Art two years later. Slowly she began to renew her contacts with the art world and in 1959 she resigned from her post at J. Walter Thompson and attended Thubron's summer school in Norfolk. Here she formed a close and constructive friendship with Thubron's principal assistant, Maurice de Sausmarez, a painter, historian and educationalist – a friendship that lasted until his death eleven years later, shortly after finishing his informed and perceptive monograph on her work. In 1959 she painted in France and Spain and initiated a basic art course at the Loughborough College of Art.

By 1960 Riley had begun to find her way. In the summer she visited many galleries and churches in Italy with de Sausmarez, and painted, studying not only masters, such as Piero della Francesca, but the Futurists, in particular Boccioni and Balla. She was deeply impressed by the black and white architecture in Pisa. The Futurists – of whose work they saw the comprehensive exhibition at the Venice Biennale – helped clarify her preoccupation with movement – however differently interpreted and the Pisan architecture helped to give her a sense, for a time, of the sufficiency of black and white.

She was already well prepared for the impact of the Futurists. Earlier that year she had collaborated with de Sausmarez in the preparation of three lectures he gave at the Royal College of Art to mark the fiftieth anniversary of the publication of the Futurist Manifesto. About the same time she made a full-size copy of *Le pont de Courbevoie* by Seurat, whose uncompromising logic affected her deeply. A big reproduction of his *Grande Jatte* hung in her flat. The most substantial picture she made after their Italian journey was *Pink Landscape*, painted, de Sausmarez has told us, 'from the experience of a stretch of landscape in the hills south of Siena, drenched in a blinding shimmering heat-haze that ended in one of the fiercest storms of that summer', and he quotes David Thompson as saying that it 'is already concerned with a kind of optical situation which constantly recurs in her later work – that of a dominant formal pattern under pressure of disintegration'. 'I talked endlessly with Maurice de Sausmarez,' she said to me, 'and gradually the gap between what I was doing and what I hoped to do narrowed, and eventually there was a breakthrough.'

Early in 1961, the year following that of so much intensive thought

and wide-ranging study, Riley made a painting which anticipates that of her maturity – *Kiss* – in which one massive black rectangle with a curving base descends upon and almost touches an almost equally massive black rectangle. It is an impressive work, but, did it not mark the beginning of her style, it would be rather less highly regarded than it is, for it affords only the faintest indication of the qualities that identify the best of the works that followed – and followed quickly. The first, unmistakably her own, painted later in the same year, was *Movement in Squares* (1961), which clearly expresses one of the principal subjects of her art, namely the interaction of opposing elements: stability and movement, discord and harmony, constancy and change, passivity and energy, light and darkness, advance and recession, ease and tension, repose and disturbance. *Movement in Squares* shows the gradual compression of the central squares into rectangles by those to the left and right, and the resulting contrast between the solid, regular and the compressed squares. The visual experience thus generated is one of dynamic contrasts. *Fission* (1962–63) is identical in theme but the compressing units are black circles and the compressed black ovals.

One of the finest of her works in black and white is *Fall* (1963), included in her second exhibition at Gallery One in 1963, to which Anton Ehrenzweig thus described his response in the introduction to the catalogue:

> We are faced with an inexorable yet almost imperceptible variation of linear elements and units. So smooth is the change that it does not allow the eye to organize the series of units into stable, larger entities on which it might linger and rest. There is a constant tug-of-war between shifting and crumbling patterns, but at a certain point this relentless attack on our lazy viewing habits peels our eyes into a new and crystal clear sensibility.

The first exhibited works were all in black and white, although she made studio experiments with colour. Then in 1965 a variety of greys were cautiously introduced and finally pure colour, as in *Late Morning* (1968). Movement, which figures constantly in her art, is entirely different from that of the Futurists whom she so diligently studied, for in their work it is a series of successive images; in hers it is a single one.

One of the original qualities in Riley's work is, in fact, a consequence of her subjects. Many abstract artists take as their subjects suggestions from nature which they reduce to purely formal terms; others, notably a number of the Abstract Expressionists, apply their medium arbitrarily and take advantage of what happens when the paint is dripped or splashed onto the surface. Riley's subjects, opposing or contrasting elements of many kinds, although not unique, are rare; for her the

subject is not a material object itself but its animating force or its contrasting stability: she is an abstract artist, therefore, on a deeper level than many others. But strangely enough, her art, which has so decisive a look (an article on it by Robert Melville was headed 'An Art Without Accidents') is far more intuitive and experimental than is apparent in the finished work. She once said, in conversation with Robert Kadielka:

> I felt that this thing, the medium, was so strong and rich, that I was just the agent who caught these various inflections . . . when these elements are not asked to do something which is against their nature – not asked to serve concepts or to represent – then I think that they are allowed to 'play freely' – to show their vitality. But there are hazards. For instance, of merely recording automatically in a random kind of way. These energies are in a proper sense 'wild'. One can easily be overwelmed, carried away. This results in images which are virtually inaccessible, beyond perception in fact. And yet this is the core of the medium and it is in this area that fruitful dialogue takes place. It is not only the one-way relationship of taming the wild, but can also be the reverse. I am supported by the medium but at the risk of being overwhelmed by it. The medium both carries you and threatens to carry you away.

These words could have been spoken by Francis Bacon, an artist as different from Riley as could well be imagined in every other way. Although both regard their medium as an active partner, their 'dialogue' with it is quite different: Bacon makes no drawings or preliminary studies and relies on taking advantage of fortunate 'accidents' in the behaviour of the paint; Riley makes many and detailed studies, and when the final version is made – usually not even by herself but by assistants – the struggle with the paint is resolved so completely that, although she often alludes to it, no trace of it remains on the canvas.

Critics have remarked on the affinity of Riley's work with Victor Vasarely's. To see how clear this affinity is one need only observe the close resemblance between her *Blaze I* (1962) and his *Mach-C*, made some eight years earlier. But Bryan Robertson, in his catalogue for Riley's retrospective exhibition at the Hayward Gallery, 1961, has pointed out with accuracy a crucial difference between the two artists:

> Vasarely confines his use of space to the picture plane: whatever obtrudes from that plane or recedes into it is implied by *perspective within that picture plane* . . . Riley's true space is not confined to the picture plane: it is the *distance between the spectator and the canvas*.

Both artists, of course, practise what is generally known as Op, or Optical, Art, that is to say an art whose primary and sometimes sole object is the viewer's retinal response. In this, as in the two earlier volumes, I have, so far as is reasonable, avoided collective terms,

groups, movements and the like, as tending to obscure the artists' individual characters. But it is relevant to observe that the object of Op Art – although the term was not used until the mid-1960s – was to use optical laws, not, as was the case in earlier times, to serve some aesthetic purpose, enhancing brilliance of colour, for instance, or likeness to the subject, but as visual stimuli. Not only have Op painters derived much from predecessors, Seurat notable among them, but from scientists' studies of the functioning of visual perception. Optical effects characterize much, perhaps most, of Riley's work, but she does not introduce them – like some other Op artists – with aggressive or startling intention but as enhancing the exhilaration – or the electric shock, to use an expression of her own – that it is her purpose that the viewer should experience through her resolution of tension between active and static and other conflicting forces already referred to. These forces as well as equivalents of various states of mind (as indicated by such titles as *Remember*, *Hesitate*, *Pause*, *Search*, *Shiver* or *Deny*), although expressed by forms of such extraordinary precision that at first glance they might seem to be products of a computer, are in fact extremely subjective. Bryan Robertson wrote that 'although Riley is patchily aware of the history of colour theory from Newton to Chevreul, and Seurat's contribution to colour analysis, her grasp of theory, of any sort, is elementary'. In *Art News*, October 1965, she herself stated:

> I have never studied 'optics' and my use of mathematics is rudimentary, confined to such things as equalising, halving, quartering, and simple progression. My work has developed on the basis of empirical analyses, and I have always believed that perception is the medium through which states of being are directly experienced . . . The basis of my paintings is this: that in each of them a particular situation is stated. Certain elements within that situation remain constant. Others precipitate the destruction of themselves by themselves. Recurrently, as a result of the cyclic movement of repose, disturbance and repose, the original situation is restated.

The development of her work and of her maturity has been impressively logical. In the earliest she used straight lines and black and white. A little later she introduced sharp angles, then narrow, curved lines, having the effect of rhythmic waves of water, in some of which, in recent years, she has used colour. Of the relation of form and colour in her work she said, again to Robert Kadieka:

> In my recent work I have been using stripes of colour, either parallel or twisting round each other. Form and colour seem to be fundamentally incompatible . . . in my earlier work, when I was developing complex forms, the energies of the medium could only be fully released by simplifying colour to a black and white constant (with occasional grey sequences). Conversely colour energies need a virtually neutral vehicle

if they are to develop uninhibited. Their repeated stripe seems to meet these conditions.

The final versions of this art – of the expression of deeply felt conflicts between opposing forces and their resolution, and of varied states of mind – are carried out by studio-assistants. The artist herself makes many preparatory studies on plain or graph paper in pencil and gouache, with elaborate notations, including detailed instructions with regard to scale – sometimes to one-sixteenth of an inch – and coloured pieces of cardboard to be placed one beside the other to try out harmonies and contrasts. Finally skilled assistants are called in (as they are by Vasarely) who carry out, under Riley's critical eye, the final versions. When asked why she did not make the final versions herself, she said, 'I need assistants for speed's sake: before one painting is done I have ideas for others (in any case I work on several at once). Without help I'd be frustratingly held up.'

The result is Riley's immaculate and logical 'art without accidents' – serene yet revealing visual energy emanating from basic forms. In spite of its deceptive simplicity – deceptive because, for instance, bands of colour and other forms that at first glance seem uniform often in fact differ minutely from one another – Riley's art has made an impression on a steadily growing public ever since she evolved her own lucid and concentrated formal language, and not only in her own country. One of her paintings was reproduced on the cover of the catalogue of 'The Responsive Eye' exhibition of Op Art at the Museum of Modern Art, New York, in 1964, and her first one-woman exhibition in the United States, at the Richard Feigen Gallery, was sold out before it opened. Her work has been included in important exhibitions in several other countries, in Paris, at the Venice Biennale, where she won a prize, and in Germany, Switzerland and Japan, as well, of course, as in Britain. Few painters of her generation have attracted more perceptive criticism, among others by David Thompson (who also made a film of her work in 1969), Anton Ehrenzweig, Bryan Robertson, in the retrospective exhibition which he selected at the Hayward Gallery in 1971, and the tribute, already referred to, by her friend and mentor Maurice de Sausmarez. Few of her British contemporaries, especially those whose work requires experienced eyes to understand, have won such international acclaim – acclaim which I believe is amply merited.

EUAN UGLOW
born 1932

It would not be surprising if a perceptive visitor to a miscellaneous exhibition in which Euan Uglow was represented did not immediately perceive his exceptional qualities. Such works, for instance, as *Gloria* (1958), *Still Life with Onions and Wine Glass* and *View Over Hyères* (both 1960) or *Two Green Apples* (1963) might easily escape attention. Much, although not all, of Uglow's work is reticent and needs close observation before its rare qualities disclose themselves. It has nevertheless brought him, early in his career, a steadily increasing number of ardent admirers, especially among his fellow artists. Unlike many of his Slade contemporaries he has never become a very well-known painter, still less a public figure.

Euan Ernest Richard Uglow was born on 10 March 1932 in West Norwood, the son of Ernest Uglow, an accountant, and his wife Jane, born Williams. He attended several schools and in 1948, at the age of sixteen, left the Strand Grammar School for the Camberwell School of Art. Here he first studied at the department known as 'The Juniors', shortly afterwards abolished, which had been set up to enable the very young, who believed they wanted a career in art, to obtain some experience. He shortly transferred to the main school, where he received a David Murray Scholarship. In 1951 he was awarded a State Scholarship to the Slade; in 1953 a Spanish State Scholarship which enabled him to visit Spain, and the following year an Abbey Minor Scholarship (Prix de Rome) to visit France, Holland, Belgium and Italy.

Uglow spent most of 1954 as a postgraduate student at the Slade. On leaving he was liable for two years national service but decided to register as a conscientious objector. This involved Uglow's appearing before a tribunal where, as an objector, he was expected to argue his case (a challenge which the Jehovah's Witnesses, who comprised the rest of the objectors, accepted with relish). Uglow, faced with trick questions to which he could see no correct or honest answers, remained silent. The magistrate, with a look of relief, accepted his appeal. Thomas Monnington, who was present as a witness supporting Uglow's case, observed with satisfaction that 'The magistrate looked at me, I looked at him, and that was that'.

From the autumn of 1954 until 1956 Uglow worked in the building trade and on a farm, taught at an evening institute and performed various other tasks. Despite this interruption of his work as an artist, he had already earned a respected reputation, and in 1956 exhibited with the London Group, for the first time of which he was elected a member four years later.

These brief *Who's Who*-ish facts, however, give no indication of the achievements – nor of the singularly gifted and highly original character of Euan Uglow.

He attended Camberwell School of Art at a time which proved fortunate for the development of his particular talent. One of the teachers there, William Townsend, wrote in his *Journals* (15 March 1951):

> At the Slade, students seem more consciously gentlemen or more consciously students . . . and though there are no doubt as many good and serious artists among them there doesn't seem any of the feeling of excitement about the business of painting and general fun of life that I notice at Camberwell. Perhaps it is that Camberwell is like a tight little island where everything is concentrated, inwards to a small group who set the tone. Anyhow there is a good, healthy, serious, enjoyable sort of 'kitchen air' about a crowd of Camberwell students.

Uglow was taught by William Coldstream as well as by Townsend, who, although both had left for the Slade in the autumn of 1949, still exercised an influence over their former students. As well, Uglow was at Camberwell when the Euston Road Group held an exhibition of the work of its fifteen members in November 1948. (Coldstream was the leading figure; among others were Townsend, Rodrigo Moynihan, Geoffrey Tibble and Robert Medley.) Although the exhibitors were of a widely differing character, the exhibition, broadly speaking, represented a recoil from the fashionable influence of the Paris School. To quote Townsend once again (9 December 1936), who referred to it as 'a decided swing back from the problems of abstraction, even from the orgies of surrealism, to the possibilities of making a new start from the Post-Impressionists. Bill Coldstream and Graham Bell have for instance renounced Picasso and all his works and in despair proclaim there is nothing to do but sit down in front of landscape and paint it.' This was an attitude that appealed strongly to Uglow, who was described to me by a fellow student and close friend as a person of an entirely pragmatic nature, averse to any mystique, suspicious of intellectuals and mistrustful of theories. Any theories as to what art might be about, or mean, were more or less nonexistent among the students, that is to say in terms of contemporary art.

From his earliest years Uglow's aspirations were more definite

than those of most of his contemporaries, but had he received his art
education in frustrating circumstances, these might easily have
become warped by their provoking reactions or conformities. He was
enabled accordingly to develop his innate aspirations and to mature
exceptionally early.

Unlike many, perhaps most students of his generation, Uglow was
scarcely affected by the movements referred to by Townsend. This
was in no way due to ignorance – scholarships had enabled him to
travel extensively in Europe, but what he primarily studied was not
contemporary art – although there were European contemporaries of
an earlier generation whom he admired, particularly Giacometti,
whose studio he visited – but the masters of the past: Seurat and
Cézanne, and even more those of a remoter past. 'I went to Dresden',
he said to me, 'especially to study the Giorgione *Nude'*. Among others
whom he most ardently revered were Masaccio, Piero della Francesca,
Vermeer and Poussin, of whose *Massacre of the Innocents* he made a
copy. But however ardent his admiration for these masters his own
outlook remained basically English, owing partly to his temperament
and partly to the effect, at a crucial period of his life, of Coldstream's
teaching, his colleagues and the example of the Euston Road School
in general. Not for a moment did he consider their work comparable
with that of the masters, but it had a particular relevance to his
outlook. He was affected little by the example of any one of these
contemporaries, but greatly by the general character of their work.
The best were highly individual, yet for a time they had in common
a particular view of their environment which, although his own
became highly individual, he also temporarily shared.

A few years later, however, the beginnings of an individual outlook
are apparent in his work, as in, for instance, *Portrait of an Old Woman*
(1952); it is more 'painterly' than those of his mature years. Somewhat
similar in other respects is *Woman in a White Skirt* (1953), but this has
one feature absent from the earlier works, namely the sharp focus of
the figures' environment. The panels and brickwork in the back-
ground, although not given the intense concentration of the figure,
are features which integrate positively in the work as a whole. For a
student, both are paintings of exceptional maturity.

The following year, 1954, Uglow, painted *Musicians*, an elaborate
work portraying six figures in a landscape. Although of a lively
interest, it is diffuse and shows that his intense way of seeing is at its
most impressive when focused on a single figure – almost invariably
female – and her immediate environment. Both *The German Girl*
(1962) – an impressive work and one more complex than a casual
glance would suggest – and the slightly later *Two Heads* are devoid of
any significant environmental features. Their complexity derives

from Uglow's growing obsession with the precise relation between his own viewpoint of his subject and the subject itself. This was the consequence of the growing intensity of his perception; combined with its fixity upon his subjects' individual features – conspicuously, for instance, in *The German Girl*. In this work the closeness of his viewpoint has involved optical distortion: certain features – those nearest, her thighs and hands – are disproportionately large and her head small. This practice of enlarging what is nearest is not a stylistic feature but simply Uglow's innate way of regarding his subject, that is to say very closely.

Painters of the nude generally represent their subjects less closely and are therefore able to view them in their true proportions. Uglow's acute awareness of the problems resulting from the habitual closeness of his observations is explicitly proclaimed in *Nude, from twelve regular positions from the eye* (1967), an exceptionally large work. Uglow told me something of the elaborate procedure by which this painting was carried out. But first let me quote the account of his aims, which he contributed to the catalogue of the eighth John Moore's exhibition held in 1972 at the Walker Art Gallery, Liverpool:

> I wanted to explain the three-dimensional relationships between the wall, the girl and my eye as I moved from one regular position to another. These relationships I tried to interpret onto the flat surface of the painting.

And, in conversation, he said to me:

> I painted the girl from twelve equal vertical positions at the same distance from her. The wall in front of which she stood on a big box I marked into equal divisions. Her neck was held in place between two pegs, with a plumbline dropped in front of her. Then, using a scaffolding platform which I had made myself with steps six inches one above another, the same distance as the divisions on the board behind her, I climbed up and down, my eyes focused successively on the nearest part of her body and the nearest division on the board. These distances are indicated by a sort of code based on the dull yellow bands: the broader the band behind her, the further that part of her body projects from the board. In order to make the various distances between body and board still clearer I introduced arrow shapes, and to enhance the two-dimensional form I used the plumbline to enable me to view the body from two slightly different angles. By these somewhat complex procedures I tried to eliminate the distortions which result inevitably from viewing the subject from a single fixed position.

I have written and quoted at some length with regard to certain ideas particularly relevant to this painting not primarily because I recognize it as one of Uglow's most notable works but because it reveals so very clearly some of his highly individual characteristics, in particular his original way of seeing, which rejects the accepted concept of per-

spective as distortion of an object, owing to what he considers the
imperfections of ordinary sight. He attempts to portray every feature
of his subject with equal clarity as though seen on its own level. He
avoids, too, any suggestion of movement or of shadow, apart from
that necessary to indicate the modelling of his figures. Such is
Uglow's sense of the complexities of figures and heads that, although
not quite invariably, he represents them either full-face or in profile,
avoiding poses liable to add to their innate complexities. In his
landscapes, too, he avoids any suggestion of atmosphere or move-
ment; everything is in focus. To take three characteristic examples,
Mosque at Cliftik Koyou (1965), *Italian Landscape* and *Pignano* (1973),
which are particularly lucid and serene.

Figures are the subjects that absorb Uglow most deeply, and
therefore evoke his most intense qualities, primarily because they are
the most complex, but still-life also inspires him, although the very
fact of their being 'still', makes them less challenging. However,
occasionally even still-life involves acute difficulty, such as *Diary of a
Pear* (1972), to which he was compelled, he told me, 'to make frequent
alterations, due to its steady subsidence into decay, which explains
why "Diary" was introduced into the title'. Fortunately he has been
able to make a number of other fine still-lifes, mostly of flowers, but
occasionally of subjects of such austere simplicity that most other
artists might find them too dull and too featureless to arouse their
interest. But just as no subject is too complex for Uglow, none is too
simple. For instance, *Oval Still Life with Model Marks* (1971) or *Half an
Apple with 50p* (1976).

In *Oval Still Life* the 'marks' are those Uglow uses to ensure that his
models retain their correct positions during their sittings – which are
almost unending, both in hours and frequency. The 'marks' are also
indicative of another respect in which Uglow differs from most other
painters, who, to whatever extent they may rely on such measure-
ments to ensure that their directions regarding poses are precisely
followed, usually obliterate them when they have served their
purpose. Uglow early developed a system of using small crosses and
dashes which he is apt to leave in the picture and which sometimes
constitute positive, if minor, features in the finished work. If placing
such marks on a painting is uncommon, placing them on the models
themselves, as Uglow does, is surely unique.

Uglow's nudes are apt to appear simple, as simple as these highly
complex subjects treated with such seriousness can be. It is a
reasonable generalization to say that some of his works are indeed
relatively simple, such as several of the still-lifes already cited, and
the plain slab of *Cheese and Tennis Balls* (1973). But his nudes are
never simple. The extreme complexity of *Nude, from twelve vertical*

positions has already been referred to. This, however, does appear complex. Another, *Root Five Nude* (1976), is not conspicuously so, yet is in fact of an even higher complexity and is likewise intended to show how perspective distorts reality. The model is lying on a table, made by the artist, which forms an arc centred on his eye from each of the ten units into which it is divided, so that at every point his eye was at precisely the same distance from the subject. The dimensions are elaborately calculated, based on the concept of a 'root-five' rectangle. The procedure enabled Uglow to represent the model without the optical foreshortening that would have been inevitable had she been depicted from a single point of view.

The following year Uglow painted another work of a somewhat similar character, *The Diagonal*, a nude stretching herself on a wooden chair, from the top left to the bottom right of the canvas. It differs from *Root Five Nude* in that its complexities are expressed primarily through colour and tone. Both are of an austere elegance which, together with *Nude, from twelve regular vertical positions*, entitle them to a special place among contemporary nudes. All three, however – and several others, including *Nude* (1963) – have one peculiar shortcoming peculiar for works composed in other respects with so scrupulous a sense of proportion, namely a markedly disproportionate shortness of the arms. It is not, however, as though this were a consistent mannerism: in other works, *The German Girl* and *Striding Nude* (1965), the arms are of normal length, indeed in the former, as already noted, disproportionately large.

Uglow takes an immense length of time to complete a painting: 'I should probably never finish one', he said to me, 'unless external circumstances forced me to'. He is probably the slowest of professional painters; it sometimes takes him three-quarters of an hour even to pose his model in the precise position he requires. His models pose for as long as he can persuade them to; three hours continuously at the least. There have been occasions when the ordeal has been more protracted than the model could endure and Uglow has then had to find different models for the same painting. The title of his *Three in One* (1968) relates to just such a situation. His output is therefore exceptionally small, sometimes amounting to no more than three or four canvases a year. This is hardly surprising, especially in view of the other highly relevant fact that so considerable a proportion of his works are imbued with different ideas. The slowness of Uglow's procedure, involving as it must the simultaneous working on paintings at different stages of completion, makes it difficult to trace his evolution with precision. There are some half-dozen easels in his studio from which canvases are removed when he is not working on them. Considering the length of time each one takes to complete, the

dates of their beginnings must vary widely. None of his own works are on view in his house, but a number by his friends – Coldstream, Claude Rogers, Philip Sutton and others are – as well as reproductions after David, Ingres and Italian masters.

It is nonetheless possible to give some indication of the development of Uglow's work, which may be divided roughly into three stages of evolution. To the first – omitting some experimental works of his very early years, such as *Cubist Picture* (1949) – belong such paintings as *Portrait of an Old Woman*, (1952), and *Skull* (1953). These, and some others of a comparable character, are apt to be regarded as 'Euston Road'. Indeed, without the example of Coldstream and his friends it is highly unlikely that Uglow would have evolved his highly realistic and very English way of seeing so early. For this the example of his Euston Road teachers and friends deserves much credit. But in all three works a highly personal character begins to declare itself – highly personal even though destined to undergo radical changes. They are almost aggressively 'painterly' in their handling, these massive figures and this skull, showing little of the delicacy of perception of the best Euston Road paintings, but a sure command of form and a delight in the richness of the quality of the paint. Although Uglow's work was to undergo radical changes in the following years, these two paintings show enduring characteristics: *Woman with a White Skirt* a preoccupation with his figures' environment, and *Skull*, in addition to a far more elaborate environment, his use of the marks he came to use so frequently to check and adjust.

A second phase is exemplified by nudes which are smoother in treatment, the brushstrokes less conspicuous and the forms sometimes less massive, exemplified by *Nude*, *A Nude with Green Background*, *Girl with Cloth*, *Head* (all of 1966), and *Large Nude Walking Towards You* (1971). A third phase is well-represented by the two works recalled earlier in some detail, *Nude, from twelve regular vertical positions from the eye* and *The Diagonal*; also by two other nudes, *Summer Picture* (1972), and *Georgia* (1973).

A number of Uglow's earliest paintings could hardly be correctly attributed by anyone not well acquainted with his work. Others of the same period clearly show that he was evolving a highly stylized way of painting very much his own. The difficulty of envisaging Uglow's works in any way approaching strict chronological order is exemplified by comparing *Large Nude Walking Towards You* with *The Summer Picture*. The latter was painted very shortly after the first, yet stylistically it belongs to the later phase; to the more formal, rather than the objective, highly naturalistic phase of the other.

Uglow displays a profound comprehension of the complexities of the female body – which he has depicted in the various ways here

indicated – as well as another, somewhat impressionistic, exemplified by *Girl in a Corner* (1961), and *Girl Lying Down (In Artificial Light)* (1965). I have made previous mention of neither because they seem to me to bear little relation to Uglow's basic preoccupation and are in effect sketches in oils. Nor have I mentioned his drawings, for these, as many of their titles show, are preliminary studies for his paintings. As for his still-lifes, a number of these manifest a rare and varied charm. They do not, however, offer a challenge to his penetrating powers of precise observation nor to his technical accomplishment comparable to that of the nudes. These merit, however, a considerably higher place in the art of his generation than they are usually accorded.

Despite Uglow's preference for a relatively isolated life, the smallness of his output and his unfashionable realism – or near realism – he is today no longer the obscure figure that he for so long remained.

DAVID HOCKNEY
born 1937

In one respect it is a curious experience for someone of my generation to write about David Hockney, because he has enjoyed an immediate, international success that began when he was still a student – something achieved by no serious painter within my earlier personal experience.

All through my own childhood and boyhood, indeed throughout the greater part of my life, 'instant success' was regarded as synonymous with the superficial. Every serious artist I had known had endured a long and often bitter struggle to achieve recognition – if he had achieved it at all. The story has often been told how fellow students at the Slade so greatly admired the drawings of Augustus John that they used to collect and paste together even those he had torn up and thrown away; but he, nevertheless, had a struggle before him. Henry Moore was approaching his mid-forties and had had no officially sponsored exhibition when we bought his first watercolours for the Tate for £5 or £6 each. From his first exhibition Francis Bacon sold nothing at all and was so discouraged – as was related earlier in these pages – that for a time he ceased to paint entirely.

There are indeed serious living painters whose work commands considerably higher prices than Hockney's, but no British artist except Henry Moore is more persistently sought after for interviews, articles and the like, and few are more widely admired. When I first visited his luxurious studio flat in Powis Terrace, Notting Hill, he had recently changed his exdirectory telephone number, and yet it rang about every fifteen minutes. I mention these circumstances to show how rare it is that a painter as young as Hockney should have become so notable a figure by the age of thirty-five; also by way of confessing that a lifelong experience of the struggles, frustrations, failures, self-doubts of all other serious artists had made me suspicious of 'instant success'.

I first saw, quite by chance, his *Rake's Progress* series in 1963 at the Alecto Gallery; they had been mostly made while he was still a student at the Royal College of Art. They impressed me as showing talent of a quite exceptional order. In the same year, impressed although not fully convinced by a painting made the previous year,

223

The First Marriage, I persuaded the Friends of the Tate to buy it, through whom it passed into the Gallery's possession. The circumstances of my first encounters with Hockney's art are mentioned here not to show my own early recognition of its qualities, but the reverse: how unjustifiably mistrustful 'instant success' can make people of my generation. Although, when I happened to see his work, I scrutinized it with care, it was not until his Whitechapel retrospective in 1970 that I recognized him at what I now believe to be something of his true worth. Nor was it until later that I learned from him how intensely he suffers, and always has, from self-doubt and worry about his work, although he has become resigned to it as the inevitable consequence of the serious practice of any art.

David Hockney was born on 9 July 1937 at St Luke's Hospital, Bradford, Yorkshire, the youngest but one of a family of three brothers and a sister, the children of Kenneth Hockney and his wife Laura, born Thompson. David attended Wellington Road Primary School and, from 1948 until 1953, Bradford Grammar School. Already determined to be an artist, he went straight from there to the Bradford College of Art where he remained for four years, working two days a week from the life and two on figure composition, concentrating on academic drawing. The degree of interest in contemporary art at the College was shown by the fact that Sickert was regarded as its culmination and Braque, Hockney recalls, 'as a freak'. A fellow student at Bradford, Norman Stevens,

> David was an incredible worker. When he was not at the College he'd walk about the little streets with a pram to carry his paints, like Stanley Spencer, whom he admired, and made fine little street scenes. I remember David's laughing when another student said he wanted to learn to draw and that the masters were no good, and he replied 'Then draw hard for three years' and the student said '*I haven't time*'.

After leaving the College, being a conscientious objector, instead of doing national service he worked as a ward orderly at St Luke's Hospital, Bradford, and St Helen's at Hastings. (He is also an impassioned vegetarian.) Two years later his application to enter the Royal College of Art was successful. There he studied from 1959 until 1962, benefiting from the teaching and from the freedom given him to spend much time in drawing. At the College, R. B. Kitaj, his dynamic American fellow student, widely extended Hockney's hitherto extremely limited knowledge of contemporary painting, helped him towards the recognition of the nature of his own talent and encouraged him to portray whatever most deeply stirred his interest. To Kitaj his debt was considerable indeed. Another fellow student told me how intensively Hockney worked there also, especially at drawing. To what purpose is evident in *A Rake's Progress*.

As often happens in the lives of artists, talent is revealed or stimulated by external circumstance. In Hockney's case the circumstance was commonplace: a total lack of money. He was living in a shed in Kemsford Gardens, Earls Court; the rent was 7s. 6d. a week and to keep on the electric fire cost about that sum. The shed had no water supply, so he used to wash at the College. Professor Carel Weight once found him having a bath in a sink. More distressing was his inability to afford to buy paints. In the print department materials were free, so he decided to etch. Julian Trevelyan, the engraving tutor, showed him how to do it (he had not learnt etching in Bradford) with the result that he won the Guinness Award for Etching in 1961 with two prints *Myself and My Heroes* (Walt Whitman and Gandhi) and *Three Kings and a Queen* – to the annoyance of several students long dedicated to its practice. The etchings that, more than any of his student work, made Hockney's reputation were *A Rake's Progress/ London/New York*. When they were shown in 1963 at the Alecto Gallery, Hockney wrote:

> These etchings were begun in London in September 1961 after a visit to the United States. My intention was to make eight plates, keeping Hogarth's original titles but moving the setting to New York. The Royal College, on seeing me start work, were anxious to extend the series with the idea of incorporating the plates in a book of reproductions to be published by the Lion and Unicorn Press; accordingly I set out to make twenty-four plates, but later reduced the total to sixteen, retaining the numbering from one to eight and most of the titles in the original state. Altogether I made about thirty-five plates of which nineteen were abandoned, so leaving these sixteen in the published set. Numbers 7 and 7A were etched at the Pratt Graphic Institute in New York in May of this year, the others at the Royal College of Art from 1961–63, But I always remained reluctant to make more than the eight originally conceived.

In 1961 he had raised £105 to enable him to visit New York, and it was the squalor he discovered there – comparable to the squalor of Hogarth's London – that inspired the series. Rarely, aside from the gambling table or the bookmaker's, can the expenditure of £105 have paid off so handsomely. *A Rake's Progress* was published by Editions Alecto, and all fifty sets were sold within a year, making the penniless Bradford student £5,000.

Such sudden wealth would have meant much to any poor student, for most, perhaps, security to pursue a vocation. To Hockney it meant this and something besides. The distinction has been drawn earlier in these pages between artists whose vision is raised to its utmost intensity by the familiar and those who respond in the same way to the unfamiliar. It is to the second category that Hockney belongs: he is exhilarated by the unfamiliar, the unexpected. 'This sum,' he told me,

'gave me freedom to live for two years without worrying about teaching or selling my work. So I was able to go to California.' He enjoys his luxurious London studio flat, but has only to think about the attractions of some city, or some region, however remote, and off he flies. (Just as, although he has close friends, he is generally accessible to anyone likely to offer information or good companionship.) This open-minded attitude towards places and people is clearly reflected in his art.

A Rake's Progress was not the proverbial 'flash in the pan'; other prints, paintings and drawings, made while still a student or shortly afterwards, brought Hockney continuing success. He not only won further official recognition in the form of the Royal College of Art Gold Medal, the Guinness Award, first prize at The Graven Image Exhibition and the junior section prize at the John Moores Exhibition, Liverpool, but the ardent admiration of a number of his contemporaries. The playwright Christopher Taylor bought a painting from The Young Contemporaries Exhibition in 1961 and not long afterwards a dozen others, besides a number of drawings and etchings. These, the writer complains, are constantly away on exhibition. 'It's just like having a beautiful debutante daughter; she's almost never at home.' A young woman who worked at the Kasmin Gallery, where Hockney had his first exhibition in 1963, said in an interview, 'Every time some Hockneys came in I fell in love with one and just bought it.' She was spurred to make her first purchase when a client asked to buy a drawing, *Pacific Mutual Trust*, which she had admired for weeks. She said, 'I'm afraid you can't. It's reserved.' 'Who by?' Mr Kasmin asked. 'Me,' she said. What, then, was the character of the work that evoked this widespread enthusiasm?

An artist's virtues (like those of others) are often complemented by weaknesses. Hockney, naturally talented, had, by hard work, made himself an accomplished draughtsman. This accompanied by a rapidly increasing knowledge of contemporary art, and a nature highly responsive to stimuli of many kinds, often led in his early years to his works being superficial and derivative – Dubuffet, graffiti and Pop being favoured exemplars – yet carried out with a wit and elegance that made it immediately attractive; also with an engaging air of simplicity, implying, 'Come on; you could do it just as well.' Examples of the influences referred to: *A Grand Procession of Dignitaries in the Semi-Egyptian Style* (1961), of Dubuffet; *We Two Boys Clinging Together* (1961), of graffiti; *Tea Painting in an Illusionistic Style* (1962), of Pop. Certain of his works are marked not so much by an air of simplicity as by its caricature; to take two examples from among his lithographs: *Picture of a Landscape in an Elaborate Gold Frame* or *Picture of a Simple Framed Traditional Nude Drawing* (both 1965). Hockney is of course exactly aware of what they are, yet he allowed them, and

others of a like kind, to be included in his retrospective exhibition at the Whitechapel Gallery in 1970. This exhibition – admirably arranged – was, Hockney believes, invaluable to him. The opportunity of being able to contemplate, for the first time, so substantial a proportion of his work gave him a clearer understanding of both his shortcomings and potentialities: of the need to concentrate more intensively on his subjects in their entirety, but also a sense of gathering momentum and of multiplying images. 'I learnt a great deal,' he said, 'from studying that exhibition.'

In sharp contrast to such a painter as, say, Mark Rothko, who over a period of years painted variations, and often slight ones, of a single theme, Hockney is reponsive to a very wide variety of approaches to many themes; it is therefore hardly surprising that as a student and for some years afterwards his attention should have been too easily attracted by trivia. This partly accounts for his early success: the interesting subject, fashionable or bizarre. What could be more bizarre than *Teeth Cleaning II* (1962) in which two embryos, depicted with exceptional skill, are locked in erotic embrace? A recipe for success.

But whatever the shortcomings apparent in some of his earliest work, no artist discussed in these pages had to his credit a volume of work as a student so various and accomplished as Hockney. A substantial part of his Whitechapel exhibition was composed of student work. It appears, however, that his qualities were not invariably appreciated. In one of his many interviews he said, 'I was threatened with not getting a diploma because they said I hadn't done enough life painting. So I copied that muscle man out of a magazine. He was in fact bored by the models at the College and used to bring in one of his own, Mo McDermott, who also figures in later paintings, as in *Domestic Scene, Notting Hill* (1963).

After he left the College, a change, at first barely perceptible but gradually accelerating, came to characterize his work. At the College he responded to innumerable influences, ideas, things seen, situations that took his fancy, personal situations in which he found himself. What he painted, drew and etched, although he early evolved an individual style, was almost infinitely various and often extremely complex. The change was in the direction of greater clarity of both subject and design.

Two paintings in particular which, however tentatively, offer intimations of this change are *The First Marriage* and *The Second Marriage* (1963). Although he does not discount the play of intuition or even chance in the process of carrying out his ideas, Hockney is perfectly clear about his ideas themselves. In his student days, in order to make his work entirely comprehensible, he even sometimes

used to introduce lettering into the composition. For instance, across *The Cha Cha That Was Danced in the Early Hours of 24th March* (1961), the words 'cha cha cha cha' are written in bold characters. He is able to explain – if explanation is necessary – not only the subject of any of his pictures but its genesis and evolution. The *Marriage* paintings he has explained in this way.'

> In August 1962, I visited Berlin with an American friend. Whilst in a museum I wandered off and lost my friend . . . I went to look for him . . . I eventually caught sight of him . . . in profile. To one side of him, also in profile, was a sculpture in wood of a seated woman of a heavily stylized kind (Egyptian, I believe). For a moment they seemed held together – like a couple posing. At first I was amused at the sight of them together; but later I made some drawings incorporating both my friend and the sculpture. When I returned to London I decided to use the drawings to make a painting. The first painting I did from the drawings was very much like the statements I had made in Berlin. I did not alter the position of the figures . . . I had made no notes on the setting there, so I placed them in the painting in a rather ambiguous setting. It looks as though they are standing on a desert island with white sand and a palm tree. But the white at the bottom is only a base for them to stand on and the rest of their setting is intended to be slightly out of focus, apart from the ecclesiastical shape in the bottom left-hand corner (an association with marriage). I called it 'The Marriage' because I regarded it as a sort of marriage of styles. The heavily stylized female figure with the not so stylized 'bridegroom'. On completing this picture I decided to do another version of the same theme . . . Taking the idea of marriage literally I decided to put them in a definite setting – a domestic interior.

The head of the woman in the second painting was made from a photograph of a carved head of an Egyptian princess, which he had seen in a book. Of *The Second Marriage* he said, 'The theme is the same but the couple are seen in a more complicated setting involving illusionistic and perspective effects,

Asked in another interview (*Arts and Artists*, April 1973) about the most significant changes in his work, Hockney answered in terms which I can imagine no other artist using but which throw light not only on his work but his mode of thought:

> Well, actually, I think the most significant change over the past three years – say since 1967 or 1966 – is that it's really got more and more naturalistic or more conventional. You saw that portrait of Henry Geldzahler? It was quite a conventional picture of two figures in a room and the space in it was quite conventional. I wanted the paintings to be clearer, more specific really, as opposed to the painting in the Tate, 'The Marriage', which is not a specific painting. Its subject is vague and there are allusions to all kinds of things. I really don't want that kind of vagueness any more.

The process of which Hockney was speaking began in fact some time

earlier than he suggested. It is conspicuous in his treatment of *The Second Marriage* as distinct from *The First Marriage*, as comparison will instantly show. Indeed in the earlier interview quoted, speaking of his aim of 'taking the idea of marriage literally,' he said, 'I decided to put them in a definite setting . . . involving illusionistic and perspective effects.' In the *First* the pine tree and the gothic window, in the *Second* the bedroom and the bottle of champagne.

In spite of Hockney's avid responsiveness, tempting him constantly to excessive diversification of interest, the general development of his work has been towards – to repeat his own words – the 'more naturalistic or the more conventional'. He is unjust to himself: the latter word is, I suspect, a synonym for 'realistic'. There is nothing to which he is more reponsive than travel. He first visited Berlin in 1962; Egypt the following year, to make illustrations for *The Sunday Times*, and on various occasions France, Italy, Mexico and Africa. The country which has most affected his art, however, has been the United States, California in particular, as he said to me:

> I had a hunch that California was a place I'd really like and in 1964 I went to Los Angeles – where I did not know a soul – and decided to work in that part of the world. When I flew over San Bernardino and looked down and saw the swimming pools of the houses, I was more thrilled than I've ever been arriving at any other city. I've spent months in California in 1964,'65,'66 and '68. It was in California that I made my first mature paintings. Almost every time I went there it was to a different place. In California I began to try to paint a place as it really looks. I was not only inspired by Californian subjects, the sense of space, the clear light, but I found it a great help living for so long away from England. It gave me a sense of detachment that I'd not had before, a greater interest in the art of other countries and a more direct understanding of where artists' ideas come from, instead of through the watered-down version that one gets staying only in one country.
>
> In California I changed my method of painting, using acrylic instead of oil. Because oil takes time to dry I had to work on several paintings at the same time, but using acrylic, because it dries almost as soon as you've applied it, I could concentrate on one painting, which I prefer. As acrylic doesn't mix easily like oil I sometimes keep the surface wet by spraying it with water but more often by glazing with successive washes in the traditional way. [When I saw him early in 1973 he was just about to leave for California intending, however, to resume painting in oil.] But I continued to paint, as I always had before, from drawings done from life – I draw a lot from life – from memory or from photographs I take myself – I almost always carry a small camera. [He has many volumes of his photographs, luxuriously bound, in his studio-flat in Notting Hill.] Sometimes I follow my drawings very closely, squaring them up on the canvas, at others to stir my memory. It takes me two weeks or about 278 hours to finish a big painting – occasionally as long as a month. Films play a part in my painting – I think the great tradition of figurative painting has moved into films.

One of the sharpest distinctions between good painters and the rest is that the former make progress, and it is evident that Hockney's later paintings are his best. I am thinking, for instance, of figures in rooms, such as *Christopher Isherwood and Don Bachardy* (1968), or *Henry Geldzahler and Christopher Scott* (1968–69). In both these double portraits he achieves a combination of utter serenity with potentiality for movement. I find myself watching them intently and waiting expectantly for whatever it is that is just about to happen. Modern furniture and men's formal clothes pose particular difficulties for a painter. The rows of men in 'business suits' is a feature that gives an exhibition of portraits its repulsive look. Bachardy wears a white pullover but – although Geldzahler has taken off his coat – his formal waistcoat, trousers, collar, tie, and the raincoat of Scott, appear inevitable constituent parts of still and harmonious compositions, and the ample but ordinary settee in the middle of which the museum official sits forms a noble base for this epitome of expectant stillness.

Hockney shows his ability to achieve something of these qualities even in such a modest work as *Still Life with TV* (1968–69), in which the TV serenely waits to be turned on, the pencils to be used. Certain of his later nudes – almost all his nudes are men – for example, *'Man Taking Shower* (1965), are elegant combinations of the realism at which he has come to aim and lucid design, shown in this painting by his use of the white spear-shaped shower to lend a touch of mystery to the body while giving a tightly knit unity to the composition. However intense his interest in paint – 'there are people who think painting old hat. But I still think it's still some use myself,' he has said – he remains essentially a draughtsman. Large areas of his pictures are often virtually monochromes. But how fine a draughtsman he is is clear from his portrait-drawings: the *Isherwood, Auden*, both *I* and *II, Richard Hamilton* (all 1968), and *James Kirkman* and *Celia Birtwell* (both 1969) are particularly penetrating examples.

I have, I hope, conveyed in the preceding pages my high regard for Hockney. His spectacular success is due not only to his exceptional talent and his capacity for work but to the time of his emergence. Most of the painters of the century are not abstract, but the concept of abstraction – involving the elimination of the subject or at least its total subordination, often to the point of unintelligibility; apt, too, to be accompanied by an attitude of denigration towards the explicit portrayal of subjects by contemporaries or near-contemporaries as 'literary' and them as 'academic' – has had immense influence. One of the manifestations of this influence is the assumption that art progresses; it has, too, fostered a pervasive atmosphere of constrictive pendantry. The painters who figure in this book are among those unaffected by it, but none so spectacularly successful at so early an

age, so 'fashionable', has treated this concept with such total and publicly expressed indifference. Hockney has not only ridiculed art, for instance, by his *Picture of a Painter's Abstraction Framed Under Glass* (1965) – although there is abstract art which he wholeheartedly admires – but as he said in *Art and Artists*, April 1970:

> I have stopped bothering about modern art, in that at one time you would be frightened of doing things in painting because you would consider them almost reactionary. I've stopped believing that it's possible for art to progress only in a stylistic way.

It is characteristic of him that he should have expressed admiration for Dubuffet as a student, later on for Klee and later still for realists such as Balthus, Morandi, Hopper and even for Sargent. 'You see,' he said, 'I admire Sargent enormously.' No other painter very closely identified with contemporary movements would, I believe, thus proclaim his admiration for Sargent.

Hockney's openness, his spontaneity, his total freedom from pendantry, his indifference to received dogma, has done much to liberate the opinions of his generation, and his own reputation as an artist has been vastly enchanced by the liberation which he has helped, by his work and his public attitudes, to bring about.

Hockney's immense and still-growing success has never diminished his self-criticism; dissatisfied, he throws many of his pictures away. And he gives himself ever greater trouble, as a number of these have taken some six months to complete; 'The more you know,' he says, 'the more difficult it gets.'

In New York, Hockney formed a close friendship with Henry Geldzahler, the Curator of Twentieth-Century art at the Metropolitan Museum. They often met and discussed a wide variety of subjects and travelled together in various countries of Europe. It was understood that Geldzahler was to write a book on Hockney. Time passed, however, and he did not do so. Eventually Hockney decided to write it himself, and he dictated for twenty-five hours into a tape-recorder for his friend Nikos Strangos, who questioned him closely and edited the replies. Thus emerged *David Hockney by David Hockney* (1976), to which Geldzahler contributed an informative introduction. It is a formidable volume and an illuminating autobiography – also entertaining. The book ends with: 'Jasper Johns . . . told me about a scene in *The Maltese Falcon* where a man says to the detective, "What does it mean, 'In the room the women come and go, talking of Michelangelo?' " And the detective says, it probably means that he doesn't know much about women. Pretty good. I like that.'

BIBLIOGRAPHY

Graham Sutherland:
Monographs on the artist by: Edward Sackville-West, 1943; Robert Melville, 1950; Douglas Cooper, 1961.

Albert Houtheusen:
Albert Houtheusen: An Appreciation, intro. by John Rothenstein, 1969.

John Piper:
Monographs on the artist by: John Betjeman, 1944; S. John Woods, 1955.

Edward Burra:
Edward Burra, John Rothenstein, 1945.

Tristram Hillier:
Leda and the Goose, Tristram Hillier, 1954.

Cecil Collins:
Cecil Collins, Paintings and Drawings, Alex Comfort, 1946.

Michael Andrews:
Notes & Preocupations, Michael Andrews, 1960.

Francis Bacon:
Monographs on the artist by: John Rothenstein, 1963; John Rothenstein and Ronald Alley, 1964; John Russell, 1967; Lorenza Trucchi, 1975.
Interviews with Francis Bacon, David Silvester, 1975.

Bridget Riley:
Bridget Riley, Maurice de Sausmarez, 1970.

David Hockney:
Seventy-two Drawings, David Hockney, 1971.
David Hockney by David Hockney, 1976.

LOCATION OF WORKS MENTIONED IN THIS VOLUME
(public galleries only)

Thomas Hennell
S.S. Polar Bear in the slips at Reykjavik, The Imperial War Museum, London
The Tithe Barn at St Pierre-sur-Dives, The Imperial War Museum, London
H.M.S. Nelson receiving a Japanese vessel to make arrangements for the British occupation of Penang, 3 September 1945, The Imperial War Museum, London

Eric Ravilious
H.M.S. Glorious in the Arctic, The Imperial War Museum, London
H.M.S. Ark Royal in Action, The Imperial War Museum, London

Graham Sutherland
Entrance to Lane, The Tate Gallery, London
Estuary with Rocks, The British Council
Thorn Tree, The British Council
Thorn Trees, The British Council
Standing Form against a Hedge, The Arts Council
Thorn Cross, Galerie des 20 Jahrhunderts, Berlin
Crucifixion, Leicester Museum
Portrait of Maugham, The Tate Gallery, London
Lord Beaverbrook, The Beaverbrook Foundation, Fredericton, New Brunswick, Canada
Hon. Edward Sackville-West, The City Art Gallery, Birmingham

Albert Houthuesen
The Butcher's Block, The City Art Gallery, Leeds
Farm on Fire, Tullie House, Carlisle
Maes Gwyn Stack Yard, The Tate Gallery, London
Painted in a Welsh Village, The Tate Gallery, London

John Piper
House of Commons, Aye Lobby, The Imperial War Museum, London
Interior of Coventry Cathedral, The City Art Gallery, Coventry
Dead Resort: Kemp Town, Temple Newsam, Leeds
St Mary le Port, Bristol, The Tate Gallery, London
All Saints Chapel, Bath, The Tate Gallery, London
Somerset Place, Bath, The Tate Gallery, London

Catherine Dean
Cat Asleep in a High Backed Chair, The Tate Gallery, London
Sheep's Skull and Ferns, The Tate Gallery, London

Edward Burra
Harlem, The Tate Gallery, London
Holy Week, Seville, The Tate Gallery, London
Mexican Church, The Tate Gallery, London
Christ Mocked, The National Gallery of Victoria, Melbourne
The Expulsion of the Money-Lenders, The Beaverbrook Gallery, New Brunswick, Canada
The Entry into Jerusalem, The Beaverbrook Gallery, New Brunswick, Canada

Tristram Hillier
La Route des Alpes, The Tate Gallery, London
Harness, The Tate Gallery, London
The Bridle, The National Gallery of Canada, Ottawa
Trinity Wharf, National Gallery of New South Wales
January Landscape, Somerset, Harris Museum and Art Gallery, Preston

233

Cecil Collins
The Field of Corn, Victoria and Albert
 Museum, London
Hymn to Death, The Tate Gallery, London
The Golden Wheel, The Tate Gallery,
 London

Victor Pasmore
Chiswick Reach, The National Gallery of
 Canada, Ottawa
*Square Motif in Brown, White, Blue and
 Ochre*, Museum of Modern Art, New
 York
Spiral Motif: The Wave, The National
 Gallery of Canada, Ottawa
*The Snowstorm: Spiral Motif in Black and
 White*, The Arts Council
*Relief Construction in White, Black and
 Indian Red*, Marlborough Fine Art,
 London

Francis Bacon
Figure Study II, Bagshawe Art Gallery,
 Batley, Yorks.
Triptych, centre panel. Figures on Beds,
 Marlborough Fine Art, London
Three Figures at the Base of a Crucifixion,
 The Tate Gallery, London
Painting 1946, The Museum of Modern
 Art, New York
Three Figures in a Room, Centre National
 d'Art Contemporain, on loan to Musee
 National d'Art Moderne, Paris
Lying Figures with a Hypodermic Syringe,
 Guggenheim Museum, New York
Three Studies for a Crucifixion,
 Guggenheim Museum, New York
*Triptych: inspired by T. S. Eliot's 'Sweeney
 Agonistes'*, The Hirshhorn Foundation,
 New York
Three Studies of Lucian Freud, Galleria
 Galatea, Turin

Robert Coloquhoun
Seated Woman with Cat, The Arts Council

Woman with a Birdcage, Bradford City Art
 Gallery
Woman with Leaping Cat, The Tate Gallery

Lucian Freud
Girl with a White Dog, The Tate Gallery,
 London
Self-Portrait, The Tate Gallery, London
Francis Bacon, The Tate Gallery, London
John Minton, The Royal College of Art,
 London
Head of a Woman, The British Council
Dead Monkey, The Museum of Modern
 Art, New York
The Woman with a Daffodil, The Museum
 of Modern Art, New York
The Hotel Room, The Beaverbrook
 Gallery, Fredericton, Canada

Michael Andrews
Family in the Garden, The Gulbenkian
 Foundation

Alan Reynolds
Keeper of the Dark Copse II, The Tate
 Gallery, London
Summer: Young September's Cornfield, The
 Tate Gallery, London
Fir Tree, National Gallery of South
 Australia
Composition Winter, The Graves Art
 Gallery, Sheffield
Vertical Construction III, The Arts Council

Bridget Riley
Movement in Squares, The Arts Council
Fission, The Museum of Modern Art,
 New York
Fall, The Tate Gallery, London
Late Morning, The Tate Gallery, London

David Hockney
The Second Marriage, The National Gallery
 of Victoria, Melbourne

INDEX

Page references in **bold type** refer to the section of the book which deals specifically with that particular artist.

240

INDEX